Adobe Photoshop CC

3rd Edition

by Peter Bauer

Adobe® Photoshop® CC For Dummies®, 3rd Edition

Published by: John Wiley & Sons, Inc., 111 River Street, Hoboken, NJ 07030-5774, www.wiley.com

Copyright © 2021 by John Wiley & Sons, Inc., Hoboken, New Jersey

Published simultaneously in Canada

No part of this publication may be reproduced, stored in a retrieval system or transmitted in any form or by any means, electronic, mechanical, photocopying, recording, scanning or otherwise, except as permitted under Sections 107 or 108 of the 1976 United States Copyright Act, without the prior written permission of the Publisher. Requests to the Publisher for permission should be addressed to the Permissions Department, John Wiley & Sons, Inc., 111 River Street, Hoboken, NJ 07030, (201) 748–6011, fax (201) 748–6008, or online at http://www.wiley.com/go/permissions.

Trademarks: Wiley, For Dummies, the Dummies Man logo, Dummies.com, Making Everything Easier, and related trade dress are trademarks or registered trademarks of John Wiley & Sons, Inc. and may not be used without written permission. Adobe and Photoshop are registered trademarks of Adobe, Inc. All other trademarks are the property of their respective owners. John Wiley & Sons, Inc. is not associated with any product or vendor mentioned in this book.

LIMIT OF LIABILITY/DISCLAIMER OF WARRANTY: THE PUBLISHER AND THE AUTHOR MAKE NO REPRESENTATIONS OR WARRANTIES WITH RESPECT TO THE ACCURACY OR COMPLETENESS OF THE CONTENTS OF THIS WORK AND SPECIFICALLY DISCLAIM ALL WARRANTIES, INCLUDING WITHOUT LIMITATION WARRANTIES OF FITNESS FOR A PARTICULAR PURPOSE. NO WARRANTY MAY BE CREATED OR EXTENDED BY SALES OR PROMOTIONAL MATERIALS. THE ADVICE AND STRATEGIES CONTAINED HEREIN MAY NOT BE SUITABLE FOR EVERY SITUATION. THIS WORK IS SOLD WITH THE UNDERSTANDING THAT THE PUBLISHER IS NOT ENGAGED IN RENDERING LEGAL, ACCOUNTING, OR OTHER PROFESSIONAL SERVICES. IF PROFESSIONAL ASSISTANCE IS REQUIRED, THE SERVICES OF A COMPETENT PROFESSIONAL PERSON SHOULD BE SOUGHT. NEITHER THE PUBLISHER NOR THE AUTHOR SHALL BE LIABLE FOR DAMAGES ARISING HEREFROM. THE FACT THAT AN ORGANIZATION OR WEBSITE IS REFERRED TO IN THIS WORK AS A CITATION AND/OR A POTENTIAL SOURCE OF FURTHER INFORMATION DOES NOT MEAN THAT THE AUTHOR OR THE PUBLISHER ENDORSES THE INFORMATION THE ORGANIZATION OR WEBSITE MAY PROVIDE OR RECOMMENDATIONS IT MAY MAKE. FURTHER, READERS SHOULD BE AWARE THAT INTERNET WEBSITES LISTED IN THIS WORK MAY HAVE CHANGED OR DISAPPEARED BETWEEN WHEN THIS WORK WAS WRITTEN AND WHEN IT IS READ.

For general information on our other products and services, please contact our Customer Care Department within the U.S. at 877-762-2974, outside the U.S. at 317-572-3993, or fax 317-572-4002. For technical support, please visit https://hub.wiley.com/community/support/dummies.

Wiley publishes in a variety of print and electronic formats and by print-on-demand. Some material included with standard print versions of this book may not be included in e-books or in print-on-demand. If this book refers to media such as a CD or DVD that is not included in the version you purchased, you may download this material at http://booksupport.wiley.com. For more information about Wiley products, visit www.wiley.com.

Library of Congress Control Number: 2020952052

ISBN 978-1-119-71177-3; ISBN 978-1-119-71179-7 (ebk); ISBN 978-1-119-71178-0 (ebk)

Manufactured in the United States of America

SKY10023575_010421

Contents at a Glance

Introduction	1
Part 1: Getting Started with Photoshop CC CHAPTER 1: An Overview of Photoshop	
Part 2: Easy Enhancements for Digital Images CHAPTER 5: Making Tonality and Color Look Natural CHAPTER 6: The Adobe Camera Raw Plug-In CHAPTER 7: Fine-Tuning Your Fixes CHAPTER 8: Common Problems and Their Cures	
Part 3: Creating "Art" in Photoshop CHAPTER 9: Combining Images CHAPTER 10: Precision Edges with Vector Paths CHAPTER 11: Dressing Up Images with Layer Styles. CHAPTER 12: Giving Your Images a Text Message CHAPTER 13: Painting in Photoshop CHAPTER 14: Filters: The Fun Side of Photoshop	191 211 235 257
Part 4: Power Photoshop CHAPTER 15: Streamlining Your Work in Photoshop CHAPTER 16: Working with Video and Animation	335
Part 5: The Part of Tens CHAPTER 17: Ten Specialized Features of Photoshop CC CHAPTER 18: Ten Ways to Integrate Your iPad CHAPTER 19: Ten Things to Know about HDR	369
Appendix: Photoshop CC's Blending Modes	399
Index	403

Complete the state of the second

Of Set Walter

and the first of the second of	T mar
Programmer of the State of the Company of the	
general Arminit grahem.	
eropacits What were	

Table of Contents

INTRO	DUCTION	1
	About This Book	1
	Conventions Used in This Book	2
	Icons Used in This Book	3
	How to Use This Book	3
PART 1	: GETTING STARTED WITH PHOTOSHOP CC	5
CHAPTER 1:	An Overview of Photoshop	7
	Exploring Adobe Photoshop	
	What Photoshop is designed to do	
	Other things you can do with Photoshop	
	Viewing Photoshop's Parts and Processes	
	Reviewing basic computer operations	
	Photoshop's incredible selective Undo	
	Installing Photoshop: Need to know	
CHAPTER 2:	Knowing Just Enough about Digital Images	. 17
	What Exactly Is a Digital Image?	
	The True Nature of Pixels	
	How Many Pixels Can Dance on the Head of a Pin?	
	Resolution revelations	
	Resolving image resolution	
	File Formats: Which Do You Need?	30
	Formats for digital photos	31
	Formats for web graphics	
	Formats for commercial printing	
	Formats for PowerPoint and Word	36
CHAPTER 3:	Taking the Chef's Tour of Your	
	Photoshop Kitchen	
	Food for Thought: How Things Work	38
	Ordering from the menus	
	Your platter full of panels	
	The tools of your trade	
	Get Cookin' with Customization	
	Clearing the table: Custom workspaces	
	Spoons can't chop: Creating tool presets	
	Season to Taste: The Photoshop Settings	
	Standing orders: Setting the Preferences	
	Ensuring consistency: Color Settings	
	When Good Programs Go Bad: Fixing Photoshop	57

CHAPTER 4: From Pics to Prints: Ph	otoshop for Beginners59
	p59
	rital camera
	61
	d66
	66
	67
	/69
Printing Your Images	71
	ct ratio
	nent solutions75
	75
0	77
	our images
	578
ereating Produce Websites	
PART 2: EASY ENHANCEMENT	rs for
DIGITAL IMAGES	79
CHAPTER 5: Making Tonality and C	olor Look Natural81
CHAPTER 5: Making Tonality and C Adjusting Tonality to Make You	olor Look Natural
CHAPTER 5: Making Tonality and C Adjusting Tonality to Make You Histograms Simplified	olor Look Natural 81 ir Images Pop 82 82 82
CHAPTER 5: Making Tonality and C Adjusting Tonality to Make You Histograms Simplified Using Photoshop's Auto Correct	olor Look Natural
CHAPTER 5: Making Tonality and C Adjusting Tonality to Make You Histograms Simplified Using Photoshop's Auto Correct Levels and Curves and You	olor Look Natural 81 ar Images Pop 82 82 ctions 84
CHAPTER 5: Making Tonality and C Adjusting Tonality to Make You Histograms Simplified Using Photoshop's Auto Correct Levels and Curves and You Level-headed you! Tonal corrections with the	olor Look Natural 81 ar Images Pop 82 ctions 84 85 eyedroppers 89
DIGITAL IMAGES CHAPTER 5: Making Tonality and C Adjusting Tonality to Make You Histograms Simplified Using Photoshop's Auto Correc Levels and Curves and You Level-headed you! Tonal corrections with the e	olor Look Natural 81 ar Images Pop 82 stions 84 85 86 eyedroppers 89 out dieting 90
DIGITAL IMAGES CHAPTER 5: Making Tonality and C Adjusting Tonality to Make You Histograms Simplified Using Photoshop's Auto Correc Levels and Curves and You Level-headed you! Tonal corrections with the e Adjusting your curves without Grabbing Even More Control	olor Look Natural 81 ar Images Pop 82 stions 84 stions 85 eyedroppers 89 out dieting 90 92
DIGITAL IMAGES CHAPTER 5: Making Tonality and C Adjusting Tonality to Make You Histograms Simplified Using Photoshop's Auto Correc Levels and Curves and You Level-headed you! Tonal corrections with the e Adjusting your curves without Grabbing Even More Control Using Shadows/Highlights .	olor Look Natural 81 ar Images Pop 82 stions 84 extions 85 86 86 eyedroppers 89 out dieting 90 92 93
CHAPTER 5: Making Tonality and C Adjusting Tonality to Make You Histograms Simplified Using Photoshop's Auto Correct Levels and Curves and You Level-headed you! Tonal corrections with the e Adjusting your curves without Grabbing Even More Control Using Shadows/Highlights Changing exposure after the	olor Look Natural 81 ar Images Pop 82 ctions 84 stions 85 eyedroppers 89 out dieting 90 92 93 e fact 96
CHAPTER 5: Making Tonality and C Adjusting Tonality to Make You Histograms Simplified Using Photoshop's Auto Correct Levels and Curves and You Level-headed you! Tonal corrections with the exadjusting your curves without Grabbing Even More Control Using Shadows/Highlights Changing exposure after the Using Photoshop's toning to	olor Look Natural 81 ar Images Pop 82 ctions 84 85 86 eyedroppers 89 out dieting 90 92 93 e fact 96 ools 96
DIGITAL IMAGES CHAPTER 5: Making Tonality and C Adjusting Tonality to Make You Histograms Simplified Using Photoshop's Auto Correc Levels and Curves and You Level-headed you! Tonal corrections with the e Adjusting your curves withe Grabbing Even More Control Using Shadows/Highlights . Changing exposure after th Using Photoshop's toning to What Is Color in Photoshop?	olor Look Natural 81 ar Images Pop 82 stions 84 85 86 eyedroppers 89 out dieting 90 92 93 e fact 96 ools 96 97
DIGITAL IMAGES CHAPTER 5: Making Tonality and C Adjusting Tonality to Make You Histograms Simplified Using Photoshop's Auto Correc Levels and Curves and You Level-headed you! Tonal corrections with the e Adjusting your curves withe Grabbing Even More Control Using Shadows/Highlights . Changing exposure after th Using Photoshop's toning to What Is Color in Photoshop? Which color mode should y	olor Look Natural 81 ar Images Pop 82 ctions 84 85 .eyedroppers 89 out dieting 90 92 93 .e fact 96 97 ou choose? 98
DIGITAL IMAGES CHAPTER 5: Making Tonality and C Adjusting Tonality to Make You Histograms Simplified Using Photoshop's Auto Correc Levels and Curves and You Level-headed you! Tonal corrections with the e Adjusting your curves without Grabbing Even More Control Using Shadows/Highlights. Changing exposure after th Using Photoshop's toning to What Is Color in Photoshop? Which color mode should y Does a color model make a	olor Look Natural 81 ar Images Pop 82 strions 84 strions 85 syedroppers 89 out dieting 90 se fact 96 ools 96 ou choose? 98 difference? 101
DIGITAL IMAGES CHAPTER 5: Making Tonality and C Adjusting Tonality to Make You Histograms Simplified Using Photoshop's Auto Correct Levels and Curves and You Level-headed you! Tonal corrections with the exadjusting your curves with C Grabbing Even More Control Using Shadows/Highlights. Changing exposure after th Using Photoshop's toning to What Is Color in Photoshop? Which color model make a Why should you worry about	olor Look Natural 81 ar Images Pop 82 strions 84 ctions 85 syedroppers 89 out dieting 90 92 93 e fact 96 sools 96 ou choose? 98 difference? 101 ut color depth? 102
DIGITAL IMAGES CHAPTER 5: Making Tonality and C Adjusting Tonality to Make You Histograms Simplified Using Photoshop's Auto Correc Levels and Curves and You Level-headed you! Tonal corrections with the e Adjusting your curves without Grabbing Even More Control Using Shadows/Highlights . Changing exposure after th Using Photoshop's toning to What Is Color in Photoshop? Which color mode should y Does a color model make a Why should you worry about Making Color Adjustments in P	olor Look Natural 81 ar Images Pop 82 ctions 84 stions 85 eyedroppers 89 out dieting 90 92 93 e fact 96 ools 96 ou choose? 98 difference? 101 ut color depth? 102 Photoshop 104
DIGITAL IMAGES CHAPTER 5: Making Tonality and C Adjusting Tonality to Make You Histograms Simplified Using Photoshop's Auto Correc Levels and Curves and You Level-headed you! Tonal corrections with the e Adjusting your curves without Grabbing Even More Control Using Shadows/Highlights. Changing exposure after th Using Photoshop's toning to What Is Color in Photoshop? Which color mode should y Does a color model make a Why should you worry about Making Color Adjustments in P Choosing color adjustment	olor Look Natural 81 ar Images Pop 82 ctions 84 stions 85 eyedroppers 89 out dieting 90 92 93 e fact 96 ools 97 ou choose? 98 difference? 101 ut color depth? 102 Photoshop 104 commands 106
DIGITAL IMAGES CHAPTER 5: Making Tonality and C Adjusting Tonality to Make You Histograms Simplified Using Photoshop's Auto Correc Levels and Curves and You Level-headed you! Tonal corrections with the e Adjusting your curves withe Grabbing Even More Control Using Shadows/Highlights. Changing exposure after th Using Photoshop's toning to What Is Color in Photoshop? Which color mode should y Does a color model make a Why should you worry abou Making Color Adjustments in P Choosing color adjustment Manual corrections in indiv	olor Look Natural 81 ar Images Pop 82 ctions 84 stions 85 eyedroppers 89 out dieting 90 92 93 e fact 96 ools 96 ou choose? 98 difference? 101 ut color depth? 102 Photoshop 104

CHAPTER 6:	The Adobe Camera Raw Plug-In	121
	Understanding the Raw Facts	121
	What's the big deal about Raw?	
	Working in Raw	124
	The Camera Raw Interface	126
	Camera Raw's Tools and buttons	126
	The histogram	132
	The preview area	132
	Workflow Options and presets	
	Making Adjustments in Camera Raw's Edit Panel	134
	The Basic section	
	The Curve section	
	The Detail section	
	The Color Mixer section	
	The Color Grading section	
	The Optics and Geometry sections	
	The Effects section	
	The Calibration section	
	The Camera Raw Cancel, Done, and Open buttons	142
CHAPTER 7:	Fine-Tuning Your Fixes	143
	What Is a Selection?	
	Feathering and Anti-aliasing	
	Making Your Selections with Tools	
	Marquee selection tools	
	Lasso selection tools	
	The Object Selection tool	
	The Quick Selection tool	
	The Magic Wand tool	
	Select and Mask	
	Your Selection Commands	156
	The primary selection commands	157
	The Color Range command	158
	The Focus Area command	
	The Select ➪ Subject command	160
	The Select ⇔ Sky command	
	Selection modification commands	161
	Transforming the shape of selections	
	Edit in Quick Mask mode	
	The mask-related selection commands	
	Masks: Not Just for Halloween Anymore	
	Saving and loading selections	
	Editing an alpha channel	
	Adding masks to layers and Smart Objects	
	Masking with vector paths	167

	Adjustment Layers: Controlling Changes	
	Adding an adjustment layerLimiting your adjustments	
CHAPTER 8:	Common Problems and Their Cures	173
	Making People Prettier	174
	Getting the red out digitally	
	The digital fountain of youth	
	Dieting digitally	
	De-glaring glasses	
	Whitening teeth	
	Reducing Noise in Your Images	
	Decreasing digital noise	
	Fooling Around with Mother Nature	
	Removing the unwanted from photos	
	Eliminating the lean: Fixing perspective	
	Rotating images precisely	
	Adding a beautiful sky	188
	3: CREATING "ART" IN PHOTOSHOP	
CHAPTER 9:	Combining Images	191
	Compositing Images: 1 + 1 = 1	
	compositing images.	192
	Understanding layers	192
	Understanding layers	192 194
	Understanding layers	192 194 195
	Understanding layers	192 194 195 198
	Understanding layers Why you should use Smart Objects Using the basic blending modes Opacity, transparency, and layer masks Creating clipping groups.	192 194 195 198 199
	Understanding layers Why you should use Smart Objects Using the basic blending modes Opacity, transparency, and layer masks Creating clipping groups. Making composited elements look natural	192 194 195 198 199
	Understanding layers Why you should use Smart Objects Using the basic blending modes Opacity, transparency, and layer masks Creating clipping groups. Making composited elements look natural Making Complex Selections	192 194 195 198 199 200
	Understanding layers Why you should use Smart Objects Using the basic blending modes Opacity, transparency, and layer masks Creating clipping groups. Making composited elements look natural Making Complex Selections Vanishing Point	192 194 195 198 199 200 201
CHAPTER 10	Understanding layers Why you should use Smart Objects Using the basic blending modes Opacity, transparency, and layer masks Creating clipping groups. Making composited elements look natural Making Complex Selections	192 194 195 198 199 200 201 204
CHAPTER 10	Understanding layers Why you should use Smart Objects Using the basic blending modes Opacity, transparency, and layer masks Creating clipping groups. Making composited elements look natural Making Complex Selections Vanishing Point Creating Panoramas with Photomerge	192 194 195 198 199 200 201 204 208
CHAPTER 10	Understanding layers Why you should use Smart Objects Using the basic blending modes Opacity, transparency, and layer masks Creating clipping groups. Making composited elements look natural Making Complex Selections Vanishing Point Creating Panoramas with Photomerge Precision Edges with Vector Paths Pixels, Paths, and You Easy Vectors: Using Shapes	192 194 195 198 200 201 204 208 211 212
CHAPTER 10	Understanding layers Why you should use Smart Objects Using the basic blending modes Opacity, transparency, and layer masks Creating clipping groups. Making composited elements look natural Making Complex Selections. Vanishing Point Creating Panoramas with Photomerge Precision Edges with Vector Paths. Pixels, Paths, and You Easy Vectors: Using Shapes Your basic shape tools	192 194 195 198 199 200 201 204 208 211 212 213
CHAPTER 10	Understanding layers Why you should use Smart Objects Using the basic blending modes Opacity, transparency, and layer masks Creating clipping groups. Making composited elements look natural Making Complex Selections. Vanishing Point Creating Panoramas with Photomerge Precision Edges with Vector Paths. Pixels, Paths, and You. Easy Vectors: Using Shapes Your basic shape tools The Custom Shape tool	192 194 195 198 199 200 201 204 212 212 213 214
CHAPTER 10	Understanding layers Why you should use Smart Objects Using the basic blending modes Opacity, transparency, and layer masks Creating clipping groups. Making composited elements look natural Making Complex Selections Vanishing Point Creating Panoramas with Photomerge Precision Edges with Vector Paths Pixels, Paths, and You Easy Vectors: Using Shapes Your basic shape tools The Custom Shape tool More custom shapes — free!	192 194 195 198 200 201 204 208 211 212 213 214 216
CHAPTER 10	Understanding layers Why you should use Smart Objects Using the basic blending modes Opacity, transparency, and layer masks Creating clipping groups. Making composited elements look natural Making Complex Selections. Vanishing Point Creating Panoramas with Photomerge Precision Edges with Vector Paths. Pixels, Paths, and You. Easy Vectors: Using Shapes Your basic shape tools The Custom Shape tool	192 194 195 198 200 201 204 208 211 212 213 214 216 217

	Using Your Pen Tool to Create Paths	
	Clicking and dragging your way down the path	
	of knowledge	226
	Customizing Any Path	
	Adding, deleting, and moving anchor points	230
	Combining paths	
	Tweaking type for a custom font	
CHAPTER 11	Dressing Up Images with Layer Styles	. 235
CHAI IER O	What Are Layer Styles?	
	Using the Styles Panel	.237
	Creating Custom Layer Styles	
	Exploring the Layer Style menu	.239
	Exploring the Layer Style dialog box	.241
	Layer effects basics	
	Opacity, fill, and advanced blending	
	Saving Your Layer Styles	
	Adding styles to the Styles panel	.254
	Preserving your layer styles	.255
CHAPTER 12	Giving Your Images a Text Message	
	Making a Word Worth a Thousand Pixels	.258
	A type tool for every season, or reason	.260
	What are all those options?	.262
	Taking control of your text with panels	.266
	The panel menus — even more options	
	Working with Styles	
	Putting a picture in your text	.272
	Creating Paragraphs with Type Containers	
	Selecting alignment or justification	.276
	Ready, BREAK! Hyphenating your text	.2//
	Shaping Up Your Language with Warp Text and Type on a Path	.2/8
	Applying the predefined warps	
	Customizing the course with paths	
CHAPTER 13	Painting in Photoshop	
	Discovering Photoshop's Painting Tools	.284
	Painting with the Brush tool	.286
	Adding color with the Pencil tool	

Working with Panels and Selecting Colors	290
An overview of options	290
Creating and saving custom brush tips	293
Picking a color	
Fine Art Painting with Specialty Brush Tips and the Mixer Brush.	
Exploring erodible brush tips	
Introducing airbrush and watercolor tips	297
Mixing things up with the Mixer Brush	
Filling, Stroking, Dumping, and Blending Colors	
Deleting and dumping to add color	300
Using gradients	
CHAPTER 14: Filters: The Fun Side of Photoshop	
Smart Filters: Your Creative Insurance Policy	
The Filters You Really Need	
Sharpening to focus the eye	308
Unsharp Mask	308
Smart Sharpen	
Shake Reduction	
Blurring images and selections	
The other Blur filters	
Correcting for the vagaries of lenses	316
Cleaning up with Reduce Noise	
Getting Creative and Artistic	321
Photo to painting with the Oil Paint filter	
Working with the Filter Gallery	
Push, Pull, and Twist with Liquify	325
What Are Neural Filters?	327
The original Neural Filters	
Neural Filters in public beta testing	
Proposed Neural Filters	330
Do I Need Those Other Filters?	330
Adding drama with Lighting Effects	
Maximum and Minimum	
Bending and bubbling	
Creating clouds	
PART 4: POWER PHOTOSHOP	222
CHAPTER 15: Streamlining Your Work in Photoshop	
Ready, Set, Action!	336
Recording your own Actions	
Working with the Batch command	

F	Find It Fast with Discover	344
(Creating Contact Sheets and Presentations	
	Creating a PDF presentation	345
	Collecting thumbnails in a contact sheet	
	Scanning Multiple Photos in One Pass	
5	Sticking to the Script	350
	Working with Video and Animation	
1	mporting and Enhancing Video Clips	
	Getting video into Photoshop	
	Adjusting the length of video and audio clips	
	Adding adjustment layers and painting on video layers	
	Transitioning, titling, and adding special effects	
	Transforming video layers	
,	Creating Animations in Photoshop	
(Building frame-based animations	
	Creating frame content	
	Tweening to create intermediary frames	
	Specifying frame rate	
	Optimizing and saving your animation	
	THE PART OF TENS	
CHAPTER 17:	Ten Specialized Features of Photoshop CC	369
l	Using Smart Object Stack Modes	.370
	The Mean Stack Mode	
1	Working with 3D Artwork	
	Creating 3D objects	
	Adding 3D objects	.373
	Rendering and saving 3D scenes	.374
	Measuring, Counting, and Analyzing Pixels	
	Measuring length, area, and more	
	Calculating with Vanishing Point	
,	Viewing Your DICOM Medical Records	
	Ignoring MATLAB	
'	ISTOCING WINTEND	.5,0
	Ten Ways to Integrate Your iPad	
	Using Sidecar to Add an iPad to Your Screen	
	Sidecar System Requirements	
	Arranging Your iPad's Screen.	
	Mirroring the Screens	
	Maximizing the Screen Space	ا ەد.

Making Use of Photoshop on the iPad	382
Using the Cloud with Photoshop on the iPad and Desktop.	
Using Other Adobe iPad Apps	384
Does the iPad Replace My Wacom Tablet?	
Setting Wacom Tablet Preferences for Touch Keys	
and Touch Ring	
Ton Things to Know shout UDD	
CHAPTER 19: Ten Things to Know about HDR	
Understanding HDR	387
Capturing for Merge to HDR Pro	
Preparing Raw "Exposures" in Camera Raw	
Working with Merge to HDR Pro	
Saving 32-Bit HDR Images	
HDR Toning	
Painting and the Color Picker in 32-Bit	
Filters and Adjustments in 32-Bit	
Selections and Editing in 32-Bit	
Printing HDR Images	397
APPENDIX: PHOTOSHOP CC'S BLENDING MODES.	399
INDEX	
INDEA	103

Introduction

dobe Photoshop CC is one of the most important computer programs of our age. It's made photo editing a commonplace thing, something for the everyperson. Still, Photoshop can be a scary thing, comprising a jungle of menus and panels and tools and options and shortcuts as well as a bewildering array of add-ons and plug-ins. And that's why you're holding this book in your hands. And why I wrote it. And why John Wiley & Sons, Inc., published it.

You want to make sense of Photoshop — or, at the very least, be able to work competently and efficiently in the program, accomplishing those tasks that need to get done. You want a reference that discusses how things work and what things do, not in a technogeek or encyclopedic manner, but rather as an experienced friend might explain something to you. Although step-by-step explanations are okay if they show how something works, you don't need rote recipes that don't apply to the work you do. You don't mind discovering tricks, as long as they can be applied to your images and artwork in a productive, meaningful manner. You're in the right place!

About This Book

This is a For Dummies book, and as such, it was produced with an eye toward you and your needs. From Day One, the goal has been to put into your hands the book that makes Photoshop CC understandable and usable. You won't find a technical explanation of every option for every tool in every situation, but rather a concise explanation of those parts of Photoshop CC you're most likely to need. If you happen to be a medical researcher working toward a cure for cancer, your Photoshop requirements might be substantially more specific than what you'll find covered here. But for the overwhelming majority of the people who have access to Adobe Photoshop, this book provides the background needed to get your work done with Photoshop.

As I updated this book, I intentionally tried to strike a balance between the types of images with which you're most likely to work and those visually stimulating (yet far less common) images of unusual subjects from faraway places. At no point in this book does *flavor* override *foundation*. When you need to see a practical

example, that's what I show you. I worked to ensure that each piece of artwork illustrates a technique and does so in a meaningful, nondistracting way for you.

You'll see that I used mostly Apple computers in producing this book. That's simply a matter of choice and convenience. You'll also see (if you look closely) that I shoot mostly with Canon cameras and use Epson printers. That doesn't mean that you shouldn't shoot with Nikon, or that you shouldn't print with HP or Canon. If that's what you have, if it's what you're comfortable with, and if it fulfills your needs, stick with it! I also mention Wacom drawing tablets here and there. Does that mean you should have one? If you do any work that relies on precise cursor movement (like painting, dodging, burning, path creation and editing, cloning, healing, patching, or lassoing, just to name a few), yes, I do recommend a Wacom Cintiq display or Intuos tablet, or even integrating your iPad (see Chapter 18).

One additional note: If you're brand new to digital imaging and computers, this probably isn't the best place to start. I do indeed make certain assumptions about your level of computer knowledge (and, to a lesser degree, your knowledge of digital imaging). But if you know your File \hookrightarrow Open from your File \hookrightarrow Close and can find your lens cap with both hands, read Chapter 1, and you'll have no problem with *Photoshop CC For Dummies*, 3rd Edition. Also, don't overlook Chapter 4, which I call "From Pics to Prints: Photoshop for Beginners."

Conventions Used in This Book

To save some space and maintain clarity, I use an arrow symbol as shorthand for Photoshop menu commands. I could write this:

Move the cursor onto the word Image at the top of your screen and press the mouse button. Continuing to press the mouse button, move the cursor downward to the word Adjustments. Still pressing the mouse button, move the cursor to the right and downward onto the words Shadows/Highlights. Release the mouse button.

But it makes more sense to write this:

Choose Shadows/Highlights from the Image

Adjustments menu.

Or even to use this:

Choose Image → Adjustments → Shadows/Highlights.

I also include keyboard shortcuts (when applicable) for both Mac and Windows. Generally the shortcuts are together, with the Mac shortcut always first, and they look like this:

Move the selection to a separate layer with the shortcut ℜ +Shift+J/Ctrl+Shift+J.

Icons Used in This Book

Icons appear in the margins throughout this book, and they indicate something special. Here, without further ado, is the gallery:

This icon tells you that I'm introducing a new feature, something just added to the program with this version of Photoshop CC. If you're brand new to Photoshop yourself, you can ignore this icon — it's all new to you. If you're an experienced Photoshop user, take note.

When I have a little secret or shortcut to share with you — something that can make your life easier, smoother, more convenient — you see the Tip icon.

This icon doesn't appear very often, but when it does, read carefully! I reserve the Warning icon for those things that can really mess up your day — things that can cause you to lose work by ruining your file or preventing Photoshop from fulfilling your wishes. If there were to be a quiz afterward, every Warning would be included!

REMEMBER

The Remember icon shows you good-to-know stuff, things that are applicable in a number of different places in Photoshop, or things that can make your Photoshop life easier.

You might notice this icon in a place or two in the book. It's not common because I exclude most of the highly technical background info: you know, the boring techno-geek concepts behind Photoshop. But when you do see the icon, it indicates something that you probably should know.

How to Use This Book

This is a reference book, not a lesson-based workbook or a tips-and-tricks cookbook. When you have a question about how something in Photoshop works, flip to the Table of Contents or the index to find your spot. You certainly can read the chapters in order, cover to cover, to make sure that you get the most out of it. Nonetheless, keep this book handy while you work in Photoshop. (Reading cover to cover not only ensures that you find out the most about Photoshop but also guarantees that you don't miss a single cartoon or joke.) If Photoshop is, in fact, something new to you, I do recommend reading Chapters 1 through 4 in order before you start getting busy with the software.

Unless you're borrowing a friend's copy or you checked this book out of the library or are reading it on your iPad, I suggest you get comfortable with the thought of sticky notes and bent page corners. Photoshop is a very complex program — no one knows everything about Photoshop. And many concepts and techniques in Photoshop are hard to remember, especially if you don't use them often. Bookmark those pages so that they're easy to find next time because you're sure to be coming back time and again to Photoshop CC For Dummies, 3rd Edition.

Also be sure to check out this book's Cheat Sheet. Go to www.dummies.com and search for "Photoshop CC For Dummies Cheat Sheet."

Getting Started with Photoshop CC

IN THIS PART . . .

Get an introduction to Photoshop.

Discover "pixels" and see how they form a digital image.

Find out which file formats you need and when you need them.

Develop an understanding of Photoshop's menus, panels, and tools.

Bring images into Photoshop, organize the image files, and get those pictures on paper with your own printer or a photo lab: Photoshop for Beginners.

- » What you need to know to work with Photoshop
- » What you need to know about installing Photoshop

Chapter **1**An Overview of Photoshop

dobe Photoshop is, without question, the leading image-editing program in the world. Photoshop has even become somewhat of a cultural icon. It's not uncommon to hear Photoshop used as a verb ("That picture is obviously Photoshopped!"), and you'll even see references to Photoshop in the daily comics and cartoon strips. And now you're part of this whole gigantic phenomenon called Photoshop.

Before I take you on this journey through the intricacies of Photoshop, I want to introduce you to Photoshop in a more general way. In this chapter, I tell you what Photoshop is *designed* to do, what it *can do* (although not as capably as job–specific software), and what you can *get* it to do if you try really, really hard. I also review some basic computer operation concepts and point out a couple of places where Photoshop is a little different than most other programs. At the end of the chapter, I have a few tips for you on installing Photoshop to ensure that it runs properly.

Exploring Adobe Photoshop

Photoshop is used for an incredible range of projects, from editing and correcting digital photos to preparing images for magazines and newspapers to creating graphics for the web. You can also find Photoshop in the forensics departments of

law-enforcement agencies, scientific labs and research facilities, and dental and medical offices, as well as in classrooms, offices, studios, and homes around the world. As the Help Desk Director for KelbyOne (formerly the National Association of Photoshop Professionals), I spent more than two decades solving problems and providing solutions for Photoshop users from every corner of the computer graphics field and from every corner of the world. (It always amazed me how some people used Photoshop in ways for which the program was never designed!) Of course Photoshop is my "go-to" program for my own fine art photography and design work. Now, as a consultant, I also use Photoshop on a regular basis to identify fraudulently manipulated images and video.

What Photoshop is designed to do

Adobe Photoshop is an image-editing program. It's designed to help you edit images — digital or digitized images, photographs, and otherwise. This is the core purpose of Photoshop. Over the years, Photoshop has grown and developed, adding features that supplement its basic operations. But at its heart, Photoshop is an image editor. At its most basic, Photoshop's workflow goes something like this: You take a picture, you edit the picture, and you print the picture (as illustrated in Figure 1-1). (Of course, many images never make it to paper — they are shared only on social media.)

FIGURE 1-1: Basic Photoshop: Take photo, edit photo, print photo. Drink coffee (optional).

Whether captured with a digital camera, scanned into the computer, or created from scratch in Photoshop, your artwork consists of tiny squares of color, which are picture elements called *pixels*. (I explore pixels and the nature of digital imaging in-depth in Chapter 2.) Photoshop is all about changing and adjusting the colors of those pixels — collectively, in groups, or one at a time — to make your artwork look precisely how you want it to look. (Photoshop, by the way, has no Good Taste or Quality Art button. It's up to you to decide what suits your artistic or personal vision and what meets your professional requirements.) Some very common Photoshop image-editing tasks are shown in Figure 1–2: namely, correcting red eye and minimizing wrinkles (both discussed in Chapter 8); and compositing images (see Chapter 9).

FIGURE 1-2: Some common Photoshop tasks.

Astronaut image courtesy of NASA

Photoshop works with actual vector shapes, such as those created in Adobe Illustrator. Photoshop also has a very capable brush engine, including erodible brush tips (they wear down and need to be resharpened) and airbrush and watercolor brush tips, further extending the fine art painting capabilities of the program. Figure 1–3 shows a comparison of raster artwork (the digital photo, left), vector artwork (the illustration, center), and digital painting (right). The three types of artwork can appear in a single image, too. (Creating vector artwork is presented in Chapter 10, and you can read about painting with Photoshop in Chapter 13.)

FIGURE 1-3: You can use Photoshop with raster images, vector shapes, and even to paint.

Photoshop also includes some basic features for creating web graphics, including slicing and animations (see Chapter 16 for info on video and animation). (Web work is best done in a true web development program, such as Dreamweaver. If you want to learn about creating websites, pick up a copy of *Dreamweaver CC For Dummies* [Wiley].)

Other things you can do with Photoshop

Admittedly, Photoshop just plain can't do some things. It won't make you a good cup of coffee. It can't press your trousers. It doesn't vacuum under the couch. It

isn't even a substitute for Zoom, Microsoft Excel, or TurboTax — it just doesn't do those things.

However, there are a number of things for which Photoshop isn't designed that you can do in a pinch. If you don't have InDesign, you can still lay out the pages of a newsletter, magazine, or even a book, one page at a time. If you don't have Dreamweaver, you can use Photoshop to create a website, one page at a time, sliced and optimized and even with animated GIFs. You can create multipage PDFs and PDF presentations (see Chapter 15). And although you're probably not going to create the next blockbuster on your laptop with Photoshop, the video editing capabilities can certainly get you through the family reunion or that school project (see Chapter 16).

Viewing Photoshop's Parts and Processes

In many respects, Photoshop is just another computer program — you launch the program, open files, save files, and quit the program quite normally. Many common functions have common keyboard shortcuts. You enlarge, shrink, minimize, and close windows as you do in other programs.

Reviewing basic computer operations

Chapter 3 looks at Photoshop-specific aspects of working with floating panels, menus and submenus, and tools from the Options bar, but I want to take just a little time to review some fundamental computer concepts.

Launching Photoshop

You can *launch* Photoshop (start the program) by double-clicking an image file or through the Applications folder (Mac) or the Start menu (Windows). Mac users can drag the Photoshop program icon (the actual program itself, with the .app file extension) to the Dock to make it available for one-click startup. (Chapter 3 shows you the Photoshop interface and how to get around in the program.)

WARNIN

Never open an image into Photoshop from removable media (CD, DVD, your digital camera or its Flash card, jump drives, and the like) or from a network drive. Although you can work with Cloud-based images, it's usually a good idea to copy the file to a local hard drive, open from that drive, save back to the drive, and then copy the file to its next destination. You can open from internal hard drives or external hard drives, but to avoid the risk of losing your work (or the entire image file) because of a problem reading from or writing to removable media, always copy to a local hard drive or work with images stored in your Cloud documents.

Working with images

Within Photoshop, you work with individual image files. Each image is recorded on the hard drive in a specific file format. Photoshop opens just about any current image file consisting of pixels as well as some file formats that do not. (I discuss file formats in Chapter 2.) Remember that to change a file's format, you open the file in Photoshop and use the Save As command to create a new file. And, although theoretically not always necessary on the Mac, I suggest that you *always* include the file extension at the end of the filename. If Photoshop won't open an image, it might be in a file format that Photoshop can't read. It cannot, for example, open an Excel spreadsheet or a Microsoft Word document because those aren't image formats — and Photoshop is, as you know, an image-editing program.

If you have a brand-new digital camera and Photoshop won't open its Raw images, check your Creative Cloud Manager's Updates section to see whether a newer version of Camera Raw is available. (But remember that it takes a little time to prepare Camera Raw for new file formats. If you purchase a new camera on its first day of release, you may need to use the software that came with the camera until the next Camera Raw update is released.)

Saving your files

You must use the Save or Save As command to preserve changes to your images. After you save and close an image, some of those changes may be irreversible. When working with an important image, consider these tips:

- >> Work on a copy of the image file. Unless you're working with a digital photo in the Raw format (discussed in Chapter 6), make a copy of your image file as a backup before changing it in Photoshop. The backup ensures that should something go horribly wrong, you can start over. (You never actually change a Raw photo Photoshop can't rewrite the original file so you're always, in effect, working on a copy.)
- ➤ Activate auto recovery. In Photoshop's Preferences File Handling panel, make sure that the Automatically Save Recovery Information Every option is selected and set to an appropriate time interval. If Photoshop crashes while you're working, when you reopen the program, it will (hopefully) be able to present you with your artwork at the stage when last saved for auto recovery.
- >> Save your work as PSD file, too. Especially if your image has layers, save it in Photoshop's PSD file format (complete with all the layers) before using Save As to create a final copy in another format. If you don't save a copy with layers, going back to make one little change can cost hours of work.

Rather than choosing File \circlearrowleft Open, consider making it a habit to choose File \circlearrowleft Open As Smart Object. When working with Smart Objects, you can scale or transform multiple times without continually degrading the image quality, and you can work with Smart Filters, too! (You can read about Smart Filters in Chapter 14.)

If you attempt to close an image or quit Photoshop without saving your work first, you get a gentle reminder asking whether you want to save, close without saving, or cancel the close/quit (as shown in Figure 1-4).

Photoshop reminds you if you haven't saved changes to an image.

Keyboard shortcuts

Keyboard shortcuts are customizable in Photoshop (check out Chapter 3), but some of the basic shortcuts are the same as those you use in other programs. You open, copy, paste, save, close, and quit just as you do in Microsoft Word, your email program, and just about any other software. I suggest that you keep these shortcuts unchanged, even if you do some other shortcut customization.

Photoshop's incredible selective Undo

Here's one major difference between Photoshop and other programs. Almost all programs have some form of Undo, enabling you to reverse the most recent command or action (or mistake). Photoshop also has, however, a great feature that lets you *partially* undo. The History Brush tool can partially undo just about any filter, adjustment, or tool — by painting. You select the History Brush, choose a history state (a stage in the image development) to which you want to revert, and then paint over areas of the image that you want to change back to the earlier state.

You can undo as far back in the editing process as you want, with a couple of limitations: The History panel (where you select the state to which you want to revert) holds only a limited number of history states. In the Photoshop Preferences Performance pane, you can specify how many states you want Photoshop to remember (to a maximum of 1,000). Keep in mind that storing lots of history states takes up computer memory that you might need for processing filters and adjustments. That can slow things down. The default of 50 history states is good for most projects, but when using painting tools or other procedures that involve lots of repetitive steps (such as touching up with the

Dodge, Burn, or Clone Stamp tools), a larger number (perhaps as high as 200) is generally a better idea.

The second limitation is pixel dimensions. If you make changes to the image's actual size (in pixels) with the Crop tool, the Image © Crop command, or the Image Size or Canvas Size commands (both in the Image menu), you cannot revert to prior steps with the History Brush tool. You can choose as a source any history state that comes after the image's pixel dimensions change but none that come before.

Here's one example of using the History Brush as a creative tool. You open a copy of a photograph in Photoshop. You edit as necessary. You use the Black & White adjustment on the image to make it appear to be grayscale. In the History panel, you click in the left column next to a snapshot (a saved history state) or the step prior to Black & White to designate that as the *source state*, the appearance of the image to which you want to revert. You select the History Brush tool and paint over specific areas of the image to return them to the original (color) appearance (see Figure 1–5). There you have it — a grayscale image with areas of color, compliments of the History Brush tool!

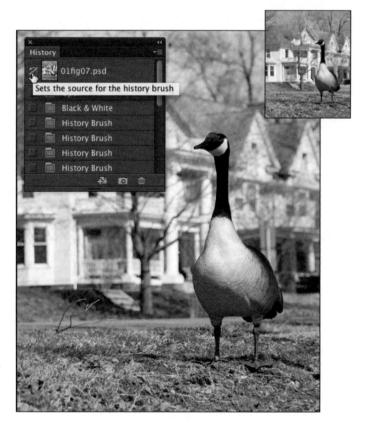

FIGURE 1-5:
Painting to
undo with
the History
Brush, with the
original in the
upper-right.

Photoshop has another very powerful partial Undo in the Fade command. Found in the Edit menu, Fade can be used immediately after just about any tool or adjustment or filter or, well, almost anything that changes the appearance of the image. (You can even fade the History Brush tool.) The Fade command enables you to change the opacity, blending mode, or both of whatever alteration you most recently made to the appearance of your artwork with tools or commands. You might, for example, use a Sharpen filter and then use the Fade command to change the filter's blending mode to Luminosity. That's the functional equivalent of sharpening the L channel in Lab color mode without having to switch color modes at all. Keep in mind that when I use the word *immediately*, I really mean it — you can't even use the Save command between applying a filter and using the Fade command.

Installing Photoshop: Need to know

If you haven't yet installed Photoshop, here are a few points to keep in mind:

- >> Install only into the default location. Photoshop is a resource-intensive program. Using the Creative Cloud Manager to install it into the default location (harddrive Applications on a Mac and C:\Program Files for Windows) ensures that it has access to the operating system and hardware as necessary. Installing into any other location or attempting to run Photoshop across a network can lead to frustrating problems and loss of work in progress.
- >>> Disable all spyware and antivirus software before installing. Antivirus software can intercept certain installation procedures, deeming them to be hazardous to your computer's health. That can lead to malfunctions, crashes, lost work, frustration, and what I like to call Computer Flying Across the Room Syndrome. If you use antivirus software (and if you use Windows, you'd better!), turn it off before installing any program, especially one as complex as Photoshop. You might find the antivirus program's icon in the Windows taskbar; or you might need to go to the Start menu, choose All Programs to locate the antivirus software, and disable it. On Mac, check the Dock. And don't forget to restart your antivirus software afterward! If you already installed Photoshop and antivirus software was running at the time, I urge you to uninstall and reinstall.
- >> If you use auto-backup software, shut it down, too. It's best not to run auto-backup software when installing software. Like antivirus software, it can also lead to problems by interfering with the installer.
- >> If you have third-party plug-ins, install them elsewhere. Third-party plug-ins those filters and other Photoshop add-ons that you buy from companies other than Adobe can be installed into a folder outside the

Photoshop folder. You can then make an alias (Mac) or shortcut (Windows) to that folder and drag the alias/shortcut to Photoshop's Plug-Ins folder. Why install outside the Photoshop folder? Should you ever need to (gasp!) reinstall Photoshop, you won't need to reinstall all your third-party plug-ins. Just create a new alias/shortcut and move it into Photoshop's new Plug-Ins folder. And don't forget to go to the plug-ins' websites to see whether the manufacturers offer updates!

- >> If you have lots of plug-ins, create sets. Plug-ins require random-access memory (RAM) (computer memory that Photoshop uses to process your editing commands). If you have lots of plug-ins, consider dividing them into groups according to how and when you use them. Sort (or install) them into separate folders. (Hint: Plug-ins that you use in many situations can be installed into multiple folders.) When you need to load a specific set, swap out the alias or shortcut in the Plug-Ins folder and restart Photoshop.
- >> If you love fonts, use a font-management utility. If you have hundreds of fonts (over the years, I've somehow managed to collect upward of 12,000 fonts), use a font-management utility to create sets of fonts according to style and activate only those sets that you need at any given time. Too many active fonts can choke the Photoshop type engine, slowing performance. The Mac OS has Font Book built right in, or you can use the excellent Suitcase Fusion (Mac and Windows) from Extensis (www.extensis.com).

- » Discovering resolution
- » Exploring the many file formats of Photoshop

Chapter 2

Knowing Just Enough about Digital Images

n the early days of photography, some less-advanced cultures viewed a photo with great suspicion and even fear. Was that an actual person, trapped in the paper? Did taking a photo steal a person's soul? You know that a camera doesn't trap anyone inside the paper — and you can be pretty sure about the stolen soul issue — but how much does the average shooter know about digital images? And how much do *you* need to know about digital images to work effectively in Photoshop?

The answers to those two questions are "Not as much as he/she should" and "Not as much as you might fear." In this chapter, I give you some basic information about how digital images exist in Photoshop, a real understanding of that critical term *resolution*, and an overview of the different ways that you can save your images. But most importantly, I help you understand the very nature of digital images by explaining the world of pixels.

Welcome to the Philosophy chapter!

What Exactly Is a Digital Image?

Whether you take a picture with a digital camera or use a scanner to bring a photo (or other artwork) into Photoshop, you are *digitizing* the image. That is, *digit* not as in a finger or toe, but as in a number. Computers do everything — absolutely everything — by processing numbers, and the basic language of computers is *binary code*. Whether it's a photo of a Tahitian sunset, a client's name in a database, or the latest box score on the Internet, your computer works on it in binary code. In a nutshell, binary code uses a series of zeros and ones (that's where the numbers part comes into play) to record information.

So what does binary code have to do with the wedding photos that you took this weekend or the masterpiece you must print for your thesis project? An image in Photoshop consists of tiny squares of color called *pixels* (*pixel* is short for *picture element*), as you can see in the close-up to the right in Figure 2-1. The computer records and processes each pixel in binary code. These pixels replicate a photo the same way that tiles in a mosaic reproduce a painting.

FIGURE 2-1: That's not really Hugo the Bulldog; it's a bunch of tiny, colored squares.

A tile in a mosaic isn't *face* or *sky* or *grass*; rather, it's beige or blue or green. The tiles individually have no relationship to the image as a whole; rather, they require an association with the surrounding tiles to give them purpose, to make them part of the picture. Without the rest of the tiles, a single tile has no meaning.

Likewise, a single pixel in a digital image is simply a square of color. It doesn't become a meaningful part of your digital image until it's surrounded by other pixels of the same or different color, creating a unified whole — a comprehensible picture. How you manipulate those pixels, from the time you capture the image digitally until you output the image to paper or the web, determines how successfully your pixels will represent your image, your artwork, your dream.

The True Nature of Pixels

Here are some basic truths about pixels that you really need to know. Although reading this section probably can't improve your love life, let you speak with ghosts, or give you the winning lottery number, it can help you understand what's happening to your image as you work with it in Photoshop.

- >> Each pixel is independent. You might think that you see a car or a circle or a tree or Uncle Bob in an image, but the image is actually only a bunch of little colored squares. Although you can read about various ways to work with groups of pixels throughout this book, each pixel exists unto itself.
- >>> Each pixel is square (except on TV). Really! Each pixel in a digital image is square except when you're creating images for some television formats, which use nonsquare pixels. It's important that you understand the squareness of pixels because you sometimes have to deal with those pointy little corners.
- **>> Each pixel can be exactly one color.** That color can change as you edit or alter the image, but each pixel consists entirely of a single color there's no such thing as a two-tone pixel. Figure 2-2, at 3,200 percent zoom, shows each pixel distinctly.

FIGURE 2-2: Each pixel is monotone, containing a single color throughout the pixel.

>>> Smaller is better (generally speaking). The smaller each pixel, the better the detail in an image. (However, when you are preparing images for the web, you need smaller images that invariably have less detail.) If you capture an image of a house with an older cellphone camera and capture the same shot with a new DSLR (digital single-lens reflex camera — you know, one of the cameras with interchangeable lenses) that captures 3 or 7 or 15 times as many pixels — it's pretty obvious which image has better detail. Take a look at Figure 2-3, which illustrates how lots more smaller pixels present a better image than do fewer-and-larger pixels.

Smaller pixels also help hide those nasty corners of pixels that are sometimes visible along curves and diagonal lines. When the corners of pixels are noticeable and degrade the image, you call it a bad case of the *jaggies*.

FIGURE 2-3: More pixels (top) means better detail. Note the zoom factors in the lower left of each window.

Keep in mind that the size at which an image can be printed — and still look good — depends on the number of pixels available. Sure, these days every cellphone seems to capture at least 10 megapixels, which is fine for 8-x-10 prints and perhaps even as large as 16-x-20 inches. But how about when your 10-megapixel pocket camera doesn't have a long enough zoom to capture little Tommy's exploits on the far side of the soccer field? That's when you might need to crop and resample the image to increase the number of pixels. I cover resampling later in this chapter.

- >> Pixels are aligned in a raster. The term raster appears regularly when you discuss images created from pixels. Raster, in this case, refers to the nice orderly rows and columns in which pixels appear. Each image has a certain number of rows of pixels, and each row is a certain number of pixels wide — the columns. Within the raster, the pixels perfectly align side to side and top to bottom.
- >> Every picture created with pixels is rectangular. Some images might appear to be round, or star-shaped, or missing a hole from the middle, but they aren't unless you print them and grab your scissors. The image file itself is rectangular, even if it appears round. Pixels actually exist in those seemingly empty areas; the pixels are, however, transparent. When printing, the transparent areas show the color of the paper you're using.

How Many Pixels Can Dance on the Head of a Pin?

You hear the term resolution a lot when working with digital images. Digital cameras have so-many megapixels of resolution; inkjet printers have so-much by so-much resolution; to work in Photoshop, your monitor must have a resolution of at least 1,024 x 768 pixels; when printing your images, you must use 300 pixels per inch (ppi) as your resolution (wrong!), but your web images must have a resolution of 72 ppi (again wrong!); and don't forget your New Year's resolution!

Resolution revelations

In this wonderful world of digital imaging, you see *resolution* used in four basic ways:

- >> Image resolution: Image resolution is the size of your image's individual pixels when you print. I go into greater detail about this concept in the upcoming section, "Picking an image resolution."
- >>> Camera resolution: Digital cameras capture each image in a specific number of pixels. Check your camera's user guide or open one of the images in Photoshop and choose Image □ Image Size. Take a look at the number of pixels that your camera records for the width and for the height. Multiply the numbers together, divide by one million, and round off the result. (If you're in the camera maker's marketing department, make sure that you round up.) That's the megapixel (MP) rating for the camera. Use it as a general guideline when shopping. But remember that a camera with lower resolution using an excellent lens generally produces a better print than a camera with more megapixels using a less expensive lens.
- >> Monitor resolution: Monitor resolution determines how many pixels are visible onscreen. Whether you use a Mac or a PC, you set the monitor resolution at the system level (as shown in Figure 2-4). When you use a higher monitor resolution, you get a larger workspace, but each pixel is smaller, which might make some jobs tougher. Experiment to find a monitor resolution that works just right for you.
- >>> Printer resolution: Unlike the three preceding terms, printer resolution doesn't involve pixels. Rather, a printer resolution tells you how many tiny droplets of ink are sprayed on the paper. Remember that it takes several droplets to reproduce a single image pixel you certainly don't need an image resolution anywhere close to the printer's resolution! (See the following section for more on image resolution.)

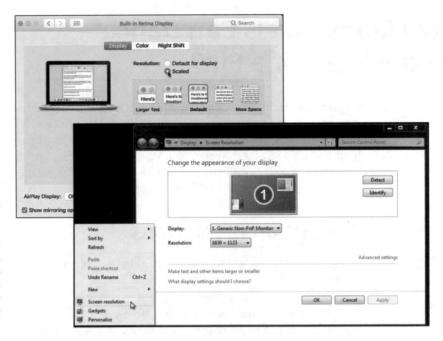

FIGURE 2-4:
Set a Mac's
resolution
through
the System
Preferences
(left), a PC's
resolution
through the
Control Panel
(right).

Resolving image resolution

Image resolution is nothing more than an instruction to a printing device about how large to reproduce each pixel. Onscreen, when working in Photoshop, your image has no resolution at all. An image that's 3,000 pixels wide and 2,400 pixels tall looks and acts exactly the same in Photoshop whether you have the image resolution at 300 ppi or 72 ppi. Same number of pixels, right? (The one real exception to this rule is type: Text is usually measured in points in Photoshop, and that measurement is directly tied to the print size of your document. You find out more about type and text in Chapter 12.)

You can always check — or change — a picture's resolution by choosing Photoshop Image Dize. Photoshop CC's Image Size dialog box (which you can see in Figure 2-5) offers the Fit To menu, which you can use to save and load presets for changes that you make regularly. The Resample box needs to be selected when changing pixel dimensions (otherwise you just change the image's resolution). Next to Dimensions, you can click the arrow to select a unit of measure, as you can next to Width, Height, and even Resolution. But the coolest new feature of the revamped Image Size dialog box is the preview. Position the cursor within the window and you can drag to reposition the preview and change the zoom factor. And rather than dragging and dragging and dragging in the small window to move the preview to a distant part of the image, simply click that area in the image

itself to jump the preview to that location. The Reduce Noise slider can be used to minimize the amount of little speckles that sometimes appear when resampling an image.

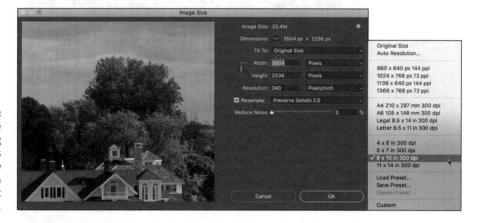

FIGURE 2-5:
The Image
Size dialog
box includes
a preview
window and an
automated Fit
To option.

You'll find it very handy to change the pixel dimensions and the print size at the same time in the Image Size dialog box. And, much to the delight of mathchallenged folks, the Image Size feature does most of the calculations for you. For example, with the Link option selected (note the tiny Link icon to the left of the Width and Height boxes), you enter a new Width, and Photoshop calculates the new Height automatically! To disable this option so that you can change only the width or the height (which is rare), just click the Link icon.

Changing the size of your artwork with the Image Size command

You have a number of ways to change the size of your photos and other art. In Chapter 4, I introduce you to *cropping* (chopping off part of the artwork to make it fit a certain size or to improve its overall appearance and impact). You can also use Photoshop's Image Size command to change the image dimensions or printing instructions without altering the *composition*, which is the visual arrangement of the image or artwork. All the content of the original image is there, just at a different size. Of course, as you can see in Figure 2–6, if you reduce the size of an image too much, some of that original content can become virtually unrecognizable.

FIGURE 2-6: As the smaller image shows at 300% zoom, you can reduce an image too much.

If you know the specific pixel dimensions that you need for the final image — say, for a web page — you can simply type a new number in the Width or Height fields in the Image Size dialog box and click OK. Of course, you probably want a little more control over the process, don't you? Figure 2-7 gives you a closer look at the resampling options in the Image Size dialog box, with names that suggest when to use each.

If you're resizing an image that uses layer styles (see Chapter 11), you want to click the gear button in the upperright corner of the Image Size dialog

	Automatic	7.1
	Preserve Details (enlargement)	72
~	Preserve Details 2.0	73
	Bicubic Smoother (enlargement)	74
	Bicubic Sharper (reduction)	75
	Bicubic (smooth gradients)	76
	Nearest Neighbor (hard edges)	77
	Bilinear	87

FIGURE 2-7:

When either Preserve Details option is selected, you'll also see a slider just below it in the Image Size dialog box to control noise in the enlargement.

box and make sure that the Scale Styles check box is selected to preserve the image's appearance as it shrinks or grows. In a nutshell, layer styles (such as shadows, glows, and bevels) are applied to a layer at a specific size. You can scale the image without changing those sizes, or you can scale the image and change the style sizes proportionally. Not scaling layer styles can dramatically alter the appearance of a resized image, as you can see in Figure 2–8. A slight bevel combined with a small drop shadow produces a subtle 3D effect in the original (upper) image. Below, when the image is scaled down to ½ the original size without scaling the effects, your chips change to chumps, and the artwork is ruined.

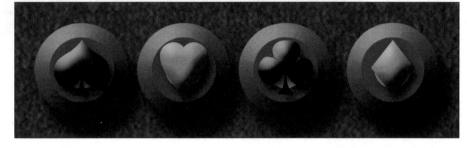

FIGURE 2-8: Scaling an image without scaling its layer styles can ruin your image.

The link to the left of Width and Height should almost always remain selected. Some exceptions might come up, but you normally want to preserve an image's aspect ratio (the relationship between height and width) when resizing to prevent distorting the image. Figure 2-9 shows you what can happen when you scale one dimension without constraining the image's proportions.

FIGURE 2-9:Resizing an image without constraining proportions. Interesting, yes, but useful?

The Resample option is the one that might require the attention of that gray matter within your skull. Not only do you need to decide whether you want to resample the image (change its pixel dimensions), but you also need to decide how you want to resample. Refer to Figure 2-7 to see that you have eight different ways to calculate the change (called resampling algorithms).

When you deselect the Resample option (as shown in Figure 2-10), you're changing the print dimensions without changing the pixel dimensions of the image.

When using Image Size without resampling, you're simply changing the instructions recorded in the image for your printing device. When you enter one dimension, either width or height, Photoshop does the math and fills in both the other dimension and the new resolution.

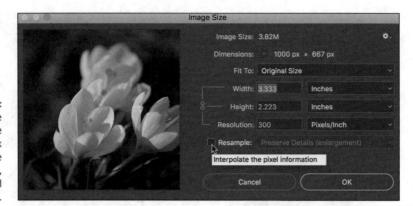

Clear the Resample Image check box to change print size, not pixel dimensions.

Take a look at Figure 2-11. I selected the Resample Image check box and entered 10 and inches for my new print width to print this image to a letter-size $(8.5 \times 11 \text{ inches})$ sheet of paper. Photoshop fills in the new height (6.667 inches). But what if I want an 8-x-10 print? If I enter 8 and inches for the height, Photoshop recalculates the width to 12 inches. If I want a true 8-x-10, I have to crop some of the image because most digital photos have a different aspect ratio than an 8-x-10. (You can read more about cropping to a specific aspect ratio in Chapter 4.)

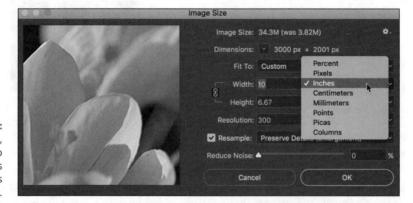

FIGURE 2-11: Enter a value, and Photoshop recalculates the fields automatically.

When you resample an image (change the pixel dimensions), Photoshop takes the image and maps it to the new size, attempting to preserve the image's appearances as much as possible at the new size, using the new number of pixels. Of course, if you take an image that's more than 3,000 pixels wide and resample it to 300 pixels wide, you're going to lose some of the detail. And, conversely, resampling an image from 300 pixels wide to 3,000 pixels wide, even when using the Preserve Details resampling algorithm, is likely to introduce some softness to the image's appearance.

TO RESAMPLE OR TO CROP: THAT IS THE QUESTION

To better understand the difference between resampling an image and cropping an image, consider this situation:

- **1.** A painter paints a picture. He paints it at whatever size he thinks is appropriate. (Or, perhaps, on the only piece of canvas he can afford on that particular day.)
- 2. A patron likes the artwork, but the painting is too large for the frame that works best with the dining room table. Yeah, patrons can be like that, can't they?
- 3. The patron asks the artist to make the painting fit the frame.
- **4.** The artist decides between cropping and resampling. He can grab a pair of scissors and cut off some of the painting (cropping) or painstakingly re-create the painting from scratch at a smaller size. Thankfully, Photoshop does the "repainting" for you, using Image Size with its resampling algorithms.
- **5.** The artist charges the patron for the extra work. (Don't forget this final, crucial step!)

Cropping cuts away part of the image to meet a target size. Resampling retains the entire image, but shrinks or enlarges it to meet the target size.

Picking an image resolution

After you have the concept of resampling under your belt, how do you know what size you should be resampling *to?* How many pixels do you need? Here are your general guidelines:

>>> Photos for your inkjet printer:
Inkjet printers are stochastic
printing devices: That is, they use a
series of droplets to replicate each
pixel in your image, as shown in
Figure 2-12. In theory, the optimal
image resolution is one-third of
the printer's rated resolution.
However, most printers don't need
an image resolution higher than
300 ppi. (For fine art prints from
my high-end Epson printers, I use
an image resolution of 360 ppi.)

FIGURE 2-12: The X to the left shows inkjet printer droplets and to the right, pixels.

If you're printing something that will be viewed only at a distance, such as a banner to be hung above the crowd or a poster that hangs on a wall, you can print at a substantially lower resolution to save ink and print faster. Banners, for example, can often be printed with a resolution of 100 ppi.

- >> Web images: Ignore resolution (including "72 ppi"). Consider only the image's pixel dimensions. Determine what area of the web page the image will occupy and then resize to exactly those pixel dimensions. Remember, too, that some social media have specific guidelines for images uploaded to their sites. Check the site's info before changing the image dimensions.
- >> Page layout programs and commercial printing: If your image is to be placed into a page layout program's document and sent to a commercial printing facility, you need to know the *line screen frequency* (the resolution, so to speak) of the printing press on which the job will be run. Ask the print shop or the person handling the page layout. Your image resolution should be either exactly 1.5 times or exactly twice the line screen frequency. (You shouldn't notice any difference in the final printed product with either resolution.)
- >> Presentation programs and word processing documents: Generally speaking, 72 ppi is appropriate for images that you place into a presentation or Word document. You should resize to the exact dimensions of the area on the page or slide that the image fills.

CONTENT-AWARE SCALING

The Edit ♣ Content-Aware Scale command is designed to be used when an image needs to be resampled to a new aspect ratio but can't be cropped. It tries (very hard) to keep the subject of the photo undistorted while stretching or shrinking the background. Here's how to use it:

- **1. Open an image or make a selection.** Make a selection if you need to scale only part of an image. If you need to resize the entire image, don't make any selection.
- 2. Convert the Background layer. You can't use Content-Aware Scale on a flattened image (an image that doesn't support transparency). If your image has a layer named Background, click the lock icon to the right of the layer name in the Layers palette.
- **3.** Choose Image Canvas Size. If increasing the pixel dimensions, resize the canvas as required. If you're reducing the size of the image, skip this step.
- 4. Choose Edit → Content-Aware Scale. Hold down the Shift key and drag the anchor points in the center of the four sides of the bounding box that appears to resize to fill the new canvas, and then press Return/Enter. (If you want to retain the original aspect ratio, don't use the Shift key.) Hold down the Option/Alt key to scale from the center. If you're resizing an image of one or more people, click the little "man" button to the right in the Options bar to protect skin tones. Before selecting Content-Aware Scale, you can also create an *alpha channel* (a saved selection) to identify areas of the image you want to protect. Make a selection, choose Select → Save Selection, and then select that alpha channel on Content-Aware Scale's Options bar in the Protect menu, immediately to the left of the "man" icon. See Chapter 7 for more on alpha channels.
- **5. Flatten (optional).** If desired, choose Layer ⇔ Flatten Image.

In this example, the original image is at the bottom. To the left, the image has been resampled from 6.67×10 inches to 8×10 inches using Image Size (with Constrain Proportions deselected). To the right, Content-Aware Scale does a much better job — in this particular case — of scaling the image to 8×10 inches, minimizing distortion of the subject.

Is Content-Aware Scale a substitute for properly composing in-camera before shooting? Absolutely not! Is it preferable to cropping to a new aspect ratio? Rarely. Is it an incredibly powerful tool for certain difficult challenges? Now we're talking!

(continued)

(continued)

File Formats: Which Do You Need?

After working with your image in Photoshop, you need to save the changes. Choosing File Save updates the current file on your hard drive, maintaining the current file format when possible. If you added a feature to the file that isn't supported by the original file format, Photoshop automatically opens the Save As dialog box and shows you which features are not supported by the selected file format. In Figure 2-13, the lower part of the Save As dialog box shows the yellow warning triangles that identify options being used in the image that are not available when saving as a JPEG.

You can go ahead and save the image in that format, but your file will no longer contain those unsupported features. In the example shown in Figure 2–13, I can click the Save button and create a JPEG file, but that JPEG won't have the alpha channel (a saved selection) or the spot colors (a custom printing color) and it will be flattened to a single layer. If I want to retain those features in the file, I need to choose a different file format, such as Photoshop's own PSD format. (Read more about alpha channels in Chapter 7 and about spot channels in Chapter 5.)

Photoshop shows you which image features are not available in your selected file format.

In Figure 2-13, there's a downward-pointing arrow to the right of the Where field. Click that arrow to expand the area for easier navigation to the folder in which you want to save the file. Also note the "Save to Cloud Documents" button to the left. Use that option to add the file to your Cloud storage.

No matter which of the file formats you choose, if you add layers, type, adjustment layers, channels, or paths to your image, keep the original as an unflattened/unmerged (all the layers are preserved) Photoshop (PSD) or layered TIFF file. In the future, should you ever need to make changes to the image or duplicate an effect in the image, you won't need to start from scratch.

Formats for digital photos

If you print your images yourself at home or the office, you can stick with the PSD Photoshop format when saving. (Remember that you cannot resave in a Raw format after opening in Photoshop.) If you send the photos to the local camera shop (or discount store) for printing, stick with JPEG — or, if the folks doing the printing accept it, TIFF. Here are the pros and cons of the major formats that you should consider for photos when saving:

>> PSD: Photoshop's native file format is great for saving your images with the most flexibility. Because the PSD format supports all of Photoshop's features, you don't need to flatten your images — and keeping your layers lets you make changes later. If your file size is very large (400MB or larger), make a TIFF or JPEG copy before printing, flattening all the layers. Don't send PSD files to the local shop for prints.

- >> TIFF: Although the TIFF file format (as you use it in Photoshop) can save your layers and most other Photoshop features, make sure to choose Layers Flatten Image before sending files for printing. Layered TIFF files generally are compatible only with programs in the Creative Cloud. The TIFF Options dialog box is shown in Figure 2-14.
- >> JPG: JPEG, as it's called, is actually a file compression scheme rather than a file format, but that's not important. What is important is that JPEG throws away some of your image data when it saves the file. Save important images in PSD or TIFF and use JPEG only for copies.

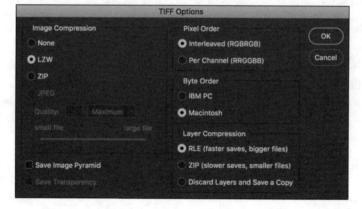

FIGURE 2-14:
Remember
to flatten TIFF
files before
saving when
using them
outside the
Creative Cloud.

When should you use JPEG? When sending images to a photo lab that doesn't accept TIFF files, uploading to most social media sites, and when sending images (perhaps by email or on CD) to people who don't have Photoshop. Unlike PSD and TIFF, you can open JPEG images in a web browser and print from there — and so can Granny, and Cousin Jim, and that overseas soldier you adopted. When saving JPEGs, the lower the Quality setting you choose in the JPEG Options dialog box, the smaller the file, but also the more damage to the image. I discuss saving as JPEG in more detail in the sidebar "Resaving images in the JPEG format."

>> JPS: Jpeg Stereo is used to create *steroscopic* images that use the left half as one copy and the right half as another. It's a specialty format for creating 3D-looking photos. You may or may not ever use the file format, but who knows what's right down the road? (Remember the "old days" when only a few cameras could capture Raw and when nobody knew what HDR stood for? Check out Chapter 6 for info on Raw and Chapter 19 for info on HDR.)

- >> PDF: It's easy to overlook Adobe's PDF format when talking about photos, but you should consider using this format. Although the local photo lab probably won't accept it, it's a great format for sharing your pictures with folks who don't have Photoshop. Unlike JPEG, your images won't be degraded when saving as PDF; and like JPEG, just about anyone with a computer can view the files. (Either Adobe Reader or the Mac's Preview, which you can also use with PDFs, is found on just about every computer now, just like web browsers for JPEG.) Keep in mind, however, that PDF files are larger than JPEGs.
- >>> Large Document Format (PSB): Really, really, really big pictures more than 30,000 pixels wide or long or both must be saved in the PSB or TIFF file formats. Will you ever need this format? Consider that 30,000 pixels at a photo-quality resolution of 300 ppi is 100 inches long. At a resolution of 85 ppi, more appropriate for a long banner to hang in a hallway, you're talking about artwork that stretches almost 30 feet! Can your printer do that? If not, you probably don't need the PSB file format.

You could theoretically use a number of other available formats, such as DCS (*never* Photoshop Raw), but there's no real need with the more common and more versatile formats about which you just read.

The JPEG file format doesn't support 16-bit color, but even when working with a 16-bit image (perhaps a Raw image from your digital camera), JPEG is available as a file format in Photoshop's Save As dialog box. The image is automatically converted to 8-bit color. It's more convenient — saving you a trip to the Image \$\frac{1}{2}\$ Mode menu to select 8-Bits/Channel — but the JPEG Options dialog box won't give you an estimate of the file size. Don't forget to save in a format that supports 16-bit color, such as PSD or TIFF, before creating the JPEG copy.

Formats for web graphics

Generally speaking, you use Photoshop's Save As to generate copies of your images for use on a website or to show off with smartphones, PDAs, and other such devices. You can, however, choose File \(\sigma\) Export \(\sigma\) Save for Web (Legacy) if you prefer the old command. Here are the three file formats that you need for the web:

>> JPG: Use JPEG for photos. Remember to resize the photo so that it fits on a web page. When selecting a Quality setting, you need to balance image appearance with file size. A smaller file downloads (and displays in a web

browser) faster, but a larger file generally looks better. If you reduce the Quality setting until just before the image doesn't look great, you've hit the sweet spot — the compromise between file size and image quality.

- SIF: GIF is more appropriate for items like web banners and buttons (such as those shown in Figure 2-15) than it is for photos. If you save a photo that's more than perhaps 100-x-100 pixels in size, you might see some degradation of the image quality as similar colors become one color. When you save an image as GIF, it can contain no more than 256 distinct colors. JPEG and the other common file formats can have thousands of different colors.
- PNG: PNG comes in two types: PNG-8 (which is a substitute for GIF) and PNG-24 (which is a substitute for JPEG). PNG has a couple of advantages for web designers, such as support for transparency.

FIGURE 2-15:Use GIF for web interface items.

Formats for commercial printing

You're the Photoshop master of your office. Everyone knows that you understand everything about digital images. So you're the right person to create the company's new brochure. Except you're a photographer. Or you're a web designer. Or you're actually pretty new to Photoshop. And you don't have a clue about preparing images for a commercial printing press.

Here's what you need to know about file formats for those CMYK (cyan/magenta/yellow/black) color images that you're sending to the print shop:

- >> TIFF: TIFF is generally a solid choice. Use TIFF for photographic images that don't contain any type layers.
- >>> EPS: Choose EPS if your image has type. Don't flatten or merge the type layers before using Save As to create the EPS. In the EPS Options dialog box, make sure to select the Include Vector Data check box to ensure that your type prints perfectly.

If you reopen an EPS file in Photoshop, your type layers get merged. Don't! Instead, make sure to save your original file as PSD and, should you need to make changes, open the PSD and create a new EPS file when you're done editing.

- >>> PDF: PDF offers support for spot color channels, alpha channels, and paths options not supported by EPS. (Spot channels are used with custom colors, and alpha channels store information about transparency in the image.) If your file uses any of these features, choose PDF over EPS, if your print shop accepts PDFs. When saving as PDF, the PDF Options dialog box offers Preserve Photoshop Editing Capabilities. If you select the option, the PDF file reopens in Photoshop with layers and editable type.
- >> PSD: Use PSD only if you're adding the image file to a project in Adobe InDesign CC. Don't send PSD files to a print shop unless specifically requested to do so by the print shop.

RESAVING IMAGES IN THE JPEG FORMAT

JPEG uses a *lossy* compression scheme: That is, as part of the compression process, it actually permanently throws away some data when you save your image. The lower the Quality setting, the more image degradation occurs. Take a look at the figure here. The original image is on the left. In the middle is the same image saved in JPEG format with medium quality and then on the right with low quality. Compare the insets on the eyelashes (400% zoom) for the left and right images. See what I mean by *degradation*? Look closely at the inset to the right and you can even see the 8-pixel-by- 8-pixel blocks used by JPEG during the compression process.

If you save by using JPEG a second time, even more data is thrown away. Every time you save, your image quality suffers. Yes, indeed, you might sometimes need to open a JPEG image, make some changes, and save as JPEG again (perhaps for the web, perhaps to share with non-Photoshop friends and family). To minimize damage to the image, either use the highest setting (12) for the Quality setting or (if you know it) the exact same setting used last in Photoshop.

Formats for PowerPoint and Word

If the final destination of your image is PowerPoint or Word, use the PNG file format. If your image has areas of transparency in it, PNG is *definitely* the way to go. (Read about the two types of PNG files in the section "Formats for web graphics," earlier in this chapter.)

What about all that neat clip art that you have on your hard drive? How do you use those images when Photoshop won't open the vector-based WMF and EMF clip art files? Here's how you get clip art into Photoshop, quickly and easily:

1. Open a new document in Word (or a comparable word-processing program).

2. Add the clip art.

In Word, choose Insert ♣ Picture ♣ Clip Art (or your word processor's comparable command). Click directly on the artwork and drag the lower-right corner to resize it to the dimensions that you need in Photoshop. (The artwork comes into Photoshop at 300 ppi.)

3. Choose Edit ⇔ Copy.

The selected image is copied to the Clipboard (the computer's memory) in Word.

- 4. Switch to your Photoshop image.
- 5. Choose Edit ⇒ Paste.

You have your clip art, ready to use in Photoshop! Use the Edit >
Transform commands to scale, rotate, and otherwise fit the clip art into your design. (See Figure 2-16.)

FIGURE 2-16:

Copy vector artwork from Word and paste into Photoshop.

- » Working more efficiently with customization
- » Determining your preferences and color settings
- » Troubleshooting Photoshop

Chapter 3

Taking the Chef's Tour of Your Photoshop Kitchen

know you're hungry to dive right in and start mixing up some masterpieces, but before you fire up the stove, look around the Photoshop kitchen. Get to know your spoons from your ladles, your pots from your pans. Figure out how to turn on the blender . . . that sort of thing.

In this chapter, rather than go through all the Photoshop menus, panels, and tools (which would take several hundred very boring pages), I show you some basic operational concepts. (But don't worry — you can read about how to use specific commands and tools throughout the book, in the chapters most appropriate for them.) Here you discover such things as how to spot which menu commands have dialog boxes, what the little symbol in the upper-right corner of a panel does, and which tools don't use the Options bar. You also read about customizing your Photoshop environment for faster and more efficient work. Next I show you how to set up Photoshop's Preferences and Color Settings. And to wrap up the chapter — perhaps the most important section in this entire book — I explain what to do when Photoshop doesn't seem to be working properly.

Food for Thought: How Things Work

A good understanding of certain fundamental operations and features in Photoshop provides you with the background that you need to follow the recipes or get creative and whip up some delicious artwork.

Photoshop now makes it easier to learn Photoshop as you work. In addition to Tool Tips and Rich Tool Tips (those very short videos you see when pausing the cursor over a tool), you'll find a Learn button in the upper-left of the home screen. It offers both "in-app" tutorials and links to web-based tutorials. You can open the home screen at any time by clicking the little house button at the far left end of the Options bar.

Even cooler is the new Search, Learn, and Help panel, shown in Figure 3–1. Rather than use the formal name, you can just call the panel "Photoshop Search." As you can see, the panel content changes depending on what you want to know. To the left is the basic appearance of the panel. In the center, you see some of the results from using the Search field to find info on (in this case) the Crop tools. To the right, you see browsing among the "Hands-on" tutorials.

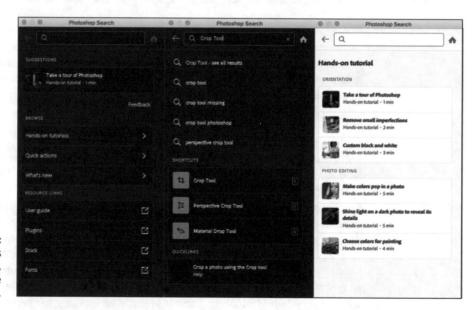

FIGURE 3-1: Some commands have submenus, and some have dialog boxes.

You access the Search, Learn and Help panel not through Photoshop's Window menu (the way you open most panels), but rather through the Help menu. Choose Photoshop Help, Hands-on Tutorials, or What's New in Photoshop to open the panel. (Each menu command opens the panel to the appropriate content.)

The keyboard shortcut to open Photoshop Search is \(\mathbb{H}\)+F/Ctrl+F. The content available through the Photoshop Search panel is regularly updated, so in that oh-so-uncommon free time you have, you might want to simply browse.

Ordering from the menus

When you're working in Photoshop, you see a horizontal list of menus spread across the very top (Mac) or near the top (Windows) of the application window: File, Edit, Image, Layer, Type, Select, Filter, 3D, View, Window, and Help. On the Mac, the program also has a menu named Photoshop, just to the left of the File menu.

As with most programs, you click the name of a menu to reveal its commands. For both Mac and Windows, you can click and hold down the mouse button until you're over the command you want; or you can click and release, move the cursor, and then click again. Some commands, such as Crop and Reveal All, are executed immediately after you choose them. When a command name in the menu is followed by an ellipsis (. . .) — the Image Size command shown in Figure 3–2, for example — you know that a dialog box will open so that you can input variables and make decisions. A triangle to the right of a command name, such as that which you see next to Image Rotation, indicates a *submenu*. If you click the command name, another menu appears to the right. The cryptic set of symbols to the right of some commands (for example, Image Size) is the keyboard shortcut for opening the command's dialog box. (I show you how to assign keyboard shortcuts later, in the section "Sugar and spice, shortcuts are nice.")

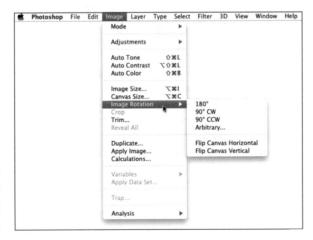

FIGURE 3-2: Some commands have submenus, and some have dialog boxes.

TIP

If you're working with a HiDPI or Retina screen, the user interface (UI) can be scaled for a better working environment. This would be a great opportunity to explore Photoshop's Discover panel! Click Photoshop's Help menu and in the Search field, enter **scale UI to font** and then press Return/Enter. In the Photoshop Search panel, double-click HiDPI and Retina Display Support FAQ. Voilà! Instant info that explains exactly what you need to do.

As you read in the upcoming section "Clearing the table: Custom workspaces," Photoshop menus are customizable — you don't have to see commands that you never use. You can also color-code your menu commands, making it easier to spot those that you use regularly.

When a specific command appears *grayed out* in the menu (in gray type rather than black), that command isn't available. Some commands, such as Reveal All in Figure 3-2, are available only under specific circumstances, such as when part of the image is being hidden with the Crop tool. When working with Photoshop's creative filters, you'll find that many aren't available unless you're working with an 8-bit RGB (red/green/blue) image. (I cover color modes and bit depth in Chapter 5, and you can explore filters in Chapter 14.)

Your platter full of panels

Photoshop, like the other programs of the Adobe Creative Cloud, uses *floating panels*. The panels, many of which you see along the right edge of your screen, usually appear on top of (float over) your image window. (As you drag panels around to customize your workspace, as described later in this section, you'll find that panels can hide other panels.) The Options bar across the top of the work area and the Toolbox (technically, it's called the Tools panel) along the left edge of the screen are also panels.

Panels contain Photoshop features that you might need to access so regularly that using a menu command is inconvenient. (I can't imagine having to mouse to a menu command every time I want to change tools or select a specific layer!) You don't always need to have your panels visible. In Photoshop, press the Tab key to hide all the panels or press Shift+Tab to hide all but the Toolbox and the Options bar. (Press Tab again to show the panels.) With fewer panels visible, you provide more room for your image. You can selectively hide and show panels via Photoshop's Window menu.

Photoshop uses expanding/collapsing panel docks. As shown to the right in Figure 3-3, clicking the double-arrow button at the top of a stack of panels expands or collapses that stack to a tidy group of icons. The Color, Libraries, and Layers panels are fully visible. The Swatches, Gradients, Patterns, Adjustments, Channels, and Paths panels — "nested" with the three visible panels — can be made

visible by clicking the panel tab. The collapsed History, Properties, Character, and Paragraph panels together occupy only a tiny fraction of the screen — those four buttons to the left of the Color panel. In Figure 3–3, the Application Frame (Mac only) is deselected in Photoshop's Window menu, allowing the program to utilize the entire screen.

FIGURE 3-3: Nesting and collapsing panels opens up the work area.

By clicking and dragging a panel's tab when the panel isn't collapsed, you can move it to another grouping or pull it out of its grouping and away from the edge of the screen. You might, for example, want to drag the Clone Source panel away from its buddies to make it more easily accessible while performing a complex clone operation. (The Clone Source panel is used with the Clone Stamp tool. You can specify up to five different source locations and easily switch among them.)

Many of the panels are resizable. Like an image window, you drag the lower-right corner of the panel to expand or contract it. Almost all the Photoshop panels have a panel menu from which you select various options. (The Toolbox and Options bar are the exceptions — they don't have menus.) You open the panel menu by clicking the small button in the upper-right corner of the panel, as shown in Figure 3-4. The panel menu contains such options as thumbnail size (for example, the Layers, Channels, and Paths panels); how to display items in the panel (Swatches, Styles, and Brush among others); or even the size and content of the panel (Info and Histogram).

Access a panel's menu by clicking the button in the upper right. (Clicking the doublearrow above the button expands or collapses the panel or panel group.)

The content of some panels changes automatically as you work with your image. Add a layer, and the Layers panel shows a new layer. Save a selection, and the Channels panel shows a new alpha channel. If you create a vector shape, the Layers panel gets a new layer, and the Paths panel shows the layer's vector path. You control some other panels by loading and deleting content through the panel menus.

In a move that some may find controversial, the Preset Manager has been degraded and is no longer used to manage the content of most panels. Brushes, gradients, and patterns, for example, are now loaded ("imported") and saved ("exported") through the panel menus only. Other items, such as custom shapes, are managed through the pickers in the Options bar when the appropriate tool is active.

The tools of your trade

Near the bottom of the Toolbox is an ellipsis (visible in Figure 3-3, shown previously). Click that and you can customize the Toolbox to optimize it for your workflow. You can also use the menu command Edit ➡ Toolbar.

You control the behavior of Photoshop's tools through the Options bar. With the exception of a few path-related tools (Add Anchor Point, Delete Anchor Point, and Convert Point), every tool in Photoshop has options. The Options bar changes as you switch tools. The behavior of some tools changes when you add one or more modifier keys (策, Shift, and Option for the Mac; Ctrl, Shift, and Alt for Windows). As an example of how modifier keys can affect tool behavior, consider the Rectangular Marquee and Elliptical Marquee tools:

>> Hold down the Shift key while dragging. Normally the marquee selection tools are *freeform* — you drag however you like. When you hold down the

- Shift key while dragging, on the other hand, you constrain the proportions of the selection to a square or circle (rather than a rectangle or ellipse).
- >> Hold down the Option/Alt key while dragging. When you hold down the Option/Alt key while dragging a marquee selection tool, the selection is centered on the point where you first clicked. Rather than being a corner of a selection, that starting point is the center of the selection.
- >> Hold down the Shift and Option/Alt keys while dragging. You can select from the center while constraining proportions by using the Shift and Option/Alt keys together.
- >> Use the Shift key to add to an existing selection. If you already have an active selection in your image, Shift+dragging a selection tool adds to that selection. (Press Shift before you click and drag.)
- >> Use the Option/Alt key to subtract from an existing selection. When you have an existing selection and you hold down the Option/Alt key, you can drag to subtract from the selection. Note in Figure 3-5 that the selection tool's cursor shows a small minus sign when subtracting from a selection.

>> "Double-clutch" with the Shift or Option/Alt key. You can even constrain proportions or select from the center and add to or subtract from a selection. Press the Shift key (to add to the existing selection) or the Option/Alt key (to

FIGURE 3-5:
Use the Option/Alt key with a selection tool to subtract from a selection.

subtract from the existing selection). Click and start dragging the marquee selection tool. While continuing to hold down the mouse button, release the modifier key and press and hold Shift (to constrain proportions), Option/Alt (to center the selection), or both; then continue to drag your selection tool. You might want to use this technique, for example, when creating a donut-shaped selection. Drag the initial circular selection and then subtract a smaller circular selection from the center of the initial circle.

Don't be afraid to experiment with modifier keys while working with tools. After all, you always have the Undo command (#+Z/Ctrl+Z) at hand!

If you're using a current version of Windows, you also have Microsoft Dial Support available, which enables you to adjust brush attributes using the Microsoft Dial (if it's on your hardware).

Get Cookin' with Customization

Customizing Photoshop not only helps you work faster and more efficiently but can also help you work more precisely and prevent tragic errors. Consider using a Crop tool preset to create a 5-x-7 print at 300 pixels per inch (ppi). Such a preset will always produce exactly those dimensions, every single time. Setting up the Crop tool each time you need a 5-x-7 at 300 ppi doesn't just waste time: It also opens the door for time-consuming or project-wrecking typos. ("Oops! I guess I made a mistake — this image is 5-x-7 at only 30 pixels per inch!")

Clearing the table: Custom workspaces

One of the easiest ways to work more efficiently is to see your image better. Generally speaking, bigger is better, so the more room you have on the monitor to display your artwork, the better you can zoom in and do precise work. As mentioned earlier, the easiest way to gain workspace is to press the Tab key to hide Photoshop's panels. Pressing Shift+Tab hides all the panels except the Options bar and the Toolbox.

Keep in mind that it's best to use 100% zoom when evaluating your image for banding (areas of similar color that should blend smoothly, but don't) or moiré (which can occur when scanning printed material — see Figure 4–3 in the following chapter for an example) and when applying filters. Any other zoom factor is a simulation of the image's appearance. If you have a computer and video card that support OpenCL drawing (take a look in Photoshop's Preferences > Performance, activate Use Graphics Processor, and click the Advanced Settings), you have much better on-screen display. But 100% zoom is safest when making critical decisions.

You can also drag the panels that you need regularly to a custom group of panels. To move a panel, drag it by the tab and "nest" it with other panels. And don't forget that the major panels have keyboard shortcuts assigned to show and hide. Although keyboard shortcuts are customizable (as you can read later in this chapter), here are the primary panels' assigned F keys, the *function keys* that appear at the top of your keyboard:

- >> Actions: Option/Alt+F9
- >>> Brush Settings: F5
- >> Color: F6
- >> Info: F8
- >> Layers: F7

TIP

Any panels nested with the panel that you show/hide are also shown and hidden. And don't forget that you can always restore all panels to their default locations by choosing Window & Workspace & Essentials (Default) from Photoshop's main menu. If the default workspace is already selected, choose Window & Workspace & Reset Essentials to get back to the default panel layout.

The most efficient way to customize your work area is to create and save specialized workspaces. Arrange the panels exactly as you need them for a particular job you do regularly, choose Window Workspace New Workspace (in the Window menu, visible panels are indicated with a check mark), and name the workspace for that type of job. Then you can make a specialized workspace for each type of work you do. For example, perhaps when you do color correction, you need to see the Histogram panel (in the expanded view), the Info panel, and the Channels panel. Arrange those panels how you need them and then hide the rest, saving the workspace named as *Color Correction*. Or, perhaps when you create illustrations in Photoshop, you need to see the Layers and Paths panels at the same time. Drag one out of the group to separate it, position them both where convenient, and save the workspace as *Illustration*.

To access a saved workspace, choose Window ♥ Workspace and select it from the list at the top of the menu, as shown in Figure 3–6. You can see some preset custom workspaces in the top section of the menu.

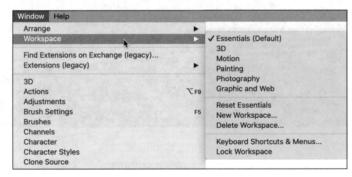

FIGURE 3-6:
Select a
workspace
from the menu
to instantly
rearrange
your panels.

TIP

You can also save the current state of the customizable keyboard shortcuts and menus in your workspace. Although streamlining the menus for the specific work you're doing is a great idea, it's probably not such a great idea to have more than one set of custom keyboard shortcuts. The time it takes to remember which shortcuts go with the current workspace (or to undo a mistake caused by the wrong shortcut) is time wasted.

To customize shortcuts for Photoshop's menu commands, choose Edit Menus, which opens the Keyboard Shortcuts and Menus dialog box, shown in Figure 3-7. Alternatively, choose Edit Keyboard Shortcuts and click the Menus tab. Here you can find every available menu command listed. (Filters available in the Filter Gallery cannot have individual keyboard shortcuts unless, in Photoshop's Preferences Plug-Ins, you have elected to list all filters on the Filter menu.) You also have the option of hiding a command or assigning a custom color to make it easier to identify in the menu. You might, for example, hide the blur filters that you never use, and color-code the others according to how you like or use them.

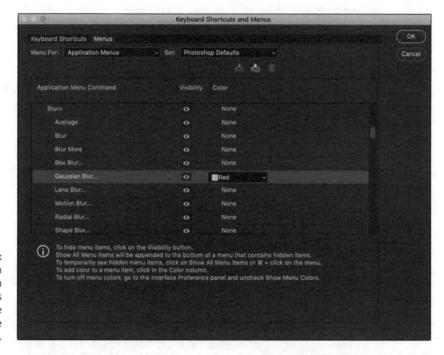

FIGURE 3-7:
You can
hide menu
commands
and color-code
the visible
commands.

In addition to the application menu commands (from the menus at the top of the screen), you can switch the Menu For pop-up to Panel menus and customize those menus, too. Don't forget to save your customized menu arrangements with the button directly to the right of the Settings pop-up. Your saved menu set appears in that Settings pop-up for easy access. Keep in mind, too, that while customizing shortcuts, you can drag the lower-right corner of the window to expand it, making it easier to find specific items for which you want to assign shortcuts.

Photoshop keyboard shortcuts can save a bunch of time. Rather than move the cursor to the Toolbox to select the Brush tool, just press the B key. To open the Levels dialog box, press #+L/Ctrl+L instead of going to the Image menu, down to

the Adjustments submenu, and then over and down to Levels. You assign keyboard shortcuts in the same dialog box in which you customize menus. Simply click Keyboard Shortcuts at the top and optimize for efficient workflow.

Spoons can't chop: Creating tool presets

One of the keys to efficient, accurate work in Photoshop is using the right tool for the job. For example, the Patch tool with Normal active in the Options bar (the default) copies texture only. If you need to cover a spot on a client's face, changing both texture and color, you may need the Clone Stamp tool or the Patch tool with the Content-Aware option. (You can read about how the tools work throughout this book.)

You can ensure that you're using not only the correct tool but also the correct settings for that tool by creating *tool presets*, which store your settings from the Options bar. You can then select the preset tool (and, of course, that's where the catchy name comes from) from the Tool Presets panel or from the left end of the Options bar, as shown in Figure 3–8.

FIGURE 3-8: Tool presets help you work faster and more accurately.

Although just about any tool is a good candidate for tool presets, some are just plain naturals. Consider, if you will, the Crop tool. As I explain in Chapter 4, a photo from a high-end digital camera has an *aspect ratio* (relationship between width and height of the image) of 2:3, and common print and frame aspect ratios include 4:5 for 8-x-10 prints, 5:7, and 13:19 for large prints. (Some digital cameras shoot in different aspect ratios.) You'll often find a need to crop an image to a specific size to meet your printing requirements. And, don't forget resolution — printing in the correct size at the wrong resolution is simply a waste of paper and ink! Set up a number of Crop tool presets for your typical print sizes and relax, knowing that you'll always be cropping correctly.

Another logical candidate for tool presets is the Type tool. When you consider all the options for the Type tool in not only the Options bar but also in the Character and Paragraph panels, you have quite a bit to select and track. To ensure consistent text from project to project, consider creating tool presets for each project,

including (as appropriate) headline and body text, special effects and accent type, and even your copyright information. Keep in mind, too, that you can use Type tool presets in conjunction with the Character Styles and Paragraph Styles panels (which are discussed in Chapter 12).

Season to Taste: The Photoshop Settings

The program-level Preferences and the Color Settings flavor all your work in Photoshop. The options that you choose in Photoshop's Preferences (or simply the *Prefs*) control many facets of the program's basic behavior. Choices made in the Color Settings dialog box determine how your work looks, both onscreen and in print. And when you get down to brass tacks, that's what it's all about — the appearance of your artwork.

Standing orders: Setting the Preferences

Photoshop's Preferences file stores a whole lot of information about how you use the program. Regardless of whether you prefer to measure in inches or pixels, how you like the grid and guides displayed, what size thumbnails you prefer in your panels, which font you used last — all sorts of data is maintained in the Prefs. Much of the info in the Preferences is picked up automatically as you work (such as the size and color mode of the last new document you created, whether the Character panel was visible when you last shut down the program, and which tool options were selected in the Options bar), but you must actively select a number of options in the Preferences dialog box, as shown in Figure 3–9.

FIGURE 3-9: Use Photoshop's Preferences to establish many program behaviors.

Many of Photoshop's handy reminder messages include a Don't Show Again option. If you someday decide that you do indeed need to start seeing one or more of those reminders again, open the Preferences and click the Reset All Warning Dialogs button at the bottom of the General pane.

Your custom styles, brushes, Actions, and the like are recorded only in Photoshop's Preferences until you actually save them to your hard drive. That makes them vulnerable to accidental loss. Use the menus of the various panels and pickers to export custom items. And make sure to export them in a safe location *outside* the Photoshop folder — you wouldn't want to accidentally delete your custom bits and pieces if you should ever have to (*oh*, *no!*) reinstall Photoshop, would you?

Open the Preferences on a Mac with the keyboard shortcut ℋ+K or choose Photoshop ⇔ Preferences to select one of the 17 specific subsets of Preferences to change. The shortcut for Windows users is Ctrl+K, and the Preferences submenu is under the Edit menu. The default settings are perfectly acceptable (after all, they are the defaults for a reason), but the following sections cover some changes to the Preferences to consider, listed by the section of the Preferences dialog box in which you find them.

Some of the changes you make in Photoshop's Preferences are applied as soon as you click OK. Other changes don't take effect until you restart the program. (You'll get a reminder about that.)

Preferences SHistory Log

The History Log maintains a record of what you've done to a specific image. You can record when you opened and saved a file with the Sessions option, see a summary of what you did with the Concise option, or keep track of every command, every feature, and every *setting* you used with the Detailed option! And the log can be recorded to a text file or stored in an image's metadata for retrieval by choosing File \Rightarrow File Info.

One option not selected by default that you may find very handy is Zoom Clicked Point to Center. When you click with the Zoom tool, this option automatically centers the view on the point where you clicked.

When using the transform commands, Photoshop shows you numerically precisely what you're doing. A small display shows the new dimensions (when scaling) or the angle (when rotating or shearing). You may find that to the upper right of the cursor isn't a good location (perhaps while using the stylus in your

right hand on a Wacom Cintiq tablet or iPad connected with Sidecar). Change the location — or select Never to hide the info completely.

If you're working with a machine that offers Gestures (pinching to zoom, three-finger swipe, and so on) and you *like* using Gestures, you can use them in Photoshop.

The Interface and Workspace panels of the Preferences offers several options of note:

- >> Appearance: You may find that Photoshop's "dark interface" is not to your taste. (Try it for a while it'll likely grow on you.) You can select from among two lighter (and one even darker) interface appearances.
- Screen Modes: You can easily customize the look of Photoshop's three screen modes.
- >> UI Font Size: If you find yourself squinting to read panel names and such, change the UI Font Size to Large and restart Photoshop. If you *still* have problems reading the screen, reduce the monitor's resolution. (See Chapter 2 for details.)
- >> Show Channels in Color: When only one channel is active in the Channels panel, it normally shows a grayscale representation of the image. If you prefer to have the active channel appear in its own color, select this option. Keep in mind, however, that after you get comfortable working with individual channels, the default grayscale is easier to see.
- >> Show Menu Colors: As I discuss earlier in this chapter, you can assign colors to specific commands in the Photoshop menus. Assigning colors might make it easier for you to quickly spot and select often-used commands. Use this option to disable the color coding without having to deselect each assigned color.
- >> Auto-Collapse Iconic Panels: If you prefer an uncluttered workplace, here's a great option for you! When selected, panels in icon mode (click the upper bar of a group of panels) collapse to buttons. To open a panel, click its button.

 When Auto-Collapse is selected, the selected panel automatically closes when you click elsewhere in Photoshop. If you need to keep a specific panel open while you work (perhaps Histogram or Info), drag it out of its group and away from the edge of the screen, and it will stay open until you close it.
- Auto-Show Hidden Panels: Position the cursor over a collapsed panel and it springs open.

>> Open Documents as Tabs: Photoshop, by default, opens each document as a tab across the top of the work area. You click a tab to bring that image to the front. If you find that you're constantly dragging tabs off to create floating windows, deselect this option in the Preferences. And if you disable tabbed image windows, you'll likely also want to disable the Enable Floating Document Window Docking option. This prevents image windows from docking as you drag them around onscreen.

Preferences ⇔ File Handling

Image previews add a little to the file size, but in most cases, you want to include the preview. On Macs, you have the option of including a file extension or not (or having Photoshop ask you each and every time). Even if you don't plan on sharing files with a Windows machine, I strongly recommend that you always include the file extension in the filename by selecting the Always option. Likewise, I suggest that you always maximize PSD and PSB file compatibility. This ensures that your Photoshop files can be opened (with as many features intact as possible) in earlier versions of the program and that they'll function properly with other programs in the Creative Cloud. Maximizing compatibility can be critical if you also work with Adobe's Lightroom CC.

Photoshop includes an auto-recovery feature, one that doesn't compromise the creative process. If, as with some programs, your open file was simply saved to your hard drive at specific intervals, overwriting the original, your artistic experimentation could be limited to that specified time frame. Say, for example, that you tried a specific artistic filter, took an important phone call, and later found out that the program had rewritten the file on your hard drive and that experimental filter has become a permanent part of your artwork. But you decided you don't like it after all. Bummer! (Or simply Undo, of course.) Rather than take such risks with your creativity, you now have the option to have Photoshop save recovery information, which doesn't affect the original file in any way, at intervals specified in the Preferences. Or you can disable the feature by deselecting the check box.

Preferences Derformance

The Performance panel contains options related to how Photoshop runs on your computer:

>> Memory Usage: Try bumping the memory allocation to 100%. If things seem slower rather than faster, back off the memory allocation to perhaps 85%. In a 64-bit environment, Photoshop can take advantage of all the RAM you can cram (into the computer).

- >> History States: This field determines how many entries (up to 1,000) appear in the History panel. Storing more history states provides more flexibility, but at a cost: Storing too many history states uses up all your available memory and slows Photoshop to a crawl. Generally speaking, 20 or 30 is a good number. If, however, you do a lot of operations that use what I call "little clicks," such as painting or dodging/burning with short strokes, that History panel fills quickly. For such operations, a setting of perhaps 50 or even 60 is more appropriate.
- >> Cache Levels: The image cache stores low-resolution copies of your image to speed onscreen display at various zoom levels. Although this process speeds up screen redraw, the price is accuracy. Unless your video card has trouble driving your monitor at your selected resolution and color depth, you might be better served by Cache Levels: 1. That gives the most accurate picture of your work. (But remember to make critical decisions at 100% zoom, where one image pixel equals one screen pixel.)
- >> Graphics Processor Settings: This area displays information about your computer's video card. If your system has the capability, you'll see a check box for Use Graphics Processor. Using this processor provides smoother, more accurate views at all zoom levels and other enhancements, including the capability to rotate the image onscreen not rotate the canvas, but rotate just the onscreen image. And that's too cool for words when painting a complex layer mask!

Preferences Scratch Disks

WARNING

Photoshop's scratch disks are hard drive space used to support the memory. Use only internal hard drives as scratch disks — never an external drive, a network drive, or removable media! If you have multiple internal hard drives, consider a dedicated partition (perhaps 15–50GB) on the second drive — not the drive on which the operating system is installed. Name the partition Scratch and use it exclusively as a scratch disk for Photoshop (and perhaps Adobe Illustrator). If you have a couple of extra internal drives, each can have a scratch partition. (On a Windows computer, you might see a message warning you that the scratch disk and the Windows paging file, which serves the same basic purpose at the system level, are on the same drive. If you have only one internal hard drive, ignore the message.) To re-order the scratch disks, click the scratch disk in the list and then, instead of dragging, use the arrows keys to the right.

Preferences Cursors

Photoshop offers you a couple of ways to display cursors for painting tools. You can show the tool icon (Standard), a small crosshair (Precise), or a representation of the tool's brush tip, indicating the size and shape of the brush (Brush

Size). With soft-edged brushes, the brush size cursor shows where the tool will be applied at 50% strength or higher. Alternatively, select the Full Size Brush Tip option, which always shows the full extent of the brush tip, regardless of the Hardness setting.

You also have the option of adding a crosshair in the middle of either brush-size cursor. The crosshair option is great for keeping a brush centered along an edge or path, and it just about eliminates the need for the Precise cursor option. As you can see in Figure 3-10 when working with a soft brush, showing all the pixels that are changed even a little (to the right) might not give you an accurate view of your work. (The Normal Brush Tip

FIGURE 3-10: When working with a low Hardness setting, Normal Brush Tip is usually best.

cursor is shown at the top center and the Show Crosshair in Brush Tip option can be seen at the lower left.)

When the Show Only Crosshair While Painting option is selected in Preferences, the brush cursor appears at the selected diameter display (Full Size or Normal) until you press the mouse button (or press the stylus to the tablet). It then automatically switches to the crosshair and remains as a precise cursor until you release the mouse button (or lift the stylus). Experienced brush-tool-using Photoshoppers might want to experiment with this option — if you know the diameter, you might want to better focus on the center of the brush when you are, for example, painting or dodging or burning along a distinct edge.

When you're sure that you have a brush-size cursor selected in the Preferences but Photoshop shows you the precise cursor, check the Caps Lock key. Pressing Caps Lock toggles the painting cursors between Precise and Brush Size.

Also found in the Cursors panel is the Brush Preview color. Click the color swatch to open the Color Picker and assign a color to use when dynamically resizing your brushes. (If you don't have OpenCL drawing capability, the brushes can still be resized, but the color preview will not be visible.) With a brush-using tool active, press and hold down the Option+Control keys on a Mac and drag left or right; on a Windows machine, Alt-right-click and drag left or right to resize the brush — on the fly! Want to change the brush hardness? Hold down those same keys and drag up or down rather than left or right.

Preferences Transparency & Gamut

If you work in grayscale regularly, you might want to change the color of the transparency grid to something that contrasts with your image; perhaps pale blue and pale yellow. If you find the gray-and-white checkerboard pattern distracting in images with transparency, you can set Grid Size to None, which gives you a plain white background in transparent areas of your artwork.

Preferences Units & Rulers

If you create web graphics rather than print images, you probably want to change the unit of measure from Inches to Pixels. Keep in mind that you can change the unit of measure on the fly by right-clicking the rulers in your image (which you show and hide with the shortcut $\Re +R/Ctrl+R$). If you regularly print at a resolution other than 300 ppi, you might also want to adjust the default resolution for print-size new documents.

Preferences Guides, Grid & Slices

Photoshop offers Smart Guides, which appear and disappear automatically as you drag the content of one layer into and out of alignment with the content of other layers. Smart Guides (magenta in color by default) show when the content of the layer you're dragging aligns perfectly with the edges or center of other layers' con-

FIGURE 3-11:

The magenta guides show how the layer aligns with other layers.

tent. See Figure 3-11. (Show/hide Smart Guides through the View ⇔ Show menu. They are active by default now.)

Preferences □ Plug-Ins

TIP

Extensions are panels created outside of the Adobe Photoshop development process that you can download or purchase. Allowing them to connect to the Internet to search for new content may or may not be a good idea, depending on your level of network security. I'm not suggesting that a panel could steal your passwords or anything like that, but unless you trust the source of the panel . . .

The creative filters of the Filter Gallery are not listed individually in the Filter menu. You open the Filter Gallery, and then select the filter you need. If you would rather have the Filter Gallery open directly to the filter you need, select Show All Filter Gallery Groups and Names option and restart Photoshop.

In the Technology Preview panel of the Preferences, your options and choices will vary both with your hardware and over time. As Adobe develops new whiz-bang ideas, you can choose to play with them. Or not. Take a couple of moments (when you have time) to click the Learn More button to find out what the new technologies are all about.

Preferences ⇔ **Product Improvement**

To help Adobe Sensei (the so-called "artificial intelligence" engine) do a better job with complicated tasks, such as selecting frizzy hair, you need to give it data. By (anonymously) participating, you provide your experiences to Adobe to improve the automated functions. You'll definitely want to click the Learn More button in order to make an informed decision. Remember that the more people who participate, the easier your work will get in the future.

Ensuring consistency: Color Settings

If one term strikes fear deep in the heart of a typical Photoshop user, it's *color management*. Few aspects of the program are so misunderstood. Yet without wise color management decisions, your images won't print accurately. For most Photoshop users, color management can be implemented with a few key choices in the Edit \Leftrightarrow Color Settings dialog box (shown in Figure 3-12), which can then be saved for future use:

- Select an RGB working space. Open the Color Settings dialog box (under the Edit menu) and select your *RGB working space*, the color space in which you edit and create. If you primarily create web graphics, shoot in the JPEG format, send your images to a photo lab for printing, or print with an inkjet printer that uses only four ink colors (cyan, magenta, yellow, and black), choose sRGB as your color space. If you shoot Raw and print to an inkjet printer that uses six or more inks, or if you prepare artwork that will be converted to a CMYK color space, choose Adobe RGB. (If you have hardware and software to create a custom profile for your computer's monitor, use that profile at the system level so that it's available to all programs.)
- >> Elect to convert images to your working space. In the Color Management Policies area of the Color Settings dialog box, choose RGB: Convert to Working RGB. This ensures that the images you see onscreen actually use your working profile.

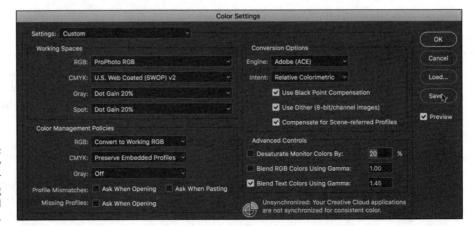

FIGURE 3-12: Choose wisely in the Color Settings dialog box for optimal printing.

- >> Turn off the mismatch warnings. Clear the check boxes for those annoying and time-wasting warnings that pop up onscreen any time you open an image with a profile other than your working space. You're intentionally converting to your working space you don't need to reaffirm the decision every time.
- CMYK and Grayscale settings: CMYK (cyan/magenta/yellow/black) color mode is used exclusively with images intended for output on commercial printing presses and some color laser printers. (Don't be fooled by the inks you purchase for your inkjet printer the printer's driver expects to convert from RGB, so sending CMYK color to an inkjet will produce substandard output.) Likewise, you'll use Grayscale very rarely. If, in fact, you have an inkjet printer that is capable of printing grayscale (such as the magnificent Epson Stylus Pro 7900), you may still want to have an RGB image and let the printer's print driver handle the grayscale conversion. If, however, you are preparing an image for output on a commercial press (in CMYK or Grayscale color mode), speak directly with the person who will place the image into the page layout or with the print shop to find out what settings to use for that particular job.

The preceding guidelines are appropriate for most, but not all, Photoshop users. You might fall into a special category. If you *exclusively* create web graphics, set the RGB color management policy to Off. In the Save for Web & Devices dialog box, when saving images in the JPEG file format, don't embed ICC profiles. (*ICC profiles* make specific adjustments to the appearance of your images to compensate for vagaries of the hardware. I discuss color profiles in Chapter 4.) When you eliminate color profiles from the equation, you're creating web graphics that any web browser can show properly (or, more accurately, "as properly as the viewer's uncalibrated monitor can display").

When it's time to print, you'll get the most accurate and pleasing color prints when you let Photoshop (rather than the printer) control color. In the Print dialog box's Options area, choose Color Handling: Photoshop Manages Colors and select the printer's own profile for the specific paper on which you're printing as the Printer Profile. Use Relative Colorimetric as the rending intent and leave the Black Point Compensation check box selected. (*Note*: If your prints are too dark, try deselecting Black Point Compensation.) Click the Print Settings button to open the printer's own options. Make sure to deactivate the printer's built-in color management and select the same paper you chose to the right in Photoshop's Print dialog box.

If you send your image files to an outside source for prints, they will likely require JPEG files using the sRGB color profile. Check the company's website (or give them a call) and see if, instead, you can send TIFF files in Adobe RGB. That avoids the image degradation produced by JPEG's compression and extends the color range for the images.

If color in your images needs to be absolutely perfect because merely accurate won't do, consider purchasing hardware and software to calibrate and profile all the devices in your workflow. X-Rite (www.xite.com), Datacolor (www.datacolor.com), and PANTONE (www.pantone.com) are three sources to explore.

When Good Programs Go Bad: Fixing Photoshop

Sometimes things happen. Bad things. Tools don't work right. Simple commands take ages to execute. Photoshop (gasp!) *crashes!* Don't give up, and please don't toss the machine through the window. (Hey, I might be walking past at the time.) Start with the easy fixes and work your way up as necessary:

>>> Check the panels and selection. If a tool isn't working as expected or isn't working at all, check whether you're inadvertently preventing it from doing its job. See whether you have an active selection elsewhere in the image or press

+D/Ctrl+D to deselect. Look at the Layers panel: Are you working on the correct layer? Is the layer itself active or a layer mask? Is there no higher layer hiding the area in which you're trying to work? Check the Channels panel: Are the color channels active? At the left end of the Options bar, right-click the tool icon and select Reset Tool. Open a flattened 8-bit RGB image and try the tool or technique in that image. If it works there, the problem isn't Photoshop but rather the specific image. Check the Image

Mode menu to ensure that you have an appropriate color mode and bit depth.

- Preferences, export any custom styles, gradients, brushes, and so forth through the various panel and picker menus. Save them in a safe place, outside the Photoshop folder. Open the Actions panel and save any sets of custom Actions with the panel menu Save Actions command. (Remember that you must click a set of Actions not an individual Action to use Save Actions.) Open the Preferences and Color Settings and make notes about any special settings you're using. Open Preferences ♣ General and click the button Reset Preferences on Quit. Confirm your choice by clicking OK. Quit Photoshop and restart the program. Reset your Preferences and Color Settings and reload your custom bits and pieces.
- >> Reinstall Photoshop. If replacing the Preferences doesn't solve the problem, try reinstalling Photoshop. Save all your custom items (as described earlier) and then uninstall Photoshop through the Creative Cloud Manager's All Apps panel. (Click the ellipsis to the far right of the program name and select Uninstall.) After uninstalling, restart your computer (not always necessary, but a good practice) and reinstall through the Creative Cloud Manager's All Apps panel.

If reinstalling Photoshop doesn't solve the problem, the source might be at the operating system level or is perhaps a hardware problem. Call in the big guns by contacting Adobe tech support. Go to this link to determine your level of support: https://helpx.adobe.com/cointact/what-contact-options.html.

- » Keeping track of your images
- » Putting pictures on paper
- » Sharing your work

Chapter 4

From Pics to Prints: Photoshop for Beginners

n this chapter, I show you how to get images into Photoshop from your digital camera and your scanner and then how to keep those images organized on your hard drives and discs. I discuss the basics of printing your images on inkjet printers (and alternatives) and tell you some things you need to know to make sure that you get the prints you expect. I also explain how to prepare images for sending by email.

Bringing Images into Photoshop

Artwork in Photoshop originates in one of four ways:

>> Photoshop's Home screen, shown in Figure 4-1, opens by default when the program launches, but you can open it at any time by clicking the button at the far left end of the Options bar. The Home screen offers you a list or thumbnails of images recently opened. In the left column, you can instantly jump to your Lightroom photos, documents in your Cloud storage, documents being shared with you through the Cloud, and even recently deleted documents (that you may want to restore).

- You can click the Open button on the Home screen or, if the Home screen isn't currently visible, you can use Photoshop's File → Open command to open a regular Open dialog box, just as you would see using any of the other programs on your operating system.
- >> You import an image (typically through a connected camera or scanner).
- >> You create an image from scratch by choosing by clicking the Create New button on the Home screen or using the menu command File ▷ New.

Photoshop's
Home screen
opens by
default when
the program
launches.

If you double-click a file in a folder or in Bridge and Photoshop doesn't launch or the wrong program launches, you need to either launch Photoshop manually and use the File Open command or associate the file format with Photoshop. (Check your operating system's Help for info on associating file types with specific programs.) If you open images through Bridge:

- Open Bridge's Preferences with the shortcut # +K/Ctrl+K.
- In the column to the left, click File Type Associations.
- 3. In the lower-right corner, click the Reset to Default Associations button.

Downloading from your digital camera

If you have the hardware, you can remove your camera's memory card, memory stick, or other media from the camera and insert it into a slot right on your computer. You can also use a card reader, which is a small device designed to read camera storage media. Transferring via the Mac Finder or Windows is often faster

than (and usually just as reliable as) transferring using the camera manufacturer's software.

I suggest that you don't open an image into Photoshop directly from a camera, Flash card, or CD/DVD. Doing so can slow down your work, and you also risk losing your work if Photoshop isn't able to immediately and efficiently read the original file while you work. And, of course, you can't save from Photoshop back to most removable media, so you need to create a new file (on a writable drive) anyway.

After the images are safely stored on your local hard drive (or a high-speed external hard drive) or in your Cloud storage, you can open them in Photoshop by using one of the methods that I describe earlier in the chapter. Depending on your color settings, you might see a warning that the image's color profile and the profile that you selected as your RGB working space don't match. You may see a simple OK/ Cancel option or you'll see the embedded profile and the working profile, and you're given three options (as well as a Cancel button, which won't open the document):

- >> Use the embedded profile (instead of the working space).
- >> Convert the document's colors to the working space.
- >> Discard the embedded profile (don't color manage).

Generally speaking, you want to convert to your working space so that you see the most accurate color on your monitor. You might want to preserve the embedded profile if you'll be returning the image to the originating computer after looking at or working on it. The third option disregards all color profiles and works with uncorrected color. This is a good choice when working with images that you'll later use with a non-color-managed program, such as a web browser or presentation program. (Without color management, you see the image as it will appear in the other program.) You can disable the color mismatch warnings in Photoshop's Edit Color Settings dialog box.

When opening an image that includes text, you might also get a message warning you that the type layers need to be updated. Generally speaking, you want to update them unless the image contains fonts that aren't available on your computer. And don't forget about the Type Amore from Adobe Fonts command to get missing fonts.

Scanning prints

You place a photo (face down) on the glass of your scanner. You push a button. It automatically appears on your computer screen. That's scanning at its most basic. You can save that file to your hard drive and use Photoshop's File Open command to bring it into Photoshop for editing.

PURCHASING COMMERCIAL IMAGES

Some projects require images that you can't run out and shoot yourself. Say, for example, that you're preparing a poster or brochure about a ski trip to Japan. In your office or studio. In the United States. In July. Pretty tough to shoot what you need, eh? Turn to stock photography. You can purchase or license stock images (photos, illustrations, video, and even audio) from a wide variety of sources, including Internet-based services and collections on CD/DVD.

On Macs, Photoshop's File Dimport Images from Device command enables you to scan right from Photoshop, right into Photoshop. It can also be used to download images from cameras or card readers. (Windows users have WIA Support on the File Dimport menu.) The scanned image can open in Photoshop as a separate file or as a layer in the currently active document. The Import Images from Device dialog box is shown in Figure 4-2.

To the right in Figure 4–2, you see a column of options available when working with a scanner. You can elect to scan as color or grayscale (the Black & White option), set the resolution and print dimensions, rotate the image, and elect to identify separate photos placed on the scanner's glass. In addition to JPEG, available file formats include TIFF and PDF (as well as a number of other formats you'll likely not use for scanning). Other available options include manual color correction (do it in Photoshop instead), three levels of sharpening (again, a task to be done in Photoshop), and descreening to remove moiré patterns (discussed later in this chapter).

When you've finished scanning, choose File \circlearrowleft Close or use the shortcut #+W/ Ctrl+W to close the window — no Quit or Cancel button is available.

FIGURE 4-2: Access your scanner directly from Photoshop on a Mac, scanning right into Photoshop.

Using Photoshop's Crop and Straighten Photos enables you to scan multiple photos in a single pass; then have Photoshop separate them into individual files. Read about using this command in Chapter 15.

Determining scan resolution

Before using a scanning to import an image, you need to make some decisions:

- >> How you want to use the image
- >> What its final size will be
- >> What resolution you need

If your scanner's software doesn't offer you the option to input final dimensions in inches, just pixels, you may need to calculate the size. By determining how many pixels you need beforehand, you eliminate the need to resize the image in Photoshop (and the possibility of image degradation). Many scanner interface windows let you input the final size and resolution you need right in the scan window. If you find the need to calculate scan resolution manually, here's how:

1. Determine the required pixel dimensions.

• For print: If you'll be printing the image, determine the size at which you want to print (in inches) and the resolution at which you want to print (typically 300 ppi [pixels per inch] is a good choice). Multiply the print width and height by the resolution to determine pixel dimensions.

 For the web: If the image is destined for your website, determine how much of your page the image will occupy (in pixels).

2. Measure the original.

Before placing it on the scanner's glass, measure the original image. If you're using only part of the image, measure that part. (Be careful not to scratch the original with your ruler!)

3. Do the math.

Divide your required pixel dimensions (Step 1) by the physical dimensions of the original (Step 2). The result is your *scan resolution*. (If you get different numbers for the width and height, use the larger and expect to do some cropping in Photoshop.)

Many flatbed scanners (scanners designed for use with documents and photos) have *transparency adapters* that let you scan film and slides. However, if you have a lot of negatives or slides to scan or if the best possible quality is required, consider a dedicated film scanner from Nikon, Minolta, or Kodak.

You can also use the camera on your iPhone or iPad as a scanner. The command File Import from iPhone or iPad connects to your device (you must be on the same network, of course) and activates the camera. You can either simply take a photo or "scan" a document into Photoshop. When you select Take Photo, Photoshop simply uses the iPhone or iPad camera to capture everything in the camera's field of view. When you select Scan Documents, Photoshop uses the camera in a different way. The device analyzes what the camera is seeing and tries to determine the corners of a document (you can adjust the bounding box manually), trim to those edges, rotate and straighten if necessary, and then bring the result into Photoshop on a transparent background. You can scan multiple documents, but when you tap Save on the device, only the first scan opens into Photoshop.

You can also add image files to your hard drive using Bridge's Get Photos from Camera. However, using Import Images from Device does offer one huge advantage — it's "sticky." In other words, the dialog box doesn't go away after the first import. Say, for example, that you have images on a single Flash card from three different projects or locations and you want to download them into three different folders. When using Get Photos from Camera, you wait for Bridge's Photos Downloader to examine the entire card, you select the first batch of photos, you download, and then Adobe Photo Downloader goes away. To download the second set, you start from scratch (including reexamining the entire card and waiting for thumbnails to generate). When importing directly from Photoshop, you select the first set of images, choose a location, download; select the second set, choose a different location, download; select the third set, choose a third location, download, close the window.

Preventing moiré patterns

Unless you spent thousands of dollars on your scanner, you probably want to forget about the scanner software's color and tonal correction capabilities — Photoshop gives you more control. However, here is one thing that scanner software does much better than Photoshop, and it's a capability that you should use when appropriate: moiré (pronounced, roughly, *mwah-RAY*) reduction. A *moiré pattern* is a visible rosette pattern created by the pattern of dots placed by the printing press to reproduce color.

When you need to scan a color image or artwork that comes from a book, magazine, or newspaper (or other material printed on an offset printing press, such as product packaging or signs), you want to use the scanner's software to reduce moiré. When you let the scanner know the pattern is there, the scanner's software compensates for the pattern and smooths

FIGURE 4-3: Scanning without (left) and with the scanner's moiré reduction option.

the scanned image (as you can see in Figure 4-3).

The moiré reduction feature in your scanner's software might not be immediately recognizable. It might be labeled Descreening, or it could be a choice between Color (Photo) and Color (Document). As always, refer to your hardware's User Guide for specific guidance.

If rescanning is out of the question and you have a moiré pattern to reduce in Photoshop, blur the image enough to disguise the problem, and then paint with the History Brush to restore areas of critical detail in the image.

Here's an important announcement from *The Department of an Ounce of Prevention is Worth a Pound of Cure:* A minute or two spent cleaning the scanner could save hours of touch-up in Photoshop. Before doing any scanning, use a can of compressed air to make sure that the scanner's glass is clean and free of dust. Likewise, check the inside of the scanner's lid. (What good does it do to clean the glass if dust from the lid is going to contaminate it again as soon as you close it?) If necessary, eliminate fingerprints or smears with appropriate glass cleaner. (Check the scanner's User Guide for cleaning instructions and be careful when using liquid glass cleaner with an electrical device! I like to use the same premoistened wipes I use for my eyeglasses.)

You can use a burst of compressed air on the original image, too, before placing it on the glass. Just be careful — first spray a quick burst away from the photo to clear the nozzle, hold the can of air some distance away from the photo, and spray at an angle so that you don't damage the surface of the print.

Keeping Your Images Organized

Because digital photography doesn't have a significant per-shot cost (as did shooting film), people certainly have a tendency to shoot more. And more. And more. You find experimental shots, this-might-be-interesting shots, special effects shots, and (at least in my case) the same shot over and over and over again. They build up on your hard drive.

It's pretty easy to stay organized after you choose a system. The hard part is actually deleting those digital photos that you really don't need to keep — you know, out-of-focus, shot at a bad angle, Aunt Betsy's eyes were closed and her mouth was open, the 400th shot of the dogs sleeping all curled up, the 401st shot of the dogs sleeping all curled up, and the like. It takes discipline! (Or an external drive, USB storage, and for older computers, an optical drive that can burn CDs and/or DVDs.)

Creating a folder structure

I generally recommend using a subject-based organization scheme, such as the one shown in Figure 4-4. For example, inside the main folder named AllVacationPhotos, you might have subfolders with names such as London-Feb2012, NHL_31CityTour, or perhaps BackyardCamping_Sept_2011. (Notice that none of the folder names use empty spaces or characters other than letters, numbers, a dash, and an underscore, which minimizes the possibility that Photoshop or another program won't be able to find a file.)

TIP

Don't overload your folders! If you find that your computer is slowing down when it tries to display the content of a folder, you have too many files in the folder. Create a second folder of the same name and add -01 and -02 to the folder names. Generally speaking, 500MB is probably as large as you want in a single folder.

You can use external drives or USB devices (or your computer's CD/DVD drive if it has one) to store folders of images. This not only provides you with a reliable backup (assuming that you store the devices or disks correctly and handle them carefully), but it can also free up space on your hard drive. Your folder/subfolder structure can also be used when creating your discs.

FIGURE 4-4: Organize with subfolders.

Using Adobe Bridge

Adobe Bridge, the asset-management program for Photoshop and other Adobe programs, is a separate program in the Creative Cloud Manager. You can open Bridge independently, or you can choose File Browse in Bridge from Photoshop's main menu to launch Bridge — seen launched in Figure 4-5. If you choose Bridge's Preferences Advanced command, you can elect to have Bridge launch automatically whenever you log in to your computer.

FIGURE 4-5:
Bridge's color
scheme is
automatically
matched to what
you choose in
Photoshop's
Preferences, but
you can change
that in Bridge's
Preferences
☐ Interface.

NEW

In Figure 4–5, note the Publish tab in the upper-right, nested with the Preview tab. That gives you direct access to Adobe Stock, enabling you to submit your images for sale as stock photos right from Bridge.

Here are a few tips for working with Adobe Bridge:

>> Use keywords and categories. Using the Keywords tab (shown in Figure 4-6), to the lower right in Bridge's default layout, you can assign keywords and categories to images. Keywords and categories are descriptive terms that you assign to individual images. Down the road, you can choose File ➡ Find to find all images with a specific assigned keyword. A check mark to the left of a keyword indicates that all the files currently selected in Bridge's Thumbnails pane have that keyword assigned; a dash indicates that some, but not all, selected images have been assigned that keyword.

FIGURE 4-6:
Assign keywords and categories to help organize (and locate) images.

- >>> Select multiple images in Bridge. You can have multiple images active by clicking and Shift+clicking (or # +clicking/Ctrl+clicking) the image thumbnails. You might want to select multiple images and then assign the same keywords to all the selected images at once.
- >> Use labels, ratings, and filters. Under the Label menu, you can assign a star rating to each image and assign colors to organize by subject or project. Use the View ♣ Sort menu to arrange images in the thumbnails area of Bridge according to either the label or the rating.
- >> Add folders to the Favorites. You invariably will visit some folders on a regular basis. Choose File ♣ Add to Favorites to get back to that folder faster and more easily. In the upper-left corner of the Bridge window, click the Favorites tab for one-click access. Keep in mind, too, that you can add a folder to the Favorites while working on a specific project, and then choose File ♣ Remove from Favorites when the project is finished.
- >> Change your view and workspace. Use the View menu to customize what the Bridge window shows, and use the Window ♥ Workspace menu to determine how it is displayed. You might find that Compact Mode fits your

- needs better in some circumstances than does Full Mode. And don't overlook Bridge's Slideshow feature — it can be a great way to show off your work!
- >> Use stacks to organize images. Select similar images or variations on the same shot and use Bridge's Stacks ⇔ Group as Stack command. All the selected images are piled into one spot as a single thumbnail, with a number in the upper-left corner to indicate how many images are stacked together. When you have ten or more images in a stack, you can scroll through the thumbnails with a slider that appears when you move the cursor over the stack.
- >> Zoom with the Loupe. Click in the Preview (in the upper-right corner of the default workspace) to zoom in. Drag the cursor to inspect the preview up close and personal. Use your mouse's scroll wheel or your trackpad to zoom from 100% to as high as 800%.
- >> Access Photoshop scripts. In Bridge's Tools menu, you'll find a submenu named Photoshop (as well as menus for other installed programs that use Bridge). Through that menu, you can easily access Photoshop's Batch, Image Processor, Photomerge, and a number of other features. Select the thumbnails in Bridge first, then select the feature you want to use. Perhaps my favorite command in the menu is Load Files into Photoshop Layers — all the files selected in Bridge are opened in a single Photoshop document, each on its own layer. It's a fabulous time saver when preparing a series of images for use with Photoshop's stack modes. (For more on layers and stack modes, see Chapter 17.)

If you enjoy macro photography — taking close up shots of little things — you can shoot a series of images with different focal points (using a tripod, of course), then use Bridge's Load Files in Photoshop Layers command. After the files load, choose Select ⇒ All Layers from Photoshop's menu bar (did you know about that command — very handy, eh?), choose Edit → Auto-Align Layers (even if you did use a tripod), then choose Edit ⇔ Auto-Blend Layers with the Stack Images option. Each of the in-focus areas is combined to a single all-in-focus image using layer masks. (See Figure 4-7.)

Renaming image files easily

All right then, you've arranged a hierarchy of folders and subfolders. You've sorted your images into those folders. You've assigned ratings and labels to the images. However, you still have no idea which is which on the File → Open Recent menu. Filenames such as _MG_1907.CR2 and PB270091.jpg don't tell you much about the image content, do they? Use Bridge's Tools ⇔ Batch Rename command (as shown in Figure 4-8) to assign more meaningful (and informative) names to your files. Select content from each field from the pop-up menu or type in a field. Click the + button to the right to add more elements or variables to each name.

FIGURE 4-7: Auto-aligning and autoblending layers.

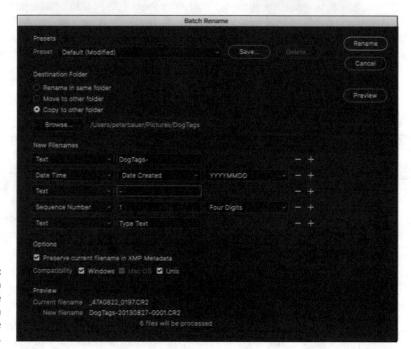

FIGURE 4-8: Use Batch Rename to assign informative names to files.

So that each of your original images gets a unique name, you *must* include a variable when using Batch Rename. (If you did try to rename all the images in a folder to say, picture.jpg, you would end up with only one image file in the destination folder — each would overwrite the previous.) Therefore, when using Batch Rename, you must choose one of the variables for one of the fields via the pop-up menu, be it the original document name or a sequence number/letter.

Also keep in mind that you shouldn't type a period (.) into any field. That character should be used only before the file extension. And, as a wonderful keep-us-from-creating-problems-for-ourselves improvement, Batch Rename automatically adds the file extension for you.

Printing Your Images

In the very recent past, the subject of printing images from Photoshop required a huge number of pages. Thankfully, improvements in hardware and software make printing much easier. Monitors are well calibrated out of the box, printers reproduce color more accurately, and inks and papers last for decades. Yes, things have come a long way in a short time. But before you click the Print button, you should make sure that your image is ready to print. Will it fit properly on the page and in the frame? Are the pixels small enough that they blend evenly into the overall picture? Will the colors you envision be the colors that appear on paper?

Cropping to a specific aspect ratio

Aspect ratio is the relationship between the width and height of your image. An image in *landscape* aspect ratio is wider than it is tall, and an image in *portrait* aspect ratio is taller than it is wide. Although digital cameras capture in a variety of aspect ratios, including 3:4 and 4:5, DSLR (digital single lens reflex) cameras typically use a 3:2 aspect ratio: One side is 1.5 times the size of the adjoining sides. Typical print (and picture frame) sizes are 8 x 10 inches (a 4:5 aspect ratio), 5×7 inches (5:7), 4×6 inches (3:2), and 3×5 inches (3:5). In Figure 4-9, the 3:2 aspect ratio is outlined in green, 5:7 is shown in yellow, and 4:5 is red.

Although an 8-x-10 print is physically larger than a 4-x-6 print, it may print less of your original image because of cropping. The 4-x-6 print, with a 3:2 aspect ratio, includes all of the original image; the 8-x-10 print (with its 4:5 aspect ratio) is missing 2 full inches of the image's longer dimension. To print 8 inches wide and retain the entire image, you'd be printing at 8 x 12. Of course, if your camera captures in a 4:5 aspect ratio, the problem is reversed — the original image fits perfectly into an 8-x-10 print, but won't fill a 4-x-6 print without cropping.

In Photoshop, you can change the aspect ratio of your image with the Canvas Size command (if one dimension is already correctly sized), the Crop tool, or the Rectangular Marquee tool with the Image Crop command. With the Crop tool selected and WxHxResolution selected in the menu to the left in the Options bar, you can enter specific dimensions and a target resolution in the three boxes to the right of the menu. Drag the tool, position and adjust the bounding box, and

then press Return/Enter to execute the crop. Whatever is within the bounding box is resampled to the exact size that you specify on the Options bar. If you crop with Canvas Size or Crop commands, you may need to use Image Size to specify the desired print resolution. (And see Chapter 2 for information on Photoshop's Content-Aware Scale command.)

Different print sizes encompass different amounts of your image.

As soon as you activate the Crop tool (use the shortcut C or click the tool icon in the Toolbox), a bounding box appears around your image. You'll also see a variety of options in the Options bar. (See Figure 4–10.) The top inset shows the various preset aspect rations available in the Options bar. Note the option WxHxResolution — select it to crop to a specific size and resolution. The left inset shows the variety of overlays available, including Grid, visible over the image in Figure 4–10. The lower-right inset, opened by clicking the gear-shaped button in the Options bar, provides options on basic Crop tool behavior.

Also notice that while the image is being slightly rotated during the crop process, the Crop tool's bounding box doesn't rotate; it's the image behind the bounding box that rotates. To the right in the Options bar is the Delete Cropped Pixels option. When Delete Cropped Pixels is selected, the pixels outside the bounding box are deleted, but when deselected, those pixels are hidden and can be restored with the Image Reveal All command.

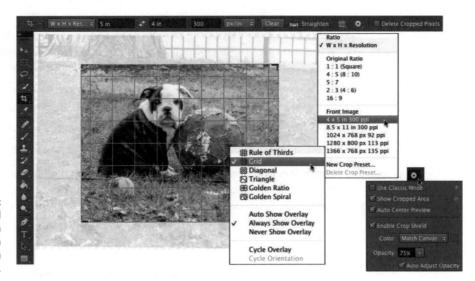

FIGURE 4-10: The Crop tool overlays can help when composing an image.

Not all programs recognize "hidden" cropped pixels. If you're going to place this image into another program or on a web page, make sure that you're working on a copy of the original image and elect to delete the cropped pixels.

When creating a cropping selection with the Rectangular Marquee tool, you can change the tool's Style pop-up menu (on the Options bar) from Normal to Fixed Ratio or Fixed Size. Generally speaking, use Fixed Ratio and drag the marquee to encompass that part of the image you want to retain. When the selection marquee is how and where you want it, choose Image \hookrightarrow Crop.

Keep in mind that the Image ⇔ Crop command doesn't resample the image — you've just changed the aspect ratio and pixel dimensions so far — you'll need to also choose Image ⇔ Image Size (which is discussed in Chapter 2).

Remembering resolution

Chapter 2 presents you with an in-depth look at resolution as it pertains to digital imaging. As a quick refresher, keep these points in mind when thinking about printing your images:

>> Images themselves have no resolution. Whether in your camera, on your hard drive, or open in Photoshop, your images consist only of tiny colored squares called *pixels*. The image looks and acts the same within Photoshop (except for adding type), regardless of resolution. An image of 3,000 x 2,000 pixels at 300 ppi is handled in Photoshop exactly as an image of 3,000 x 2,000 pixels at 72 ppi.

- >> Resolution is an instruction to a printing device. The resolution value that you assign to an image in your digital camera or in Photoshop's Image Size dialog box is recorded with the image strictly as an instruction to the output device.
- **>> Resolution measures the size of individual pixels.** A resolution of 300 ppi really means that each pixel will print at a size exactly $\frac{1}{300}$ of an inch square. Likewise, 72 ppi equates to each pixel printing at $\frac{1}{72}$ of an inch square.
- >> Web images use only pixel dimensions. Most web browsers aren't capable of reading the resolution information embedded in your simple graphics by Photoshop. Each image is displayed in the web browser strictly according to the number of pixels in the image.

In the past few years, reproducing accurate color from monitor to printer has become much easier. Although the process of color management still strikes fear into the hearts of many, the actual need for complex hardware and software to control color is greatly reduced. Why? Simply because computer manufacturers recognized that we, the consumers, wanted better color. Monitors ship from the factory calibrated and accurate. Printers use smaller droplets and better inks. Software does a better job of communicating color.

For most Photoshop users, accurate color is important. After spending hours tweaking an image's appearance onscreen, surely you want the print to look exactly like the monitor. Here's how to get that great color:

When you're ready to output your image, choose Photoshop's File

→ Print command.

A large, one-stop-shopping Print Settings dialog box opens (see Figure 4-11). The Print Settings buttons give you access to printer-specific options. (Different printers offer different options.)

2. Select your printer and the number of copies you want to print.

In the Position and Size section, you can center the image within the printer's margins or offset the print. You can also elect to scale the image to fit the paper rather than printing at the image's actual size. (The Printing Marks, Functions, and PostScript Options sections of the Print Settings dialog box are used almost exclusively by print shops.)

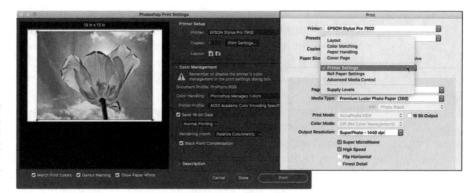

Photoshop's
Print Settings
dialog box
offers basic
control over
your print.

3. Set up color management.

- In the Color Handling pop-up menu, select Photoshop Manages Colors.
- In the Printer Profile pop-up menu, choose the printer's profile for the paper on which you're printing. If the Send 16-Bit Data option is available, and your image is in 16-bits/channel mode, you should take advantage of that feature.
- Select Normal Printing (rather than Hard Proofing) for Rendering Intent, choose Relative Colorimetric, and select the Black Point Compensation check box. (If your prints are too dark, deselect this last option.)

4. Click the Print button.

This takes you from the Photoshop Print Settings to the actual Print dialog box. If you want to print at a later time, click the Done button to record your settings in the image's metadata.

5. Print.

Make sure the correct printer and paper size are selected and click the Print button to send the image to the printer and starts the actual process of putting ink on paper.

Considering color management solutions

If your prints don't match your monitor, first evaluate your monitor's settings. Open an image with known color values (you know what the image should look like) in a non-color-managed program. You might, for example, open Microsoft Word and choose Insert Picture Prom File to add an image with known color values (or a downloaded color chart) to a blank document. Use the monitor's controls to make that image look the best possible, and then print. If the image prints accurately, great — you're all set.

If the monitor looks great but the print is strange, first try cleaning and calibrating the print head, and then print from Photoshop. And take another look at the Print dialog box to make sure that you're selecting the proper paper and color settings. (Again, refer to the User Guide for your printer for specific instructions.)

If your work (or play) requires extreme color fidelity, a number of companies offer hardware and software that regulate color. You can create custom profiles for monitors, printers, and even scanners and digital cameras. Although not inexpensive, skillful handling of these tools (in accordance with the User Guides!) can not only result in better prints, but also reduces the amount of aw-shucks wasted paper and ink from bad output. If you fall into this category, explore the current offerings from X-Rite (www.xrite.com), PANTONE (www.pantone.com), and Datacolor (www.datacolor.com).

Keep in mind that all the color management hardware and software in the world doesn't do you a bit of good if you're not controlling your environment. If your work requires perfect color — not *good*, but *perfect* — you need to take some additional steps. In the office or studio, you need to regulate ambient light so that you have a consistent color-viewing situation, day in and day out, rain or shine, summer and winter. If you have windows, you need shades or drapes that you can close before doing color-critical work. The walls visible behind the monitor and the immediate work area should be neutral in color. (And that means no brightly colored sticky notes on the bezel of your monitor!) You probably need a hood for your monitor and perhaps a D50 (or D65) viewing station in which to evaluate your prints under optimal lighting conditions.

Printing alternatives

Many Photoshop folks use an inkjet printer to put their photos on paper. Although inkjet printers are the most popular and perhaps the most practical, you do have alternatives. If, for example, your work consists mainly of brochures and flyers rather than photos, a color laser printer might better fit your needs. The initial cost of a high-quality color laser printer is generally higher than all except wideformat inkjets, but the cost per page is much lower. Color laser printers generally don't print photographs as well as a mid- to high-end inkjet, and the prints aren't archival (they won't last for a whole lot of years without fading), but such prints might be just fine for sharing snapshots among friends and family. Take a look at the User Guide for the specific printer you use to set up your job correctly.

Dye sublimation printers use rolls of film impregnated with dyes to reproduce prints. Prices for these printers range from less than \$200 to several thousand dollars. The quality and longevity of the prints is generally tied to the price.

Here's another output alternative available to virtually all Photoshop users. Save your images in JPEG format (highest quality, 300 ppi), and then copy to a USB flash drive (or burn onto a CD) and take your photos to the local photo lab or perhaps a pharmacy. Alternatively, use an online service with which you upload your JPEGs to the service's web service to order prints. (Check with the lab or service to see whether you need to use the sRGB color profile for your images.) You'll get back glossy or matte prints at the size(s) requested. And the cost per print can be substantially less than using your inkjet printer. The local photo lab is often a great alternative for stacks of vacation photos and family reunion shots that need to be sent to a whole passel of kin.

Unless your inkjet printer is specifically designed to handle grayscale images, you might want to use a photo lab for such prints. Inkjet printers designed with grayscale in mind output using black ink plus one or more supplemental gray (or "light black") inks to increase the tonal range and ensure adequate detail in your shadows. Inkjets that aren't designed to print grayscale can either print using only black ink (which severely limits the detail and tonal range) or they print with all the installed inks (which invariably leads to some color tint or color cast in the supposedly neutral grayscale images). Check the printer's User Guide.

Sharing Your Images

Photoshop offers a number of nifty ways to make it easy to share your images with others. (And, of course, you might simply send a CD of JPEG files to a friend or client with instructions to double-click each one to view the images.) However, there are certainly more elegant ways to showcase your talents. Images can also be uploaded to a variety of social media sites and you can email links to those pages to anyone with whom you want to share your work. Photoshop's File Share command give you direct access to a number of ways to share images (see Figure 4-12).

Before uploading images to a social media site, check that site's image size and format requirements. And make sure that you make a copy of your original before preparing it for upload.

FIGURE 4-12: You can share your images directly from Photoshop (assuming your computer is connected to the Internet, of course).

Emailing and AirDropping your images

When emailing or AirDropping images keep in mind that if you like these folks enough to send them your images, you probably want to keep their friendship. And to that end, you want to be a responsible sharer —you don't want to send out an email attachment so large that it disrupts service for the recipient. ("Hi Marge. You know those images from your vacation that you emailed me on Tuesday? They're still trying to download. Yeah, today is Saturday. Anyway, why don't I drive up to Maine and look at the snapshots — it's probably faster than waiting for the email.")

As a general rule when emailing, your attached images should rarely if ever total more than 2MB in size (unless you verify through direct communication that everyone on your To list can handle large attachments). Each image should be no more than 1,200 pixels tall so that it can be viewed in a web browser on most monitors and the most popular tablets. You can certainly use your computer's compression utility to compress one or more images before sending. But if you do compress your attached images, make sure to include instructions to save the compressed file to the hard drive and double-click to expand.

Creating PDFs and websites

Portable Document Format (PDF), the native file format of Adobe Acrobat, has become an incredibly useful and near-universal format. It's hard to find a computer that doesn't have Adobe Reader (free software to open and view PDF files) or another PDF-capable program (such as the Mac's Preview), which helps make PDF a wonderful format for sharing or distributing your images. Photoshop offers PDF Presentation in the File menu. Read about PDF Presentation and the very useful Contact Sheet II feature in Chapter 15.

Easy Enhancements for Digital Images

IN THIS PART ...

Discover brightness and the definitions of *black* and *white*.

See how to adjust the colors in your image to make them look natural.

Get the lowdown on Raw images and working with the Camera Raw plug-in.

Discover how to tell Photoshop to work with only part of your image, controlling where your adjustments are made.

Explore some of the most common problems in photos and see how to overcome them.

- » Making the easy Auto repairs
- » Making adjustments with Levels and Curves
- » Using advanced tonality correction
- » Seeing reds, greens, and in-betweens
- » Sailing with the Photoshop color correction armada
- » Fixing flesh tones

Chapter 5

Making Tonality and Color Look Natural

hen an image really *pops* — when it jumps off the page at you — it's generally because the shadows are dark, the highlights are light, and the colors are rich. I'm sure it's no surprise to you that Photoshop can handle the job. (That's one of the reasons why you subscribe to the program, right?)

In this chapter, I introduce you to the concept of *tonality*, which is the range of brightness in your image. I also introduce to you the various commands that Photoshop offers for you to adjust your image's tonality. A couple of tools even give you pin-point control of shadows and highlights. After reviewing and adjusting the tonality of the image, it's time to work with color. The second half of this chapter explores the various features available for working with your image's color.

Adjusting Tonality to Make Your Images Pop

Most photos look better with a little tweaking. For pictures that look good to begin with, you might still want to perk them up a little with a tonal adjustment. Making the shadows a little darker and the highlights a bit lighter increases your image's perceived tonal range, which is sort of the distance between black and white. Take a look at Figure 5–1. It's a pleasant enough snapshot, with decent composition and an interesting subject. But it lacks pizzazz.

With Photoshop, you can darken the shadows and lighten the rest of the image to make it more interesting. By intensifying the difference between what the eye sees as dark and what the eye sees as light in the image, you add some semblance of depth to this simple picture. Comparing Figure 5-1 with Figure 5-2, you can see that one basic tonal adjustment can also make the colors seem richer and even produce a perceived increase in detail and sharpness.

FIGURE 5-1:
A nice snapshot, but not art.

FIGURE 5-2: One simple tonal adjustment darkens, lightens, enriches color, and brings out detail.

You might hear a number of words used for the same concept: the lightness and darkness of your image. Tonality, luminosity, and even brightness can be used virtually interchangeably when you're talking about the general subject. However, you typically use *brightness* when talking about specific pixels and *tonality* when referring to the image as a whole.

Histograms Simplified

In most photographs of general subject matter, your eye sees the darkest neutral (gray) tone as black and the lightest neutral as white. (If the darkest color is obviously purple and the lightest a bright yellow, you probably wouldn't classify the

photo's subject matter as "general.") In a given image, the shadow under the shoe might be just a dark gray, and the shirt looks like it might need some bleach, but your mind (in cooperation with your eye) compensates to some degree and lets you see black and white.

For a more accurate look at the tonal range of your image, Photoshop offers the Histogram panel, which displays the distribution of the pixels in your image at various luminosity values. The darker pixels (shadows) are stacked at the left end, the lighter pixels (highlights) are stacked at the right end, and the rest of the brightness values (midtones) are stacked between. The taller a column in the histogram, the more pixels at that luminosity value.

Consider, if you will, an image that consists primarily of white pixels, perhaps a beautiful Alpine snow scene or an ugly creepy-crawly thing on porcelain (as you can see in Figure 5-3). Either image has a histogram skewed dramatically to the right — what you call a *high-key* image. Nothing is wrong with the image (despite the histogram); it just happens to have a huge number of light-colored pixels.

FIGURE 5-3:
The histogram
is skewed
to the right
because of
the many
white pixels.
Or maybe
it's trying to
escape the
spider.

As you look at histograms in this chapter and in your own work, keep in mind that the color coding in the histogram shows where there are preponderances of pixels of a specific color at certain luminosity values. Where the histogram shows red or green or blue, the pixels at that brightness level are primarily in one channel of an RGB image. The cyan and magenta and yellow areas of the histogram show pixels in two of the RGB channels. When pixels in a specific tonal range appear in all three RGB channels, you see gray in the histogram. Likewise, a *low-key* image has a preponderance of dark pixels, which skews the histogram to the left. Just about any night scene has a very large number of very dark pixels, pulling the distribution to the left in the histogram. But many night scenes also include lights, which produce a spike at the far right end.

Keep in mind, too, that the heights of the individual columns in the histogram area are relative: The tallest goes all the way to the top of the box, and the others are scaled accordingly. For example, an image on a black background — say, a large black background — might have so many pixels in the leftmost column that the other columns in the image appear tiny and almost unreadable, like the histogram shown in Figure 5-4.

FIGURE 5-4:
Too many pixels in the leftmost column make the distribution for the midtones hard to see.

If the histogram is skewed to one end or the other, making it hard to read, you can make a selection within the image and the histogram updates to show information for only the selected area. (Read about making selections in Chapter 7.) If the image has multiple layers or adjustment layers, the little pop-up menu below the histogram (when in Expanded View mode) enables you to specify what layer to calculate.

As you read later in this chapter (in the section "Level-headed you!"), you can use the histogram to help avoid degrading your image while making adjustments, and (as you can read in Chapter 6) it's very important for working with the Camera Raw plug-in. But don't forget about your eyeballs — you don't need the Histogram panel to spot a low-key or high-key image.

Using Photoshop's Auto Corrections

Adjusting the tonality of your image can be as simple as selecting one of the Auto commands from Photoshop's Image menu. With many photos, the tonality (and even the color) jump to just the right look for your image. No muss, no fuss — just a great-looking picture with a single command. Auto Color usually does the best

job for most images that are close-but-not-perfect. If you don't like the result, simply use Undo and use one of Photoshop's more powerful tools.

Although Auto Color (and, to a lesser extent, Auto Tone and Auto Contrast) might do a good job with images that need simple corrections, take an extra few seconds and try the Auto buttons in Levels and Curves. On the Image Adjustments menu, choose Levels or Curves and click the Auto button, and the algorithm will search for an adjustment that, when applied, improves both brightness and contrast in all three channels in an RGB image.

If, for some reason, you prefer one of the other algorithms for Levels and Curves, open either dialog box, click the Options button, select your desired algorithm, and then click OK (see Figure 5–5).

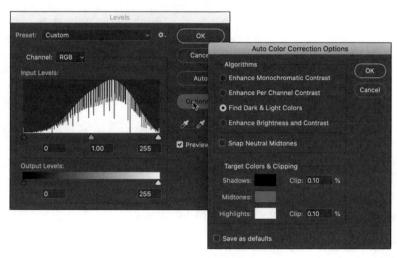

Levels and Curves and You

Sometimes you need (or simply want) more control than what's offered by the Auto commands. You might have a more demanding problem or a more expansive artistic vision. You might need to make major corrections or create stupendous effects. Photoshop, not surprisingly, offers that sort of control over your image. In fact (and also not surprisingly), you have several features at your disposal to manipulate the tonality of your images. Two of the most commonly used are Levels and Curves, both found on the Adjustments menu at the bottom of the Layers panel (see Chapter 7), the Layer New Adjustment Layer menu, and the Image Adjustments menu.

You can also use the tonal adjustment tools in Camera Raw prior to opening the image into Photoshop. Camera Raw is also available as a filter for images that have already been opened into Photoshop. Using Camera Raw as a filter isn't the same as using the plug-in on a Raw image. Read about working with Camera Raw in Chapter 6.

Before I introduce you to the Levels and Curves commands, let me quickly explain and dismiss a couple of other available options, one at the very top of the Adjustments menu the other at the very bottom. Since the early days of Photoshop, the Brightness/Contrast command has lurked among the Image Adjustments commands. In fact, it was the image adjustment command way back when. Now, however, the feature is somewhat lacking in control and sophistication and is perhaps of most use when fine-tuning an alpha channel or layer mask. (Alpha channels are discussed in Chapter 7, and layer masks appear in Chapter 9.) In both alpha channels and layer masks, you use a grayscale representation to identify specific areas of your image. Brightness/Contrast is perfectly adequate for many adjustments that you might make to those channels. Although its behavior is vastly improved from the early days, it is still a two-slider adjustment. But if you're an old-timer and absolutely love that old-time behavior of the Brightness/Contrast adjustment, click the Use Legacy check box to restore the older adjustment performance.

Also of limited use is the Equalize adjustment. It finds the lightest pixel in the image and calls that *white* and also finds the darkest pixel and calls that *black*. The rest of the pixels in the image are distributed between those values, creating an extended tonal range. In practice, you'll find that the adjustment results in extreme highlights and extreme shadows, with a rather garish image overall as well as a lack of details in the midtones.

Always keep in mind that you don't have to make changes to the *entire* image. If only part of an image needs repair, make a selection of that area before opening the particular adjustment dialog box you want to use. (Read about making selections to isolate areas of your image in Chapter 7.) Say, for example, that you take a beautiful photo of a room in your house — "beautiful" except that the view out the window is far too bright. Isolate the window with a selection, and then use one of your image adjustment commands to tone it down.

Level-headed you!

The Image \Leftrightarrow Adjustments \Leftrightarrow Levels command ($\Re +L/Ctrl+L$) or adding a Levels adjustment layer (discussed in Chapter 7) gives you control over shadows, highlights, and your image's overall tonality individually. Using a slider with three controls, you adjust the picture both to suit your eye, and with an eye on a

histogram for reference. You even have numeric fields in which you can type exact values, should you find the need.

To perform the basic Levels correction, spreading the image's tonality over the full range of values available, simply drag the slider controls under the histogram in the Levels dialog box inward until they're under the point where the histogram begins to rise in a mountain shape. Ignore those little flat tails that extend outward — they represent individual stray pixels — and drag the little pointers under columns that are at least a few pixels tall. The histogram in the Levels dialog box (as shown in Figure 5-6) is for reference as you make changes, showing changes to the overall luminosity of each pixel. Note, however, that while you work in Levels, the Histogram panel also updates, showing you the changes that will be made to each color channel.

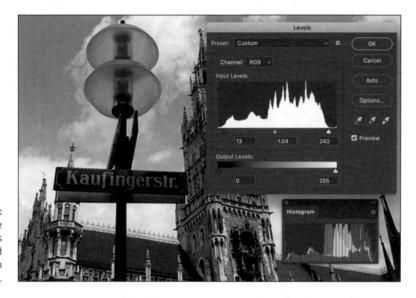

FIGURE 5-6: Compare the Levels histogram and the Histogram panel.

Dragging the middle slider in Levels to the right moves the bulk of the histogram toward the left, making the overall appearance of the image slightly darker. Dragging the middle slider to the left lightens the overall image.

When you're working in Levels (or just about any dialog box), remember that holding down the Option/Alt key changes the Cancel button to Reset. When you click Reset, all values in the dialog box are restored to the defaults, letting you start over without having to cancel and reselect the command.

DEFINING WHITE AND BLACK

The Options button in the Levels (and Curves) dialog box opens a door through which you might never need to walk. However, should your path lead you to that door, I want you to know what lies behind it. Neither pit nor tiger awaits you, only the possibility of controlling your highlights and shadows — or making a total mess of your image, of course. (Adobe does a good job of hiding those it-could-cost-me-a-fortune-if-screw-it-up features.) The Options button gives you control over the behavior of the Auto button in both Levels and Curves. (I suggest that you leave the algorithm set to Enhance Brightness and Contrast.) The Options button also lets you define what colors Photoshop should use for the lightest pixels and for the darkest pixels. The definition of black and white is not always black and white.

Generally speaking, if you print to an inkjet, you want the full tonal range of the printer, so you should leave white and black set to the extremes, as far apart as possible. However, if you're creating gallery prints, you might want to change the definition of "white" from RGB 255/255/255 to RGB 245/245/245 to ensure that you produce 100 percent ink coverage, with no paper showing through in the highlights. Instead of changing overall the definition of "white" and "black" when preparing a print, you can use a Levels adjustment or adjustment layer, setting the Output Levels slider in the lower right to 245.

Earlier in this chapter, I mention that you can use the Histogram panel to avoid introducing problems into the image. Note in Figure 5-6 that the Histogram panel shows slight gaps appearing among the columns. Technically called *posterization*, these gaps represent tonal values that are being squished together into a single value. The pixels at one brightness level are being shifted to the next higher or the next lower value, leaving that empty column in the histogram. Is this a problem? No, as long as you don't see wide gaps, representing a number of consecutive tonal values not in use. (Extensive posterization ruins the subtle transitions between colors in your image.) And *that*'s why you want to keep an eye on the Histogram panel — to make sure you're not creating wide gaps in the histogram and noticeable posterization in your image.

TIP

Posterization is rarely a problem with an image captured in (and processed in) 16-bit color, such as a Raw photo brought into Photoshop through Camera Raw. If, however, you shoot JPEG (which requires 8-bit color), here's an easy way to minimize that posterization, one that lets you make your Levels adjustment but keep a pretty histogram that doesn't show posterization. Immediately after using Levels, choose Edit > Fade Levels and change the blending mode from Normal to Luminosity. As you see in Figure 5-7, the posterization is greatly reduced with a minimal change in the effect of the Levels adjustment. Remember that the Fade command is available only *immediately* after applying an adjustment (or filter or tool) — you can't even use the Save command between. (Read more about the Fade command in Chapter 14.)

FIGURE 5-7:
Change
the Levels
adjustment
blending mode
to Luminosity
with the Fade
dialog box.

Tonal corrections with the eyedroppers

The Levels dialog box (and the Curves dialog box, too) offers another way to make tonal corrections to your image — sort of a half-automated technique — using the three eyedroppers in the right side (Levels) or at the bottom (Curves) of the dialog box. (When adding an adjustment layer rather than using the Adjustment commands, the eyedroppers are to the left in the Properties panel.) Open your image, open the Levels dialog box, and correct both tonality and color in your image with three little clicks:

1. Click the left eyedropper on something that should be black.

This might be a shadow, a piece of clothing, or the tire of a car. Generally, you click something in the image that's already quite dark.

2. Click the right eyedropper on something that should be white.

A cloud, the bride's dress, perhaps an eye . . . all are likely targets for the highlight eyedropper. You usually click something that's already quite light.

3. Click the middle eyedropper on something that should be gray.

Click something that should be neutral in color (should be, not already is). It doesn't have to be mid-gray, just something that should be neutral. This reduces or eliminates any unwanted color cast (tint) in the image. If you don't like the result, click somewhere else in the image. Keep clicking until the colors in the image look right.

In Figure 5–8, the shadow under the bridge, the splash of water, and the weathered wood of the bridge itself provide excellent targets for the three eyedroppers.

TIP

Here's another way to adjust color using Levels. Duplicate the image layer by dragging it to the New Layer button at the bottom of the Layers panel and apply the Blur Average filter. The layer becomes a solid color. Open the Levels dialog box. Click in the layer with the middle eyedropper and click OK. Delete that blurred layer. This technique doesn't work with every image (such as extremely bright, super-saturated images), but it does a great job on most.

FIGURE 5-8:
Use the eyedroppers in Levels to set the black and white points; then neutralize your image's colors.

Adjusting your curves without dieting

One step up from Levels in complexity, and about five steps ahead in terms of image control, is Image Adjustments Curves (H+M/Ctrl+M). The Curves dialog box has a pair of slider controls (similar to the left and right sliders in Levels) to easily control the endpoints of your shadows and highlights. The curve line itself gives you control over various parts of the tonal range independently. Curves also offers eyedroppers for tonal and color correction. They're used the same way you use the eyedroppers in Levels.

At the very beginning of this chapter, I show you how a simple tonal adjustment can add some drama and some interest to a rather bland image. Figure 5-9 shows the simple Curves adjustment that I applied to that image. Dragging the curve downward in the shadows makes them darker; dragging upward for the highlights makes them brighter. The *midtones* (that section of the tonal range between shadows and highlights) have improved contrast using this adjustment.

When you first open the Curves dialog box or add a Curves adjustment layer, you see a graph with a diagonal line running from an anchor point in the lower-left corner to another in the upper-right corner. You can click and drag that line up or down (not sideways) to add anchor points and make changes in the curve (and in your image). By default, the shadows are in the lower-left corner, so dragging down will darken and dragging up will lighten. In the Show Amount Of area (in the Curves dialog box or the Properties panel menu when adding an adjustment layer), switching from Light to Pigment/Ink will reverse the shadows/highlights. Use this option when preparing CMYK images for page layout programs. You can add more than a dozen anchor points to the curve — although you generally need only between one and three new points.

A simple "S-curve" adjustment makes the image more dramatic.

Most snapshots can benefit from a slight tweak in Curves. Click at the intersection of the first vertical and horizontal gridlines in the lower left (the *three-quarter tones*) and drag down slightly. The Input field should read 64, and the Output field should be somewhere between 55 and 60 for a shot that looks pretty good to start. Next, click at the intersection of the grid lines in the upper right (the *quarter tones*) and drag up slightly. The Input field should show 192, and the Output field can be anywhere from 195 to 205. This is called a basic *S-curve*.

Both the Curves and Levels dialog boxes offer you the Load and Save options using the gear-shaped button to the right of the Preset menu. (You find the commands in the Properties panel menu when adding an adjustment layer.) If there's a correction that you'll use more than once or a correction that needs to be precise time after time, use Save. Then, later, you can click Load to apply that adjustment to another image. If, for example, you used the wrong setting in your camera while taking a series of shots all under the same lighting conditions, they probably all need the same correction. Make the adjustment once, save it, and then apply it to the other images with the Load button.

If you want to correct a specific area in the image, move the cursor into the image window (where it appears as the Eyedropper tool). Hold down the mouse button and you'll see a circle on the curve, telling you where those pixels fall in the tonal range. To add an anchor point there, \mathcal{H} +click/Ctrl+click in the image.

Curves offers the option to adjust the curve by clicking and dragging right in your image window. Activate the onscreen adjustment option by clicking the tool to the lower left of the grid in the Curves dialog box (or to the upper left of the grid when adding a Curves adjustment layer through the Properties panel). With the onscreen adjustment option active, click in the image window on an area that

needs improvement and drag upward to lighten or downward to darken. (See Figure 5–10.) The adjustment is applied to the entire image or selection, not just the area where you click. (Working with adjustments layers in the Properties panel is discussed more fully in Chapter 7.)

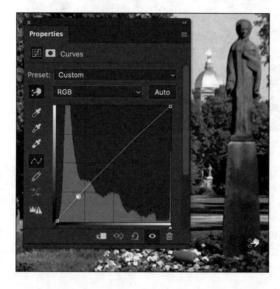

FIGURE 5-10: Drag up to lighten, down to darken. Adjustments are applied throughout the image.

When your curve has multiple anchor points, the active anchor point shows as a filled-in square. Deselected anchor points are hollow squares. For precision, you can use the arrow keys on your keyboard to move the active anchor point, or you can type specific values in the Input field (starting position for the anchor point) and Output field (where you want the anchor point to go).

Option+click/Alt+click in the grid area to toggle between a 4-x-4 grid and a 10-x-10 grid or use the two buttons in the Grid Size section to switch back and forth. And, rather than clicking and dragging on the curve, you can activate the Pencil tool and draw your curve by hand. When hand-drawing your curve, the Smooth button is available, too, to ensure that the transitions in your tonal adjustments aren't too severe.

Grabbing Even More Control

The Image Adjustments menu in Photoshop includes a couple more extremely powerful ways to work with tonality in your images. You can use the Shadows/Highlights adjustment to isolate and change whatever range of dark and light

pixels you want. By specifying what range of tonal values that you want to be considered dark or light, you control how broadly or narrowly your change is applied. The Exposure feature lets you change the overall tonality of the image, much as if you'd taken the photo with a different camera setting. And don't forget about making spot corrections with the Dodge and Burn tools!

The Image → Adjustments → HDR Toning command is designed — like the Exposure adjustment — to be used with 32-bit/channel high-dynamic range images. You can read about HDR (and HDR Toning) in Chapter 19.

The Shadows/Highlights and Exposure adjustments are *not* the same as working with Raw images in the Camera Raw plug-in. (See Chapter 6.) Camera Raw works with unprocessed image data, the so-called *digital negative*. Using Photoshop's Adjustment commands or using Camera Raw as a filter within Photoshop, you're working with image data that has already been manipulated in the camera, in Photoshop, or both. When working with unprocessed data in Camera Raw, you truly have control over the exposure, the shadows, the highlights, and much more.

The Shadows/Highlights adjustment is not available as an adjustment layer. Changes that you make with the Shadows/Highlights command are a permanent part of your image. However, if you convert the layer to a Smart Object, Shadows/Highlights can be applied as a Smart Filter. (Smart Objects are introduced in Chapter 9, and Smart Filters are discussed in Chapter 14.)

Using Shadows/Highlights

The Shadows/Highlights adjustment is designed to rescue two specific sorts of images — you've seen them (and maybe taken them): The background is perfectly exposed, but the subject in the foreground is in horrible shadow. Or, equally bad, the background looks great, but the subject is washed out by a strong flash. (See both examples in Figure 5–11.) By controlling the shadows and highlights separately from the rest of the image, this feature helps you restore more balance to the image.

The default settings in Shadows/Highlights are intended to repair backlighting problems, as you see on the left in Figure 5-11. When the foreground lacks detail because of flash (as you can see in the top dog image on the right), minimize changes to the shadows and drag the Highlights slider to the right. And, as shown in Figure 5-12, with Show More Options selected, Shadows/Highlights gives you incredible control over images that have problems at *both* ends of the tonal range.

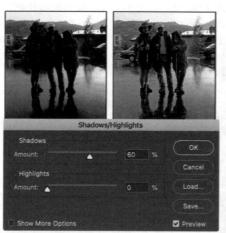

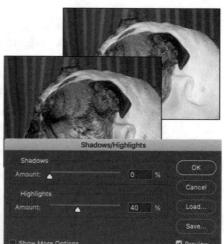

FIGURE 5-11: Shadows/ Highlights does a rather good job with these very common problems.

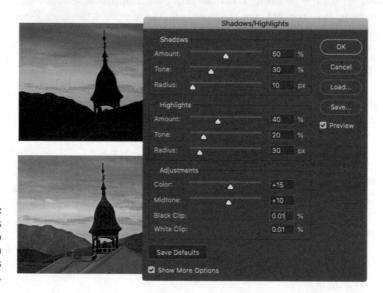

FIGURE 5-12: Some images need help to show detail in both shadows and highlights.

In the Shadows/Highlights dialog box, the Shadows slider lightens the darker areas of your image and the Highlights slider darkens the lighter areas. Generally, you'll use one slider or the other to fix a specific problem in an image, but you can use both if you need to lighten shadows and tone down highlights in the same image.

When you enable the Show More Options check box, Shadows/Highlights has a rather intimidating set of controls. Not to worry! It's actually pretty simple:

- >> Amount: For both Shadows and Highlights, the Amount slider is how much of a correction you're making. This is the nuts and bolts of the Shadows/Highlights adjustment. For a backlit subject, you'll use the Shadows slider a lot and not the Highlights slider. When working with a washed-out subject, you'll probably move the Shadows slider to 0% and work with the Highlights slider.
- >> Tone: Use the Tone sliders to specify how much of the image's tonal range you want to include as shadows or highlights. If you drag either Tone slider to 100%, you're working on the entire tonal range of the image not a particularly appropriate job for Shadows/Highlights. (Use Curves instead.) The default of 50% is rather too high most of the time. Instead, start your adjustment with a range of perhaps 20% and fine-tune from there.
- >>> Radius: You adjust the Radius sliders to tell Shadows/Highlights which pixels should be identified as being in the shadow or highlight. With too low of a Radius setting, an individual black pixel stuck in the middle of a light area in your image might get classified as a shadow area. Too high of a setting has a tendency to apply the adjustment to the entire image. Generally speaking, start with a Radius of perhaps 10 pixels for very small images and 30 pixels for large digital photos. After adjusting your Amount and Tonal Width sliders, move the Radius slider back and forth while watching some of the smaller patches of shadow or highlight (whichever you're correcting) to make sure that those areas are being included in the adjustment.
- When working with a color image, you see Color. When you apply Shadows/
 Highlights to a grayscale image, the slider's name changes to Brig (Brightness).
 Don't use this slider until you make your Amount adjustment. In a color image, lightening the shadows or darkening the highlights shows the actual color of the pixels in those areas. Use this slider to increase (drag to the right) or decrease (drag to the left) the saturation of those pixels. Remember that Color slider works only on the pixels that you identify with the Tonal Width and Radius sliders. (If you set both sets of Tonal Width and Radius sliders to 0%, Color Correction has no effect on the image at all.) When you correct a grayscale image, on the other hand, the Brightness slider affects all pixels except those that are already pure white or pure black.
- Midtone: You can increase or decrease the contrast throughout the image with the Midtone slider. Much like clicking in the middle of the curve in the Curves dialog box and dragging up or down, you adjust the whole range of your image, including the shadows and highlights. When the overall appearance of your image needs improvement, start with Midtone and then work with your shadows and highlights individually.
- >> Clip: Most of the time, you don't want to change the clipping values. Clipping takes pixels that are almost black and forces them to pure black, or it takes

pixels that are *almost* white and forces them to pure white. Clipping your shadows or highlights reduces those subtle differences in color that provide the detail in the shadows and highlights. When would you want to clip shadows or highlights? When you don't care about detail in those areas of your image and need more contrast through the midtones.

Changing exposure after the fact

Photoshop also offers the Exposure feature in the Image ⇔ Adjustments menu. It simulates how the image would have looked if you changed the exposure setting on your camera before clicking the shutter. Think of it as an across-the-board adjustment of tonality in the image or within a selection in the image. The Offset and Gamma Correction sliders are designed primarily to work with very high-bit images (the special 32-bit/channel high-dynamic-range images), and you likely will find them too sensitive to be of much use for most images.

Exposure is a rather specialized tool, and you probably won't find it nearly as user friendly or effective as Curves and Shadows/Highlights. If you do actually work with 32-bit/channel images, take it for a test drive; you might decide that it fills a need.

Using Photoshop's toning tools

You have a couple more ways to work with tonality in Photoshop — the toning tools. These two brush-using tools let you paint corrections on your image, giving you incredible control over the appearance. Select the Burn tool to darken or the Dodge tool to lighten. Select a brush tip on the Options bar and drag the tool in your image to apply the correction. (You can read about controlling the brush-using tools and that incredibly powerful Brush panel in Chapter 13.) In Figure 5–13, you see the Burn tool darkening a specific area of the fence on the right.

TIP

The Dodge tool is great for minimizing (without removing) shadows in an image. You'll find it particularly useful for reducing wrinkles in faces and other such jobs that require lightening specific areas of an image. Figure 5–14 compares the original (left) with a working copy in which I'm using the Dodge tool to reduce the appearance of the wrinkles. By reducing rather than eliminating those wrinkles completely, I retain the character of the man's face as well as prevent that phony, just-out-of-plastic-surgery look.

In almost all circumstances when working with the Dodge and Burn tools, you should activate the Minimize Clipping button (the second from the right on the Options bar in Figure 5–13). With this option selected, the tools do a much better job of protecting color and retaining detail in shadows and highlights.

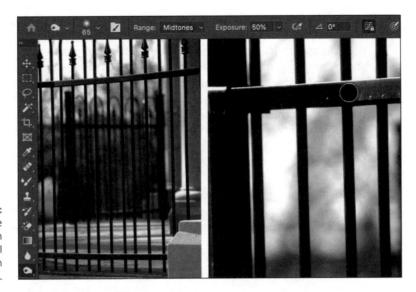

"Painting" the fence with the Burn tool to darken the rails.

FIGURE 5-14:
Use the
Dodge tool
to minimize
wrinkles
without
removing
them.

REMEMBER

For most of the work that you do with the Dodge and Burn tools, the default Exposure setting of 50% is *way* too strong. In the Options bar, reduce the Exposure to about 15–20% for most work. And unless you're specifically working on lightening shadows or toning down highlights, set the tools' Range to Midtones in the Options bar.

What Is Color in Photoshop?

In the end (and the middle and the beginning), your image in Photoshop is nothing but little squares of color. Each square — each pixel — can be exactly one color. Which color for which square is up to you. I'll say it again: There is no car or circle or tree or Uncle Bob in your Photoshop image — just a bunch of little squares of color.

Photoshop works with digital images — including digital photos, images that have been digitized with a scanner, and artwork that you create from scratch in Photoshop. The *digits* are the computer code used to record the image's information. The number of pixels, the color of each pixel, and any associated information are all recorded in a series of zeros and ones on your computer's drive. Color, therefore, is nothing more than numbers — at least as far as Photoshop and your computer are concerned. For you and me, however, color is far more than binary code on a hard drive. It's the image, the artwork, the message. The artwork is the color, and color is the artwork, pixel by pixel.

Photoshop records the color of each pixel in your image in any of several different ways. Every pixel in any given image has all color recorded in a single color mode, which is the actual color format for the image file. While working with your image, however, you can define specific colors in any of a variety of color models, which are sort of the formula or recipes with which you mix color. And an image can have only one color depth, which is the limitation on the number of colors in an image.

Before I get into too many details, you need to understand one of the basic concepts of color: gamut. Consider gamut to be the range of colors that can be theoretically reproduced in a specific color mode or with a specific color profile. A wide gamut, therefore, has many more colors available than does a limited gamut. Those extra colors are generally the brighter, more vibrant colors . . . the ones that make an image come alive. The red/green/blue (RGB) color mode generally offers you a wider range of colors than does cyan/magenta/yellow/black (CMYK). See, for example, the comparison in Figure 5-15, paying particular attention to the purples, oranges, and yellows. And keep in mind that the specific color profile (the working space that you select; see Chapter 4) also has an impact on the colors in your image.

Which color mode should you choose?

If you'll be printing to an inkjet printer, sending photos to a lab for prints, or posting your image on the web, you need RGB color mode. (Despite the CMYK inks that you load into your inkjet printer, the printer's software expects and must receive RGB color data.) If you're prepping an image for inclusion in an InDesign document destined for a commercial offset press, you need CMYK. You select the image's color mode from the Image Mode menu. That's the simple summary. Here's a bit more detail, presented in the order in which you're likely to need the various color modes:

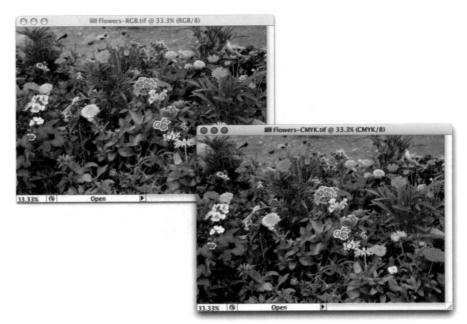

FIGURE 5-15: A wide-gamut image (on the left) and the same picture with a smaller gamut.

- **>> RGB:** RGB is the color mode for digital photos, computer monitors, the World Wide Web, and inkjet printers. All colors are recorded as proportions of the three component colors: red, green, and blue. RGB color is recorded in the three color channels (described a bit later in this chapter). RGB is an *additive* color mode that is, the more of each component color you add, the closer you get to white.
- >> CMYK: CMYK is used primarily for printing on a commercial offset press, but you might need it for a color laser printer or a high-end inkjet printer with which you use a RIP (raster image processor, which is a specialized bit of hardware or software that lets your inkjet pretend it's a printing press). CMYK is the color mode of magazines, books, and other mass-produced printed material, such as the example in Figure 5-16. CMYK is a subtractive color mode that is, the less of each component color you have, the closer you are to white (or the color of the paper on which you're printing).
- Solution
 When most people talk about a black-and-white photo, they really mean grayscale. The image does contain black and white but also a wide range of grays in between. You might use grayscale mode for web-based images or for prints. Keep in mind that unless your inkjet printer is designed to reproduce grayscale images with black and gray inks (or black and light-black inks), you probably won't be happy with grayscale output. Using just one black ink doesn't reproduce the full range of grays in the image. Using the color inks adds a tint to the image. You do have an alternative for grayscale images: Send them to the local photo lab for printing.

FIGURE 5-16: You typically use CMYK images for bulk-print materials.

- >> Indexed Color: Using a color table, or a list of up to 256 specific colors, Indexed Color mode is for the web. You save GIF and PNG-8 images in Indexed Color, but only those file formats require such a limited number of colors. Things like buttons on your web page, which need only a couple of colors, should be created as GIFs using Indexed Color mode. That keeps the file size down, reducing the amount of space the image requires on your web server and also speeding the download time (how long it takes for the image to appear on your site-visitor's monitor).
- >> Lab: Also known as L*a*b and CIELAB (and pronounced either lab, as the dog or a research facility, or verbally spelled out, as el-ay-be), this is a color mode that you might use when producing certain special effects or using certain techniques in Photoshop, but it's not one in which you'll save your final artwork. The three channels in a (or "an") Lab image are
 - Lightness, which records the brightness of each pixel
 - a, which records the color of the pixel on a green-to-red axis
 - b, which records each pixel's color value on a blue-to-yellow axis

You shouldn't try to print Lab images on an inkjet or post them on your website. You might see (not in *this* book!) a tip that you should convert your RGB or CMYK images to Lab mode before using one of Photoshop's Sharpen filters. Bah! Apply the Sharpen filter, choose Edit ♣ Fade Unsharp Mask (or Fade Smart Sharpen — the Fade command changes its name to match the last-used filter, adjustment, or tool), and change the blending mode from Normal to Luminosity. Same result, less work, and less potential for degradation of your image.

- >>> Duotone: Duotone (including tritone and quadtone) is a very specialized color mode, exclusively for commercial printing, that uses only two (or three or four) inks spread throughout your image. Although that might sound good for an inkjet printer, in fact, Duotone is not an acceptable color mode for inkjets. Duotone images require that specific premixed inks are poured into the printing presses, which isn't something that you can do to your inkjet.
- >> Multichannel: Like Duotone, the Multichannel color mode is restricted to commercial printing because it depends on specific premixed colors of ink that are applied to the paper. Unlike Duotone, in which the inks are generally spread across the page, Multichannel images use certain inks in certain areas. You might need Multichannel mode when creating a logo for a client.
- >>> Bitmap: Bitmap color mode is *true* black and white (as you see in Figure 5-17).

 Each pixel is either black or white. The placement of the black and white pixels produces shading, but the image doesn't really have any gray pixels. You might use Bitmap mode to create images for some wireless devices, use on the web, or commercial print, but that's about it.

FIGURE 5-17: Bitmap images contain only black and white pixels; no grays, no colors.

Converting between color modes or gamuts (done with the Image Node menu) can reduce the quality of your image by compressing variations of a color into a single color value. You would not, for example, want to convert from RGB (which has a comparatively large number of colors available) to CMYK (with a more restricted color gamut) and then back to RGB. After colors are compressed by a conversion, you can't restore their original values by converting back to a wider gamut.

Does a color model make a difference?

Although the image itself has a single color mode, you can use any of the available color models when defining a color in Photoshop. Say, for example, that you're preparing to use the Brush tool to paint some artistic elements for your latest project. The project is in RGB mode because you'll be printing it with your inkjet printer. You can use the Color panel to define your foreground color any way you please — RGB, CMYK, Grayscale, Lab, or even HSB (hue/saturation/brightness, which isn't available as a color mode, just a color model). It doesn't matter how you set up the Color panel, which you do through the panel's menu, as shown in Figure 5–18. When you add the color to your image, Photoshop uses the nearest RGB (or CMYK) equivalent.

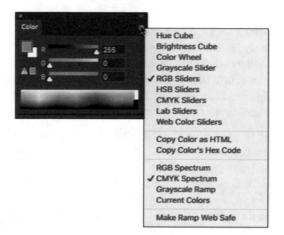

FIGURE 5-18: Choose your preferred color model from the Color panel menu.

Notice that the Color panel menu in Figure 5–18 doesn't list Duotone or Multichannel. Those are color modes only, not color models. A couple of other things to note about working with the Color panel: The warning triangle visible in Figure 5–18 in the lower–left corner of the panel indicates that the selected color is outside the CMYK color gamut. Clicking the swatch to the right of the triangle would select the nearest equivalent color (if, that is, you were actually working in CMYK mode). Also note that the foreground swatch is selected in the panel, highlighted with a black outline — click the background swatch to make changes to the background color.

You can also select or define a color using the Color Picker, which you open by clicking the foreground or background color swatches near the bottom of the Toolbox or in the Color panel. The Color Picker is explained in detail in Chapter 13.

Why should you worry about color depth?

Color depth is the actual number of different colors that you have available. (Remember that each pixel can be only one color at any time.) When you work in 8-bit-per-channel color, simply called 8-bit color, each of the component colors is recorded with exactly 8 bits of information per pixel in the computer file. (At the beginning of this section, I mention digits. These are the actual numbers — the zeros and ones recorded on the hard drive to track each pixel's color.) In an 8-bit RGB image, each pixel's color is recorded with three strings of eight characters. When you work with 16-bit-per-channel, or 16-bit color, each of the component colors is recorded with 16 digits. The larger numbers mean more possible ways to record each color, which means more possible variations of color (as well as files that take up more space on your hard drive).

What that means to you, in practical terms, is possibly a better-looking image when working in 16-bit color. You'll have smoother transitions between colors throughout your image, no *banding* in gradients (those annoying areas in a gradient where you can actually see one shade of a color stop and the next shade of that color start), and no splotchy shadows. *Posterization*, which I explain earlier in this chapter, is the degradation of your image's appearance when similar colors are forced to the same color, making transitions between colors more abrupt. Many tonal and color corrections that produce posterization in your 8-bit images won't harm a 16-bit image in the least. Take a look at Figure 5-19. Above, the Histogram panel shows the result of a Levels adjustment for a 16-bit image. When the same adjustment is applied to an 8-bit version of the image, posterization becomes visible in the Histogram panel (represented by the gaps in the histogram).

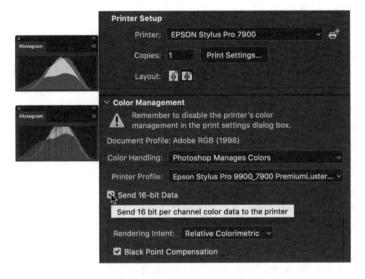

FIGURE 5-19: Compare the Histogram panels to see posterization (below).

Some of the top inkjet printers can process and use 16-bit color — but unless Photoshop's Print dialog box offers the Send 16-Bit Data option (shown in Figure 5-19), you won't be using more than 8 bits of color data.

So, should you use 16-bit color all the time? No. You can't post a 16-bit image on the web, and 16-bit color is rarely used for CMYK images. Digital photos taken in JPEG format are 8-bit because that file format doesn't support 16-bit color. And unless you're using a 16-bit-capable inkjet printer, you won't see any improvement in the final print. If you shoot in 16-bit color, typically using a Raw file format, it makes sense to keep the image in 16-bit color. Do all the processing

in 16-bit color, save the file as a 16-bit image, and send the 16-bit data to your inkjet printer. If you'll be sending the file off to a print lab or eventually posting the image on a website, create a copy of the file and convert the copy to 8-bit/channel color through the Image Node menu.

You might consider converting an 8-bit image to 16-bit color as part of a larger project, perhaps one that includes a large gradient as part of the artwork. But, generally speaking, if the image was captured in 8-bit color, keep it in 8-bit color; if the image was captured in 16-bit color, keep it in 16-bit color.

One other note on color depth: Photoshop can work with 32-bit/channel images. These monstrous files are called *high dynamic range* (HDR) images and are typically constructed by combining different exposures of the same photo. Chapter 19 takes a look at HDR.

Making Color Adjustments in Photoshop

Sometimes you have an image that needs some help in the color department. It might have been shot with an incorrect camera setting, it might have a *color cast* (an unwanted tint of a specific color), or it might just be dull and dingy. Photoshop provides you with an incredible array of commands and tools to make the colors in your images look just right. You'll hear the term *color correction* being tossed about, but not all images have incorrect color. Some have very good color that can be *great* color. Instead of color *correction*, I like to think in terms of color *improvement*. And just about every image can use a little tweaking to improve its color.

How do you know when the color is right? Your primary tool for the job is in your head. Literally. Make your decisions based primarily on what your eyes tell you. Sure, you can check the Info panel and the Histogram panel to make sure that your shadows are black and your highlights are white, but adjust your images until they look good to you — until you're satisfied with the color.

WARNING

That little symbol to the left of this paragraph is a little scary, but it does get your attention, doesn't it? This isn't a your-computer-will-blow-up sort of warning but more of a you-don't-want-to-waste-your-time-and-effort warning. Do your tonal adjustments before you start working with the image's colors. Go through the procedures in the first part of this chapter first and then use the techniques here. Why? If you get perfect hue and saturation and then start making tonal adjustments, you're likely to knock your colors out of whack again. And, of course, there's also the possibility that adjusting your image's tonality will make the colors look perfect!

"HERE, SPOT!": WHAT IS A SPOT COLOR?

Spot colors in your image are printed using premixed inks of exactly that color. (I'm talking commercial printing press here, not your run-of-the-mill inkjet printer.) To properly prepare a spot color for press, it needs to be in its own *spot channel*, which is a separate color channel in which you show where and how the ink will be applied. (Channels in your image are eventually used to create the actual printing plates that pick up ink and put it on paper.) Because spot channels are used with CMYK images, *dark* represents *more*. Where you need the spot color at 100% strength, the spot channel should be black. In areas where you want only a light tint of the spot color, use a light gray.

You create your spot channel by selecting the Spot Channel command from the Channels panel menu. Click the color swatch in the New Spot Channel dialog box to open the color libraries. (If you see the regular Color Picker, click the Color Libraries button.) Select the appropriate *book* (collection of colors; see the figure here) for your project, and then select your color. Click OK in the New Spot Channel dialog box to accept the color, do *not* change the name of the spot channel, and then click OK. You can now paint, fill, or copy/paste into that new channel.

When saving images with spot channels, you can use the PSD file format (if the image will be placed into an InDesign document), PDF, TIFF, or DCS 2.0. Check with the person handling the layout or the print shop to see which is required.

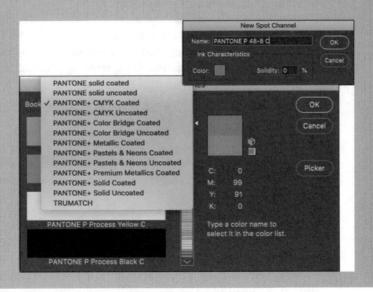

Choosing color adjustment commands

Photoshop offers almost two dozen different commands that you can use to improve the appearance of your images, all of which are easily accessed through the Image Adjustments menu (as you see in Figure 5-20). Some have specialized purposes, and some are extremely versatile, but all are worth understanding so that you choose the most appropriate feature for the problem staring at you from the screen. Most (but not all) of the commands that I discuss here can be added to your images as an adjustment layer, which gives you added flexibility. (Adjustment layers are discussed in detail in Chapter 7.)

In addition to the Adjustment commands and adjustment layers, you can also take advantage of the color adjustment features of Camera Raw. If shooting Raw, you can open the image directly into Camera Raw, or

FIGURE 5-20:
Photoshop's flexibility is truly evident on the Image ♣ Adjustments menu.

after the image has been opened in Photoshop, you can use the Camera Raw filter. (See Chapter 6 for information about working with Camera Raw.)

Brightness/Contrast, Levels, Curves, Exposure

These commands are generally used to work with tonality rather than color (discussed earlier in this chapter). However, you can select an individual channel in Levels or Curves, as shown in Figure 5-21, to adjust color in an image. Keep in mind that changes to an individual color channel are reflected throughout all colors in an image.

Vibrance

The Vibrance adjustment gives you control over both vibrance (the saturation of near-neutral colors) and saturation (the saturation of colors throughout the image). You can increase Vibrance to make the near-neutral colors more saturated, or you can reduce Vibrance to make those colors even more neutral, while increasing Saturation to make the brighter colors in your image stand out even more.

FIGURE 5-21:
Correct each
channel
individually
with Curves to
adjust color in
your image.

Hue/Saturation

Often overlooked and rarely exploited to the fullest, Hue/Saturation is a very powerful tool. Using the three sliders together, you can adjust the hue to eliminate a color cast, increase saturation so that your colors appear richer and more vibrant, and adjust lightness to improve your image's tonality. (See Figure 5–22.) Keep in mind that when you adjust something that's very dark, start with the Lightness slider so that you can evaluate the other changes (Hue and Saturation) properly. Remember, too, that you can apply Hue/Saturation (like a number of other adjustments) to a specific range of colors in the image, selected in the pop-up menu at the top of the dialog box or at the top of the Properties panel when adding an adjustment layer.

Using the pop-up menu (shown with the default Master visible in Figure 5-22), you can elect to apply an adjustment to only a certain part of the color in your image. After a color is selected, the eyedroppers become active, to add to or subtract from the range of color being adjusted, and sliders become active between the gradients at the bottom, giving you yet another way to control the range of color being adjusted.

Visible in Figure 5-22 are the Adjustments and Properties panels, which you use to add adjustment layers to your images. Select the type of adjustment in the Adjustments panel, or in the menu at the bottom of the Layers panel, or through the Layer New Adjustments Layer menu. Make the actual adjustment in the Properties panel. (Adjustment layers are discussed in more detail in Chapter 7.)

The content of the Properties panel offers the same options as the Image ⇔ Adjustments ⇔ Hue/Saturation dialog box, but the Preview check box is replaced by the eyeball icon you see at the bottom of the panel in Figure 5-22 (the second icon from the left), which toggles the visibility of the new adjustment layer on and off. Use the Adjustments panel to add adjustment layers for the 16 commands you saw in the top three sections of the Adjustments menu (refer to Figure 5-20).

FIGURE 5-22: Hue/Saturation can cure three problems at once.

Color Balance

The Color Balance command presents you with three sliders that you use to make changes to the balance between your color opposites. If the image is too blue, you drag the third slider away from Blue and toward Yellow. (This is also a great way to remember which colors are opposite pairs!)

You can control the highlights, midtones, and shadows of your image individually by using radio buttons in the Color Balance dialog box and the Adjustments panel. And, in almost all cases, you'll want to leave the Preserve Luminosity check box marked so that the brightness of the individual pixels is retained.

You can also use Color Balance to throw an image out of whack for special effects or (getting back to the adjustment's roots) compensating for a color cast being introduced by the printing device.

Black & White

The Black & White adjustment creates outstanding grayscale copies of your color images. As you can see in Figure 5-23, you can control the amount of each major range of color used to create the grayscale copy. In this particular example, the original consists primarily of greens and browns, so the top three sliders are key. Reducing Reds and increasing Yellows both lightens the browns and greens and increases contrast among the brown tones. When adding a Black & White adjustment layer, you have an onscreen adjustment tool available, which you click in the image and drag up or down to adjust the brightness of a color throughout the image.

FIGURE 5-23: Black & White enables you to determine grayscale tones by mixing color values.

...

Note the Tint check box, with which you can easily create sepia or Duotone looks for your images. Click the color swatch to the right of Tint to open the Color Picker to select a specific tint. If you'll be printing on an inkjet printer (rather than sending the file to your photo lab), you'll want to use a Black & White adjustment layer rather than the menu command. Your inkjet printer may introduce an unwanted color shift. If so, you can reopen the adjustment layer and work with the sliders to compensate. Keep in mind that the Black & White adjustment you open through the Image Adjustments menu offers Hue and Saturation sliders when adding a tint.

Photo Filter

Photoshop's Photo Filter is actually an image adjustment rather than a filter. The filter in the name refers to those physical photographic filters that you screw onto the end of a lens. This adjustment is a great way to correct problems with *temperature* in an image — the perceived warmth or coldness of an image. When the camera takes a picture under unexpected lighting conditions, a color problem is apparent. (Say, for example, that the camera is set to Daylight when shooting

indoors.) When an image is too blue, it's too *cool*; conversely, an image that's orangey is too *warm.* (Remember that these are perceptual evaluations — blue light is technically hotter than yellow or red light.)

Channel Mixer

Designed to repair a defective channel in an image, Channel Mixer lets you use sliders to replace some of (or all of) the intensity of one color channel with content from the others. Should you come across an image with damage in one channel, you can certainly use the Channel Mixer adjustment to work on it (with some degree of success). You reduce the value of the target channel by dragging the slider to the left. You then drag one or both of the other sliders toward the right. Generally speaking, you want to add an amount (combined between the two other channels) just about equal to what you subtract from the target channel.

If you drag a slider to the left past 0 (zero), you invert the content of the channel. You can produce some incredible (and incredibly weird) effects with this technique, partially inverting one or two channels. When you get a chance, give it a try. Using the Monochrome check box in Channel Mixer gives you an alternative to the Black & White adjustment for a controlled grayscale effect.

Color Lookup

A color lookup table is, at its most basic, a formula for applying color changes. Color Lookup takes the image's original colors and maps them to new colors based on the table you select in the dialog box. (See Figure 5-24.) Typically used with video, it may have some applicability to your work (depending on what lookup tables — "LUTs" — you find online). The "3D" in "3DLUT," by the way, refers to three color channels (RGB) and has nothing to do with 3D objects.

NEW

In Figure 5-24, take a look at the list of LUTs available. It's greatly expanded from earlier versions of Photoshop and has some rather interesting options. In addition to simulating the appearance of various types of film, you have such options as Moonlight, FoggyNight, LateSunset, HorrorBlue, and the fun FuturisticBleak.

Invert

More creative than corrective, the Invert command (no dialog box) simply reverses the colors in your image or the selected area. Although inverting areas of an image (like desaturating) can draw attention to the subject of the image, it's an edgier technique and generally requires touch-up after inverting. You'll find that any specular highlight — a pure-white area (mainly reflections) — becomes a distracting black spot.

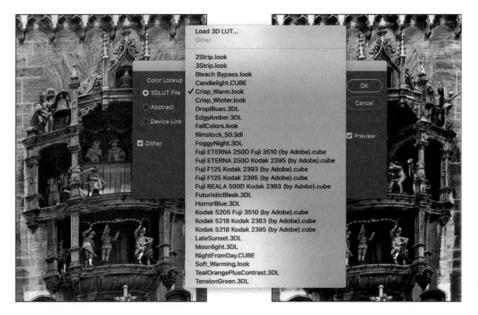

FIGURE 5-24:
Color lookup
tables are
often used to
match lighting
in a computergenerated
scene to livemotion video
or film.

Posterize

The Posterize command forces your image's broad range of colors into a few selected colors. You automatically get black and white, and then a limited number of additional colors, based on the content of the original. You pick the number of colors that you want to use, and Photoshop picks which colors to use. You can use as few as two colors (plus black and white) or as many as 255, which pretty much gives you your original image. Posterize can create a rather pleasing rendering of a photo with very few colors.

TIP

When experimenting with Posterize, click in the Levels field and use the up- and down-arrow keys to preview different numbers of colors. Start low and work your way up. If you see something that you like, you can stop or you can keep going and come back to that number later — the image will look exactly the same when you try that number again.

Threshold

Threshold converts each pixel to either black or white (no colors, no grays). You adjust the border between black and white with a slider or by entering a value in the Threshold Level box. For an eye-catching special effect, open a color image and make a selection of the background (or the subject!) and apply Threshold, mixing color and black and white.

Sometimes, when adjusting color in an image, you need to find the darkest and lightest pixels in an image (for use with the eyedroppers in the Curves dialog box, for example). Open Threshold, drag the slider all the way to the left and then slowly back to the right. The first black spot you see is the darkest in the image. Add a color sampler (so you can find the spot again) by Shift+clicking in the image. Drag the slider all the way to the right and then slowly back to the left to find and mark the lightest pixels. After placing your color samplers, click Cancel.

Gradient Map

Again, more creative than corrective, the Gradient Map feature re-creates your image by using a gradient. The leftmost color stop (the anchor points where a gradient color is assigned) in the gradient is mapped to the shadows, the rightmost to the highlights, and any color stops in between are appropriately assigned to the rest of the tonal range. In Figure 5-25, you can see how a two-color gradient (upper left) lacks detail compared with the four-color gradient being created for the lower image.

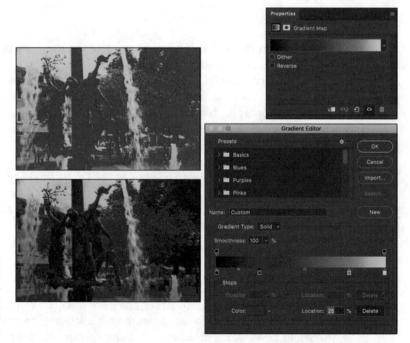

FIGURE 5-25:
Using more colors in your gradient produces more detail.

Generally speaking, you use darker colors for the color stops on the left and lighter colors for the color stops on the right (although you can create extremely interesting effects by mixing things up). Using a black-to-white gradient produces a grayscale image.

To edit the gradient, simply click directly on the sample gradient in the Gradient Map dialog box. Click to add color stops, drag to move color stops, and click the color swatch near the bottom to change the color of the selected stop. (You can find more detailed information on creating and working with gradients in Chapter 13.)

Selective Color

Although designed to help you compensate for the vagaries of printing presses, Selective Color can do other great things for you! The command's dialog box, shown in Figure 5–26, has a pop-up menu that offers the six basic colors of Photoshop, as well as Whites, Neutrals, and Blacks. You select which range of colors to adjust and then drag the sliders. You can work on one set of colors, switch to another and make adjustments, switch to another, and so on without having to click OK in between. For example, you can adjust the reds in the image and leave the blues untouched, or you can adjust the reds and then tweak the blues without having to exit the dialog box.

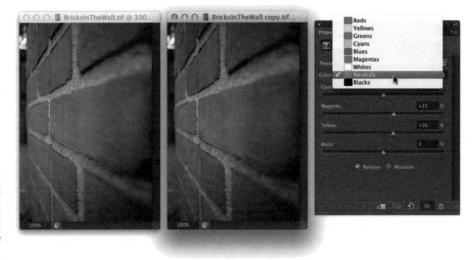

FIGURE 5-26:
Tweaking
the Neutrals
can adjust
the overall
appearance of
an image.

When you have reasonably small adjustments to make and are using the Selective Color adjustment (or as an adjustment layer), select the Relative radio button at the bottom. If you have substantial changes — rather radical alterations — select the Absolute radio button.

Shadows/Highlights

The Shadows/Highlights adjustment is discussed at length earlier in this chapter as a tonal-correction tool, the job for which it was designed. However, keep in

mind that the Shadows/Highlights dialog box also includes the Color Correction slider. After you lighten shadows or tone down highlights, you can increase or decrease the saturation of the colors in the adjusted areas of your image with the Color Correction slider.

HDR Toning

Designed for use with high dynamic range images (32-bits/channel), the HDR Toning adjustment provides a different way to adjust color. It can be used with flattened images in 8-bit or 16-bit color, but keep in mind that small adjustments are usually required. HDR Toning is examined in Chapter 19.

Desaturate

The Photoshop Desaturate command creates a grayscale representation of a color image without changing the color mode. However, with no dialog box or adjustments, it doesn't offer the control you get by using a Black & White adjustment.

Match Color

Now this is a feature to savor! There you are, adding Cousin Joe to the family reunion photo because he wasn't bailed out in time, and you see that the lighting is all kinds of different and he sticks out like a sore thumb (or bum). Or you return from a major shoot only to find that something wasn't set correctly in the camera, and all your images have a nasty color cast.

Match Color lets you adjust one image to another (and you can even use selections to identify areas to adjust or areas of the images to use as the basis for adjustment), but keep in mind that you get better results with images that are already rather similar. You can also fix one shot and use that shot as a standard by which others are corrected. (Like most image adjustments, you can record a change in an Action and use Photoshop's Batch command to apply that adjustment to a series of images. Read more about Actions and the Batch command in Chapter 15.) Take a look at Figure 5-27 to see the Match Color dialog box.

Because Match Color is such a powerful tool, it's worth taking a look at what's going on in the dialog box:

>> Ignore Selection when Applying Adjustment: If you have an active selection in the target layer or image (for calculating the adjustment; see the upcoming bullet on that) and you want the adjustment to be applied to the entire target, select this check box. If the box is left clear, the adjustment is applied only within the selection. Note that you can use selections to apply Match Color to only a portion of your image, such as flesh tones, or you can adjust sections of the image one at a time.

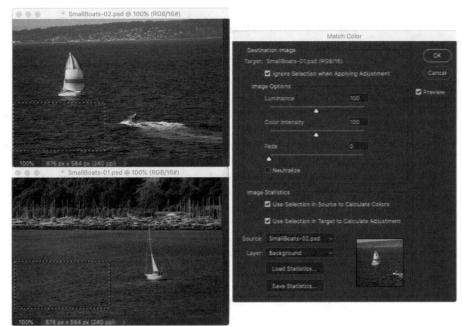

FIGURE 5-27: Using selections of water in both images adjusts color throughout the target image.

- **>> Luminance:** After the preview shows in your image window, you can tone down or brighten up the target area with the Luminance slider.
- >> Color Intensity: Think of this slider as a saturation adjustment.
- >> Fade: Using Fade lets you blend the adjustment, reducing its intensity.
- >> Neutralize: If a color cast is introduced by the adjustment, selecting the Neutralize check box often eliminates it.
- >> Use Selection in Source to Calculate Colors: You can make a selection in the image to which you're trying to match (the *source*) and use the colors within that selection as the basis for the Match Color calculation.
- >> Use Selection in Target to Calculate Adjustment: You can make another selection in the target layer or image that presents Match Color with a sample of those pixels to use for calculating the adjustment.
- >> Source: The Source pop-up menu lists all the open images that can be used as a basis for adjustment. Only images of the same color mode and color depth get listed. Think of *source* as the image whose colors you're trying to match. (The selected image or the active layer within an image is what you're adjusting.)
- >> Layer: When a multilayer image is selected in the Source pop-up menu, you can designate which layer (or a merged copy of the layers) is the actual source.

>> Load Statistics/Save Statistics: If you're doing a series of images and you want to speed things up, click the Save Statistics button to record the adjustment you're making and then click the Load Statistics button with other images.

In Figure 5-27, an area of water is selected in the target image and a comparable area of water is selected in the source image. (The selection in the source image is visible in Figure 5-27 for illustrative purposes only — a selection in an inactive image window isn't normally visible.) With the two selections, I tell Match Color to adjust the target image based on the difference between the water color in the two images. Using selections prevents any skewing of the adjustment that would be caused by the colors in the sail (source image) and the trees (target image). But with the Ignore Selection When Applying Adjustment check box enabled as well, I make sure the entire target image is adjusted, not just the areas within the selection.

Replace Color

Sort of a cross between the Select Color Range command (see Chapter 7) and the Hue/Saturation adjustment, Replace Color is an outstanding tool for swapping out one color for another. It's truly great in a production environment where, for example, a certain blouse is available in several colors. Shoot one color and then use Replace Color to produce the additional product shots.

The Replace Color dialog box, as shown in Figure 5–28, has two separate parts: Selection and Replacement. Click with the left eyedropper in either the preview area or in the image windows and adjust the Fuzziness slider (how much variation counts as "selected") to make your initial selection. Use the middle eyedropper to add colors or shades of your initial color, and use the right eyedropper to subtract from the selection. Choose only variations of one color. Then drag those Hue, Saturation, and Lightness sliders in the Replacement section of the dialog box to produce your new look.

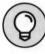

TIP

Rather than switching eyedroppers back and forth, use the left eyedropper and the Shift key (to add) or the Option/Alt key (to subtract). You can also hold down the Shift key and drag through an area to select all the colors in the area. If you accidentally select some colors you don't want, release the Shift key and click once to start over.

When the Localized Color Clusters option (at the top of the Replace Color dialog box) is active, Replace Color looks at each range of color you add to the selection as a separate entity. This enables much better technical control over the colors selected, but may not be appropriate for most uses of Replace Color, in which you generally want smooth and complete transformation of all the selected colors.

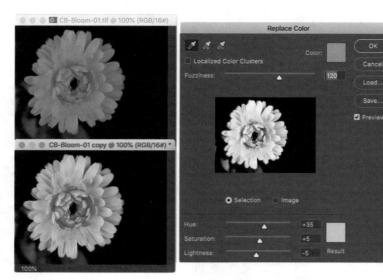

FIGURE 5-28:
Make a selection and change the selection's hue, saturation, and lightness.

Equalize

When you select the Equalize adjustment, Photoshop finds the darkest pixel in the image and maps it to black, maps the lightest pixel to white, and distributes the rest of the tonal values between. You can pretty much skip Equalize — use Auto Color or — even better — the Auto button in Curves or Levels.

Manual corrections in individual channels

Sometimes different areas of an image require different corrections or adjustments. You can, for example, "paint" corrections into specific areas of a channel by using the toning tools in Photoshop's Toolbox. The image in Figure 5–29 has a distinct problem (okay, well, maybe a few problems). In the lower-left corner is a light-green blob that needs to be eliminated if there's any chance of salvaging this photo. By using the Burn tool on one channel at a time, you can darken that specific area of each channel — each channel according to its needs.

On the left, you can see the distinct light area in the thumbnail of the Red and Green channels. On the right, after using the Burn tool, those lighter areas are gone in the Green channel, and a similar adjustment to the Red channel eliminates the problem completely.

In addition to the Burn tool, you can use the Dodge, Blur, Sharpen, and Smudge tools. You can use the Brush tool and paint with black, white, or gray. You can use Levels or Curves on an individual channel or even a selection within one or more channels. When fine-tuning (or salvaging) an image, don't be afraid to work in one channel at a time, perfecting that channel's contribution to the overall image.

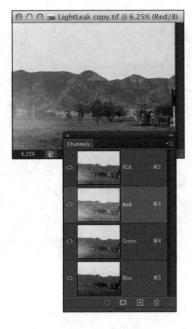

FIGURE 5-29: The problem is only in one area of each channel, but you can fix it manually.

Take another look at the two Channels panels shown in Figure 5–29. Obviously that's a composite image because there's only one Channels panel in Photoshop, right? On the right, the Green channel is active (you can tell because it's highlighted), and only the Green channel is visible (only it shows the eyeball icon to the left). The other channels are invisible, and you see only the grayscale representation from the Green channel in the image window. On the left, however, only the Red channel is active, but *all* the channels are visible (indicated by the eyeball to the left of each channel). Any change I make to that image in that state is applied only to the Red channel. But because all channels are visible, I can see the overall impact on my image.

Sometimes you want only one channel visible, such as when you're trying to balance the tonal range throughout the channel, for example. But most of the time, you want to see what's going on in the image as a whole. Click the one channel (or Shift+click two channels) in which you need to work. Then click in the left column next to the composite channel at the top to make all channels visible.

The People Factor: Flesh Tone Formulas

One of the toughest and yet most important jobs in Photoshop is making sure that skin looks right. People come in a wide variety of colors and shades and tints, and all people vary in color in different places on their bodies and at different times of

the year. (The top and bottom of your forearm are likely different colors, and the difference is generally much greater in summer than in winter.) There are even some exceptions to those broad generalities. Making skin tones look great is often a major, yet often critical, challenge. Many of today's DSLRs can identify skin in an image (particularly faces) and expose the image based on the skin color.

When you have skin in your image, it's generally part of the focus of the image — the person whom you're photographing. And even when a person isn't the subject of the image, skin attracts attention in the image. The eye naturally goes to people in just about any image (perhaps not first, but eventually).

You'll also find that unnatural variations in skin color are *very* noticeable. Consider how often you think to yourself that someone looks a little pale, or flushed, or sunburned, or tanned, or just plain sick. You're making that judgment call based to a large degree on the appearance of the skin.

Keeping in mind that the numbers shown in Figure 5-30 are general guidelines and that real people vary quite a bit, I've prepared for you some target values for skin tones. Use these formulas loosely when using the techniques in this chapter to adjust the color in your images, keeping in mind the individual you photographed and the lighting at the time.

Flesh Tone Formulas

These are guidelines only, not absolute values!

	Pale Caucasian	Dark Caucasian	Afro-American	Asian
Highlights	C:4 - M:17 - Y:15 - K:0	C:11 - M:35 - Y:42 - K:0	C:5 - M:14 - Y:22 - K:0	C:3 - M:11 - Y:13 - K:0
Midtones	C:14 - M:35 - Y:35 - K:0	C:14 - M:38 - Y:49 - K:0	C:23 - M:50 - Y:63 - K:5	C:12 - M:35 - Y:42 - K:0
Shadows	C:31 - M:63 - Y:71 - K:31	C:35 - M:64 - Y:73 - K:27	G235 - M:67 - Y.72 - KS2	C:29 - M:60 - Y:56 - K:25

Note that the numbers are CMYK, even for use with RGB images. Open the Info panel menu, choose Panel Options, and set the Second Color Readout to CMYK Color. (See Figure 5–31.) Remember, too, that you can use the Color Sampler tool to add placeholders in the image, monitoring the changes that you're making in the Info panel. Set the color sampler readings to CMYK in the Info panel itself by clicking the eyedropper symbol to the left of the color mode listed for each sampler.

Promise me that you'll keep in mind that these numbers are for reference only, okay? Your individual image determines what the correct adjustment should be. You can use these numbers as a starting point, but trust your eyes and evaluate your image as you work.

FIGURE 5-31: Use the panel options to set up the Info panel.

- » Understanding "Raw"
- » Using the Camera Raw plug-in

Chapter 6 The Adobe Camera Raw Plug-In

he wonderful thing about the various Raw file formats is that you use them to record unprocessed image data, which gives you incredible control over the final appearance of your image. When we first started capturing digital photos in a Raw file format, it required an investment of tens of thousands of dollars in equipment. As I write this, you can spend under \$400 and purchase a quality digital camera that captures both JPEG and Raw from Canon, Sony, Panasonic, or Kodak. Many smartphones also capture Raw images (although the iPhone's HEIC format is not Raw). In this chapter, I explain how Raw differs from other image file formats and why those differences can be important. I show you how to determine whether you have what you need to capture in Raw and whether Photoshop's Adobe Camera Raw plug-in is capable of handling your camera's image files. Most of the rest of the chapter looks at the Camera Raw interface and what all those sliders do for you and your image.

Understanding the Raw Facts

Raw file formats are, at their hearts, nothing but unprocessed image data. They come in a number of variations — one or several for each camera manufacturer. Each has its own file extension (such as .crw, .cr2, or .nef), and many have

their own special features that are totally incompatible with each other and even incompatible with Raw images from different camera models that use the same file extension. And those camera manufacturers love to tinker with their proprietary formats, changing them regularly. But each of the formats, at the basic level, is Raw. (Check your camera's User Guide to see whether it's capable of recording image data in a format other than JPEG or TIFF. If so, it's probably a variation of Raw.)

Thankfully, Adobe updates the Camera Raw plug-in for Photoshop (as shown in Figure 6-1) on a regular basis, adding the capability to work with the newest cameras shortly after they're available. (Plug-ins, like Camera Raw and most of Photoshop's filters, extend the program's capabilities. Updating your plug-ins regularly ensures that you have the greatest capabilities.) Be warned, however, that purchasing a new camera model the day it comes on the market might mean using the camera's own software for a while until Camera Raw is updated.

FIGURE 6-1:
The impressive
Camera Raw
window, with
the Basic
section of
the Edit pane
visible.

The bulk of the work you'll do in the Camera Raw plug-in takes place with the various adjustments in the Edit area to the right of the preview. Rather than separate panes or windows for each of the types of adjustments, Camera Raw now has one long Edit pane with collapsible sections. (See the section "Making Adjustments in Camera Raw's Edit Panel.") In Figure 6-1, notice the downward-pointing arrow to the left of the word *Basic*. Click that arrow, and the Basic section collapses to show you the next area. You can, of course, leave Basic expanded and simply scroll down to the next area.

Select multiple Raw images in the Photoshop File ⇔ Open dialog box or in Bridge, and they all open in Camera Raw together. Click a thumbnail to work on that particular image. If you open images that all need a similar correction, adjust one and then use your standard keyboard shortcut for Select ⇔ All. Click and hold on the button in the lower left, next to the zoom factor, and in the menu select Sync Settings to apply the adjustment to all the images. You can select only some of the thumbnails to sync adjustments for only those images.

Also note that the thumbnails in the Filmstrip are arranged along the bottom of the workspace rather than to the left. (Look closely and you see that one of the five images is in portrait orientation.) If you're working with a series of images that are all portrait oriented or a mix of orientations, having the Filmstrip at the bottom makes sense. However, if you have a number of landscape-oriented images open in Camera Raw, switching the Filmstrip to the left edge might be more practical. In the menu visible in Figure 6-1 (and in the Camera Raw Preferences, opened through the gear icon in the upper right), you can switch the Filmstrip to the left edge by selecting Vertical for the Filmstrip Orientation.

Adobe also offers the free DNG Converter software for converting supported Raw files to the open source DNG file format. (Open source means that anyone can freely use it. The DNG format is also known as "digital negative.") Although some camera manufacturers have adopted the DNG format for their cameras, it's more commonly used "to promote archival confidence, since digital imaging software solutions will be able to open raw files more easily in the future" (Adobe). Simply put, DNG Converter enables new versions of Raw formats to be used with current (or even older) versions of Photoshop.

What's the big deal about Raw?

Cameras that record images using the Raw format save unprocessed image data. When recording as JPEG or TIFF, the camera manipulates the image data, processing it in a variety of ways. So what's the big deal with unprocessed — Raw image data? Assuming that you're as hungry for food as for knowledge, I'll use a cooking analogy.

Say you purchase frozen lasagna and heat it up in your microwave oven. It probably tastes good and fulfills your needs ("Food!"). However, the chef who designed this prepared meal and the good folks who churn it out use a specific recipe designed to appeal to a large number of people, hopefully offending very few. When you reheat your lasagna in the microwave, you have some choices. For example, you decide how warm to make it (generally following the package's reheating instructions). Perhaps you'll add some pepper or hot sauce.

What you can't do with that frozen lasagna is take out some of the salt or fat in it from the recipe designed by the chef and prepared by the good folks. You can't substitute olive oil for butter. You can't cut back on the garlic a bit (just in case your date goes well). You're pretty much restricted by what the original chef and his good folks prepared. Sure, you could pour a half-bottle of blue food coloring over it, creating a special effect, but you're not likely to turn that microwavable lasagna into a gourmet dinner. So if you're just hungry and your demands aren't too severe, no problem — shoot JPEG (the digital photo equivalent of a microwave meal).

The gourmet dinner is what Raw is all about! If you consider yourself a gourmet chef of the camera, creating art from light, Raw is the format for you. Avoid the limitations put on your image editing by preprocessing and dive right in with the greatest flexibility. (And you don't even have to go down to the farmers' market for fresh tomatoes.)

Working in Raw

There's one critical difference between working with Raw images and working with JPEGs or TIFFs: You never actually make changes to the Raw file. Instead, you record your adjustments in the image's *metadata* (non-image data recorded with the image data) or in a *sidecar* file (a separate file in which Camera Raw records any information that can't be recorded in the metadata). If you work with the DNG format, the metadata is saved inside the DNG file. Because adjustments are recorded separately rather than applied to the images, the original image data remains unchanged, waiting for you to create again and again, all from the same unprocessed, un-degraded image data.

You can also open JPEG files into the Camera Raw plug-in. In Bridge, rightclick the thumbnail and select Open in Camera Raw. Doing so doesn't convert the JPEG to Raw, but it does give you many of the advantages of using Camera Raw. For example, your adjustments are recorded in metadata and can be changed (or removed) just as they can be for a Raw file.

WARNING

Sidecar files have the same name as the image file, but they use the .xmp file extension. Keep each sidecar file in the same folder as the image with which it is associated. If you move the image file without taking the sidecar file along for the ride, the information stored in the sidecar file won't be available when you reopen the image file, so you'll need to adjust the image's appearance all over again.

If at some point you decide that you don't like the adjustments made, you can open the image into Camera Raw and change the settings. If you decide that you'd like to start from scratch, right-click an adjusted Raw image in Bridge and select Develop Settings Clear Settings or Camera Raw defaults.

The menu that opens when you right-click a Raw image in Bridge offers a number of other options, including an option to change the date and time that the image was captured. Although this capability might be helpful if you forgot to set the date/time in your camera or were shooting in a different time zone, it also opens the door to monkey business. Thankfully, the *real* capture info remains embedded in the file's metadata.

When capturing in Raw, you can basically ignore all the camera's settings other than aperture, shutter speed, ISO, and (of course) focus. Everything else can be adjusted in the Camera Raw plug-in. However, because Raw devotes significantly more resources to recording highlights than shadows, it's not a bad idea to concentrate on those highlights when shooting. When the highlights are great to start with, you can reallocate some of the image's tonal range to the deprived shadows, thus reducing unwanted digital noise and increasing detail.

Keep in mind that in addition to the Photoshop Camera Raw plug-in, you also have available the software that came with your camera. And you might even have additional software packages available, such as Adobe Lightroom. And now there are Photoshop- and Lightroom-related apps for use on your smartphone or tablet. (See Chapter 18 for info about Photoshop on the iPad.) Which package is best? As usual, "best" is a relative term. For example, Nikon's proprietary software does a great job with sharpness when processing the files, but it lacks some of Camera Raw's features. If sharpness is your overriding requirement, you might prefer the Nikon software. (Remember that your Raw file can't be processed by both the camera's software and then by Camera Raw, but you can process the data with either and then further refine your image in Photoshop itself.)

While working in Camera Raw, keep in mind that what happens when you move the image from Camera Raw to Photoshop (or save your adjustments and close with Camera Raw's Done button) is governed by Camera Raw's Workflow Options. Discussed later in this chapter, Workflow Options controls the color space, color depth, pixel dimensions, and resolution of the image after you're done in Camera Raw. Workflow Options is where you also control whether the formerly Raw file opens into Photoshop as an image or a Smart Object and whether a sharpening preset is applied.

Photoshop's Save As dialog box offers you the option of the Photoshop Raw file format. Photoshop Raw is *not* compatible with the Camera Raw plug-in and does not provide you with the benefits of using the Raw format with your digital camera. It is, however, necessary for certain high-end graphics and animation programs into which someone, somewhere, sometimes places images from Photoshop.

The Camera Raw Interface

The cornerstone of Photoshop's Raw capability is the Camera Raw plug-in. After an image is open in Photoshop itself, you manipulate the pixels directly, rather than manipulating the metadata. When you work in the Camera Raw plug-in, you never change the image itself, only the adjustments recorded in the file's metadata (or in a sidecar file). As shown previously in Figure 6-1, the Camera Raw window is filled with tools and sliders. Even though you might not work with all the Camera Raw features, here's the lowdown on the features you find there.

Camera Raw can also be used with any 8- or 16-bit RGB or Grayscale image that's already open in Photoshop, on pixel layers, rasterized type and shape layers, and on layer masks. You can access Camera Raw through Photoshop's Filter menu. Keep in mind, however, that the true power of Camera Raw isn't there when used as a filter — the image data has already been processed and Camera Raw as a filter is simply another adjustment tool. Understand that the Camera Raw filter doesn't suddenly "un-process" your image data and make it a Raw file, it simply lets you use Camera Raw's adjustments as you would with, for example, a sharpening or noise reduction filter, or a Curves adjustment. Also keep in mind that you can select one or more layers and convert them to a Smart Object (Layer Smart Objects Convert to Smart Object) and use Camera Raw as a Smart Filter, which enables you to return to the filter and changes settings later.

Camera Raw's Tools and buttons

Along the right side of the Camera Raw window are 13 tools and buttons for manipulating your image and the workspace. From the top: Toggle Full Screen Mode, Edit Mode, Crop & Rotate, Spot Removal, Adjustment Brush, Graduated Filter, Radial Filter, Red Eye Removal, Snapshots (to create and show the image at various stages of adjustment), Presets, an ellipsis button (to open a list of commands), and, near the bottom, the Hand tool, Toggle Samplers (to show and hide color samplers along the top), and Toggle Grid Overlay. At the top, to the left, are a gear icon to open the Preferences and a button to jump to Save Options.

Before and After

There's another very important button to the lower-right of the preview/Filmstrip. As you can see in Figure 6-2, this button offers you lots of ways to view your work in Camera Raw. Open a Raw image into Camera Raw and try each of the options to see whether you might not prefer a side-by-side view or even a split-screen view while you work. (Split-screen views are generally best with images that are pretty much left-right or top-bottom symmetrical. If the image has substantially different content in different parts of the image, split-screen views might lead to inappropriate adjustments in part of the image.)

FIGURE 6-2: Click and hold to open the menu, or clickclick-click to rotate through the view options.

Trash

When multiple images are open in Camera Raw, you also have the Trash icon available in the center, below the preview alongside the star ratings. With one or more image thumbnails selected, click the Trash button to mark the files for deletion. When you click the Done or Open Images button, marked images are sent to your computer's Trash or Recycle Bin. Mark images for deletion only when you're *sure* you have no use for them.

Crop & Rotate

Click the Crop tool icon to open a workspace pane in which you select an aspect ratio (relationship between width and height), as shown in Figure 6–3. Drag the Crop tool to create a bounding box, which will automatically adjust to Landscape or Portrait orientation as you drag. You can then adjust the size of the bounding box by dragging its anchor points. You can also rotate an image while cropping: Position the tool just outside the bounding box and drag to rotate.

If you drag the Straighten tool (found to the right of the Angle slider in the Crop workspace) along a line in the image that should be horizontal or vertical — perhaps the intersection of two walls or the horizon — a crop bounding box is created with that alignment. Using the Crop tool's Custom option enables you to specify the resulting

FIGURE 6-3: The Crop tool can ensure perfect aspect ratio.

image's dimensions in aspect ratio, pixels, inches, or centimeters. Keep in mind that the Straighten tool uses the aspect ratio currently selected for the Crop tool, so pick the aspect ratio before dragging the Straighten tool.

When you have the Crop tool's bounding box just right and you've finished adjusting the image's appearance, click the Open or Done button. Should you change

your mind about cropping even after leaving Camera Raw, reopen the image into Camera Raw, click the Crop tool, hold down the mouse button to show the menu, and select Clear Crop. Or you can eliminate the bounding box (when the Crop tool is active) by pressing Delete (Mac) or Backspace (Windows).

Spot Removal

The Spot Removal tool gives you the ability to make minor corrections right in the Camera Raw dialog box. As shown in Figure 6-4, it offers capabilities similar to the Healing Brush and the Clone Stamp, including an Opacity slider. It can be used to either heal or clone. However, the Spot Removal tool's behavior is quite different. To use the Spot Removal tool, follow these steps:

- 1. Set the size of the brush and click the area that you want to heal or clone over.
- Drag to expand the tool's diameter.

You can also set the diameter using the Size slider to the right.

Position the source (green) and destination (red) circles.

> When you release the mouse button after setting the tool's diameter, a pair of circles appears. Click within the green circle and drag it over the element from which you want to clone or heal. You can also drag the red circle to fine-tune the location of the destination. You can click the edge of either circle and drag to resize them both (or use the Size slider).

FIGURE 6-4: Camera Raw's Spot Removal tool offers both healing and cloning modes.

Repeat, accept, or clear.

Clicking outside the circles accepts the change and starts the next healing/ cloning process. Changing tools and continuing with your adjustments accepts the changes. Clicking the Clear All button (just above Camera Raw's Done button) deletes the changes you made with the Spot Removal tool.

Pressing the forward slash key jumps the source circle to someplace that the tool thinks might be a good place from which to heal or clone. Press it repeatedly and you'll see that the "auto patch" is more like "random patch." It's your image; you should decide the source location according to your artistic vision.

The Visualize spots option at the bottom shows you a black and white version of the image, the better to see problem areas. Compare Figure 6-4 with Figure 6-5. They show the same image and the same spot adjustment — just a different way to look at things. The Visualize spots option is useful for very complex images such as this, and it's even better for images in which you might not notice a spot that needs correction.

FIGURE 6-5: The Visualize spots option.

Red Eye Reduction

To use the Red Eye Reduction tool, drag a rectangle around the entire eye, including some surrounding skin. (See Figure 6-6.) It automatically tries to hunt down and eliminate any suspicious red eye in the rectangle. You might need to adjust the Pupil Size and Darken sliders (in the area to the right, under the Histogram) to fine-tune the adjustment, but you can also simply click and drag the edges of the box created by the Red Eye Removal tool.

FIGURE 6-6: Minimize the haunted red eye effect right in Camera Raw.

Notice the Type field in Figure 6-6. It's set to Red Eye, but it also offers the option of Pet Eye to reduce or eliminate that spooky "green eye" effect common in photos of dogs and other animals.

Adjustment Brush

To make localized adjustments in specific areas of your image, select the Adjustment Brush (shown in Figure 6-7), drag the sliders, and paint in the image. You can paint the same adjustment in different areas or click the Plus button (below Brush in Figure 6-7) to add a different adjustment elsewhere in the image. And remember that these adjustments are only recorded in the metadata, and therefore can be changed any time down the road. It's not quite the same as duplicating layers and using layer masks in Photoshop, but it's still a great non-destructive way to paint adjustments!

FIGURE 6-7: Paint to make adjustments to exposure, brightness, contrast, and more.

Graduated Filter

The Graduated Filter tool enables you to set the adjustment in the area to the right, and then drag the tool in the image window. The adjustment is applied at full strength in the area before your first click, and is gradually faded through the area where you dragged (see Figure 6-8). You can add more than one graduated adjustment if necessary. Note that in addition to the adjustments shown to the right in Figure 6-8, you also have additional sliders for Saturation, Sharpness, Noise Reduction, Moiré Reduction, and Defringe. You can also adjust the various sliders after you have created the original adjustment.

There's also the Brush option, which enables you to paint (and erase) adjustments in the image. In addition, near the bottom of the Graduated Filter and Radial Filter options, is the Range Mask feature. You can set it to concentrate the adjustment(s) based on luminance or color, and use sliders to control the effect. Consider, for example, adjusting the saturation of the sky behind a tree. Drag the Gradient Filter tool and you make changes to the sky and those parts of the tree within the adjustment. Range Mask can be used either to set Color or Luminance to darken the tree limbs to mask them out of the adjustment.

FIGURE 6-8: Like using a graduated filter when shooting, but with more control!

Radial Filter

The Radial Filter works in much the same way as the Graduated Filter. However, as you can probably guess by its name, it uses circular or oval areas of adjustment rather than linear adjustments. Like the Graduated Filter, the Radial Filter enables you to add more than one area of adjustment. The Radial Filter also has the Brush and Range Mask options, and the same sliders as the Graduated Filter, as well as a Feather slider that enables you to soften the edges of the adjustment.

Sampler Overlay and the Color Sampler tool

Click the Toggle Sampler button near the bottom right (just below the Hand tool) to open a panel at the top of the workspace in which you can see color values for various areas in the image while you work. When you add color samplers (a maximum of nine) to the image preview, their values are displayed in the area above the preview. When you haven't added color samplers, that area is collapsed, leaving more room for the preview area. Color samplers in Camera Raw function the same as they do in Photoshop (see Chapter 5). Color samplers are visible as numbered targets in the preview area, strategically located in critical areas of the photo. You can use the Color Sampler tool to drag existing color samplers to new locations or delete them by Option/Alt+clicking the sampler. Clicking the Reset Sampler button deletes all existing color samplers. Remember, too, that the position of the cursor can function as an additional color sampler — the RGB values are shown below the histogram.

Camera Raw Preferences

In the upper-right of the work area is the gear button to open Camera Raw's Preferences (the same as using the keyboard shortcut $\Re+K/Ctrl+K$). In addition to the orientation of the Filmstrip (when multiple images are open) in the General Preferences, the File Handling area has options for saving metadata and for working with JPEG, TIFF, and HEIC files in Camera Raw. The defaults in the Performance and Raw Defaults sections are best left alone unless you're having problems. The primary preferences (such as color space and bit depth, as well as file size) in Workflow are shown below the preview. You can also click that line of info to open that section of the Preferences. (See the upcoming section "Workflow Options and presets.")

The histogram

Because of the unprocessed nature of Raw images, the histogram you see in the upper-right corner of the Camera Raw is generally far more important than the Histogram panel in Photoshop itself. (You can see different examples of histograms in Figure 6-3, Figure 6-4, and Figure 6-6, all shown previously.) By keeping an eye on the histogram while you adjust sliders, you can ensure that you're not blowing out the highlights (when the very right end of the histogram starts crawling up the edge) or clogging the shadows (the left edge gets too tall). The RGB values that you see just below the histogram represent the values of the pixel directly under the cursor when the cursor is in the preview area of the window. To toggle a preview of any "clipping" in your image, click the triangles in the upper left (shadows) and upper right (highlights) of the histogram. Any place where the shadows are being forced to pure black, losing detail that you could retain, you see a bright blue overlay. Use the Shadows and Blacks sliders to correct the problem. Anywhere that the highlights are being blown out to pure white, again losing valuable detail, click the triangle to the right and you see a bright red overlay. Use the Highlights and Whites sliders to bring the problem under control. (Using the individual sliders is discussed later in the chapter.) You can hide these clipping warnings by again clicking the triangles. The triangles change color to tell you what's wrong or which colors are causing the problem. You might want to hide the overlays when creating special effects. (I readily admit that I often intentionally clog shadows and blow out highlights to produce special effects and to focus attention on the subject of my photos.)

The preview area

As shown previously in Figure 6-1, the bulk of the Camera Raw window is filled with the image preview, giving you the best possible view of your work. Remember that you can drag a corner or edge of the Camera Raw window to resize it and

click the angled arrows button in the upper-right corner to maximize the size. The preview area benefits/suffers from the changes that you make as you enlarge/shrink the window. To the lower left is a pop-up menu with preset zoom factors. You can also use the standard keyboard shortcuts to zoom in and out. Camera Raw's maximum zoom percentage is 1600%.

Workflow Options and presets

Just below the preview area in Camera Raw is a line of information including the file's color space, color depth, dimensions, file size, and resolution. Click that line to open the Workflow Options dialog box. (And, as mentioned previously, you can access the options through Camera Raw's Preferences.)

Workflow Options enables you to change any of the specifications you saw in the line you clicked, add a sharpening preset, and the option to open images from Camera Raw into Photoshop as Smart Objects by default.

>> Space: Camera Raw offers the four major color spaces — Adobe RGB, ColorMatch RGB, ProPhoto RGB, and sRGB — as well as other profiles available in Photoshop. Color spaces (read about them in Chapter 5) determine which colors are available in an image.

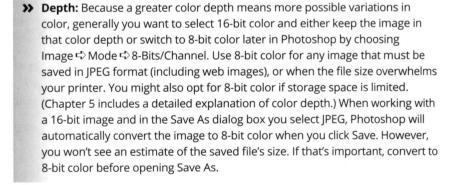

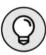

TIP

- >> Image Sizing: Select Resize to Fit and you can specify the resulting image size in a number of ways: Width & Height, Dimensions, Long Side, Short Side, megapixels, and Percentage.
- >> Resolution: Resolution is simply an instruction to a printing device about what size to make each pixel. It can be assigned in Camera Raw or later in Photoshop's Image Size dialog box (with Resample deselected). Generally speaking, 300 ppi (now, finally, the default) is a more appropriate resolution for images that will be printed.
- >> Output Sharpening: The Output Sharpening menu provides you with presets designed for specific purposes, including onscreen presentation, inkjet prints on glossy paper, and prints on matte paper. Each category includes Low, Standard, and High options. This sharpening is in addition to the sharpening you add on Camera Raw's Detail section. (Generally I leave this set to None and sharpen each image according to the image's content in Camera Raw and Photoshop.)
- >> Open in Photoshop as Smart Objects: This option enables you to automatically open your Raw image into Photoshop as a Smart Object. Smart Objects, which are discussed in Chapter 9, can be scaled and transformed multiple times with minimal degradation of the image quality. And, as explained in Chapter 14, you can apply Smart Filters filters that can be reopened and changed to Smart Objects.

Making Adjustments in Camera Raw's Edit Panel

Alright, now it's time to look at the actual adjustments you can make in Camera Raw. Rather than appear in a series of panels that open one at a time, the adjustments are in one long Edit panel with collapsible sections. Clicking the arrow to the left of a section's name expands or hides the various sliders and adjustments in that section. The sections are Basic, Curve, Detail, Color Mixer, Color Grading, Optics, Geometry, Effects, and Calibration. If you don't see the Edit panel, click the topmost icon in the Tools section on the right, just below the angled arrow button (Full Screen mode).

The Basic section

When it comes to actually adjusting your images in Camera Raw, the meat-and-potatoes portion is the Basic section. It's the topmost section of the Edit Panel, as shown in Figure 6-9.

Here are some general guidelines for working in the Basic pane (but remember that each image has its own particular requirements):

- >> First adjust the white point. Generally, you adjust the white point (the Temperature and the Tint sliders) by clicking with the White Balance tool in some area that should be neutral and close to white. If the image doesn't look right, click elsewhere or manually adjust the Temperature and Tint sliders.
- Adjust the exposure. Drag the Exposure slider right or left to spread the histogram across most of the space available. (Remember, these are general guidelines for typical images, not "rules.")
- >> Fine-tune the contrast. Drag the Contrast slider to the right to increase contrast or to the left to flatten out the image's contrast.
- >> Fine-tune the shadows and highlights. Use the Highlights and Shadows sliders to adjust the relationship between the brightest pixels and the midtones and between the darkest pixels and the midtones. You can fine-tune the highlights a bit more with the Whites slider and touch up the shadows with the Blacks slider.

FIGURE 6-9: The Basic section is where you do the bulk of your image correction.

- >> Fine-tune skin, hair, and other detail with the Texture slider. Drag the Texture slider to the left to smooth medium-sized detail in the image, such as skin. Drag to the right to increase the appearance of detail, for areas such as hair. You can use the Texture slider in conjunction with the Graduated Filter, Radial Filter, and Adjustment Brush to localize adjustments.
- **>> Make the image "pop" with the Clarity slider.** Drag the Clarity slider to the right to increase the contrast among neighboring areas of color. Somewhat akin to sharpening, this slider can do a great job of adding life to most images.
- >> Clear the fog with Dehaze. Drag the Dehaze slider to the right for outdoor shots with overly diffused light. Drag to the left to add haze for a special effect. (Always set the white balance before using Dehaze.)
- >> Tweak the colors. Using the Vibrance slider in conjunction with the Saturation slider, adjust the appearance of the color in your image.

 Remember that the Saturation adjustment is applied to all colors in the image, while Vibrance works primarily with the near-neutral colors.

VIBRANCE AND SATURATION

Both the Vibrance and the Saturation sliders in Camera Raw adjust the intensity of colors in your image. So what's the difference? The Saturation slider changes all color in the image, whereas the Vibrance slider works its magic primarily on those pixels that are least saturated. To see how this works, open an image in Camera Raw and adjust the sliders to make the image look great. Drag the Saturation slider all the way to the left. Grayscale, right? Move the Saturation slider all the way to the right. Oversaturated, right? Drag the Vibrance slider slowly to the right while keeping an eye on areas of the image that are close-to-but-not-quite gray. Watch how they increase in saturation, gradually going from near gray to almost colorful. Now here's the coolest trick of all: With Saturation still at +100, drag the Vibrance slider all the way to the left, to -100. Starting with an appropriate image, this can be a *very* interesting effect. (Also take a look at Figure 6-13 for another way to create this effect.)

Double-click any slider control to reset that slider to its default value. This works not only for sliders in the Basic pane, but also for sliders anywhere in Camera Raw.

TIP

As you work, the best adjustments are those that make the image look great to you and meet your creative goals. The order of adjustments and the histogram suggestions here are not appropriate for *all* images. Let your artistic sense be your guide.

The Curve section

The second section in Camera Raw's Edit panel enables you to adjust the tonality of the image several ways. The most basic is the Tone Curve. Click the line and drag up or down to smoothly adjust a range of tonality ion the image. You can have several points. In Figure 6–10, the "S-curve" increases contrast in the image's midtones.

You can also drag the sliders below the curve to make adjustments. Using the buttons to the right of Adjust, you can work in the color channels individually. To the right of those buttons is the Targeted Adjustment tool. To adjust a range of tonality throughout the image, identify an area in the preview that shows the problem, click the Targeted Adjustment tool in that area, and then drag up (to lighten) or down (to darken).

The Detail section

Three sliders in the Detail section (as shown in Figure 6-11) control sharpness and noise in your image. When you're ready to work with the Detail sliders, zoom in to 200% or even 400% on an area of shadow in your image and drag the sliders all the way to the left, setting them to 0 (zero). Drag

FIGURE 6-10:
You make changes to tonality on the Tone Curve tab.

the Color Noise Reduction slider slowly to the right until all red/green/blue specks in the shadows disappear. Next, drag the Noise Reduction slider to the right until the bright specks in your shadows are reduced but not so far to the right that detail in your image is damaged. After noise is reduced, zoom back out and use the Sharpening slider to make the image "pop."

Here's the coolest part: Zoom in to at least 100% and hold down the Option/Alt key while dragging any of the Sharpening sliders — you'll see a grayscale preview of what you're actually doing to your image!

TIP

Figure 6-12 shows three views of the same image: The unsharpened original (top), the Sharpening slider set to Amount-85 (middle), and the preview of the Detail adjustment (bottom).

The Color Mixer section

Working with eight sliders for various color ranges on three tabs for Hue, Saturation, and Luminance, Camera Raw's Color Mixer feature gives you incredible control over hue, saturation, and luminance (HSL) of specific color ranges in your image. Need to perk up the reds in your image? Not a problem — just boost the Reds slider in Saturation and Luminance! Yellows a bit too garish? Tone 'em down with the Yellows slider. Maybe the green grass looks a bit yellow. Drag the Greens slider all the way to the left for Saturation and you get an interesting partial–grayscale look, as shown in Figure 6–13.

Of course the example in Figure 6-13 is a special effect. You're more likely to use these sliders to selectively enhance color in an image. You have extremely fine control when working with the individual sliders in all three of the Hue, Saturation, and Luminance sets.

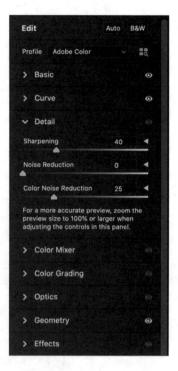

FIGURE 6-11: Reducing noise and sharpening can greatly improve the overall appearance of an image.

The Color Grading section

I'm not going to say that Color Grading is a miracle worker. I'll just ask you to compare the before and after images in Figure 6-14. Based on Adobe Premier's video editing capabilities, Color Grading replaces Split Toning in Camera Raw.

For more control, you can click the Shadows, Midtones, and Highlights buttons to the right of Adjust. You can also click the fifth button for *global* adjustments (which are single adjustments applied throughout the image). And don't forget about the Blending and Balance sliders below to help blend the adjustments throughout the tonal range of the image.

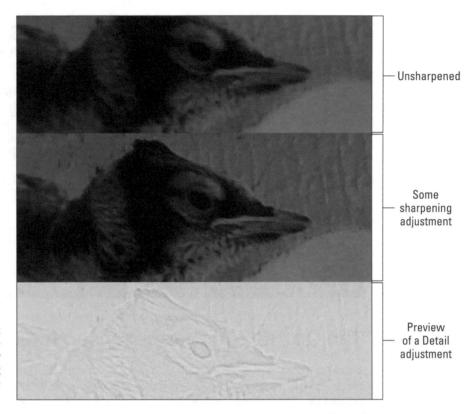

FIGURE 6-12: Hold down the Option/Alt key while dragging to preview the sharpening.

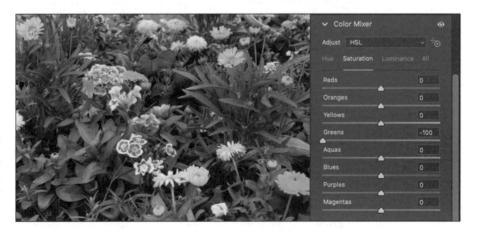

FIGURE 6-13:
Grayscale
"greenery"
contrasts nicely
with highly
saturated
blooms.

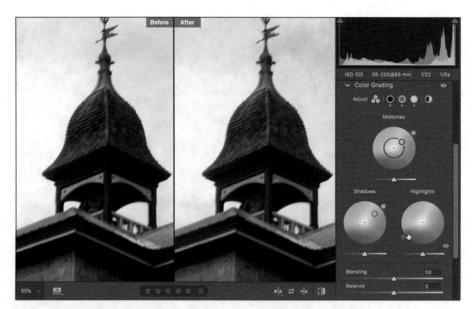

FIGURE 6-14:
A photo of a bland building in front of an overcast sky is improved with Color Grading.

The Optics and Geometry sections

Think of these panes as providing "lens correction." You can compensate for certain peculiarities of your lens or rectify problems with angles and cropping created by circumstances when capturing an image. If the camera and lens combination is embedded in the image's metadata (and readable by Camera Raw), you can use the Optics section's automatic corrections (see Figure 6–15) and, if necessary, tweak them for a specific image. You can also elect to use the Manual mode and work by eye. Thankfully, as you drag sliders, a grid automatically appears to assist you with corrections.

The Geometry section is a more radical approach for more severe problems. For example, when taking photos of tall buildings without the aid of a tilt-shift lens can make it appear that the building was leaning away from you. Geometry can help with that (see Figure 6-15).

To the right of Upright, you have the following options: disable the Upright correction; use an automated adjustment (which you can further adjust with the sliders); fix only problems with an unlevel horizon; work with level and vertical problems; go all in with level, horizontal, and vertical adjustments; or create guides for an automated correction. With the sixth button, you draw two or more guides to tell Geometry what should be straight lines in the image. Whichever option you choose, work with the sliders to fine-tune the adjustment until it looks correct to you.

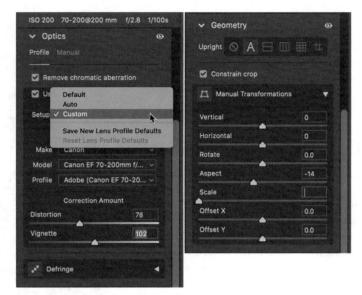

FIGURE 6-15: Correct aberrations created by a lens by using a preset, or making them manually.

The Effects section

The Effects pane of Camera Raw does only two things: add grain and add or subtract vignetting. The pane offers two sliders — one for each adjustment. Adding grain can simulate the look of old-fashioned film. But because people spend so much time trying to remove noise from digital images, you're not often likely to want to add grain, which looks like noise to those of us fully in the digital world.

Vignetting, on the other hand, might be a slider you'll use. With some zoom lenses, you might find that there's some darkening (or lightness) around the edges of the image. This slider can make short work of that problem. And, of course, you may want to add a light or dark vignette around the outside of an image to help focus the eye on the subject.

The Calibration section

WARNING

Generally you'll skip the Calibration section completely, with one exception: Make sure that the Process menu is set to the latest version, "Version 5 (Current)" (or later when an update is available), to take advantage of the improvements in this version of Camera Raw. You might, however, want to use the Camera Calibration tab to compensate for what you perceive to be regular and consistent deviation in your particular camera's behavior. You might, under some circumstances, want to use the sliders on the Camera Calibration tab (see Figure 6–16) to reduce a *color cast*, an unwanted color tint in the image. Use very small adjustments!

The Camera Raw Cancel, Done, and Open buttons

In lower-right corner of Camera Raw are three buttons: Cancel, Done, and Open. Cancel, as you can imagine, discards all the work you've done (if any) and closes Camera Raw. Done saves the adjustments in the metadata for the image(s) and closes Camera Raw. The Open button offers three options: Open, Open as Object, and Open Copy. Open applies the adjustments (and saves them to the metadata) and then opens the adjusted image(s) into Photoshop. Click the arrow to the right of Open to access the other two options. Open as Object saves and

FIGURE 6-16:The Camera Calibration sliders might be useful for correcting a color cast.

applies the adjustments and opens the image as a Smart Object in Photoshop. Open as Copy applies the adjustments without saving them to the image metadata and then opens the image into Photoshop.

You might want to use the Open as Copy option when you have previously adjusted an image and don't want to overwrite those settings. Possibly you made a perfect adjustment the last time you opened the image into Photoshop, and this time you've created some creative special effect that you'll use only the one time.

- » Masking for layer visibility and to protect parts of your image
- » Keeping your options open with adjustment layers

Chapter 7

Fine-Tuning Your Fixes

here you are, repainting the bedroom — all by yourself, saving money, being productive — and it's time to do the windows. Now, you probably don't want to paint over the glass, right? Just the frame, the sash, the sill, those little whatch-ya-call-its between the panes, right? (Okay, technically the dividers between the panes are called *muntins*.) There are several ways you can avoid painting the glass. You can use a little brush and paint *very* carefully. You can use a larger brush, paint faster, and scrape the excess from the glass afterward. You can grab the masking tape, protect the glass, and paint as sloppily as you like — when the tape comes off, the glass is paint-free.

Those are unbelievably similar to the choices that you have in Photoshop when you need to work on only a part of your image. You can zoom in and use tools, dragging the cursor over only those pixels that you want to change (just like using a tiny paintbrush). You can use the History Brush feature (which I introduce in Chapter 1) to restore parts of the image to the original state (like scraping the glass). You can isolate the area of the image you want to change with a selection (much like protecting the rest of the image with masking tape).

In this chapter, you read about getting ready to make changes to your image rather than actually making those changes. You can isolate groups of pixels in your image in a variety of ways. For example, you can select pixels that are in the same part of the image (regardless of color), or you can select pixels that are the same color (regardless of location in the image). This is *power*: the ability to tell Photoshop exactly which pixels you want to alter. After you make that selection,

you can manipulate the pixels in a variety of ways — everything from making color and tonal adjustments to working with Photoshop's creative filters to simply copying them so you can paste them into another image.

I discuss "taping the glass" first by making selections and then by using *masks* — channels that actually store selection information. After that, I tell you about working with *adjustment layers*, which are special layers that help you apply certain color and tonal adjustments without actually changing any pixels in the image. An adjustment layer even lets you restrict the change to one or several layers in the image.

What Is a Selection?

When you make a *selection* in your image, you're simply isolating some of the pixels, picking them (*selecting* them) so that you can do something to those pixels without doing it to all the pixels in your image. Photoshop shows you what part of the image is within the selection with a flashing dashed line. (Now that you're part of the Photoshop Inner Circle, you call that selection boundary the *marching ants.*) Say, for example, that part of your image looks great, but part of the image looks, well, just plain wrong. Figure 7-1 is an excellent example.

FIGURE 7-1: Sometimes only part of the image needs changes.

By making a selection and applying an adjustment, I can make this image look much, much better. Of course, you might choose to make a different selection and apply a different adjustment, but you can see what I chose to do in Figure 7-2. By selecting the rails (in this case, with the Polygonal Lasso tool, which I explain later in this chapter), I isolate those areas from the rest of the image, enabling me to change the color of those pixels without changing anything else. (Rather than selecting and darkening the rails to make them appear to be in front of a glow, I could have selected the lighter area and created a uniform sky color. But this is visually more interesting.)

FIGURE 7-2: The selection (visible to the right) restricts the change to some parts of the image.

The tonal and color adjustments that I discuss in Chapter 5 are often applied to an image as a whole. You can, however, apply them to specific areas of an image. Much of the rest of the work that you do in Photoshop is not global in nature, but rather is done to only restricted areas of your image. You use selections to do that restricting.

You can also use selections for a variety of other jobs in Photoshop. One of the most common is copying from one image and pasting into another. You can see one example in Figure 7–3. The subject of one image (upper left) is selected. You can see a close-up of the selection to the right. Choosing Edit \Leftrightarrow Copy copies the selected pixels to the Clipboard. You can then switch to another image and choose Edit \Leftrightarrow Paste to drop those pixels into a second image (lower left). You can adjust the size by choosing Edit \Leftrightarrow Transform \Leftrightarrow Scale, adjust the position by dragging with the Move tool, and perhaps add some shadows by using the Brush tool or a Drop Shadow layer style (discussed in Chapter 11). The composited picture is ready for whatever nefarious purpose you might have in mind!

FIGURE 7-3:

Make a selection, copy, switch to another image, and paste.

Any pixel in your image can be selected, deselected, or partially selected. For example, if you have a selection and fill it with red, the selected pixels turn red, the deselected pixels don't change, and the partially selected pixels get a red tint. How much tint depends on the level of selection. (Photoshop generally uses 8-bit grayscale for selections, so there are 256 different levels of "selected.")

Feathering and Anti-aliasing

You need to keep in mind a couple of very important terms as you read about the various tools and commands with which you make selections. Both *feathering* and *anti-aliasing* make the edges of your selections softer by using partially transparent or differently colored pixels. That, in turn, helps blend whatever you're doing to that selection into the rest of the image.

Don't forget that all pixels in your image are square, aligned in neat, orderly rows and columns. (That's the *raster* in raster artwork.) When you create a curve or diagonal in your artwork, the corners of the pixels stick out. Feathering and antialiasing disguise that ragged edge. You can also use feathering to create larger,

softer selections with a faded edge. Generally speaking, use anti-aliasing to keep edges looking neat and use feathering to create a soft, faded selection.

Nothing illustrates the power of feathering quite like a simple black-on-white demonstration, as you see in Figure 7-4. In the upper-left, I made an unfeathered selection and filled it with black. To the upper-right, the filled selection is exactly the same size but has a 2-pixel feather. Below, I used a 15-pixel feather when making the selection.

A close-up look at no feathering, feathering, and lots of feathering.

Note that there's feathering on both sides of the selection border. And don't be fooled by the amount that you enter in the Feather field on the Options bar — that's a general guideline, not a precise value. A 15-pixel feather for the Elliptical Marquee tool might give you 50 or 60 partially transparent pixels, half on either side of the selection border. Even a 1-pixel feather gives you a selection with several "soft" pixels on either side.

Anti-aliasing is similar to feathering in that it softens edges: It's designed to hide the corners of pixels along curves and in diagonal lines. You use anti-aliasing with type (as I explain in Chapter 12). You'll often find that anti-aliasing is all you need to keep the edges of your selections pretty; feathering isn't required. Anti-aliasing is a yes/no option, with no numeric field to worry about. Figure 7-5 compares a diagonal with no anti-aliasing, with anti-aliasing, and with a 1-pixel feather.

At 100% zoom (to the upper left), the first line looks bumpy along the edges (it has a case of the jaggies, you would complain to a friend or co-worker). The lower line looks soft and mushy, out of focus. And the middle line? To quote Goldilocks, "It's just right!" When zoomed to 600%, you can really see those jaggies and that softening. And in the middle, you see that the anti-aliasing uses light gray and mid-gray pixels interspersed along the edge among the black pixels. At 100% zoom (upper left, middle line), your eye is fooled into seeing a straight black edge.

FIGURE 7-5: Anti-aliasing helps smooth the appearance of curves and diagonals.

Generally speaking, use anti-aliasing with just about every selection (other than rectangular or square), and use feathering when you want to really soften the edges to create a special effect.

Making Your Selections with Tools

Photoshop offers you 10 tools whose whole purpose in life is to help you make selections. You also use those tools to alter your selections by adding to, subtracting from, and intersecting with an existing selection. The 10 selection tools are divided into three groups:

- >> Four marquee tools
- >> Three lasso tools
- >> The Quick Selection tool, the Magic Wand, and the new Object Selection tool

Marquee selection tools

You have four marquee selection tools, although you'll generally use only two of them. Figure 7-6 shows the marquee selection tools, along with each tool's Options bar configuration. (Note that the Select and Mask button is available even when you do not have an active selection in your image.)

FIGURE 7-6: Marquee selection tools come in four flavors, two of which are tasty.

You drag the very useful Rectangular Marquee and Elliptical Marquee tools to make selections. Click and drag in any direction to make your selection. After you start dragging, hold down the Shift key (while still dragging) to constrain proportions. When you constrain the proportions of a selection, you create a square or circle rather than a rectangle or an ellipse. If you start dragging a selection and press the Option (Mac)/Alt (Windows) key, the selection centers itself on the point where you click. The Shift and Option/Alt keys can be used together. Holding down the Shift key *before* you click and drag adds the selection to any existing selection. Holding down the Option/Alt key *before* dragging subtracts the new selection from any existing selection.

The Single Row Marquee and Single Column Marquee tools are simply clicked at the point where you want a 1-pixel selection, running from side to side or from top to bottom. These tools create selections that extend the full width or full height of your image. You might use these tools to create a gridlike selection that you can fill with color. Or you might never use them at all.

Take another glance at the Options bar in Figure 7–6. The four buttons to the left on the Options bar, which you can use with any of the tools, determine how the tool interacts with an existing selection.

>> New Selection: When you select the first button, any selection that you make replaces an active selection (deselecting any previous selection). If, with a

selection tool, you click inside an active selection when the first option is active, you can drag that selection in your image without moving any pixels. When you haven't already made a selection, these tools always make a new selection, regardless of which button is active.

- Add To: When you have an active selection and need to add to that selection, use the second button or simply press and hold down the Shift key before dragging.
- >> Subtract From: When you have a selection and need to deselect part of it, use the third button. Say, for example, that you make a round selection and want to chop out the middle to make a donut shape. Click the third button and then drag within the original selection to deselect the donut hole. This is comparable to holding down the Option/Alt key before dragging the selection tool.
- >> Intersect With: You have a selection, but you want to keep only part of the selection. You could set your selection tool to subtract from the existing selection, or you could intersect with that original selection and deselect a number of areas at once.

Figure 7-7 presents a visual explanation of how all four buttons work. On the left, you see the selected option for the active marquee selection tool. Next is an original selection. In the third column, you see another selection being made (with the selection tool dragged from the lower right to the upper left). Finally, on the right, you see the result of combining the two selections.

FIGURE 7-7:
The buttons at the left on the Options bar control selection interaction.

In the bottommost example, you could do a whole series of subtractions from the existing selection to chop off the "points," but using the intersect option takes care of the job with a single drag.

While you're dragging a selection with the Rectangular Marquee or the Elliptical Marquee tool, you can hold down the mouse button and press and hold the spacebar to reposition the marquee. When you have it where you want it, release the spacebar and continue to drag.

Take another look at the four views of the Options bar shown earlier in Figure 7–6. Take note of these variations among them:

- Anti-aliasing isn't available for the Rectangular Marquee tool. That's because all four edges of the selection will align perfectly with the edges of the pixels — no need to disguise corners of pixels. (You can, of course, soften the selection with feathering.)
- >> Both the Rectangular Marquee and the Elliptical Marquee tools offer the options of Normal (unconstrained, just drag as necessary), Fixed Aspect Ratio (the relationship between width and height you specify on the Options bar is maintained as you drag), and Fixed Size (just click in the upper-left corner of your intended selection).

CONTROLLED SELECTIONS

Lurking within the Options bar Style drop-down menu are two options worth noting: Fixed Aspect Ratio and Fixed Size. Using the Fixed Aspect Ratio option with the Rectangular Marquee or the Elliptical Marquee tool forces the selection to the height and width relationship that you specify on the Options bar. This is great for composing an image that you need at a specific size, say to fit in a standard 5-x-7-inch picture frame. The selection tool won't resize the image for you, but you can make the selection and choose Image \Rightarrow Crop and then choose Image \Rightarrow Image Size to resize to your required dimensions and resolution. (Read about resizing and cropping your images in Chapter 2.)

The Fixed Size option changes the behavior of the tools. After you enter an exact width and height on the Options bar, position the cursor in the upper-left corner of the area that you want to select and click once — the selection is created to the lower right of that point. Don't worry about being exact because you can drag the selection marquee into position afterward. (You'll want to have the leftmost of the four buttons on the Options bar selected to reposition your selection.) When you're using the Fixed Aspect Ratio or Fixed Size styles options, there is a button between the Width and Height fields on the Options bar that swaps the values in the two fields.

>> The Single Row Marquee and Single Column Marquee tools offer the four buttons to determine how the tool will interact with an existing selection and the Feather field. Although feathering a 1-pixel-wide or -tall selection seems a little strange. . . .

Lasso selection tools

Three lasso selection tools are available in Photoshop. On the Options bar, all three of the lasso selection tools offer the same basic features that you find in the marquee selection tools, as you can see in Figure 7–8. You can add to, subtract from, or intersect with an existing selection. You also have the feathering and anti–aliasing options available. The Magnetic Lasso tool offers three additional settings that help determine how it identifies edges as you drag.

FIGURE 7-8:
The basic options for the lasso selection tools match those for the marquee selection tools.

So what makes lasso tools different from a marquee tool? Read on to find out:

- >>> Lasso tool: The Lasso tool is a true *freeform* tool; that is, you click and drag it wherever you want the selection to go. You can drag around and return to the starting point, or you can release the mouse button anywhere, and your selection is finished along a straight line from that point to the spot where you start your selection. If you press and hold the Option/Alt key while dragging, you'll temporarily switch to the Polygonal Lasso tool.
- >>> Polygonal Lasso tool: Rather than dragging, you click-click to make straight selection segments, at any angle, for any distance. When you position the cursor directly over your starting point, a little circle appears to the lower right of the cursor to indicate that you're back to the start. Or simply double-click to finish the selection. If you press and hold the Option/Alt key while dragging, you'll temporarily switch to the regular Lasso tool, which lets you drag your selection any way you want. Using the Option/Alt key lets you switch

back and forth between the freeform drag of the Lasso tool and the perfectly straight selection borders of the Polygonal Lasso tool.

Magnetic Lasso tool: When you need to select around a subject that has good contrast with its background, the Magnetic Lasso tool can do a great job. The perfect candidate for this tool is a simple object on a very plain background. You can, however, use it with just about any image where the edges of the area you want to select differ substantially from the rest of the image. Click and drag the tool along the edge of your subject. If the tool misses the edge, back up and drag along the edge again. If the edge makes a sudden change in direction, click to add an anchor point. If the tool places an anchor point in the wrong spot, back up and then press Delete/Backspace to remove the point. (By the way, if you have a Wacom pressure-sensitive tablet hooked up, you can set the Magnetic Lasso tool to vary its width according to pen pressure. Use the button just to the right of the Frequency field on the Options bar.)

The Magnetic Lasso tool works by identifying the difference in color along the edges, using all available color channels. From the Options bar, use the Width field to tell the tool how wide of an area it can look in to find an edge. The Edge Contrast field tells the tool how much the edge must differ while searching. Use the Frequency field to choose the number of anchor points the tool sets while outlining the selection.

You can open the Channels panel and click each of the channels individually to see if there's greater contrast between what you want to select and the surrounding pixels in one of the channels. With just that channel active, use the Magnetic Lasso to make the selection, then click the composite channel (RGB or CMYK, located at the top of the Channels panel) to make all the channels active again.

The Object Selection tool

NEW

The new Object Selection tool looks for edges and color to determine what is an "object" in an image. Remember that there aren't actually any objects in a digital image, just pixels. This tool tries to determine which pixels are related and, therefore, represent an object. Drag a rectangular marquee around the object you want selected and the tool will work its magic. It performs best with objects against simple backgrounds and objects that have a relatively strong color or tonal difference from the surrounding pixels.

The Quick Selection tool

Consider the Quick Selection tool to be sort of a color-based-selection-in-a-brush. You drag the tool through an area of color and based on the color variations

under the brush and the brush size, the tool automatically selects similar colors in the surrounding area. Keep in mind that you can adjust the brush size as you work by using the square bracket keys. (When working with a Wacom tablet, this tool works great with brush size set to pen pressure.) The Auto-Enhance option on the Options bar may slow down the performance of the Quick Selection tool a bit, but the great job it does analyzing edges usually produces a better selection. With just a little practice, you'll likely find the Quick Selection tool to be quite simple to use, even for rather complex selections (see Figure 7-9).

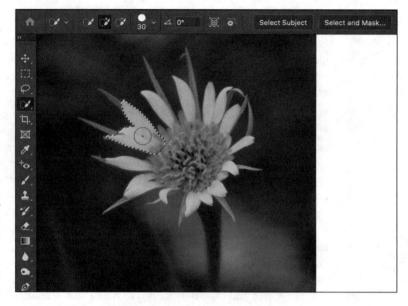

FIGURE 7-9:
Drag through
an area of
color to select
the pixels
under the
brush and
nearby pixels
of similar color.

The Magic Wand tool

The Magic Wand tool selects pixels similar in color to the pixel on which you click with the tool. Like the other selection commands, you can add to, subtract from, or intersect with an existing selection, and you can select anti-aliasing. *Tolerance* determines how closely pixels must match your target color to be included in the selection. When you select the Contiguous check box and then click a spot, only pixels connected to the spot by pixels of the same color are selected. The Sample All Layers option lets you make a selection of similarly colored pixels on every visible layer in your image, not just the currently active layer.

When you use a low Tolerance setting, you select only those pixels in the image that are very similar to the pixel on which you click. A high Tolerance setting gives you a much wider range of color, which might or might not be appropriate for the selection you're making.

Select and Mask

You may have noticed the Select and Mask button in Figures 7-6, 7-8, and 7-9. It sits quietly to the right of the other options on the Options bar, waiting for you to click. This button replaces the Refine Edge option in earlier versions of Photoshop. (The Refine Edge brush is still available in the left column of Select and Mask.) Select and Mask's Properties panel is shown in Figure 7-10.

Here's what you need to know about each of the options in Select and Mask:

select from among several different ways to view the selection you're refining. Using a black or white or red mask is great for many images, and the On Layers option shows you the content of the selection as if it was floating on a separate layer. Show Radius and Show Original are great for a quick preview of what you're doing, but you'll generally take a look and then disable those options. The keyboard shortcuts for the various views are also handy, especially X to disable all views and show the original and F to cycle through the view modes to see which is most appropriate for the current task.

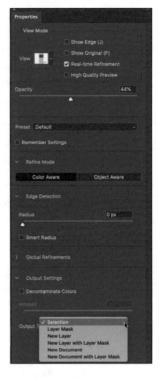

FIGURE 7-10: Select and Mask is a very powerful feature for finetuning selections.

- >> Refine Mode: The Color Aware option is best for subjects on simple backgrounds. If you have a more complex background or subject (perhaps including hair, fur, or leaves), opt for Object Aware.
- >> Edge Detection: The Radius slider determines how much of an area surrounding the initial selection will be refined. The Smart Radius option enables Select and Mask to differentiate between hard edges and soft edges think in terms of the edge between the subject's shirt and the background (usually a well-defined "hard" edge) versus the subject's hair and the background (usually a fuzzy "soft" edge).
- Slobal Refinements: Smoothing the selection edge minimizes any jagged areas. Feathering (as described earlier in this chapter) softens the edge. Contrast makes the selection edge more distinct. (You rarely use Feather and Contrast together.) Shift Edge expands or contracts the selection edge.

- Output Settings: Here's where Select and Mask really rocks! (The Output options are shown in the inset of Figure 7-10.) You can click OK and see a newly refined selection marching around some pixels in your image, but you also have the options of clicking OK and producing a layer mask (background layers are automatically converted), a new layer with only the content of the refined selection, a new layer using a layer mask to reveal the content of the selection, a new document with only the content of the selection, or a new document consisting of a layer using a layer mask to reveal the content of the selection! Decontaminate Colors can do a great job of eliminating that fringe of background color that sometimes appears when you're making complex selections. (With this option selected, you output to a new layer or document, with or without a layer mask.)
- >> Tools: To the upper left of your workspace is the Tools panel for Select and Mask. You have the usual Zoom and Hand tools for inspecting your work up close. Above them are the Quick Selection tool, the Refine Edge Brush, the Brush tool, and the Lasso tool for adjusting the original selection.
- >>> Remember Settings: If you hit upon a sweet set of refinement settings that look like they are a sure-fire answer to most of your selection challenges, by all means make sure to select the Remember Settings box before you click OK. Select and Mask then starts with those preferred settings each time you open the dialog box. (The Remember box is not shown in Figure 7-10, but you'll see it when you scroll down.)

Select and Mask can also be used to tweak an existing layer mask. In the Layers panel, click the layer mask thumbnail to make it active. In the Select menu or the Options bar, choose Select and Mask. Use the options discussed in the previous list, elect to output to a layer mask, and click OK. The selected layer mask is updated to reflect the changes you specified.

Your Selection Commands

You have 23 menu commands at your service when selecting pixels and layers in your artwork. Some, like those near the top of the Select menu, are rather simple and aptly named. See Figure 7-11 for a list of the Select commands. The All Layers, Deselect Layers, Find Layers, and Isolate Layers commands are not used to select pixels, but rather to change the activation of layers in the Layers panel.

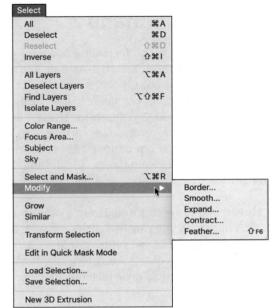

FIGURE 7-11:
The Deselect
or Reselect
command —
or both — are
always grayed
out, depending
on whether
there is (or
was) an active
selection in
your image.

The primary selection commands

The commands near the top of the Select menu are features that you're likely to use regularly. (Okay, maybe not the Reselect command.) Memorizing their keyboard shortcuts and using them regularly is a timesaver:

- >> Select All (第 +A/Ctrl+A): Select All does exactly what the name implies it makes a selection of all the pixels in your image on the active layer (or in an active layer mask).
- >> Deselect (# +D/Ctrl+D): Use the Deselect command to make sure that no pixels are selected. This is a handy command when it seems that a tool or a filter or adjustment command isn't working. There could be an unnoticed selection in the image, preventing the command from appearing how or where you expect.
- >> Reselect (# +Shift+D/Ctrl+Shift+D): This is a great little command for those times when you're making a complex selection, and a little slip accidentally deselects. Just use Reselect to restore the most recent selection. Or use the Undo command.
- >>> Inverse (策 +Shift+I/Ctrl+Shift+I): The Inverse command reverses the selection. What was selected is deselected, and what wasn't selected becomes selected. (You must include the Shift key without it, you invert the colors in your image rather than inverting your selection!)

The Color Range command

In the middle of the Select menu is the incredibly powerful Color Range command. Rather than dragging the Quick Selection tool or Shift+clicking with the Magic Wand, you can select by color quickly and easily with the Color Range command. The pop-up menu at the top of the Color Range dialog box lets you pick among the RGB (red/green/blue) and CMY (cyan/magenta/yellow) colors, as well as the image's highlights, midtones, or shadows, and even any out-of-gamut colors in the image (colors that can't be reproduced within the selected color space). When you choose one of the presets from the top menu (other than Skin Tones), the Fuzziness slider isn't available, limiting that feature's value.

In Figure 7–12, I clicked and dragged through some orange areas in the image with the middle Eyedropper tool. You can also click once with the left eyedropper and use the other eyedroppers to add and subtract colors from the selection. The Fuzziness slider near the top of the dialog box determines how close a color must be to those through which you dragged to be included in the selection.

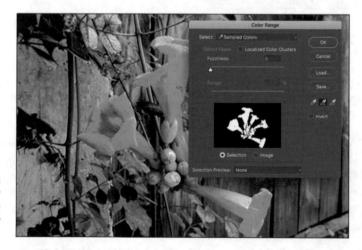

The Color Range feature selects by color.

Here are a couple of ways that you can get a better look at your selection as you create it. In Figure 7–13, you see the options available from the Selection Preview menu. The Grayscale (upper left) and Black Matte (upper right) do a good job of showing that the background will be partially selected if you click OK. You can lower the Fuzziness or use the eyedropper on the right to click in those areas of the fence behind the blooms that shouldn't be selected. The White Matte (lower left) does an excellent job of showing that the tips of some leaves below the blooms will also be selected. (Ignore that and Option+drag/Alt+drag with the Lasso tool later to deselect that area.) Because of the color of this image's subject, the red Quick Mask preview (lower right) is almost worthless for this image, although it is often good with other images that don't have red and orange.

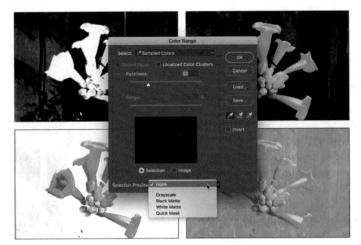

FIGURE 7-13:
Color Range
offers four
ways to
preview —
five, if you
include None.

The Localized Color Clusters option looks for distinct areas of the selected color and tightens up edges along those "clusters" of color. When your target color appears distinctly in different areas of the image, this option is a plus. When selecting a range of color with subtle transitions, deselect this option. (Think "leopard's spots" compared to "blue sky.")

When the Localized Color Clusters option is active, Color Range also offers Detect Faces. If you have people in the image that you want to select, Detect Faces does a rather good job of identifying them. You'll still need to Shift+drag through the rest of the person to make the selection, but faces are a good starting point. And don't overlook the Skin Tones option in the Select menu — it's a great way to start selecting flesh tones in an image.

Also available only when the Localized Color Clusters option is active, the Range slider determines how far from the point where you clicked in the image Color Range should look for similar colors. When set to 100%, Color Range looks at the entire image for similar colors. If you want to restrict the area in which you want to create a selection, you can reduce that value.

The Focus Area command

The Focus Area command is useful primarily when the subject of the shot is in focus and the background of the image is out focus. It offers the same View options as Color Range, as well as the Hand and Zoom tools and a pair of brushusing tools to add to or subtract from the initial selection. The In-Focus Range slider enables you to define what is "in focus." (Don't overlook the Auto box.) The Advanced section includes only an Image Noise Level slider. (Why isn't this with In-Focus Range instead of being hidden in a separate section? I don't know.) You also have the various Output To options found in Color Range. The Soften Edge

option slightly feathers the selection, but you have no control over it. If you want a feathered edge, click OK and use the Feather command.

The Select Subject command

NEW

Great for selecting the subject of a portrait, this command works even better than you might guess. Picking out a person from a background shot in a studio or against a green screen shouldn't be too tough, should it? You'll find that this command does a very nice job with a variety of images — even with subjects that aren't (quite) human. In Figure 7-14 you see, from the upper-left: an easy selection of a subject against a rather monochrome background; a selection of a subject against a complex background; a selection where part of the subject is a close match to the background; and a selection of a, shall we say, "nontraditional" subject. (I've highlighted the selection edges in red for clarity.) The Subject selection command does a very nice job with them all! I will note, however, that this is a one-step procedure, with no variables for you to adjust prior to making the selection. You may need to enter Select and Mask afterward to fine-tune the selection.

FIGURE 7-14: Selecting subjects is now a one-step feature in Photoshop.

The Select ⇔ Sky command

This one-step command (again, no variables or you to tweak prior to making the selection) is, for all practical purposes, part of the Sky Replacement feature (described in Chapter 8). After all, the first step in replacing a sky is to select it. You might choose this command rather than Sky Replacement if the existing sky is good and just needs a tweak. It does a fine job with tough skies, such as a cloudy sky that touches a watery horizon.

Selection modification commands

The next group of commands in the Select menu includes a menu path to the Select and Mask feature, as well as five separate Modify commands (shown in Figure 7–11), each of which has a single numeric field.

The Border option creates a selection of your specified width, centered on the original marching ants visible in the image window. It's great for creating borders or vignettes and can also be used to delete pixels along a selection edge to neaten it up. The other four commands are poor cousins to the control you have in the Select and Mask dialog box — none of them offers a slider or a preview. However, if you know exactly how many pixels you need to smooth or expand or contract or feather, these commands are quick and simple. (How do you know? That knowledge comes only with experience.)

As you make your way down the Select menu, you come across the Grow and Similar commands, which are somewhat like the Magic Wand with Contiguous (Grow) and without Contiguous (Similar) selected on the Options bar. (In fact, they use the Magic Wand's Tolerance setting.) Grow adds to your selection any adjacent pixels of the appropriate color, and Similar looks throughout the entire image for similarly colored pixels. Use Grow and Similar when your initial selection consists primarily of a single color. Using these commands with a selection that contains lots of different colors generally results in most of your image being selected.

Transforming the shape of selections

As you work with selections, you might find times when the selection features don't match your need. For example, the Elliptical Marquee tool can certainly make oval selections, but those ovals are either vertical or horizontal. What if you need an oval selection at an angle? That's where the Select Transform Selection command comes into play. Make your initial selection, choose the Transform Selection command, and then manipulate the selection to fit your needs, as shown in Figure 7-15.

The many faces of selection transformations.

Here's what you see in Figure 7-15:

- >> Top left: This is the original selection.
- >> Top center: Shift+click an anchor point on any side of the bounding box and drag to change the height or width of the selection.
- >> Top right: Position the cursor outside the bounding box and drag to rotate. The selection is rotated around the crosshair, located by default in the middle of the selection. Before rotating, you can drag that crosshair anywhere, even outside the selection's bounding box. If you don't see the crosshair, click the box at the left end of the Options bar to show the reference point. You can also click any of the boxes on the sides and corners of the box immediately to the right to jump the crosshair to that position in the selection.
- >> Middle left: Drag any corner anchor point to manipulate the selection's width and height at the same time.

- **>> Middle center:** Hold down the Shift key while dragging a corner anchor point to avoid distorting the selection while changing size.
- >> Middle right: Hold down the Option/Alt key while dragging a corner anchor point, and you end up scaling the image based on that crosshair in the center of the bounding box. (You can drag that crosshair anywhere, even outside the bounding box, to change the point of transformation.) You can use the Shift key with Option/Alt, too.
- >>> Bottom left: Hold down the ## /Ctrl key and drag any side anchor point to skew.
- >>> **Bottom center:** Hold down the 第 /Ctrl key and drag a corner anchor point to distort.
- **>> Bottom right:** If you ℜ /Ctrl+drag two or four corner anchor points, you can add perspective to the selection. I might, for example, fill this transformed selection with color, move the selection, scale it down a bit, fill again, and repeat a number of times to create a series of paw prints marching into the distance.

Edit in Quick Mask mode

With Photoshop's Quick Mask mode, you make a basic selection, enter Quick Mask mode (by choosing Select Edit in Quick Mask Mode, clicking the button second from the bottom of the Toolbox, or by pressing Q on the keyboard), edit the selection as if it were a mask, and then exit Quick Mask mode (by deselecting this command in the Select menu, by clicking again on the button in the Toolbox, or by pressing Q again). Heck, you don't even have to start with a selection! In Quick Mask mode, your mask appears onscreen as a red overlay, just like the red overlay for Refine Edge or Color Range (as you can see in Figure 7-13 at the bottom of the dialog box). Paint, apply filters or adjustments, or make selections — anything you can do to a grayscale image, you can do in Quick Mask mode. (The following sections go into further details on working in masks.)

TIP

If you're more comfortable with the Brush tool than the Lasso tool, you might want to use Quick Mask mode to make all your selections. You might find it faster and easier to "paint" a selection in Quick Mask mode rather than to drag a selection with a lasso tool or use the selection commands. Enter Quick Mask mode, paint the mask, exit Quick Mask mode, and you have your selection. You can also enter and exit Quick Mask mode by clicking the button near the bottom of the Toolbox. Double-clicking the button opens the Quick Mask Options dialog box (as shown in Figure 7–16). You can reverse the behavior of the overlay, making it show selected areas instead of the deselected areas, and you can change the color and opacity of the overlay. (Hop back to Figure 7–13 to see how hard it is to see

the edges of the orange blooms with the red overlay. Changing the overlay to, say, blue would solve that problem.)

By default, you paint with black in Quick Mask mode over areas that you don't want selected, paint with white over areas that you do want selected, and paint with shades of gray over areas that you want partially selected.

Quick Mask Options Color Indicates: Masked Areas Selected Areas Color Opacity: 50 %

FIGURE 7-16:

You can change the opacity and color of the Quick Mask overlay.

The mask-related selection commands

Near the bottom of the Select menu (just above the New 3D Extrusion command, which has nothing to do with selections), you see a pair of commands that you use to store your selections for future use and to actually reuse them. When you save a selection, you create an alpha channel in the image. The *alpha channel*, like a color channel, is a grayscale representation of the image. White areas in the alpha channel represent areas that are selected when the channel is loaded as a selection. Black areas in the channel show you deselected areas. Gray represents feathering and other partially selected pixels.

I discuss channels in greater depth in the next section of this chapter. While you're exploring selection commands, the key points to remember are that you can use the Save Selection command to save any selection as an alpha channel, and then later you can use the Load Selection command to reactivate the selection without having to re-create it from scratch.

Masks: Not Just for Halloween Anymore

In Photoshop, a *mask* is a channel (in the Channels panel) that stores information about a selection or about layer visibility (or that can be used with certain filters as a *bump map*, a grayscale representation of 3D in the image). When you talk about selections saved as masks, you can refer to them as *alpha channels*. Any time you make a complex selection, consider saving it as an alpha channel, just in case. So what exactly counts as *complex*? That depends on how much time you have on your hands. If it takes me more than a minute or two to do *anything* in Photoshop, I want to save it. And what counts as *just in case*? You might need to return to the image at some later date to make changes, you might need to shut down for the day, or maybe you'll even (fingers crossed against!) have a crash. Save your selections, just in case . . .

Saving and loading selections

Creating an alpha channel from a selection is as simple as choosing Select \Leftrightarrow Save Selection and selecting a name for the new channel. If you have more than one document of exactly the same pixel dimensions open in Photoshop, you can select any of the available documents for the new channel. If you already saved a selection as an alpha channel, you can elect to have the two selections interact in a single channel.

When you need to work with a saved selection, choose Select ⇔ Load Selection or simply ૠ+click/Ctrl+click the alpha channel's thumbnail in the Channels panel — both will activate the selection. As you see in Figure 7-17, when loading a selection, you can add to, subtract from, or intersect with an active selection. You can also invert a selection when loading by selecting the Invert check box. Using that check box produces the same result as loading the selection and choosing Select ❖ Inverse, but it's faster and easier.

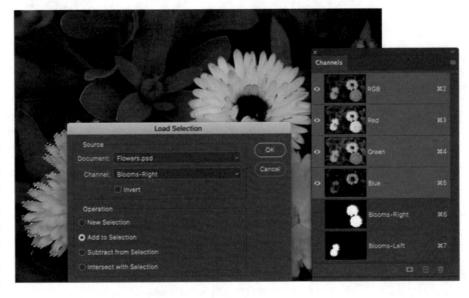

FIGURE 7-17:
When you already have an active selection, an alpha channel can replace, add to, subtract from, or interact with it.

Editing an alpha channel

Alpha channels, like color channels, are grayscale representations. As such, you can edit them like you would any grayscale image. Click the channel in the Channels panel to make it active and visible. You see it in the image window as a grayscale (or black and white) representation of the saved selection. If you want to see the image while you work on the channel, click in the left column (the eyeball column) to the left of the RGB (or CMYK) channel. The alpha channel then appears as

a red overlay on top of the image, just like working in Quick Mask mode or using the red overlay in Select and Mask or Color Range. Figure 7-18 shows you what the screen looks like with just the alpha channel visible (left) and how it appears when the alpha channel is active and the RGB channel is also visible. Also take a look at the difference in the Channels panel. See the eyeball column on the left?

FIGURE 7-18: You can see just the alpha channel itself (left) or as a red overlay (right).

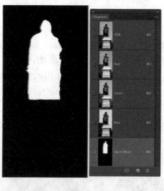

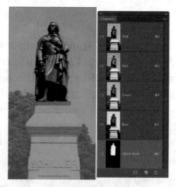

Here are some of the things that you might want to do to an active alpha channel:

- >>> Blur the alpha channel. Blurring an alpha channel (using your favorite of the Filter

 □>→ Blur commands) is much like feathering a selection it softens the edges. One of the big differences is that you can see a preview of the blur, which is much better than guessing how much feathering you need while dragging a selection tool.
- >>> Sharpen the alpha channel. Sharpening a saved selection (Filter ▷ Sharpen command) makes the edges cleaner and more precise.
- >> Paint in the alpha channel. Painting with the Brush tool using black, white, and gray in the channel changes the selection. Paint with white to add areas to the saved selection; paint with black to remove areas from the selection; paint with shades of gray to partially select areas of the image. You can edit an alpha channel with the Brush tool very precisely, adding and eliminating stray pixels, as well as creating precise edges.
- >> Use Levels or Curves on the alpha channel. If the saved selection has feathering or other areas of partial selection (grays in the alpha channel), you can manipulate them with a Levels or Curves adjustment (from the Image
 □ Adjustments menu). The Levels adjustment is particularly appropriate for controlling the feathering along an edge.
- Apply one or more filters to an alpha channel. Use artistic filters on a saved selection to create special effects, such as borders and frames. Chapter 14 covers filters.

Adding masks to layers and Smart Objects

When your image has multiple layers (as I discuss in Chapter 9), including Smart Objects, you can partially hide the content of the layer or Smart Object with *layer masks*. Layer masks and alpha channels have much in common: Layer masks are selections saved as channels; you can paint in the layer mask, you can apply filters and adjustments to the layer mask, and so on. Just keep in mind that a layer mask appears in the Channels panel only when you select its layer in the Layers panel. (In the Layers panel, you'll see the layer mask thumbnail to the left of the layer's name.) If you want to edit a layer mask, click its thumbnail in the Layers panel (or the channel name in the Channels panel) and then edit it as you would an alpha channel or choose Select \hookrightarrow Select and Mask to edit the mask as you would edit a selection with Select and Mask. Remember to click the layer thumbnail afterward to reactivate the layer itself.

The easiest way to add a layer mask is to make a selection of the pixels that you want visible on that layer and then click the Add Layer Mask button at the bottom of the Layers panel (third button from the left). You can also make a selection and choose Layer \Leftrightarrow Layer Mask \Leftrightarrow Reveal Selection or Layer \Leftrightarrow Layer Mask \Leftrightarrow Hide Selection. That menu also offers Reveal All and Hide All as well as commands to disable (hide) or delete the layer mask. You can also apply the layer mask, which deletes any hidden pixels on that layer.

By default, the layer mask is *linked* to the layer or Smart Object. If you drag the layer in the Layers panel, the mask comes right along, staying in alignment. If you like, you can unlink the mask from the layer content by clicking the Link icon between the two thumbnails in the Layers panel. Re-link the mask to the layer content by clicking in the empty space between the thumbnails.

If the image's Background layer is active in the Layers panel and you want to add a layer mask, simply make the selection and click the Add Layer Mask button. The Background layer is automatically converted to a regular layer.

Masking with vector paths

A layer or Smart Object can also be masked with a vector path. (Paths are explained in Chapter 10.) Vector masks can have very precise edges, and you can edit them as a path with the Direct Selection tool. A layer can have both a regular pixel-based layer mask and a vector mask. To show up in your artwork, pixels on that layer must be within both the layer mask and the vector mask. When a layer has both a layer mask and a vector mask, the vector mask thumbnail appears to the right in the Layers panel.

Adjustment Layers: Controlling Changes

Photoshop gives you the capability of making tonal and color adjustments that you can later refine, change, or delete. Most of the adjustment commands (discussed in Chapter 5) are available as *adjustment layers*. An adjustment layer applies the selected change to color or tonality just as the comparable command would, but using an adjustment layer offers a few major advantages:

- >> Adjustable adjustments: You can reopen an adjustment layer's options in the Properties panel at any time to change the settings.
- >> Reversible adjustments: You can delete an adjustment layer, removing the change from your image.
- **>> Hidden adjustments:** Click the eyeball column to the left of the adjustment layer in the Layers panel to temporarily hide that change.
- >> Tweakable adjustments: You can change the opacity and blending mode of adjustment layers to fine-tune the effect.
- >> Limitable adjustments: You can add layer masks and vector masks to your adjustment layers to restrict their effect to only some of the pixels below. And you can later edit the masks as necessary.

Because of the added flexibility, you'll generally want to use adjustment layers rather than adjustment commands in your images. Of course, you still need the Image Adjustments menu for those several commands that can't be added through an adjustment layer.

Adding an adjustment layer

Photoshop uses the Adjustments and Properties panels (shown in Figure 7–19) as a quick and easy way to add adjustment layers to your images. Open the panel, select a preset or, for a custom adjustment, click the button for the type of adjustment layer you want to add. The Properties panel changes to a small version of that particular adjustment's dialog box, presenting you with the same options you have when using the Image \Rightarrow Adjustments menu.

When an adjustment layer is selected in the Layers panel, several buttons appear at the bottom of the Properties panel (to the right in Figure 7-19):

>> Clip the adjustment layer to the layer immediately below: Click the button to toggle between the adjustment layer being applied to only the one layer immediately below in the Layers panel and it being applied to all layers below. (Clipping adjustment layers is explained more completely in the next section.)

FIGURE 7-19:
To the left, the Adjustments panel; to the right, a Curves adjustment layer being added to the image using the Properties panel.

- >> Review previous adjustment: Click and hold down the mouse button to see the image as adjusted prior to returning to the adjustment layer. Say, for example, that you have added a Curves adjustment layer and later return to the Adjustments panel to tweak the curve a bit. To see the difference between the current appearance of the image and the appearance of the image with the original Curves adjustment, use this button. If you prefer the untweaked version, use the Undo command.
- >> Reset adjustment: Click the curled arrow button toward the right to reset the current adjustment to the adjustment's default settings.
- >> Toggle adjustment layer visibility: Click the eyeball button to hide the current adjustment layer; click again to show it. Use this button to preview the adjustment as you work.
- >> Delete adjustment layer: Click the Trash icon to the far right at the bottom of the Adjustment panel to delete the current adjustment layer.

You can also add an adjustment layer through the menu at the bottom of the Layers panel (click the fourth button from the left) and then move the cursor to the type of adjustment layer that you want to add, and also through the Layer New Adjustment Layer submenu. The choices are the same. When you select the particular adjustment that you want to add from the bottom of the Layers panel, that specific adjustment's options appear in the Properties panel. (Selecting the adjustment through the Layers menu presents you with the New Layer dialog box first.)

The top three options in the menu that you open from the bottom of the Layers panel are *fill layers* — layers completely filled with a color, gradient, or pattern. You can add a new empty layer and choose Edit r Fill to do the same thing, or you can add such a layer through the Layer r New Fill Layer menu. (Note that these three options are not available through the Adjustment panel.)

Limiting your adjustments

When your image has multiple layers and you want to apply an adjustment layer to only one layer, the new adjustment layer must be clipped — restricted to the one layer immediately below it in the Layers panel. (That's the layer that's active when you add the adjustment layer.) You can clip it to the layer below by Option+clicking/Alt+clicking the line between the two layers in the Layers panel (which is also how you unclip a pair of layers). Figure 7-20 shows the difference between a clipped adjustment layer (left) and an unclipped adjustment layer (right). When unclipped, the adjustment is applied to all the layers below rather than to the one layer immediately below. When adding an adjustment layer through the Layers menu, select the Use Previous Layer to Create Clipping Mask option.

Restrict an adjustment to one layer by clipping it to the layer.

On the left side of Figure 7–19, the Hue/Saturation adjustment is applied only to the upper layer — the layer named Symbol. On the right, the adjustment layer isn't clipped, so it changes both the Symbol layer and the Background layer. By the way, the thumbnail in the Layers panel shows the Symbol layer's original copper color prior to the addition of the Hue/Saturation adjustment layer. Among the beauties of using adjustment layers is the joy you might feel when the client says, "Yup, you were right — let's go back to the original design."

TIF

But what if you want an adjustment layer to change, say, three of the layers in your image? Create a layer group from the layers (click the New Group button at the bottom of the Layers panel and drag the layers into the Group icon in the panel), add the adjustment layer within the group and above the layers in the group, and change the layer group's blending mode from Pass Through to Normal at the top of the Layers panel. The adjustment layer, within the layer group and at the top of the layer group, is applied to all your layers in the group and only the layers in that group.

Because they're layers, you can use a layer mask to apply the adjustment layer to only part of your layer. You may find it easier to make a selection of the area where you want the adjustment before selecting the adjustment layer — the mask will be automatically created from the selection.

Chapter 8

Common Problems and Their Cures

ometimes you take perfect photos of imperfect people, and sometimes you take imperfect photos of, well, imperfect people. (Even the top models benefit from a little Photoshopping.) Although capturing absolute reality is the goal of some artists and most photojournalists, the people in your photos probably prefer to look as good as you (and Photoshop) can make them look.

In this chapter, I present you with some basic techniques for curing many of the most common problems that you encounter as a photographer. I show you how to remove that spooky *red-eye* effect that appears when your camera's flash reflects off the blood vessels in the back of a subject's eyes. I also show you tricks for removing wrinkles, whitening teeth, and tightening waistlines. Digital *noise* (those distracting red, green, and blue pixels scattered in your image's shadows) is easy to minimize when you use the tricks here. I cover how to remove some larger problems from images using the almost-magical Content-Aware Fill and show you how to work with Puppet Warp. At the end of the chapter, you learn how to fix problems with perspective, rotation, and barrel distortion in photos, as well as Photoshop's new one-stop-shop for adding beautiful skies to outdoor shots. Throughout this chapter, I use real-world examples — the types of photos with which you're most likely to work. (After all, you probably don't get to shoot beautiful models *all* the time.)

Making People Prettier

You can do lots of things in Photoshop to improve your images, but few are appreciated as much as fixing a person's photographed flaws (the appearance kind, not their bad habits). Whether it's a studio portrait or a snapshot, the people in your images generally can benefit from a little touching up.

Although you can theoretically make almost anyone look truly beautiful and glamorous using Photoshop, remember to balance *improving* with *reality*. Always work on a copy of your image. I also recommend saving separate copies at different stages during the editing process. The client might say that he wants the braces removed from his teeth, but after you present the finished product, he might just (gasp!) change his mind.

Getting the red out . . . digitally

When a subject looks directly into the camera and the camera-mounted flash fires, the result is often red-eye. This result is caused when light (such as a flash) bounces off the blood vessels at the back of an eye, and it gives the subject a spooky vampire look. Among the many ways to minimize this problem is with the Red Eye tool, nested in the Toolbox with the healing and patch tools. Zoom in and drag a small rectangle over the iris and pupil to watch the red disappear, leaving the natural highlights and a perfect eye. As you see to the right in Figure 8-1, the default settings are good for typical cases of red-eye.

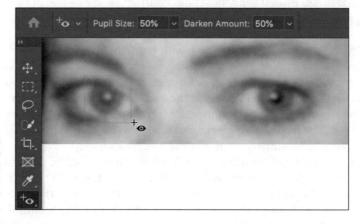

FIGURE 8-1:
To the left, the
Red Eye tool
being dragged;
to the right, the
result.

The Red Eye tool finds red and not green. For *green-eye* (in photos of animals), for too-bright white reflections from eyes, and for those times when you're not happy with the performance of the Red Eye tool, you can use the Camera Raw

filter. The Red Eye Removal tool in the Camera Raw filter offers Pet Eye, as shown in Figure 8–2. You can also use the Brush tool to remove red-eye or green-eye problems. Set the foreground color to black; on the Options bar, select the Normal blending mode and an Opacity of about 75%. Use a brush diameter just slightly larger than the pupil and a brush hardness of about 85%. Click once and evaluate the result; if necessary, reduce the Opacity to 20% and click again.

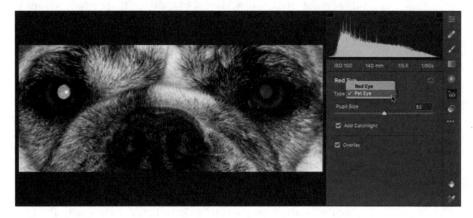

FIGURE 8-2: The Camera Raw filter offers Pet Eye removal.

Here's one more red-eye/green-eye trick: Use the Sponge tool to desaturate, followed by the Burn tool (Midtones, 25% exposure). The Sponge tool is nested in the Toolbox with the Dodge and Burn tools.

The digital fountain of youth

In Chapter 5, I show an example of using the Dodge tool to fade wrinkles without removing them completely. Photoshop, being a complex and capable animal, has lots of other ways to minimize or eliminate wrinkles. Among the most powerful tools for this job are the Healing Brush, the Spot Healing Brush (especially with the Content-Aware option), the Patch tool (also with the Content-Aware option), and the Clone Stamp.

Both the Healing Brush and the Patch tool work by copying texture from one area to another. You can, for example, overlay smooth skin texture onto a wrinkled area, smoothing the wrinkles while retaining the area's general tonality and color. To work with the Healing Brush, Option+click (Mac)/Alt+click (Windows) the area from which you want to copy texture, and then click and drag over the area that you're fixing. When you select the Aligned option from the Options bar, you maintain the relationship between the point from which you're healing and the area over which you drag. No matter where you move the cursor, the source point retains the same distance and direction. When repairing areas of a face,

however, you might find it easier to deselect the Aligned check box. Every time you release the mouse button, you start over from the same source point. By using short strokes, you can heal from the same source area to any area of your image.

The Spot Healing Brush works much like the Healing Brush to repair and replace texture. However, instead of designating a source point by Option+clicking/Alt+clicking, the Spot Healing Brush samples from the immediate surrounding area, which makes it perfect for repairing little irregularities in an area of rather consistent texture. The Content-Aware option for the Spot Healing Brush makes it a "smart" tool — it looks at the surrounding area and tries to replicate both the texture and the content.

To work with the Patch tool, make a selection with the Patch tool (or with any of Photoshop's selection features) and then drag with the Patch tool. Depending on which option you select from the Options bar, you can either select and drag the damaged area to a good area (select Source from the Options bar), or you can select a good area and drag to the damaged area (select Destination). You can use both the Healing Brush and the Patch tool to apply a predefined pattern, too. That can be handy for adding a texture where one doesn't already exist in your image.

Like the Healing Brush, you Option+click/Alt+click with the Clone Stamp to set the area from which you're copying and then paint over an area to make a change. The Healing Brush copies texture, but the Clone Stamp copies pixels, completely replacing the area over which you drag. (That is, of course, subject to the blending mode and opacity that you select from the Options bar.) Like the Healing Brush, the Clone Stamp offers the Aligned option. Outside the eye in Figure 8–3 shows a comparison of wrinkle reduction using the Clone Stamp (set to Normal and 100% Opacity) and using the Healing Brush. (If you use the Clone Stamp to repair skin, reduce the opacity and make sure to select a source area that has similar skin color and lighting.) Also on the Clone Stamp's Options bar, you have the choice of working on the active layer (ignoring pixels on other layers), working on the active layer and the layer immediately below (which you'll choose when you add an empty layer to hold your cloned pixels), or using all layers in the image (helpful in layered images with areas of transparency and adjustment layers).

Dieting digitally

You can certainly use the Clone Stamp tool to reduce a bit of a bulge at the waistline or below an upper arm, but you might find it easier (and more natural-looking) to make a selection and rotate the outer edge inward a bit. Take a look at Figure 8-4. Although this subject hardly has what you'd call a "spare tire," that bit of extra sticking out above her skirt isn't particularly flattering. Make a selection with the Lasso tool that includes some of the background and some skin (or shirt or dress). Copy the selection to a new layer with $\Re +J/\operatorname{Ctrl} +J$. Press $\Re +T/\operatorname{Ctrl} +T$ to enter Free

Transform (or choose Edit ❖ Transform ❖ Rotate). Drag the *point of rotation* (the little crosshair symbol in the middle of the bounding box) to the top of the bounding box, and then position the cursor slightly outside the bounding box and drag to rotate. When you're satisfied, press Return/Enter to accept the transformation and merge the layers with ૠ+E/Ctrl+E. (With complex backgrounds, you might need to do a little cloning to even things out.)

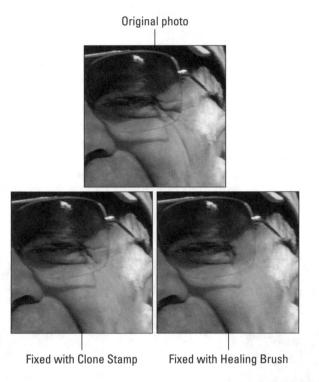

FIGURE 8-3:
The Clone
Stamp (lower
left) covers
wrinkles,
whereas the
Healing Brush
(lower right)
melts them
away.

When working with double chins, your best bet is usually to minimize rather than eliminate. Putting a skinny neck under a fleshy face looks unnatural. You can certainly tuck in the sides of the second chin a bit by using the rotate method, but rely on the Burn tool to darken. By darkening the excess flesh under the chin, you make it appear to be in shadow —

FIGURE 8-4:Rotate a selection to pinch in a waist.

and, therefore, under the actual chin. (See Figure 8-5.) Use the Dodge tool or the Clone Stamp (if necessary) to hide any creases or wrinkles associated with the excess chin. When redefining a jaw line and chin remember that the result must not only look natural, it needs to be acceptable to the client.

TIP

When working with the Burn and Dodge tools, don't forget to reduce the Exposure setting on the Options bar — 15% to 20% is plenty strong for this type of work. You'll also want to juggle between Highlights and Midtones (the Range setting on the Options bar) when creating an artificial shadow on a double chin with the Burn tool. Zoom in when doing

FIGURE 8-5: Burning and dodging can reduce even a very prominent double chin.

this sort of work, but also open a second window via Window \Leftrightarrow Arrange \Leftrightarrow New Window for [filename] to keep an eye on the overall impact of your changes.

You can use the Filter Diquify feature to push, pull, twist, pucker, bloat, and otherwise manipulate pixels into the shape and position you need. There's really nothing more powerful when it comes to reconfiguring a figure. In Figure 8-6, you see how leveling off a beltline with Liquify is sometimes all that's needed to restore that trim-man-she-married look. And a little touch-up with the Healing Brush or Dodge and Burn tools can eliminate the wrinkles in the shirt, helping improve the overall appearance of the image by reducing distraction. (Chapter 14 has full info on using Liquify.)

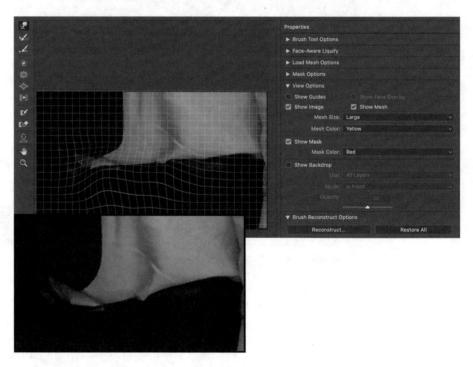

FIGURE 8-6: The original beltline is shown to the lower left.

De-glaring glasses

Although hindsight is usually 20/20, many people need spectacles. Unfortunately, those eyeglasses can be a photographer's nightmare! The reflections off glass are usually *specular highlights* — that is, areas of pure white with absolutely no detail in them. To properly evaluate flash reflections in eyeglasses, open the Info panel and move the cursor through the area. If you see a noticeable variation among the RGB values in the Info panel, you might be able to restore the area with the Burn tool.

If the Info panel shows RGB values of 255/255/255 or close to it, the area has no detail. Zoom in close and use the Clone Stamp tool to copy over the area from another part of the image. In severe cases of glare, you might need to copy from another photo of the same person. When possible (say, in a portrait sitting), try to take one shot of the subject without eyeglasses, just in case.

Whitening teeth

Teeth generally aren't truly white (unless somebody has spent a lot of time and money getting ready for a portfolio shoot). Instead, you see shades of ivory and yellow in teeth, but they don't necessarily have to be unattractive or distracting shades of yellow. The Sponge tool is great for desaturating teeth, moving them from yellow to gray. Use the Dodge tool to lighten teeth. From the Options bar, set the tool to Midtones (not Highlights) and an Exposure of perhaps 30% for front teeth. Paint over each tooth individually, making sure that you don't eliminate the shadows that differentiate the individual teeth. Then switch to Shadows and lighten those molars visible in back. Don't overdo it — remember that folks who don't

make their living in Hollywood or on TV generally don't have snow-white teeth. Figure 8-7 shows normal people teeth, "improved" normal people teeth, and Hollywood teeth. Balance your judgment with the client's needs.

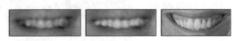

FIGURE 8-7:
Coffee and caps; Dodge tool digital correction; show-biz-white teeth.

Reducing Noise in Your Images

The move from the darkroom to digital may have saved you thousands of dollars in film and processing costs (not to mention a reduction in possible environmental pollution), but has added a new set of challenges to the art and business of photography. Perhaps foremost among the problems presented by digital photography is *noise*. Those pesky red, green, and blue (or light and dark) specks in an image can ruin a digital photo. Noise is generally most prominent in shadow areas and against dark colors in your images.

The higher the ISO setting on your camera, the more digital noise it will record. Use the lowest ISO setting that's suitable for the environment in which you're shooting. When you *must* use a high ISO (low light, moving subject), be prepared for digital noise. Using a tripod can also help keep the problem to a minimum.

Decreasing digital noise

If you shoot Raw, reduce noise in Camera Raw, as described in Chapter 6. If you shoot JPEG, apply Camera Raw as a filter or use the Reduce Noise filter (under the Filter \Leftrightarrow Noise menu). As you see in Figure 8-8, Reduce Noise does a very good job of neutralizing the random red, green, and blue pixels while preserving detail in the image.

FIGURE 8-8:
The Reduce
Noise filter
keeps your
image
sharp while
eliminating
RGB noise,
which is visible
in the original
image to
the left.

Notice that Reduce Noise also offers a Remove JPEG Artifact option. When saving in the JPEG file format, you compromise between image quality and smaller file size. The smaller the file, the greater the likelihood of compression damage to your image. That damage generally shows itself as visible lines between blocks of pixels measuring eight pixels square.

You'll also find the Color Replacement tool very handy for noise reduction, especially in areas of rather uniform color. Option+click/Alt+click right in the area to set the foreground color; then simply paint away the digital noise. As you move from area to area in your image, Option+click/Alt+click to pick up a new foreground color.

Eliminating luminance noise

In addition to the red, green, and blue specks of digital noise, you might face *luminance noise*, the bright and dark specks sprinkled throughout your photo. Under the Filter \Leftrightarrow Noise menu, you can find the Despeckle command. No dialog box appears and you have no options to choose from. You simply run the filter two or three times. For more challenging noise, try Photoshop's Blur \Leftrightarrow Smart Blur filter or work with the Camera Raw filter. (If Smart Blur is grayed out in the Filter \Leftrightarrow Blur menu, convert the image to 8-bit color through the Image \Leftrightarrow Mode menu.) For supreme control over blurring, Smart Blur even lets you enter fractions for both the Radius and Threshold values (as shown in Figure 8-9).

FIGURE 8-9:
The Smart
Blur filter is a
good choice
for luminance
noise
reduction,
which is visible
in the original
image, to

Fooling Around with Mother Nature

Sometimes a very nice photo has something in it that you want gone . . . a piece of litter, telephone lines in the distance, or perhaps a building that distracts from the composition. Other times, everything in the image is fine, but the image looks wrong because of the angle at which it was taken, or you want to change the angle of something *in* the photo. Photoshop offers you quite a variety of tools and techniques for cutting out, copying over, cleaning up, and even correcting perspective.

Removing the unwanted from photos

Perhaps the easiest way to remove something from an image is to *crop* the photo, that is, cut off that part of the picture as explained in Chapter 4. This technique

is easy enough if that piece of litter or whatever happens to be at the edge of the image and cropping won't ruin your composition. (Of course, picking up that piece of litter and disposing of it prior to taking the photo is the best solution.) When you must cover up rather than crop out, consider the very powerful Content-Aware option for Edit \Leftrightarrow Fill.

Content-Aware Fill analyzes the pixels within a selection and compares them to pixels elsewhere in the image, and then re-creates the area within the selection. (Making selections to isolate part of an image is discussed in Chapter 7.) In Figure 8-10, the waterfall within the selection is both natural and normal. However, it does visually water down (pun intended!) the message of "Motion: Horizontal and Vertical." With a single waterfall, the single railroad train is better balanced.

FIGURE 8-10: The original photo (left); using Content-Aware Fill in the selected area (right).

When you're not satisfied with Content-Aware Fill, undo and try changing the size of the selection, perhaps including a bit more (or less) of the surrounding image. You can also use the Clone Stamp tool to do some touching up after using Content-Aware Fill.

If Content-Aware Fill is picking up areas of the image that aren't appropriate for the fix, try this:

TIF

1. Make a selection of the area you want to remove.

Generally speaking, you'll use the Lasso tool, but any selection tool or command can be used.

2. Hold down the Shift key and select the pixels you want to use to replace the problem area.

The Shift key adds the new selection to the existing selection. This selection should include an area of "good" pixels that's somewhat larger than the area of "bad" pixels you want to replace.

3. Copy to a new layer.

Use the keyboard shortcut $\Re +J/Ctrl+J$ to put the selected pixels on their own layer.

4. Reselect the problem area.

This can be a very loose selection, including some of the transparent pixels around the problem area. Select only the problem area, not the pixels you want to use for the repair.

5. Choose Edit ⇔ Fill with the Content-Aware option.

Only the unselected pixels on the new layer will be used to replace the problem area.

You can also move something in your image to a new location to create a new look in the shot. As shown in Figure 8-11, copy the entire image, reposition it, use a layer mask to hide parts of the upper layer, and clone to remove anything not needed on the exposed areas of the lower layer. In Figure 8-11, the background layer is copied and moved upward (after using the Image 🖒 Canvas Size command to expand the canvas), and a layer mask hides everything except the boy, his racket, and the ball. On the lower layer, the boy is cloned out. (The look of surprise from the guy in the red hat in the background is simply a fortuitous coincidence that seems to add credibility to the adjusted image.)

The Edit ➡ Puppet Warp feature, like Liquify (presented in Chapter 14), enables you to very easily produce complex distortions in an image. Here's the workflow I recommend for most jobs using Puppet Warp:

1. Make a selection of the area of the image you want to alter.

You can use whatever selection technique works best for the part of the image that needs to be selected — Lasso tool, Color Range command, or any of the selection tools and techniques described in Chapter 7.

2. Copy to a new layer.

Use the keyboard shortcut $\Re + J/Ctrl + J$ to put the selected pixels on their own layer.

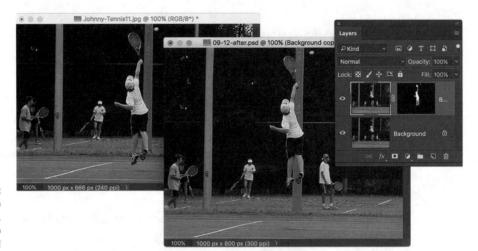

FIGURE 8-11:
One small step
for Photoshop,
one giant leap
for mankind!

3. Remove the selected pixels from the lower layer.

Hide the upper layer by clicking the eyeball icon to the left of the layer name in the Layers panel. Click the lower layer in the panel to make it the active layer. Clone or copy/paste or use Content-Aware Fill over the selected pixels using the techniques in the preceding section. (This stage of the workflow is shown to the upper right, next to the original shot, in Figure 8-12.)

4. Make the upper layer visible and active.

Click in the eyeball column to the left of the upper layer's name to make the layer visible, and then click the layer name or thumbnail to make the layer active.

5. Activate the Puppet Warp feature.

Choose Edit ➪ Puppet Warp.

6. Set pins.

Click in two or more places along the axis that you want to change to set anchor points known as *pins*. If you're manipulating an arm, you would generally place pins at the shoulder, elbow, and wrist. When manipulating a leg, place pins at the hip, knee, and ankle.

7. Select your options.

On the Options bar, choose a mode. Normal is usually appropriate, Distort enables you to change perspective while dragging pins, and Rigid helps maintain special relationships. You can also change the density of the now-visible mesh and use the Expansion slider and field to expand or contract the content within the mesh.

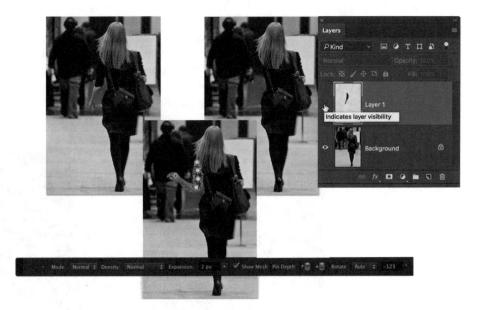

FIGURE 8-12:
The original in
the upper left;
layered and
cloned in the
upper-right;
Puppet
Warping and
the left part
of the Options
bar below.

8. Drag the pins and accept the warp.

Click a pin to make it the active pin; drag as desired. You can switch among pins as often as necessary, and you can remove a pin by clicking it and pressing Delete/Backspace. To the right on the Options bar, you'll see three buttons that remove all pins, cancel Puppet Warp, and accept the transformation. When you're happy with the new look of your "puppet," click that third button or press the Return/Enter key.

Eliminating the lean: Fixing perspective

When you take a photograph at an angle, perhaps shooting upward at a building, you get *foreshortening* (also called *keystoning*), with the upper part of the subject shrinking into the distance. If you shoot Raw, you can work with the Camera Raw Transform tool (see Chapter 6). If you shoot on a recent-model high-end DSLR, Camera Raw may show a custom profile created for your camera/lens combination to correct many lens-related vagaries. You can use the buttons and sliders below to fine-tune the adjustment if necessary. Generally speaking, if you want to work with Camera Raw, you do so before opening the image in Photoshop. However, you may find it convenient to use Camera Raw as a filter (perhaps as a Smart Filter with a Smart Object so that the adjustments can later be readjusted).

With JPEG images, as an alternative to using Camera Raw as a filter, Photoshop's Filter 🖒 Lens Correction does a great job of fixing perspective. If Photoshop can determine the make and model of your camera and lens, the Auto tab may have a great correction. If not, in the Custom panel of Lens Correction, drag the Vertical

Perspective slider to the left to correct images shot from below, or to the right for shots from above. In Lens Correction, as shown in Figure 8-13, you can also adjust horizontal perspective, barrel distortion (when the center of the image bulges out), pin cushioning (when the center of the image bulges in), and chromatic aberration (blue/yellow or red/cyan fringing along edges), as well as add a vignette.

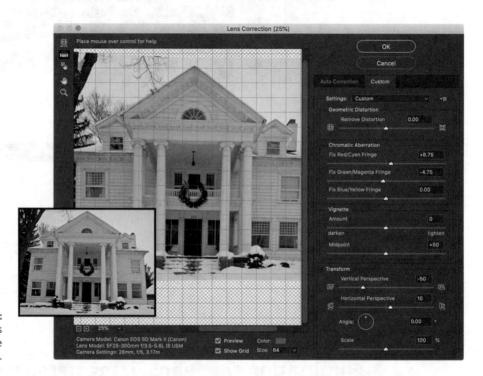

FIGURE 8-13: The original is shown to the lower left.

TIP

Before entering Lens Correction, double-click the layer named Background in the Layers panel and rename the layer or click the Lock icon to the right of the layer name. Use Image Canvas Size to add some empty area all around the image. That way, you won't chop off any of the photo when dragging the perspective sliders. Notice in Figure 8-13 that a generous amount of extra canvas was added, which can easily be cropped off after correcting perspective.

You can also use Photoshop's Edit r? Transform r? Perspective command, but that usually produces some foreshortening of the image, requiring you to scale it upward a bit afterward. The Perspective Crop tool (nested in the Toolbox with the Crop tool) can also fix perspective. For best results, position the four corners of the bounding box on visible corners of something in the image that should be rectangular or square; drag the side handles outward to expand the bounding box to encompass your image. Press Return/Enter when you're done.

Also found in the Filter menu is Adaptive Wide Angle, another way to compensate for vagaries of specific wide-angle and fisheye lenses. When Lens Correction's Remove Distortion slider isn't enough to correct barrel distortion, try Adaptive Wide Angle. If the camera model and lens information can be read from the image's metadata (it will be shown in the lower-left corner), the Auto adjustment is applied. When the camera and/or lens is unknown, you can choose from the other adjustment options (shown in Figure 8-14), which you use to manually adjust the image.

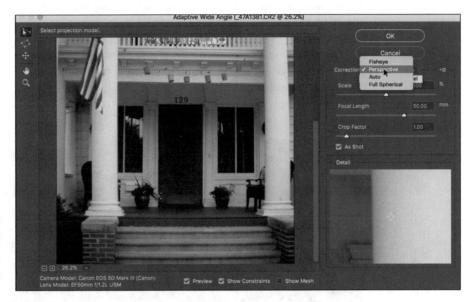

Adaptive
Wide Angle is
another filter
for adjusting
photos.

Rotating images precisely

While it's certainly possible to rotate an image while working with the Crop tool and the Lens Correction filter, you have another, very precise option. With the Crop tool selected, try the Straighten button. Click the button, then in the image window, click and hold down the mouse button (or trackpad or whatever you're using) and drag a line along something in the image that should be vertical or horizontal.

Adding a beautiful sky

NEW

Photoshop now makes it simple to replace a drab, cloudy sky with a brilliant blue sky including puffy white clouds. Or perhaps do the opposite. It's really, truly a piece of cake now to swap out a sky. Open the image by choosing Edit Sky Replacement (shown in Figure 8–15), select the new sky, fiddle with a few sliders (if necessary), and click OK. You have the option to output to a duplicate layer or, as I usually choose to do, output to new layers. Outputting to new layers creates a layer group, which enables you to adjust the layer mask created in by Sky Replacement, and perhaps adjust the foreground lighting or color.

Sky Replacement comes with its own set of various skies (several of which are visible in Figure 8–15). You can also use your own skies by clicking the Plus button below the default set. You might even create your own sets of skies to use over and over again!

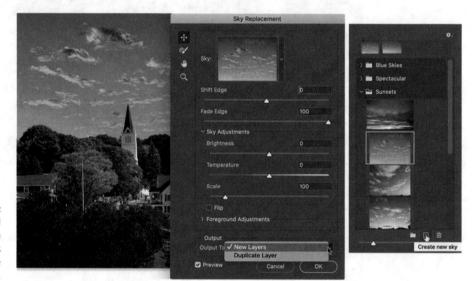

FIGURE 8-15: The original image, with a cloudy sky, is shown to the lower left.

TIP

One final thought for this chapter: When you come across an image that requires more fixing than you have time for, or one with such severe luminance noise that smoothing removes too much detail, or just a problem photo in general, make sure that the image is in 8-bit mode (check the Edit Mode menu), and head for the Filter Gallery. It's amazing how many flaws you can hide with a few artistic effects. Creating an artistic rendering of an image is often preferable to deleting a lousy photo. Blur away the noise and add a canvas texture with the Texturizer filter. Blown out highlights? Try the Colored Pencil filter. (Read more about the Filter Gallery in Chapter 14.) When faced with lemons, think of the Filter Gallery as your own personal lemonade stand.

Creating "Art" in Photoshop

IN THIS PART . . .

Combine images or parts of images to create composites and complex imagery.

Move beyond pixels and start adding vector shapes to your artwork.

Get control over the individual paths and anchor points in your vector shapes.

Add layer styles, including bevels and drop shadows, to your layers.

Tap out your message with Photoshop's powerful type capabilities.

Bring out your inner Picasso or Rembrandt with Photoshop's powerful painting tools.

Understand the concept of filters, and see which ones you'll use regularly and which ones probably not at all.

Take a walk through the filter galleries for some outstanding creative opportunities.

- » Integrating with blending modes and opacity
- » Masking for complex selection problems
- » Keeping it in perspective with Vanishing Point
- » Creating panoramas with Photomerge

Chapter 9

Combining Images

pharaoh's head on a lion's body. A lion with the head, talons, and wings of an eagle. As evidenced by the sphinx and the mythological griffin, compositing elements has been around a lot longer than Photoshop, but Photoshop certainly makes it easier! Take part of one image, drop it onto another image, and sell the composite to the tabloids for thousands of dollars. (One of the most infamous misuses of image compositing occurred during the 2004 U.S. presidential campaign, with the publication of a fake photo of candidate John Kerry with actress and antiwar activist Jane Fonda. That incident pretty much shut the door on this sort of Photoshop hijinks in major media.) Photoshop offers you incredible power — use it wisely!

In this chapter, I show you some basic techniques for *compositing* (combining two or more images into a single picture), how to use channels to select part of an image for compositing, the Vanishing Point feature, and then wrap up the chapter with a look at combining images automatically to create panoramas.

Compositing Images: 1 + 1 = 1

You make a selection in one image, copy, switch to another image, and paste. There you have it — the basic composite! Pretty simple, isn't it? Whether you're putting together two images or creating complex artwork involving dozens of elements, the trick is making the composited image look natural. The key techniques are blending the edges of your selections and matching color among the elements.

Understanding layers

When you put together images, you work with *layers*. Think of layers in Photoshop as stackable elements, each of which holds part of your image. Where an upper layer is transparent, the lower layer or layers show through. Where the upper layer has pixels that aren't transparent, those pixels either block or interact with pixels on the lower layer. (You control that interaction with blending modes and opacity, explained later in this chapter.)

Take a look at Figure 9-1 (which reveals how Figure 12-3 is created). The Layers panel shows the individual layers and their content. The individual elements come together to create a single image.

FIGURE 9-1: Elements on different layers form a single image.

You can manipulate the content of each layer independently — moving, resizing, erasing, painting, or adjusting color and tonality — to suit your needs and artistic vision. Remember to click a layer in the Layers panel to make that layer active for editing. The Move tool's Options bar offers the option Auto-Select: Layer (and Auto-Select: Group), which enables you to make a layer (or group) active by clicking any visible pixels on that layer (or in that group).

You can *link* two or more layers so that they maintain their positions relative to each other as you move them. (光/Ctrl+click to select the layers in the Layers pane) click the Link button at the bottom of the Layers panel — a Link symto the right of linked layers when active in the Layers panel.) Linked moved together without knocking them out of alignment.

in the Layers panel, known as the *eyeball column* (for an obvious u to hide a layer, making the content of the layer invisible. The e; they're just not visible. Click the eyeball icon to hide the layer mpty space in the left column to make the layer visible again. w adjustment layers, too, which lets you see their impact on t adjustment layers in Chapter 7.)

nu at the top of the Layers panel (which shows Kind by n layers — perhaps only the type layers or adjustment also isolate layers by selecting one or more layers ing from the filtering menu at the top-right of the ect Isolate Layers. Only the isolated layer(s) are n be edited. To restore all the layers, deselect Isovitch the filtering menu back to Kind, or right-Remove from Isolation. You can also choose ire content of the Layers panel.

the order of layers in the panel from the top down), the it will be. The layers Clouds-Dark and Clouds-Light are on top of every mg in the image. The layer Man is in front of everything except the clouds. Because of the stacking order, the man appears to be standing on top of the musical notes, and the notes appear to be on top of the CD.

You can also create *groups*, which are two or more layers packaged together in the Layers panel so that you can show or hide them together. As you can see in the Layers panel in Figure 9–1, you can have *nested groups*: a group within a group. The group named Background Items includes another group, named Sun, as well as several layers that aren't part of the Sun subgroup.

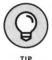

Video layers can also be added to your projects, but generally speaking, you're more likely to add regular pixel layers, type layers, shapes, and adjustment layers to a video project than to add video layers to another sort of project. Working with video is discussed in Chapter 16.

Why you should use Smart Objects

Smart Objects provide you with additional flexibility in Photoshop. When working with Smart Objects, you preserve your editing options without risk to the image quality. For example, you can transform a Smart Object as often as you like because each time you rotate or scale or otherwise manipulate a Smart Object, Photoshop goes back to the original pixels and resamples again. This prevents the sort of image degradation — especially loss of fine detail — in the image you would see if you were to shrink, enlarge, or rotate a regular layer's content numerous times.

When working with Smart Objects, you can apply a filter to a selection in Photoshop and then later go back and change the filter settings or even remove the filter entirely. But this feature is available only when you're working with Smart Objects. Again, it goes back to Photoshop's ability to return to the original source pixels when working with Smart Objects. (Filters are discussed in Chapter 14.) In the Layers panel, Smart Filters very much resemble layer styles: You can click an eyeball icon to temporarily hide a filter's effect, and you can double-click the filter name to reopen the dialog box so that you can make changes. (See Figure 9-2.)

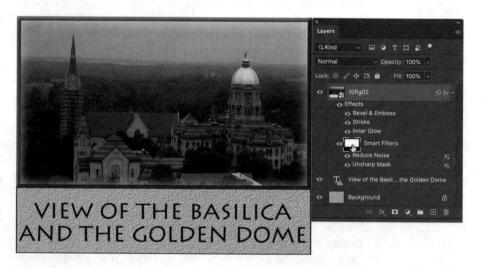

FIGURE 9-2: Filters applied to the Smart Object are listed under Smart Filters.

If you want to apply a Smart Filter to only a section of a Smart Object, make a selection before selecting the filter. In keeping with the whole concept of "smart,"

the filter is applied to the entire Smart Object but the filter's visibility is controlled with a mask. (A filter mask is visible to the left of the words Smart Filter in the Layers panel in Figure 9–2.) And, of course, you can — at any time — paint in the mask with black, white, and shades of gray to alter where the filter is visible. (Painting in masks is discussed later in this chapter.) Note, too, that a Smart Object can have both Smart Filters and a layer style.

When you choose File \Rightarrow Place Embedded or Place Linked, a Smart Object is automatically created. To create a Smart Object from an existing layer (even a Background layer), choose Layer \Rightarrow Smart Objects \Rightarrow Convert to Smart Object. When you choose Place Embedded, a copy of the placed image is added to your working document. When you choose Place Linked, the file itself is not added to your document; only a line of info in the document's metadata noting the location of the placed image.

If you link a placed document and later move it on your drive or to another drive or change its name, the link is broken and when you reopen the document into which you placed the image, it can't be found. Also keep in mind that if you send the document to another person you'll need to include the linked file. While embedding a placed image increases the size of the working document, it can avoid all sorts of problems that can arise from linking a placed document.

When working with Raw images, click the arrow to the right of Camera Raw's Open button to select Open as Object. If you want Open Object to be the default, click the line of image info below the preview to open Workflow Options. That's also where you specify the default color profile and bit depth of images opened through Camera Raw.

Using the basic blending modes

The pop-up menu near the upper-left corner of the Layers panel offers more than two dozen different *blending modes*. (The menu shows "Normal" by default.) A layer's blending mode determines how the pixels on that layer interact with the visible pixels on the layers below.

Because a layer named Background can't have any layers below it, you can't change the blending mode of background layers. Convert a background layer to a regular layer by clicking the Lock icon to the right of the layer name.

In Figure 9-3, the black-white and rainbow strips of gradients overlaid on the garden photo below each use the blending mode shown by the text outline. (You can see the original gradients in the Normal stripe.) Normal, Multiply, Screen, Overlay, and Luminosity are the blending modes you're most likely to use regularly.

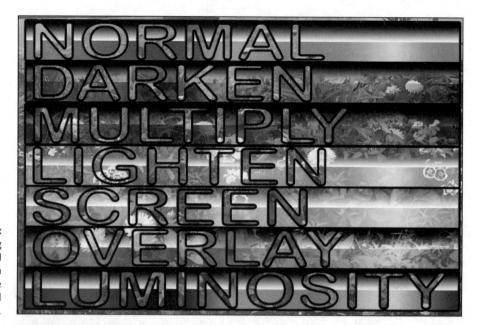

FIGURE 9-3:
Blending modes control the interaction between the gradients and the photo.

When working with layer blending modes, always keep in mind that you can use the Layers panel's Opacity and Fill sliders to help determine the layer's visibility and appearance. The Opacity slider controls the visibility of the layer's content and any layer style applied to the layer. The Fill slider controls the visibility of the layer content without hiding any layer style. For a practical example of the difference between the two sliders, take a look at the section "Opacity, fill, and advanced blending" in Chapter 11.

The Layers panel blending mode pop-up menu is divided into six sections, based loosely on how the pixels on the upper layer affect the pixels on the lower layer. Here's a quick look at how you use the key layer-blending modes:

- >> Normal: Photoshop picks Normal by default. Pixels on the upper layer completely hide the pixels on the lower layers (subject, of course, to the Opacity and the Fill settings). Use Normal to show the content of the layer without any interaction with lower layers.
- >> Multiply: The Multiply blending mode darkens where your upper layer is dark and ignores white. Use Multiply when you want the upper layer to darken but not obscure the lower layer and also for shadows and dark glow effects.
- >> Screen: The Screen blending mode the opposite of Multiply uses lighter pixels to lighten the pixels below. Use it for highlights and light-colored glows.
- >> Overlay: Overlay works like a combination of Multiply and Screen. Use it when you're working with an upper layer that includes both dark and light pixels that you want to interact with pixels on layers below.

- >> Soft Light: Soft Light is a subtle blending mode. Like Overlay, where your upper layer's pixels are dark, the lower layer is darkened; where they're light, the lower layer is lightened. Soft Light is like adding a diffused spotlight to the lower layer useful for adding a little drama to the lower layer.
- >> Hard Light: The Hard Light blending mode is much like a more vivid version of Soft Light. Use it to add a *lot* more drama to the lower layer. Hard Light works well with colors that aren't overwhelmingly bright.
- >> Difference: Where the upper layer (using the Difference blending mode) and the lower layer are exactly the same, you see black. Where the two layers are different, you see brightness or color. For example, use Difference (temporarily) when trying to align two overlapping photos. Set the upper layer to Difference, move the upper layer until the areas of overlap show black, and then switch the upper layer's blending mode back to Normal.
- >>> Color: When the upper layer is set to Color, the lower layer's brightness and saturation are retained, and the upper layer's color is used. If you want to create a color picture from a grayscale picture, convert the image to RGB (choose Image ♣ Mode ♣ RGB), add a new layer, change the upper layer's blending mode to Color, and paint on the upper layer (as shown in Figure 9-4).
- >>> Luminosity: When the upper layer is set to Luminosity, the color and saturation of the lower layer are retained, and the brightness (luminosity) of the upper layer is applied. Because the luminosity (dark and light) generally provides texture, use this blending mode to produce detail in the lower layer.

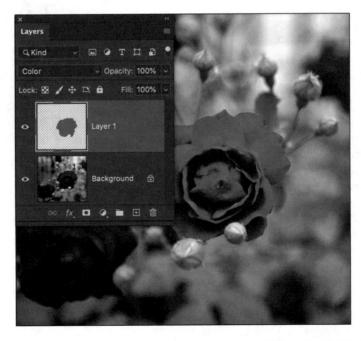

FIGURE 9-4: Paint on a layer set to Color to retain the detail of the layer below.

Photoshop also offers two pairs of blending modes that you might find useful, but confusing. Lighten and Lighter Color compare a pixel on the upper layer to the pixel immediately below to determine the resulting color. Lighten chooses the higher (brighter) value in each of the RGB color channels and produces a new color based on those three independent lightness values. Lighter Color, on the other hand, looks at the color on the upper layer created by all three channels, compares it to the color on the lower layer, and makes visible whichever of those two colors is lighter overall. The Darken and Darker Color blending modes work similarly, but choose the darker values.

For a look at the rest of Photoshop's dozens of blending modes, see the appendix.

Opacity, transparency, and layer masks

Blending modes help determine how pixels on an upper layer interact with pixels on a lower layer, but those upper pixels have to be *visible* before they can do any interacting at all. When looking at any pixel on a layer, you have to consider four factors about transparency:

- >> Whether the pixel has any color to start with
- >> The Opacity value
- >> The Fill value
- >>> Whether there's a layer mask

When you add a layer and paint on it, for example, you color some of the pixels yet leave other pixels transparent. (Every layer in every image is completely filled with pixels, whether visible or not.) If nothing is done to color some pixels, they remain transparent, and the lower layers can be seen through that part of your upper layer. In Figure 9-5, the words *upper layer* are on a separate layer above the layer containing the words *LOWER LAYER*. Where the upper layer has transparent pixels, the lower layer shows through.

FIGURE 9-5: Where you see the lower layer, the upper layer is transparent.

A layer named Background in the Layers panel can't have transparent pixels. Simply click the Lock icon to the right of the layer name to convert it to a regular layer.

Lowering the Opacity or the Fill slider in the Layers panel (or the Layer Style dialog box) makes all visible pixels on the layer partially transparent: The pixels on layers below can be seen through the upper layer's pixels. (The Opacity slider controls the pixels on the layer and any layer style; the Fill slider works only on the pixels, not the layer style.)

For a "glass text" effect, useful for adding your copyright info over an image you don't want others to use, add the type, add a narrow stroke layer effect and perhaps a drop shadow, and then reduce the Fill slider to zero. Flip ahead to Chapter 11 for an example (specifically, Figure 11–20).

Chapter 7 discusses layer masks and vector masks. Remember that any pixel inside the mask is at least partially visible, and any pixel outside the mask is transparent, regardless of whether it has color. But, as you can guess, any completely transparent pixels inside the mask remain completely transparent.

Creating clipping groups

This being Photoshop, here is yet another way to restrict the visibility of pixels on an upper layer: clipping groups. *Clipping* an upper layer to the layer below, in effect, creates a mask for the upper layer. The opacity of the pixels on the lower layer is applied to the pixels on your upper layer. Where the lower layer is transparent, the upper layer (regardless of original content) becomes transparent. In the Layers panel, Option+click (Mac)/Alt+click (Windows) the line between two layers to clip the upper layer to the lower. When you hold down the Option/Alt key, the cursor turns into the icon shown between the two layers in Figure 9–6.

After you Option+click/Alt+click the line between Layer 1 and the type layer, the upper layer is visible only within the text on the lower layer. The upper layer is indented to the right in the Layers panel, with a downward-pointing arrow to let you know that it's clipped to the layer below. Note that the upper layer's thumbnail in the Layers panel shows the entire layer, not just the visible area. To unclip a layer, Option+click/Alt+click again on the line between the two layers in the Layers panel. Also note in Figure 9-6 that the layer style is applied to the lower layer rather than the upper layer.

Photoshop lets you show the layer thumbnails in two ways. Normally, the entire layer, including all areas of transparency, shows in the thumbnail. Although that gives you a good indication of how large or small the particular layer's content is in the image, layers with little content have little to show in the thumbnail.

By using the Panel Options (from the Layers panel menu) or Control+clicking/right-clicking the empty area below the layers in the panel, you can elect to show a thumbnail that includes only nontransparent areas of the layer. Little things fill the thumbnail, but they also appear out of proportion to the other thumbnails. Your choice.

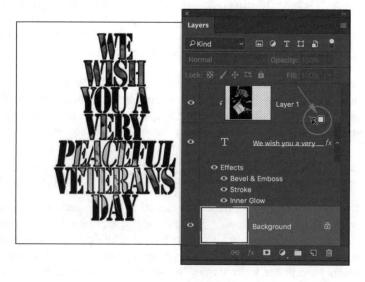

FIGURE 9-6:
Option+click
or Alt+click the
line between
two layers to
clip the upper
to the lower.

Making composited elements look natural

One of the keys to compositing two images is a slight fade to the edges of the element you're adding to the original image. That fade, called *feathering*, makes the edges of the image appear to fall off into the distance very slightly rather than having a sharply defined edge that sticks out like a sore thumb. (See Chapter 7 for full information on feathering.) You have a number of ways to feather a selection, including the following:

- >> Use the Feathering field on the Options bar before you use a selection tool.
- >> Choose Select 🖒 Modify 🖒 Feather after you make a selection.

>> Use one of Photoshop's Blur filters on a saved selection's alpha channel in the Layers panel (or on a layer mask).

Matching color between two layers is also critical for a natural appearance. Take a look at Chapter 5 for full information on Match Color and Photoshop's other color adjustment capabilities.

You also need to be aware of *perspective* and *scale*. When an element in your composited image seems to be too large or too small or when it seems to be facing the wrong way or standing on air, rely on the Edit Transform commands. Although the Scale and Rotate commands are self-explanatory, Figure 9-7 shows visually how you can use the other Transform commands, such as Skew, Perspective, and Warp. Drag the bounding box anchor points to transform the selected pixels.

The Edit 🕏 Transform 🕏 Warp command adds a simple mesh over the content of the layer or selection. You click and drag the direction lines for the corners of the mesh and at the intersection of mesh lines to distort your artwork. As you see in Figure 9–8, the Warp distortion gives you

a level of control second only to Photoshop's Liquify feature (discussed in Chapter 14). You can also use Warp with paths and vector shapes.

FIGURE 9-7: Drag anchor points to transform.

Making Complex Selections

In order to combine elements from separate images into a single piece of artwork, you sometimes need to make very complex selections. Photoshop can automate some of the tasks for you, including the often-difficult process of isolating a person from a

FIGURE 9-8:Use the Warp transformation to distort layers or selections.

background. In the Select menu, you find Subject and Focus Area. The Select □ Subject command simply tries to identify the subject of the image and make a selection around it. It's fully automated; you have no control over the process.

Focus Area looks for the sharpest part of the image (the part of the image that's most in focus) and creates a selection. In the dialog box, you have a slider to fine-tune what's considered to be in focus, a variety of different ways to preview the selection, and the choice of how the selection is output when you click the OK button.

Your output options include:

- >> Create a selection or mask.
- >> Place the selected pixels on a new layer or a layer with a mask.
- >> Create a new document with or without a mask on the new document's layer.
- After making your Output to decision, you can click the Select and Mask button to jump to that feature for some fine-tuning.

When Photoshop can't do the job automatically, making complex selections is often best done with an alpha channel, which can then be made into an active selection with the aptly named Select Doad Selection command. Among the alpha channel creation techniques available to you are

- >> Save a selection: If you already have a selection, perhaps created with the Lasso tool, Select ▷ Subject, or Select ▷ Color Range, you can choose Select ▷ Save Selection to create an alpha channel. This saved selection can then be edited as necessary by painting, or it can be combined with another selection or additional alpha channels.
- >> Duplicate a quick mask: Press Q to enter Quick Mask mode, paint your quick mask (as described in Chapter 7), and then before exiting Quick Mask mode drag the Quick Mask channel to the New Channel button at the bottom of the Channels panel to duplicate it.
- >> Paint from scratch: Click the New Channel button at the bottom of the Channels panel, and paint with black, white, and shades of gray. White will be included in the selection, black will be excluded from the selection, and gray indicates partial selection.
- >> Duplicate an existing channel as the basis for a mask: You can also examine the color channels to see which provides the best contrast between the subject and the background, drag that channel to the New Channel button, and then adjust the duplicate channel.

Duplicating a color channel is often the most effective way to extract a complex subject from a complex background. Here's one way to approach the task:

1. Examine each channel individually to see which offers the most contrast between subject and background.

Open the Channels panel and click each color channel, one at a time, to see which presents the best contrast between the edges of the subject and the surrounding background.

Don't forget that you have 10 color channels — that's right, 10 channels — from which to choose! In addition to the Red, Green, and Blue channels in your image, you can choose Image \hookrightarrow Duplicate and then convert the copy to CMYK or Lab mode. One of the CMYK channels often offers much better contrast between subject and background than do the RGB channels. In Lab mode, the a and b channels are also worth a try. And after creating your alpha channel, you don't even need to switch back to RGB mode.

2. Duplicate the selected channel.

Drag the color channel of your choice to the New Channel button at the bottom of the Channels panel to create an alpha channel from it.

3. Maximize the contrast between subject and background.

Ideally, you'll end up with a subject that's completely white and a background that's completely black. (If your alpha channel shows a dark subject and a light background, simply press $\Re + |/\text{Ctr}| + |$ or choose Image \rightleftharpoons Adjustments \rightleftharpoons Invert.) Generally speaking, the first place to start maximizing the contrast is Levels. Drag the end sliders way in under the middle of the histogram, and then adjust the middle slider. After clicking OK, you may want to use Levels again. After Levels has done most of the work, grab the Brush tool and clean up any additional areas, painting directly in the channel with black and white.

4. Load the channel as a selection.

If you duplicated the image and used one of the CMYK or Lab channels to create the mask, click the original RGB image to make it the active window. (If you used one of the RGB channels, you only have the one version open.) Choose Select ➡ Load Selection. You can load an alpha channel from any open document of exactly the same pixel dimensions.

As you adjust your duplicated channel, pay attention only to the edge between the subject and background. Don't worry about areas away from the edge — those are easy to clean up with the Brush. It's that narrow band that separates the subject and background that's critical.

FIGURE 9-9: Duplicating a color channel is often the fastest way to a great alpha channel.

When working with Raw images, you have another option available. After making the subject look great in Camera Raw, click Open Image to open the image into Photoshop, and then save it as <code>.psd</code> or a <code>.tif</code> file. Reopen the original Raw image back into Camera Raw. This time, maximize the differences between the edges of the subject and background in the Basic and Color Mixer panels — without regard for how ugly the image becomes. Click the arrow to the right of Open and select the Open Copy button (which opens the new copy without overwriting your earlier Camera Raw adjustments). Select a color channel, duplicate the channel, and create your alpha channel as described in the preceding section.

Vanishing Point

When combining images to create a scene, you might find a need to add texture or a pattern along what is supposed to be a three-dimensional object. You might, for example, add a product box to a photo of a kitchen and need to add a logo to the

front of the box. Or maybe you will create a room, perhaps in a house high on a hill, and you'll need to add a realistic brick texture to the walls. Use the Vanishing Point feature to "map" a pattern to angled surfaces, such as walls, floors, buildings, and boxes. Vanishing Point, using information that you provide, automatically determines the correct angle, scale, and perspective. You can also use the Brush tool to paint in perspective in Vanishing Point. (Vanishing Point is rather complex, so for simple jobs, you might want to stick with the Paste and Edit
Transform commands.)

To use Vanishing Point, you follow a specific sequence of steps:

1. Copy your pattern.

Open whatever pattern file (or texture or logo or whatever) you're going to add to the walls or sides in your image, make a selection, and then choose Edit Copy. You can now close the pattern file.

2. Make a selection in your working image.

Identify where you want the pattern to be applied. If you're working with walls, for example, make a selection that includes the walls but doesn't include windows and doors.

3. Open Vanishing Point (choose Filter ➪ Vanishing Point).

The Vanishing Point window opens, displaying your image.

4. Create planes on your image in the Vanishing Point window:

- Select the Create Plane tool (the second tool from the top on the left edge of the window).
- b. Click in your image where you want to place the three corners of your plane and then move the cursor to the fourth corner.

You see the plane extending along the last two sides.

c. Click the fourth corner to create the plane.

If the plane is yellow or red rather than blue, it's not aligned properly. Drag the corners of the plane to realign them, using the Edit Plane tool (the top tool on the left). Drag the side anchor points outward to expand the plane's mesh to cover the whole wall or side.

d. Create perpendicular planes by holding down the ℜ /Ctrl key and dragging the side anchor point at the point where the two planes should meet. If the second plane should be at an angle other than 90 degrees to the first plane, Option+drag/Alt+drag one of the anchor points to rotate the grid.

If the second plane's angle is off a little, drag one of the corner anchor points to adjust it. In Figure 9-10, you see two perpendicular planes.

FIGURE 9-10: Use the Create Planes tool to identify surfaces.

5. Paste your pattern.

- a. Press 第 +V/Ctrl+V to paste your pattern into Vanishing Point.
 Your pattern is pasted into the upper-left corner of the Vanishing Point window.
- b. Select the Marquee tool (third from the top) and drag the pattern into your plane.

The pattern automatically adopts the orientation of the plane. If necessary, click the Transform tool (or press T on your keyboard) and then rotate and scale the pattern.

6. Replicate the pattern.

Unless your pattern is an exact fit, you need to replicate it to fill the plane. With the Marquee tool selected, hold down the Option/Alt key. Then click and drag in your pattern to replicate it. Repeat as necessary to fill the plane. As you see in Figure 9-11, you can replicate a relatively small pattern to fill a large area.

TIP

If the lighting in your original image varies, set the Healing pop-up menu (at the top of the window, only with the Marquee tool active) to Luminance. That helps maintain the original lighting on the new pattern or texture.

Click OK to exit Vanishing Point and apply the pattern or texture to your image.

After exiting Vanishing Point, you might need to do some touch-up work on your image with the Clone Stamp tool (depending on how precise you were when dragging). You might also, depending on the original image, need to add a layer and paint some shadows or highlights to reproduce the original lighting in the scene.

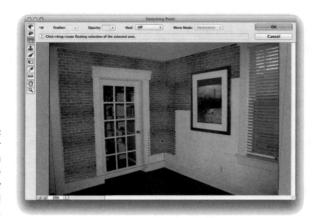

FIGURE 9-11:
Option+drag or
Alt+drag with
the Marquee
tool to copy
your pasted
selection.

In Figure 9–11, the pasted and replicated brick pattern doesn't cover the door, window, or artwork because they were not selected prior to opening Vanishing Point. Without that active selection when opening Vanishing Point, it would have been much more difficult to properly align the pattern without covering those areas.

Here are some tips for working with Vanishing Point:

- >> Create accurate planes; then drag. Click in four corners of any identifiable area of your plane perhaps a window and drag the side anchor points outward (or inward) to identify the whole plane.
- >>> Press the X key to zoom. Pressing and holding the X key on your keyboard makes the preview area zoom to show the area where you're working. Release the X key to zoom back out.
- >> Press T to transform. After pasting your pattern, you can press T on your keyboard and then scale and rotate your pasted pattern.
- >> Use the Shift key to drag in alignment. Hold down the Shift key while Option+dragging/Alt+dragging to replicate your pattern. That keeps the new part aligned to the old.
- >> Paste over objects in Vanishing Point. Create your plane. Use the Marquee tool to select an area that you want to replace, and then hold down the # / Ctrl key and drag to an area that you want to paste into the marquee selection.

- >> Clone in Vanishing Point. Define your plane, select the Clone Stamp tool, and Option+click/Alt+click at the source point. Release the Option/Alt key and move the cursor to the point where you want to start cloning. When the preview is properly aligned, click and drag to clone.
- >> Paint in perspective. With a plane identified, the Brush tool in Vanishing Point shrinks or grows in accordance with your perspective plane.
- >> Work on an empty layer. You can add an empty layer in the Layers panel before entering Vanishing Point. Your result is added to the new layer, which lets you work with blending modes and opacity to merge your pattern into the original.

Creating Panoramas with Photomerge

Sometimes a snapshot doesn't adequately portray a scene. (It's hard to capture the majesty of the Grand Canyon in a single frame.) For those situations, take a series of images and combine them into one large panorama with Photomerge (found on the File \Leftrightarrow Automate menu).

The first step in using Photomerge successfully is taking appropriate photos. Here are some tips:

- >> Use a properly leveled tripod. Use a tripod, making sure that the tripod's head is steady and level so the individual photos align properly. If necessary, set the legs to different heights.
- >> Turn off auto-exposure. If you use your camera's auto-exposure feature, each image is actually exposed differently because of the lighting in that frame. Instead, expose for the center (or most important) photo and use the same settings for all shots.
- >>> Don't use auto-focus with zoom lenses. Auto-focus can change the zoom factor of the lens. Instead, set the lens to manual focus after using auto-focus on your most important shot.
- >> Move or rotate the camera. If you have a long panorama to shoot, say an entire city block, you might want to physically move the tripod for each shot. If you want a more typical panorama, you'll leave the tripod in one place and rotate the camera between shots.
- >> Overlap by at least 15 percent. Up to one-quarter of each shot (on each side) should overlap so that Photomerge can properly align neighboring images.

When working with images that are properly exposed and have suitable overlap, Photomerge is fully automated. Open Photomerge, select the images you want to use, select how you want the component images to interact, click OK, sit back, and watch the magic as the elements are put into order, aligned, and blended.

After Photomerge completes its mission, you're left with a layered image that uses layer masks to combine individual photos (one per layer) into a unified whole. Each layer is named for the file from which it was created. Typically, you'll need to crop the image a bit to neaten up the edges and remove any areas of transparency.

At the bottom of the Photomerge dialog box you'll find an option named Content-Aware Fill Transparent Images. If your panorama ends up with some empty areas (perhaps due to camera angle), Photomerge can use Content-Aware Fill to add content to those areas, using the surrounding pixels.

g to a market some read on the six of the six Means of the six of

- » Understanding vector artwork
- » Creating objects with shapes
- » Making a new path
- » Changing the shape of an existing path
- » Editing the shapes of type characters

Chapter **10**

Precision Edges with Vector Paths

ost of the images with which you work in Photoshop — digital photos and scanned artwork, layers on which you paint, and filled selections — are created with pixels. There's also another type of artwork: *vector art*, which you create by defining a *path* (an outline) and adding color within and along that path. That path has a very precise edge, enabling vectors (when printed appropriately) to give you very crisp, clean lines in your artwork.

Typically, vector art consists of specific elements (objects) that are uniform in color (although vector art can also include gradients and patterns). You might have, for example, a red triangle, a blue square, and a green circle as your logo (boring!). These three solid-color objects are best defined as *vector artwork*. Vectors, however, are not appropriate for photographic images and other such imagery that include subtle transitions among colors.

In Photoshop, you have tools that create predefined shapes, you have tools that create freeform shapes, and you have tools to edit the paths that define those shapes. You also have a shape picker and a bunch of menu commands. You can even bring in artwork from Adobe Illustrator and create your own shapes, too. After reading this chapter, you'll have a solid understanding of all these bits and pieces. I even tell you where to find dozens, or even hundreds, of custom shapes already on your computer — absolutely free!

Pixels, Paths, and You

The vast majority of the artwork with which you work (or play) in Photoshop is raster artwork. *Raster imagery* consists of uniformly sized squares of color (*pixels*), placed in rows and columns (the *raster*). Digital photos, scanned images, and just about anything that you put on a layer in Photoshop consists of pixels. When you

edit the image, you're changing the color of the individual pixels, sometimes in subtle ways and sometimes in dramatic ways.

Vector artwork is a horse of another color. Rather than pixels, *vector art* consists of a mathematically defined path to which you add color. In Photoshop, as in Adobe Illustrator, the path produces the shape of the object, and you can add color both along the path (*stroke*) and within the path (*fill*) to make the shape become an object.

Figure 10-1 shows a fine example of vector artwork. Observe that each element in the image consists of a single color. Each section of the image is easily identifiable as an individual object, consisting of a specific color. (Remember, though, that vector objects can be filled with gradients rather than color.)

FIGURE 10-1:

Each element in most vector art has a single specific color.

Each element in the artwork is defined by its path, which consists of a number of path segments. In Figure 10-2, you see the path that defines the tongue. (You read about the anatomy of a path later in this chapter, in the section "Understanding paths.")

You can change the thickness and color of a path. Simply click the Gear button on the Options bar for any shape or other path-creation tool and set the color and thickness you desire to make your path more visible.

When artwork is defined by pixels, the little square corners of the individual pixels can be noticeable along curves and diagonal lines. With vector artwork, the path is sharp and the edges are well defined. However, to truly get the best appearance from vector art or vector type, the artwork must be printed to a PostScript-capable

device, such as a laser printer. *PostScript* is a pagedescription language that takes advantage of the mathematical descriptions of vector art. When you print to an inkjet printer, the vector art is converted to pixels. If you print to such a non-PostScript device, use a high image resolution for best output — 300 pixels per inch (ppi) is usually good. If you know you'll be outputting to a non-PostScript device, before you start creating shapes, go to Photoshop's Preferences

Tools and make sure to select Snap Vector Tools and Transformation to Pixel Grid.

FIGURE 10-2:
Paths define the outline of an object — the snake's tongue, in this case.

A vector path can be *scaled* (changed in size) almost infinitely without losing its appearance. A vector logo can be used for both a business card and a bill-board without loss of quality because the path is

mathematically scaled before the stroke or fill is added. Raster art, on the other hand, can be severely degraded by such scaling. For a simple demonstration of the difference between scaling rasterized text and scaling Photoshop's vector type, see Figure 10–3.

FIGURE 10-3: Using text as an example shows the advantage of vector artwork when scaling. Raster type from 30 to 72 pts

Vector type at 30 pts

Vector type at 30 pts

Vector type at 30 pts

Vector type from 30 to 72 pts

Easy Vectors: Using Shapes

If you made it through the preceding section, you're officially an expert on the theory of vector graphics. It's time to see how you can actually create these little devils in your artwork. The easiest way to create a shape in Photoshop is with the aptly named *shape tools*, which automatically create a vector shape that you can stroke with a solid, dashed, or dotted line, and fill with color, a gradient, or a pattern. Could you have it any easier? Just drag a tool and create a vector-based object!

Your basic shape tools

Rectangles, rectangles with rounded corners (rounded rectangles), circles and ovals, multisided polygons, straight lines and arrows, and a whole boatload of special custom shapes are all at your command with a simple click-drag. Select the appropriate tool in the Toolbox, select the desired options on the Options bar, and click-drag to create your object. (The various shape tools are nested in the Toolbox, as shown in Figure 10-4.) Sounds simple, right? It is — no tricks. Here are some additional features to make things even easier for you:

- (both Mac and Windows) while you drag constrains proportions (maintains the width-to-height ratio). With the Shift key, the Rectangle tool creates squares; the Ellipse tool creates circles; the Polygon tool creates proportional polygons; the Line tool creates horizontal or vertical lines (or lines at 45° angles). When using custom shapes, pressing the Shift key ensures that the shape retains the width-to-height ratio with which it was originally defined.
- >> Use the Option (Mac) or Alt (Windows) key. The Option/Alt key creates the object centered on the point at which you click. Without the Option/Alt key, the object is created in whichever direction you drag.

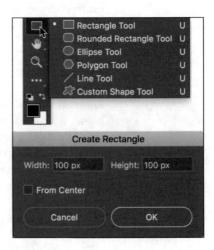

FIGURE 10-4:
The shape tools are collected in one spot in Photoshop's Toolbox.

- >> Use the Shift and Option/Alt key. Pressing Shift and Option/Alt together creates a proportionally constrained object, centered on the point at which you click.
- >> Click the shape tool. If you click rather than drag, you'll open a small dialog box that allows you to enter precise dimensions for your new shape. Click OK and the shape is created to the lower right of (or centered on) the point where you clicked. The dialog box for the Rectangle tool is visible in Figure 10-4.
- >> Use the Properties panel. The Properties panel automatically opens (if it isn't already open) after you create a shape. You can input new dimensions, change the color or the stroke or fill, and even input new coordinates for the object's location in the document.
- >> Check the Options bar. When you switch from shape tool to shape tool, the Options bar changes to fit your needs. For example, with the Rounded

Rectangle tool active, you choose the radius of the rounded corners. The Polygon tool offers a simple field in which you choose the number of sides for the shape. When you're using the Line tool, choose the thickness (weight) of the line on the Options bar. Click the Gear button to the left of the Weight field on the Options bar to add arrowheads to the lines.

- >> Change the layer content. With a shape layer selected in the Layers panel, select any shape tool and change the shape's attributes on the Options bar. You can easily change (or remove) both the fill and the stroke.
- **>> Edit the vector path.** As you can see later in this chapter (in the section "Adding, deleting, and moving anchor points"), you can use the Direct Selection tool to change the course of the path, customizing the appearance of the shape.
- >> Create work paths or pixel-filled shapes. Using the Shape, Path, and Pixels options in the menu to the left on the Options bar, you can elect to create shapes, work paths (temporary paths used to make selections or masks), or add pixels in the selected shape to your currently active layer.

You can easily spot a shape layer in the Layers panel — especially when the default layer name starts with the word *Shape* or *Rectangle* or *Rounded Rectangle* or *Polygon*. (You can, of course, change the layer name by double-clicking it in the Layers panel.) You can see in the Layers panel shown in Figure 10–5 that the shape layer thumbnail includes the shape badge in the lower-right corner. When a shape layer is selected in the Layers panel, that shape's path is visible in the Paths panel.

FIGURE 10-5:
Dragging a shape tool creates both a shape layer and the path that defines the shape.

After adding a rectangle or rounded rectangle shape, you can drag the "dots" within the shape's bounding box to adjust the rounded corners. The Triangle and Polygon shape tools also offer a dot that you can drag to round the points of the shape.

The Custom Shape tool

Although the basic shape tools are great for circles and squares and lines and arrows, you'll probably get the most use out of the Custom Shape tool. With this tool selected, you click the triangle to the right of the sample shape on the Options bar to open the Custom Shape picker, as shown in Figure 10-6. The Custom Shape picker offers a number of ready-to-use shapes, but the current default set is of limited use. (How many pirate ships and leaping deer do you need?)

FIGURE 10-6: The Fill and Stroke options are available for all shape-creation tools.

NEW

Rather than click the Custom Shape picker in the Options bar, go to Photoshop's Window menu and open the Shapes panel. Click the button in the upper-right corner of the panel (see Figure 10-7) and select Legacy Shapes and More. Arrows, picture frames, cartoon talk bubbles, and dozens of other useful shapes will be loaded into both the Shapes panel and the Custom Shape picker.

FIGURE 10-7:
You now import and export custom items, such as shapes (shown here), using the various panel menus.

Note to the far right of the Options bar the check box for Align Edges. Using that option ensures that the edges of your vector shapes align to the pixel grid and print more precisely when using a non-PostScript printer, such as an inkjet printer. (Make sure that this box is selected even if you selected the comparable option in Preferences © Tools.)

More custom shapes — free!

The custom shapes already available in Photoshop cover a wide range, but they might not fill all your needs. You can purchase commercial collections of custom shapes from a couple of sources. You can create custom paths and define shapes from them, too. But you've already got bunches of custom shapes on your computer, just waiting for you to use them. Select Photoshop's Type tool and take a look in your Font menu. Check out the fonts already there with names like Wingdings, Webdings, Symbol, and MT Extra. (Your font list may vary.) These are all examples of symbol fonts, which are fonts that have shapes and symbols rather than letters and numbers. Many more typical fonts also have special characters available when you use the Shift key, the Option/Alt key, and the Shift key in combination with the Option/Alt key.

Here's how you can define a custom shape from a symbol:

1. Choose File New to open a new document.

The document can be virtually any size and can be either grayscale or color.

2. Select the Type tool and pick a font.

With the Type tool active, choose a symbol font from either the Options bar or the Character panel. The font size doesn't matter much because you're creating a vector-based shape that you can easily scale. The foreground color doesn't matter either because shape tools rely on the foreground color active at the time you create the shape.

3. Type a single symbol and then end the editing session.

Click the check mark button to the right on the Options bar, switch tools in the Toolbox, or press # +Return (Mac) or Ctrl+Enter (Windows) to end the editing session. (The symbol visible in Figure 10-8 can be produced by pressing the "V" key when using the Webdings font. By the way, National School Bus Glossy Yellow has been an official color since 1939. The RGB value is 255/216/0 and the Hex Code is FFD800.)

4. Convert the type character to a shape layer.

With the type layer active in the Layers panel, choose Type ♣ Convert to Shape.

5. Define a custom shape.

Choose Edit Define Custom Shape, give your new shape a name in the Shape Name dialog box (shown in Figure 10-8), and save it. Your new shape is added to the Custom Shape picker and the Shapes panel, ready to use.

FIGURE 10-8: Name your new shape and click OK.

Later in this chapter, after you master using the Pen tool, remember this section. You can also define a custom shape from paths that you create with the Pen tool — any shape at all!

Remember that your custom shapes aren't truly saved until you use the Custom Shape picker or Shapes panel menu command Export Shapes. (See Figure 10-7.) Until you take this step, the shapes exist only in Photoshop's Preferences file. If the Preferences become corrupt, you could lose all your custom shapes. This holds true, too, for custom brushes, layer styles, swatches, and the like — use the various panels' Export commands to save all your custom items.

When saving (using a panel's Export command) custom shapes or layer styles or brushes or any of your other custom bits and pieces, save them in a folder outside the Photoshop folder. That prevents accidental loss should you ever need to (gasp!) reinstall Photoshop. When you installed Photoshop, you were offered the option of migrating presets from earlier versions of the program. If you did not do so then, you can add those older presets to Photoshop's new Presets folders by choosing Edit \Rightarrow Presets \Rightarrow Migrate Presets.

Changing the appearance of the shape layer

After you use any one of the numerous shape tools in the Photoshop arsenal to add a shape layer to your artwork, you have a number of ways that you can enhance, adjust, and simply change its appearance:

>>> Add a layer style. Layer styles, such as bevels, glows, and shadows (applied through the Layer ♣> Layer Style menu), can certainly spice up a shape layer. Compare, for example, the pair of shapes in Figure 10-9. (Layer styles are presented in Chapter 11.) By working with blending modes and opacity, you can combine a Gradient Overlay or a Pattern

FIGURE 10-9: A simple layer style makes your shape jump off the page.

Overlay effect with a shape's gradient or pattern (or color) fill.

- >> Change the layer content. As with any shape, you can use a shape tool's Options bar to make changes to fill, stroke, and other custom shape attributes.
- >>> Edit the path shape. Click a path with the Direct Selection tool and drag to change the path's shape. (This is discussed in more detail later in this chapter.)

>> Change the layer blending mode or opacity. By default, your shape layer's blending mode is Normal, and the Opacity is set to 100%. Your shape layer blocks and hides the content of every layer below. By changing the blending mode or opacity, you can make your shape layer interact with the layers below in interesting ways. Experiment with different blending modes to find one that suits your artistic vision. (Blending modes are covered in more detail in Chapter 9.)

Simulating a multicolor shape layer

Shapes can be filled with a single solid color, a gradient, or a pattern. Sometimes, however, you're better served with a multicolor shape. Take a look at Figure 10-10 and compare the pair of shapes to the left with the same shapes to the right.

Pressing up the shapes can make a world of difference.

In addition to the layer styles applied, *layer masks* hide parts of the more elaborate pair of shapes on the right. A layer mask determines what areas of the layer are visible. You can use layer masks with shapes, as you can see for three of the four layers in Figure 10–11.

Comparing the shapes' color in the left thumbnail in the Layers panel to the artwork helps you identify what you see in Figure 10-11:

>> Shape 1 copy: This is the top layer and would normally hide everything on the layers below. The shape, as you can tell from the left thumbnail in the Layers panel, is green. The thumbnail to the right is the layer mask. By painting with black in the layer mask, you can hide parts of the layer. In this case, only the left part of the shape is visible.

FIGURE 10-11: Layer masks determine layer visibility.

- >> Shape 2 copy: You can see that the shape is an entire pair of gray scissors. The thumbnail to the right shows that most of the layer is hidden by a layer mask, leaving only the blades of the scissors shape visible.
- >> Shape 2: This layer requires no layer mask for the artwork. The shape layer just above hides what would be black scissors blades.
- >> Shape 1: The layers above partially hide the red shape layer. Notice how, because of the order of the layers in the Layers panel, the blades of the scissors appear to be in front of the red part of the object and behind the green part of the object.

Adding a layer mask to your shape is as easy as clicking the Add Layer Mask button at the bottom of the Layers panel (third button from the left) and then painting with black to hide, white to show, and gray to partially hide. You can also make a selection in your image and use the Layer 🖒 Layer Mask menu commands. You can add layer masks to any layer except those named Background. (You can't have transparent areas on a background layer, but you can convert it to a regular layer by clicking the Lock icon to the right of the layer name in the Layers panel.)

Using Your Pen Tool to Create Paths

Even with all the custom shapes available, you might need to create a path that's unique to a specific image. For that, Photoshop offers the Pen tool and its associated tools. Before you start creating paths willy-nilly, you can probably benefit from a little bit of background information about paths.

Understanding paths

As you click and click-drag, you place *anchor points*, which connect the *path segments* that create your path. Path segments can be straight or curved. You control those curves not with diet and exercise but rather with *direction lines* and *control points*. A straight path segment is bordered on either end by *corner anchor points*, and a curved path segment is bordered by two *smooth anchor points* or one of each type. As shown in Figure 10–12, Photoshop helps you differentiate between path segments and direction lines by using squares (hollow and filled) for anchor points and round shapes for control points.

Paths have square anchor points and circular control points.

Only smooth anchor points have direction lines and control points. The angle and length of the direction line determine the shape of the curve. When you create a curved path segment between a corner anchor point and a smooth anchor point, only the smooth point's direction lines adjust the curve. When you create a curved path segment between two smooth anchor points, both points' direction lines affect the curve.

Here's another important way to classify paths in Photoshop:

- An open path has two distinct and visible endpoints; think of it as a pencil line or piece of string.
- A closed path has no beginning or end like a circle or an unbroken rubber band.

When you use a shape tool, you're creating closed paths. When you click-click-click with the Pen tool, you create an open path — unless, that is, your final click is back on the very first anchor point.

Clicking and dragging your way down the path of knowledge

All that theory about how paths work is fine, but you'll get a better understanding by playing around with the Pen tool. Open a new document (any size, resolution, and color mode will do) and select the Pen tool. On the Options bar, click the menu to the left (as shown in Figure 10-13) and select Path so that the tool creates work paths rather than shapes, and then start clicking around. Randomly click in various places in the image, adding new straight path segments as you go.

FIGURE 10-13:

Use the menu to the left on the Options bar to determine whether the Pen tool creates a shape or a work path.

The third option in the menu, Pixels, is used only with Shape tools.

I'm sure Picasso would be proud, but it's time to let go of your new artwork and move on — press Delete (Mac) or Backspace (Windows) twice. The first time deletes the most recent anchor point; the second time deletes the rest of the path.

Now, in that same canvas, start click-dragging to create curved path segments. Watch how the distance and direction in which you drag control the segment's curve. Just because it's fun, try a click-drag and, with the mouse button held down, move the mouse around and around in a circle. "Path Jump Rope!" Press Delete/Backspace twice to delete the path.

Now, to get a feel for how to control your curved path segments, follow these steps:

- 1. Choose File < New to open a new document.
- 2. Click Web at the top of the panel, choose 1024 x 768, and click Create.

A reasonable size to work with, it fits on your screen at 100% zoom.

3. Show the Grid.

Press # +' (apostrophe; Mac) or Ctrl+' (apostrophe; Windows) to show the Grid in the image. The Grid makes it easier to control the Pen tool as you drag. You can also show the Grid by choosing View ▷ Show ▷ Grid. In Photoshop's Preferences ▷ Guides, Grid & Slices, the Grid shown in Figure 10-14 is set to Gridline every: 1 inch and Subdivisions: 6.

4. Select the Pen tool in the Toolbox.

5. Click and click-drag as shown in Figure 10-14.

Don't worry about precision — you won't be creating a work of art this time. Click the dots in numeric order; where you see a dashed line, click-drag in that direction for approximately that distance.

FIGURE 10-14: You don't need to be precise; just more or less follow the four patterns.

You've just created four of the more useful scallops and curve sets! These sorts of paths can be used in a variety of ways, including stroking, filling, and creating selections (all of which I discuss later in this chapter) to create decorative borders and artistic elements in your images.

You should know about a couple of other features of the Pen tools before you move on. With the Freeform Pen tool active, take a look at the Options bar (or look at Figure 10-15, which shows the Options bar).

The Pen tool has a couple of tricks up its sleeve! With a path active in the Paths panel, the Pen tool's Options bar enables you to load the path as a selection and create a layer mask. (A Background layer is automatically converted to a layer that supports transparency.) You can also create a shape from the path. Note, too, that when the Freeform Pen tool is active, the Options bar offers a *Magnetic* option — more on that option in a bit.

When you have the Freeform Pen tool selected in the Toolbox you can click and drag around your image, creating a path as you go. It's much like painting with the Brush tool or drawing lines with the Pencil tool — wherever you drag the tool, the path is created. When you need to make a path (or selection) around the outside of something of uniform color in your image, using the Magnetic option forces the path to look for and follow edges. Take a look at Figure 10–16, which shows an example of an appropriate use for the Freeform Pen and the Magnetic option. (If you selected Enable Narrow Options Bar in Photoshop's Workspace preferences, you see a magnet button. If you're using the full-size Options bar, it's a check box named Magnetic.)

NEW

The Content-Aware Tracing tool is a new pen tool that's designed to help you make paths that will become selections or masks. Like using an enhanced magnetic option, the tool automatically snaps to edges (based on color differences) as you drag.

Photoshop has another pen tool, one you may never need. The Curvature Pen tool functions much like the Pen tool with which you're already familiar. There are a couple of differences. By default, the Curvature Pen tool assumes you want to create a curved path segment, so you click, move the cursor, click, move the

mouse, and click a third time, and a curved path appears through the three anchor points. If you need a corner anchor point, double-click or Option/Alt+click. Press the Escape key to finish a path. You can click and drag an anchor point to move it (no need for 光/Control as you would with the Pen tool).

A closer look at the Paths panel

You can save, duplicate, convert, stroke, and delete paths via the Paths panel (which, like all panels, you can show and hide through the Window menu). You can even create a path from a selection by using the Paths panel. Without the Paths panel, your paths have no meaning or future and probably won't get into a good university or even a good collage (pun intended).

Pick a path, any path

The Paths panel can hold as many paths as you could possibly want to add to your artwork. You can also see the seven buttons across the bottom of the panel that you use to quickly and easily work with your paths. You can classify paths in five different ways, as shown in Figure 10–17.

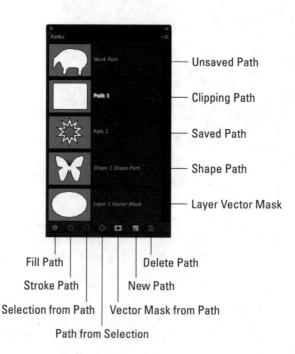

The Paths panel is your key to organizing and controlling vectors in your artwork.

You might not use them all, but it's good to know the five types of paths:

- >> Unsaved Path: As you create a path, Photoshop generates a temporary work path. You can have multiple paths in a single work path. They are even preserved when you save and close your artwork. However, it's usually best to double-click the Work Path name and give your path a meaningful name.
- >> Clipping Path: Clipping paths are used primarily with some page layout programs, such as QuarkXPress 2019 and earlier. Much like how a vector path determines what parts of the layer are visible, a clipping path identifies what part of the image as a whole is visible. You won't need a clipping path when you work with Adobe InDesign simply create your artwork on a transparent background and place that Photoshop file into an InDesign document. To create a clipping path, first make your path, give it a name in the Paths panel, and then use the Paths panel menu command Clipping Path.
- >> Saved Path: Much like working in the Layers panel, you can double-click the name of any path and rename it in the Paths panel.
- >> Shape Path: When a shape is active in the Layers panel, its path is visible in the Paths panel. If you want to customize a shape's path, you need to make the layer active first. When a shape path is visible, you can drag it to the New Path button at the bottom of the panel to create a duplicate. (It's the second button from the right.)
- >> Layer Vector Mask: When a regular layer has a vector mask assigned and that layer is visible in the Layers panel, the layer's mask path is visible in the Paths panel.

When creating a clipping path, leave the Flatness field completely empty unless your print shop specifically instructs you to use a specific value. The Flatness value overrides the output device's native setting for reproducing curves. Using the wrong value can lead to disastrous (and expensive!) mistakes.

To activate a path in the Paths panel, click it. You can then see and edit the path in the image window. With the exception of shape layer and vector mask paths, the paths in the Paths panel are independent of any layer. You could create a path with the Background layer active and then later use that path as the basis for some artwork on, for example, Layer 3.

You can Shift+click (or \Re +click/Control+click) multiple paths to select more than one. You might then use the Path Selection tool to move all the paths at the same time or perhaps scale them uniformly by choosing Edit \hookrightarrow Transform Path \hookrightarrow Scale.

The Paths panel buttons

The seven buttons across the bottom of the Paths panel (refer to Figure 10-17) do more than just simple panel housekeeping. Use them to create artwork from a path and to convert back and forth between paths and selections.

- >> Fill Path: Click a path in the Paths panel and then use this button to fill the area inside the path on the active layer with the foreground color. If you fill an open path (a path with two distinct endpoints), Photoshop pretends that there's a straight path segment between the endpoints. If a shape layer or a type layer is selected in the Layers panel, the Fill Path button isn't available. You can see filled (and stroked) paths in Figure 10-18.
- >>> Stroke Path: Click a path in the Paths panel and then click this button to add a band of the foreground color along the course of the path. Most often, you can think of it as painting the path itself with the Brush tool. If you have a different brush-using tool active in the Toolbox (Clone Stamp, Healing Brush, Dodge, Burn, Eraser, and so on), the path is stroked with that tool. Like a fill, a stroke is added to the currently active layer in the Layers panel. (Strokes are added to shapes on the Options bar.) Take a look at Figure 10-18 to see how stroking and filling can be used in combination with each other.
- >> Selection from Path: When you have a path selected in the Paths panel, you click this button, and *voilà!* An instant and very precise selection is at your disposal. You can create a selection from any path. If you want to add feathering while making the selection, use the Paths panel menu command Make Selection rather than clicking the Selection from Path button.
- >> Path from Selection: You can create a work path from any selection simply by clicking this button. If the path isn't as accurate as you'd like, or if it's too complex because it's trying to follow the corner of every pixel, use the Paths panel menu command Make Work Path and adjust the Tolerance setting to suit your needs.
- >> Vector Mask from Path: If the layer active in the Layers panel supports transparency and you have a saved or work path selected, you can add a vector layer mask to the layer.
- >> New Path: You'll likely use this button primarily to duplicate an existing path. Drag any path to the button, and a copy is instantly available in the Paths panel. When you click this button, you're not creating (or replacing) a work path but rather starting a new saved path.
- >> Delete Path: In the Paths panel, drag a path to the Delete Path button or click the path and then click the button. Either way, the path is eliminated from the panel and from your artwork.

FIGURE 10-18: Think about whether you want to stroke first (left) or fill first (right).

The order in which you stroke and fill a path can make a huge difference in the appearance of your artwork. The stroke is centered on the path, half inside and half outside. The fill extends throughout the interior of the path. If you stroke a path and then add a fill, the fill covers that part of your stroke that's inside the path. As you can see in Figure 10–18, that's not always a bad thing.

Rather than using the buttons at the bottom of the Paths panel to fill and stroke, you can also use the Paths panel menu commands Fill Path and Stroke Path. The commands open dialog boxes that offer more options than simply using the current foreground color. When using the Stroke Path command, you can choose from any of the brush-using tools, which enables you to, for example, very precisely dodge, burn, or clone along a path you create. When using Fill Path, you can add color or a pattern within the path, or fill to a designated state in the History panel.

Sometimes the easiest and fastest way to create a complex path is to make a selection and convert the selection to a path. You might, for example, click once with the Magic Wand and then click the Path from Selection button at the bottom of the Paths panel.

When using the Shape tools to create shapes (rather than paths), you should use the Fill and Stroke features on the Options bar. If you later edit the shape, the fill and stroke conform to the shape's new path. Using the Fill and Stroke options in the Paths panel with paths (rather than shapes) results in pixels added to the active layer. If you later change the path shape, the fill and stroke don't change with the new path shape.

Customizing Any Path

Photoshop gives you a lot of control over your paths, not just when creating them, but afterward as well. After a path is created, you can edit the path itself. While the path is active in the Paths panel, the Edit 🖒 Transform Path commands are

available, giving you control over size, rotation, perspective, skewing, and even distortion. But there's also much finer control at your fingertips. You can adjust anchor points, change curved path segments, add or delete anchor points, and even combine multiple paths into *compound paths*, in which one path cuts a hole in another. (Think *donut*.)

Adding, deleting, and moving anchor points

Photoshop provides you with a number of tools with which to edit paths, although you might never use a couple of them. Consider, for example, the Add Anchor Point and Delete Anchor Point tools shown in Figure 10–15. With the Pen tool active, activating the option to the right of the gear icon in the Options bar enables you to automatically switch to the Delete Anchor Point tool when over an anchor point, and automatically switch to the Add Anchor Point tool when the cursor is over a path segment. Smart tool, eh? The Convert Point tool, on the other hand, can be invaluable . . . or valuable, at least. Click a smooth anchor point to convert it to a corner anchor point. You can also click-drag a corner anchor point to convert it to a smooth point.

Nested in the Toolbox with the Path Selection tool (which you use to select and drag a path in its entirety), the Direct Selection tool lets you alter individual path segments, individual anchor points, and even the individual direction lines that control curved path segments. (When you click a shape with the Direct Selection tool, the Options bar can also be used to change the shape's attributes, including fill, stroke, and size.)

When you click an anchor point with the Direct Selection tool, you can drag it into a new position, altering the shape of the path. If it's a smooth anchor point, clicking it with the Direct Selection tool makes the point's direction lines visible (as well as those of immediately neighboring smooth anchor points). When manipulating paths, the Direct Selection tool follows a few simple rules of behavior (which you can see illustrated by pairs of "before" and "after" paths in Figure 10–19):

- Drag a path segment. Drag a path segment with two corner anchor points, and you drag those points along with you. If the path segment has one or two smooth points, you drag the segment (reshaping the curve), but the anchor points remain firmly in place. Note in Figure 10-19 (upper left) that when you drag a curved path segment, the adjoining direction lines change length, but they retain their original angles.
- >>> Drag a corner anchor point. Click a corner anchor point and drag, and the Direct Selection tool pulls the two adjoining path segments along with it. As you can see in Figure 10-19 (upper center), the other two anchor points (and the path segment between them) are unchanged.

- >> Drag a smooth anchor point. When you drag a smooth anchor point, all four of the direction lines associated with the path segments on either side retain both their lengths and their angles. The direction lines don't change; only the curved path segments connected at the smooth anchor point are altered. In Figure 10-19 (upper right), the path continues to flow smoothly through the anchor point, even as the point moves.
- >> Drag a smooth point's direction line. Dragging a direction line changes the curves on either side of the anchor point so that the path still flows smoothly through the point. (Remember that you click the control point at the end of a direction line to drag it.) Figure 10-19 (lower left) illustrates how the path segments on either side of the smooth point adjust as the direction line is changed. However, paths don't always flow smoothly through a smooth anchor point not if you use the following trick!
- >> Option+drag/Alt+drag a direction line. Hold down the Option/Alt key and drag a smooth anchor point's direction line, and you'll break the flow of the path through that point. With the Option/Alt key, you change only the path segment on that side of the anchor point, leaving the adjoining path segment unchanged. In Figure 10-19 to the lower left, the direction line on the left is being dragged without the Option/Alt key (as described in the preceding bullet point). To the lower right, adding the modifier key preserves the appearance of the adjoining path segment.

The pairs of paths are shown in color, which you select by clicking the gear icon in the Options bar for a pen or shape

You can hold down the Shift key with the Direct Selection tool to ensure that you're dragging in a straight line. You can also hold down the Shift key to select multiple anchor points before you drag.

Combining paths

As you've probably noticed through the course of this chapter, some paths are very simple (like the paths in the preceding figure) and some paths are more complex (like the shapes shown earlier in Figure 10-11). Complex paths are often compound paths: that is, paths that contain two or more paths (called subpaths) that interact with each other. Think about a pair of circles, different sizes, centered on top of each other. What if the smaller circle cut a hole in the middle of the larger circle, creating a wheel (or, depending on how early you're reading this, a bagel)? Take a look at Figure 10-20.

FIGURE 10-20:
Two (or more) paths can interact with each other, creating a compound path, consisting of two or more subpaths.

Two (or more) paths can interact in several ways. Complete this sentence with terms from the following list: "The second path can (fill in the blank) the original path."

- >> Combine Shapes with: The areas within the two subpaths are combined as if they were within a single path (although they remain two subpaths).
- >> Subtract Front Shape from: The second path is used like a cookie cutter to delete an area from within the first path. (When you need to make a bagel, this is the option!)
- >> Intersect Shape Areas with: Only the area where the two subpaths overlap is retained.
- **>> Exclude Overlapping Shapes from:** All the area within both subpaths is retained *except* where the two paths overlap.

When any shape tool, the Pen tool, the Path Selection tool, or Direct Selection tool is active, the Options bar presents you with four options to determine the behavior of multiple paths. (The first path that you create is always a normal path. The options don't come into play until you add additional subpaths.) Figure 10–21 shows each option name and provides a simple graphic representation to demonstrate the interaction. The upper–left path is the original, with the lower–right path showing how each option controls the interaction between subpaths.

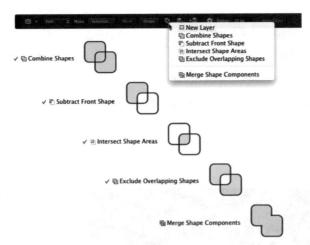

FIGURE 10-21:
The buttons control how a second path (and any subsequent paths) interacts with your original path.

As you can see in Figure 10-21, when a tool is set to create a shape, the New Layer option is available. Using the Merge Shape Components option merges overlapping paths, creating a single path rather than a compound path. (In Figure 10-21, compare the black line to the right of Merge Shape Components to the pair of black lines to the right of Combine Shapes.)

Tweaking type for a custom font

I want to show you one more little thing you can do with vectors in Photoshop — a last bit of fun before this chapter ends. Each individual character in a font consists of paths. You can convert the type to shape layers (or work paths) and change the appearance of the individual characters by editing their paths with the Direct Selection tool. Follow these steps:

- 1. Open a new document in Photoshop.
- 2. Create a new document measuring 800 x 600 pixels.
- 3. Select the Horizontal Type tool in the Toolbox and set the font.

From the Options bar, choose Arial, set the font style to Bold, set the font size to 72, choose Sharp for anti-aliasing, left-align, and click near the lower left of your document.

Okay, in all honesty, you can use just about any settings you want — but if you use these settings, your image will look a lot like mine.

- 4. Type the word Billiards in your image.
- 5. Press **# +Return/Ctrl+Enter** to end the text editing session.

- 6. Choose Type

 Convert to Shape.
 This changes the type layer (editable text on its own layer) to a shape.
- 7. Activate the Direct Selection tool.
- 8. Edit the shapes of the Ls and the D to simulate billiard cues.
 Drag the uppermost anchor points even farther upward to create cue sticks.
 See the result in Figure 10-22.

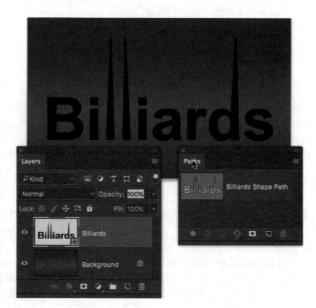

You can convert vector type to shapes and edit the individual character shapes with the Direct Selection tool.

- » Applying layer styles with the Styles panel
- » Creating your own styles
- » Preserving your custom layer style

Chapter **11**

Dressing Up Images with Layer Styles

n artwork and photography, you use shadows and highlights in your image to produce the illusion of depth. Highlights and shadows lead the viewer to imagine that a light is falling on parts of a 3D object. You can also use a shadow or glow to make it appear that some distance exists between one object in the image and another object behind it. Photoshop's built-in layer styles help you add shadows, glows, and other effects almost instantly.

In this chapter, I explain how transparent areas on layers enable lower layers to show through and let your layer styles appear on those lower layers. You get a good look at the Styles panel and how you use it to store and apply layer styles, including your very own custom styles. I then present the all-important (for layer styles) Layer Style dialog box and the various effects that you can add with it. I also show you how to save (and protect) your custom layer styles.

What Are Layer Styles?

A *layer style* comprises one or more effects that surround or are applied to all the pixels on your layer. Effects that surround pixels include strokes (thin or thick outlines of color), shadows (just like the one you're casting right now), and glows

(outlines of semitransparent color). Effects that are applied to pixels include overlays of color, patterns, or even gradients. But Photoshop offers even more, including the ever-popular Bevel and Emboss effect, which does a great job of giving the content of your layer a 3D look. And, of course, effects can be used in combination; check out Figure 11–1 for an example. You can add effects to layers in several ways, including through the Layer Style menu at the bottom of the Layers panel, as shown in Figure 11–2. I explain each of the effects individually later in this chapter in the section on creating your own custom layer styles.

FIGURE 11-1:
Strokes,
shadows, and
bevels are
just some of
the effects
available.

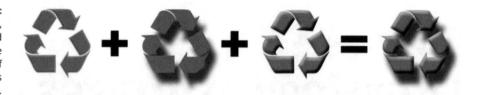

Just so everyone is on the same sheet of music, when you refer to a drop shadow or an outer glow or a color overlay or any one of the other items shown in the menu in Figure 11–2, call it a *layer effect* or simply an *effect*.

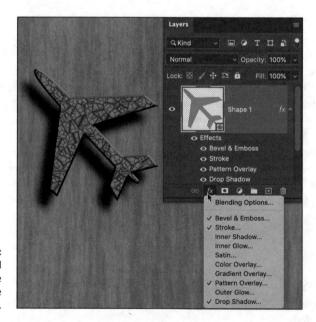

You can add a layer style through the Layers panel.

Some layer effects, such as drop shadows and outer glows, appear outside the content of the layer. For those effects to be visible in your artwork, the layer must have at least some area of transparent pixels. If the layer is filled edge to edge,

the effect has no place within the image to appear because the glow or shadow would logically be outside the image's canvas. Take a look at a couple of layer style examples in Figure 11-3.

FIGURE 11-3: Some layer effects need transparent areas on the layer, or they won't appear.

In the sample on the left, you can imagine that the shadow logically also appears to the lower right of the object as a whole (as it does in the sample to the right). However, that's outside the image's canvas, so that part of the shadow doesn't appear in the artwork.

Keep in mind that every layer in an image has the same number of pixels — but some of those pixels can be transparent. When a layer has areas of transparency, layers below in the image can show through. In the two examples in Figure 11–3, the yellow background layer is visible, giving the upper layer's shadows a place to fall. (And remember that a layer named Background can't have areas of transparency. Convert it to a regular layer by clicking the Lock icon to the right of the layer name.) Chapter 9 is full of information on working with layers.

Using the Styles Panel

The Styles panel is hidden by default. Choose Window \Rightarrow Styles to make it visible. This panel, which you see with its menu open in Figure 11-4, is where you find and store layer styles and is the easiest way to apply a layer style to your active layer.

NEW

When you first open the Styles panel, you see four sets: Basic, Natural, Fur, and Fabric. The 20 styles in those sets are great — if you happen to need a wood or rabbit fur or tweed texture. If you want some *useful* styles, open the panel menu and select Legacy Styles and More (as shown in Figure 11–4).

To apply a layer style via the Styles panel, make the target layer active by clicking it in the Layers panel; then click the style that you want to apply. It's truly that simple! To remove a layer style from the active layer, drag it to the Trash icon at

the bottom of the Layers panel. To create a new set of styles (perhaps for custom styles you may create later in this chapter), click the left button at the bottom of the Styles panel. You can click the middle button to save a custom layer style (which I explain later in this chapter), and you can drag a layer style to the Trash icon on the right to delete it from the panel.

The Styles panel holds your preset and saved layer styles.

Take a look at the Styles panel menu shown in Figure 11–4, starting from the top and making your way down to the bottom. The first command simply adds the style applied to the active layer to the panel (like clicking the Create New Style button). You can also create a new group from the menu rather than use the button at the bottom of the panel, rename an existing style, or delete a style from the panel.

In the second section of the menu, you can choose from five different ways to view the content of the Styles panel. The Text Only, Small List, and Large List options might come in handy after you create a bunch of custom styles with names you recognize, but until you become familiar with the styles in the panel, their names are pretty much meaningless. The Large Thumbnail option gives you a better view of the effects in the style, but you see fewer styles at a time in the panel than you can with the default Small Thumbnail view.

Appending the default set of styles simply adds another copy of the four basic sets I mention above. If you download styles from a website, use the Import command to add them to the panel. After you create some custom styles, use the Export command to save them to a folder on your drive. The last two commands in the

Styles panel menu are used to control the visibility of the panel (Close) and the visibility of the panel and those panels nested with it (Close Tab Group), which depends on how you've arranged Photoshop's panels in your workspace.

Creating Custom Layer Styles

You create a custom layer style by applying one or more layer effects to your active layer. (Once again, remember that you can't apply layer effects or layer styles to a layer named Background.) When you have the effects looking just the way you want them, you can add that new style to the Styles panel and even save it for sharing with friends and colleagues. Combining multiple layer effects lets you create complex and beautiful layer styles that change simple shapes and text into art.

Exploring the Layer Style menu

In addition to the pop-up menu at the bottom of the Layers panel (refer to Figure 11-2), you can apply layer effects through the Layer \$\sim\$ Layer Style menu. As you can see in Figure 11-5, the Layer Style menu has a few more commands than the menu at the bottom of the Layers panel.

FIGURE 11-5: You can use the Layer Style menu to apply layer effects and more. The ten items on the Layer Style menu below Blending Options are the actual layer effects. A check mark to the left of the effect indicates that it's currently applied to the active layer. The Copy Layer Style and Paste Layer Style commands come in handy, but if you're more mouse— or stylus—oriented than menu—oriented, you'll find it easier to add the style to the Styles panel and click the style to apply it to other layers. You can also Option/Alt+drag a layer style from layer to layer in the Layers panel to duplicate it. Clear Layer Style removes all layer effects from the target layer. The four commands at the bottom of the menu are worthy of a little special attention:

>> Global Light: A number of layer effects are applied at an angle. Drop shadows, for example, simulate light coming from a specific angle (which, of course, determines where in your artwork that shadow falls). You use the Global Light command to set the default angle at which your effects are applied. Generally speaking, you want the angle to be consistent from effect to effect and from layer to layer in your artwork. There are exceptions, however, such as the situation shown in Figure 11-6. In that artwork, the two type layers have shadows receding at different angles to simulate a light source positioned immediately in front of and close to the image. (As you can read in the next section of this chapter, when you use layer effects that are applied at an angle, you have the option of using or not using the angle in Global Light.)

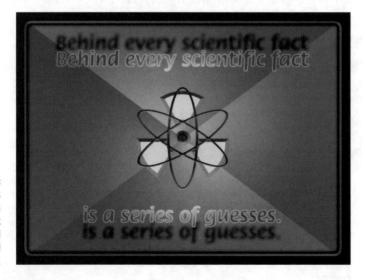

FIGURE 11-6: Sometimes shadows in your artwork shouldn't all use the Global Light setting.

>> Create Layers: Sometimes you need to edit a layer effect — say, to control where a drop shadow falls on the lower layers in the image. The Create Layers command rasterizes each layer effect (adds it to the image as a separate layer

or layers containing pixels). You can then erase portions of the new layers, apply artistic filters, or otherwise customize each effect layer. Remember that after a layer style is rasterized with this command, you can no longer edit it through the Layer Style dialog box, but the original style (if you added it to the Styles panel) is still available.

- >> Hide All Effects: You can temporarily hide a layer style with the Hide All Effects command. Alternatively (and more conveniently), you can click the eyeball icon next to the layer style in the Layers panel to hide the effects.
- >> Scale Effects: Use the Scale Effects command to uniformly make the layer style larger or smaller.

Exploring the Layer Style dialog box

The first step in creating custom layer styles is to become familiar with the individual layer effects. Selecting a layer effect from the Layers Layer Styles menu opens the Layer Style dialog box (see Figure 11–7). Each of the ten effects has its own set of options. Most of the basic default values are very good starting points. You might need to change only a color or perhaps adjust a Size, Distance, or Opacity slider. You can, of course, do lots and lots of customizing for some of the effects.

In the column to the left in the Layer Style dialog box, you can select a check box to apply the effect, but you need to click the name of the effect to open that effect's options pane. In Figure 11–7, the check marks show that this particular layer style includes a bevel, a couple of strokes, two color and one pattern overlays, and a drop shadow. The options pane for Bevel and Emboss is visible, as you can tell by the highlighting in the left column (not to mention the subtle Bevel & Emboss at the top-center of the dialog box). And in the far right of the Layer Style dialog box, note the Preview check box (upper right, which shows what the layer style will look like) and the small sample just below. That sample shows how your style will look when applied to a square about 140 x 140 pixels.

Take a look at the left column in the Layer Style dialog box. Several effects have a plus sign to the right. That indicates that you can add multiple versions of that effect in a single layer style. In this example, you can see that there are two Stroke and two Color Overlay effects added in this style.

Take a look at the bottom of the Layer Style dialog box in Figure 11–7 to see the buttons Make Default and Reset to Default. In addition to saving a new layer style every time you hit upon a winning combination of settings, you can make those favorite settings the default. Change your mind later? One click is all it takes to reset to Photoshop's defaults.

FIGURE 11-7: The Layer Style dialog box has separate options for each layer effect.

As you read the descriptions of the various sets of options, keep in mind some generalities about a few key options that you'll see a number of times:

- >> Color Selection: When you see a color swatch a small rectangle or square, usually near the Blending Mode option you can click it to open the Color Picker and select a different color.
- >> Noise: When you see the Noise slider, you can add a speckling effect to help diffuse a glow or shadow.
- >> Contour: Glows, shadows, and the like can be applied linearly, with a steady fade from visible to not visible. Or you can elect to have that transition vary with a nonlinear contour. Generally speaking, nonlinear contours can be great for bevels, but linear is usually best for shadows and glows unless you intend to create concentric halos.
- >> Angle/Use Global Light: You can change the angle for several layer effects by entering a specific angle in the numeric field or by dragging in the circular Angle controller. If the Use Global Light check box is selected, you change all the angles for that layer style.

Layer effects basics

In this section, I explain the basics of each of the ten layer effects, showing the options available in the Layer Style dialog box for that effect in an insert, as well as one or more examples. And don't forget to take a look at the nearby sidebar, "The four key blending modes." Later in this chapter, you can read about the Opacity and the Fill sliders as well as some other advanced blending options.

Bevel and Emboss

Perhaps the most fun of all the Photoshop layer effects, Bevel and Emboss is a quick and easy way to add a 3D look to your artwork. You can apply a Bevel and Emboss layer effect to text or to buttons for your website. You can also use this effect to create more complex elements in your artwork, examples of which appear in Figure 11–8.

FIGURE 11-8: The Bevel and Emboss layer effect is very versatile.

TIP

When you feel the need and have the time to let your imagination frolic through the fertile fields of Photoshop fun, filters are first, but the Bevel and Emboss layer effect follows fruitfully. Take the time to play with the various settings in the Bevel and Emboss pane of the Layer Style dialog box to see what they do. Add a new layer, create a simple shape (perhaps with one of the shape tools), select Bevel and Emboss from the pop-up menu at the bottom of the Layers panel, and experiment — that's a far more efficient way to get to know this effect than reading technical explanations of each of the options. (One caveat: You won't see any change in your layer with the Stroke Emboss style unless you're also using the Stroke layer effect.) Don't forget to play with the various Gloss Contour presets!

Remember, too, that you can add a second contour effect and/or a texture using the two check boxes below Bevel and Emboss in the left column of the Layer Styles dialog box. (As with other effects, click directly on the name Contour or Texture to access the effect's options.)

As you read this book, keep an eye out for the Bevel and Emboss layer effect. When you come across a bevel or emboss effect, such as those shown in Figure 11-9, you might want to take a moment to remember your experimentation and then try to puzzle out what settings I might have used.

FIGURE 11-9:
Many
illustrations in
this book use
the Bevel and
Emboss layer
effect.

Stroke

As you read this chapter, you see the Stroke layer effect often. For example, in Figure 11-3, shown previously, a simple black stroke indicates the extent of the canvas for each of the examples. Not only is Stroke a handy and practical production tool, it's also a wonderful creative effect, especially when you use it in conjunction with other layer effects. For example, a stroke of a contrasting color is a great way to redefine the edge of your object when working with an outer glow and an inner shadow. (In the Stroke effect's options, remember that you click the color swatch to open the Color Picker.) A simple stroke can convert even the plainest text into an eye-catching statement. And don't forget that without the Stroke effect, the Bevel and Emboss effect's Stroke Emboss option does nothing for your artwork. Figure 11-10 has a few examples of layer styles that include a Stroke effect.

FIGURE 11-10:
The Stroke
effect can
stand alone or
be used with
other layer
effects.

Inner Shadow

You can do a couple of things with the Inner Shadow layer effect, as you can see in Figure 11-11. Compare the two sets of options. On the left, a soft, light-colored inner shadow using the Screen blending mode softens edges. On the right, a hard inner shadow, using a dark color and the Multiply blending mode, produces a totally different look. Despite what your eyes might be telling you, the layer effect is applied to the red shape, which is on the *upper* layer.

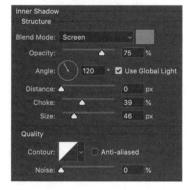

FIGURE 11-11: Inner shadows can be soft or hard, light or dark.

Inner Glow

The Inner Glow effect is much like a non-directional Inner Shadow effect. As you can see in Figure 11-12, an Inner Glow can be the base for a neon glow style. (Add an Outer Glow effect, perhaps a Stroke effect, and there you go!)

Inner Glow offers more control than Inner Shadow.

You can also develop some rather amazing styles by using the Inner Glow and the Inner Shadow in combination. Using similar Size settings and varying the colors and blending modes lets you overlay a pair of effects in combination. And when you play with Inner Glow and Inner Shadow in combination, don't overlook the Contour variations.

Satin

The Satin layer effect uses the shape of the object to produce a wave-like overlay. As you can see in Figure 11-13, it's more effective with type and complex shapes than it is with large plain shapes.

Color Overlay

The key to using the Color Overlay layer effect is the blending mode. (See the sidebar, "The four key blending modes," later in this chapter.) When you use Normal, in effect, you paint all the pixels on the layer with the selected color. To blend the color with the original artwork or other effects (such as pattern overlays), choose an appropriate blending mode — Multiply with dark colors, Screen with light colors — or simply experiment with blending modes. However, using the

Color Overlay layer effect with the Normal blending mode in a custom layer style is a good way to ensure consistency in artwork, such as buttons and banners for a website. Keep in mind, however, that Cover Overlay at 100% opacity used with the Normal blending mode completely hides any Gradient Overlay or Pattern Overlay effect.

The Satin layer effect is very effective with complex shapes.

THE FOUR KEY BLENDING MODES

Photoshop offers over two dozen different blending modes, many of which you see in the Layer Style dialog box. You really need only a few on a regular basis, although it's always fun to experiment with the others, just in case one of them gives you a cool effect.

The *Multiply* blending mode generally darkens. When working with dark shadows or glows, choose the Multiply blending mode so that the layer effect darkens (but doesn't hide completely) the pixels on the layers below. The *Screen* blending mode lightens. Use Screen with light glows and other such effects. The *Overlay* blending mode is a mix of Multiply and Screen. When working with patterns that contain both dark and light colors, you might opt for Overlay as the blending mode.

Of course you should remember the *Normal* blending mode, too! If you want a glow or shadow to completely block whatever lies below, choose Normal at 100% opacity. You might also want to use Normal with a somewhat lower opacity for a uniform coverage over both dark and light pixels. And don't be afraid to experiment — run through the blending modes (and opacity settings) to see whether you can tweak that custom style just a little more. (For more information on blending modes, see the appendix.)

Although you'll generally find Color Overlay most useful for simple shapes in artwork and on web pages, you can certainly use it for more exciting effects, such as the ones shown in Figure 11–14. The original is in the upper left, and each example shows the color, blending mode, and opacity selected. Remember that when you use a layer effect, you can later return and alter or remove that change from your image.

FIGURE 11-14:
Color
Overlay can
produce subtle
or dramatic
changes in
your artwork.

Gradient Overlay

Unlike the Gradient Map adjustment (see Chapter 5), which applies a gradient to your image according to the tonality of the original, the Gradient Overlay effect simply slaps a gradient over the top of the layer content, using the blending mode and opacity that you select. You also control the shape of the gradient, the angle at which it's applied, and the gradient's scale. (See Figure 11–15.) And don't forget that a Gradient Overlay using the Normal blending mode and 100% opacity will hide any Pattern Overlay effect.

When working with gradients, you click the triangle to the right of the gradient sample to open the Gradient panel. You directly click the gradient sample itself to open the Gradient Editor. (See Chapter 13 for more information on editing and creating gradients.)

Pattern Overlay

Like the Color Overlay layer effect, Pattern Overlay relies on the blending mode and opacity settings to determine how the artwork (pattern) interacts with your original artwork. As you see in Figure 11–16, you can scale the pattern, align it to

the upper-left corner of your image (with the Snap to Origin button), and link the pattern to your layer so that the appearance of your artwork doesn't change as you drag the layer into position. Click the triangle to the right of the sample pattern to open the Pattern panel and then select a pattern.

In keeping with its name, the Gradient Overlay effect overlays a gradient.

FIGURE 11-16: The Pattern Overlay layer effect adds texture to your layer's artwork.

Outer Glow

The Outer Glow layer effect is much like a non-directional shadow when applied using a dark color. However, it also has a variety of uses with a light color and the Screen blending mode. As you can see in Figure 11-17, it has practical and whimsical uses. (Please remember that in real life, stars do *not* appear between the horns of a crescent moon!)

An Outer Glow layer effect (seen here on the left) is a multipurpose layer effect.

In the Structure area at the top of the Outer Glow options, you can select the blending mode and opacity, add noise if desired, and select between a color (click the swatch to open the Color Picker) or a gradient (click the sample to open the Gradient Editor). You define the size and fade of the glow in the Elements area. The Technique pop-up menu offers both Softer and Precise — try them both. And don't overlook the options at the bottom, in the Quality area. Although you use Jitter only with gradients to add some randomness, the Range slider is an excellent way to control the distance at which your glow is offset. When you get a chance, play with different contours for an Outer Glow effect.

Drop Shadow

A drop shadow is a great way to separate the content of one layer from the rest of the image, as you can see by comparing the two versions of the artwork in Figure 11–18. In effect, the content of the target layer is copied, converted to black, and placed behind your layer. The blending mode and opacity determine how the shadow interacts with the layers below. You decide how much to offset and blur the duplicate with the sliders. (Remember that this is a layer style, so no extra layer is actually added to your image.) You'll generally want to leave the Contour option of your drop shadows set to the linear default. As you saw in Figure 11–6, drop shadows are great with type layers!

FIGURE 11-18: Drop shadows can visually separate the upper layer from the lower layer.

Opacity, fill, and advanced blending

In the Blending Options area of the Layer Style dialog box and the upper-right corner of the Layers panel, you see a pair of adjustments named Opacity and Fill Opacity, as shown in Figure 11–19. Both have an impact on the visibility of the content of your layer.

When you reduce the Opacity setting for the layer, you make the layer content and any layer style partially or completely transparent. Reducing the Fill slider changes the opacity of the pixels on the layer but leaves any layer effects fully visible. When might you want to use the Fill slider? The first thing that comes to mind is when creating the ever-popular Glass Type technique, which produces see-through text that's perfect for your copyright notice on any image:

1. Add some text to an image with the Type tool.

This is a wonderful trick for adding your copyright information to sample images because everyone can see the image, but no one can use it without your permission. Start by adding your copyright information or perhaps the word *Sample*.

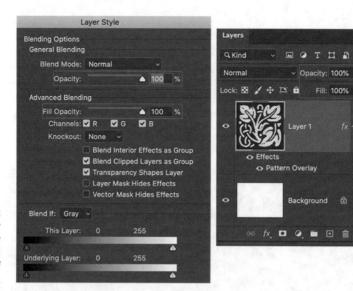

The Opacity and Fill Opacity sliders control the visibility of a layer.

2. Apply a layer style to the type layer.

A bevel, a thin black stroke, and perhaps an inner shadow or white outer glow make an excellent combination. (Select the individual effects as described earlier in this chapter.)

3. Reduce the Fill slider to 0%.

Adjust Fill at the top of the Layers panel or in the Layer Style dialog box's Blending Options pane. You can click and type in the Fill field, click the arrow to the right of the field and drag the slider, or simply click the word *Fill* and drag to the left. The type layer disappears, but the layer effect remains.

You can see all three steps in Figure 11-20.

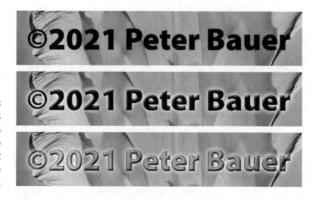

FIGURE 11-20: Using the Glass Type effect is a great way to add copyright info to sample images. The Blending Options pane of the Layer Style dialog box offers you a number of other choices in the Advanced Blending area, as shown in Figure 11-19.

Other than the Fill Opacity slider, you'll probably never change the Advanced Blending options from their default settings, but you might be curious about what they do. Here's a short explanation of each:

- >> Channels: Clear one or more of the color check boxes in the Advanced Blending area to hide the layer's content in that color channel. Clear the R check box, for example, and you hide the target layer in the Red channel.
- >> Knockout: You can use the content on the target layer to create transparency on lower layers. The top layer becomes transparent, as do the layers below every place that the upper layer had visible pixels. (I think of it as a "cookie cutter" effect.) If you want to restrict the effect, use the Shallow option, and the knockout extends only to the lowest layer in your layer group. The Deep option knocks out to the Background layer (or to transparency if your image doesn't have a background layer).
- >> Blend Interior Effects as Group: You can blend the Inner Glow, Satin, and your overlay effects before the layer as a whole is blended with lower layers. Use this option if it seems your layer effect's blending mode is being canceled out by the layer's own blending mode.
- >>> Blend Clipped Layers as Group: If you have layers clipped together (see Chapter 9), you can elect to use the base layer's blending mode for all the layers or let each layer interact independently. You generally want to leave this check box selected.
- >> Transparency Shapes Layer: This is another option that you'll almost always want active. Transparency Shapes Layer restricts the layer style to the visible pixels on the target layer. If, for example, you're working with a small rounded rectangle and a Color Overlay layer effect, deselecting the check box fills the entire layer not just the rounded rectangle with color.
- >>> Layer Mask Hides Effects: If the target layer's visibility is controlled with a layer mask (see Chapter 7), you can opt to have the layer style hidden by the mask, too. You can also use a layer mask to hide just the layer style with this option say, when you need to make sure that your drop shadow doesn't fall where it shouldn't. Simply create a layer mask that hides those areas where you don't want the style visible and select the Layer Mask Hides Effects check box.
- >> Vector Mask Hides Effects: This option uses a layer's vector mask in exactly the same way that the Layer Mask Hides Effects option uses a layer mask. (Remember that a vector mask is a path that determines which areas of a layer are visible see Chapter 10 for information on creating vector masks with paths.)

If you have an image with a plain white (or plain black) background, you can make that background disappear with the Blend If sliders. (See Figure 11–21.) In the Layers panel, unlock the Background layer by clicking the Lock icon to the right of the layer name. At the bottom of the Layers panel, click the second button from the right to add a new layer. Move the new layer below the original layer. With the original layer active, open the Blending Options pane of the Layer Style dialog box and drag the upper-right Blend If slider control to the left until the background disappears. As the white background disappears, the checkerboard *transparency grid* becomes visible. Press $\Re +E$ (Mac)/Ctrl+E (Windows) to merge the layers and retain the now-transparent background.

FIGURE 11-21:
Make a white
background
disappear with
the Blend If
sliders.

Saving Your Layer Styles

Creating custom styles takes some time and effort. Saving the styles means that you don't have to spend time re-creating the style. Save your styles not only in the Styles panel but also on your hard drive.

Adding styles to the Styles panel

After you have your layer style looking just right, you can add it to the Styles panel. From the Styles panel, you can apply your custom style to any layer (except,

of course, layers named Background) in any image with a single click. You simply make the target layer active in the Layers panel by clicking it; click your custom style in the Styles panel.

To add your style to the Styles panel, you must first create it. Select a layer in the Layers panel, open the Layer Style dialog box, and select the layer effects and options. Click the New Style button to save the style or, after clicking OK in the Layer Style dialog box, click the middle button at the bottom of the Styles panel. Then, in the New Style dialog box that appears, assign your custom style a name and click OK. If desired, you can also elect to save the target layer's blending mode as part of the layer style.

Preserving your layer styles

Adding your custom styles to the Styles panel makes them available day in and day out as you work with Photoshop. However, should you ever need to replace the Preferences file (see Chapter 3) or reinstall the program, all your custom styles are wiped from the Styles panel. To make sure that you don't accidentally lose your custom styles, create and save a set of styles, which you can then reload into the panel whenever necessary. The Styles panel menu offers the Export Selected Styles command (refer to Figure 11–4), which lets you save styles currently in the panel as a set. (You can select all the styles in the panel or just some of them before exporting.)

Saving sets of styles, brushes, custom shapes, and the like in the Photoshop Presets folder adds those sets to the various panels' menus. You can then easily load the set into the panel: Just choose the set from the panel menu. However, you should also save a copy of the set some place safe, outside the Photoshop folder, so that it doesn't accidentally get deleted when you upgrade or (horror!) reinstall.

A part with the agree that was to be a recommendable as the comment of the commen

and the second of the second o

The state of the second second

The place of the second of the

- » Testing your type techniques
- » Creating paragraphs with type containers
- » Shaping up with Warp Text and type on a path

Chapter **12**

Giving Your Images a Text Message

n bon croquis vaut mieux qu'un long discours. Or, as folks often paraphrase Napoleon, "A picture is worth a thousand words." (Yes, 1,000 words might equal "a long speech.") But sometimes in your Photoshop artwork, nothing says Bob's Hardware quite like the very words Bob's Hardware. A picture of a hammer and a picture of a nail — perhaps toss in some nuts and bolts — all are great symbols for your client's logo. However, you also need to give Bob's customers a name and an address so they can actually spend some money, which goes a long way toward helping Bob pay you.

For a program that's designed to work with photographic images, Photoshop has incredibly powerful text capabilities. Although it's not a page-layout program such as Adobe InDesign, a web development program such as Dreamweaver, or a word processing program such as Microsoft Word, Photoshop can certainly enable you to add lines, paragraphs, or even columns of text to your images.

Photoshop offers you three categories of text:

>> Point type is one or more lines of text, comparable with the headlines in a newspaper or the text that you add to, say, a Bob's Hardware advertisement. Click with a type tool to add point type.

- >> Paragraph type consists of multiple lines of text. Like in a word processing program, a new line is started whenever your typing reaches the margin. Drag a type tool to create paragraph type.
- >> Warp type and type on a path are typically single lines of type that are bent, curved, or otherwise distorted as a special effect. Use the Option bar's Warp Text feature (or choose Edit ♣ Transform ♣ Warp), or click with a type tool on a path.

In this chapter, I discuss the tools and panels that you use to add text to an image. I also tell you how to add paragraphs and columns of text (as you might use in a brochure or booklet), and even how to make your type bend and twist along paths.

Making a Word Worth a Thousand Pixels

To control your basic work with text, Photoshop offers you four type tools, the Options bar, and several options in the Preferences dialog box, both in the Type section, visible in Figure 12-1, and in the Units & Rulers section. Photoshop also has a menu of type-related commands.

Photoshop gives you lots of tools and menus for working with text. As you can see in Figure 12-1, the Font menus in the Options bar can show a sample of the typeface (using the word Sample) when you click it. You can activate the preview and choose from six (including None) different sizes for the font preview in the Type menu's Font Preview Size list (shown is the Large option).

If you look closely at the Preferences shown in Figure 12–1, you see that the second-to-the-last item in the left column is "Fill new type layers with place-holder text." When you click and drag the Type tool to create a type container (explained later in this chapter), this option enables Photoshop to fill that type container with so-called "placeholder text" (also known to some as "garbage text" or "dummy text"). The pseudo-Latin paragraph starts with the made-up "words" *Lorem ipsum* and is there simply to allow you to make changes to the selected font, font options, and font size before actually adding text. This sample text is nothing more than a convenience that enables you to see how things will look when you're done. (*Lorem ipsum* placeholder text has been used by printers and typesetters since the 1500s.) As soon as you start typing (after, of course, making any changes to font, options, size, and so on), that placeholder text disappears and is replaced with your typing. If it drives you nuts to see *Lorem ipsum*, simply deselect the option in the Type section of Photoshop's Preferences.

In addition to the Type options shown in Figure 12-1, you'll also find four panels for more advanced work with text. Along with the Character and Paragraph panels, Photoshop offers Character Styles and Paragraph Styles panels. (See Figure 12-2.) By default, the panels are hidden because you can make the primary type-related decisions (such as font style and alignment) in the Options bar. You might need to show the panels if you're doing some fine-tuning of the text appearance. When you need the panels, you can show them through the Type \Rightarrow Panels menu or Photoshop's Window menu. (Until you start saving your own character and paragraph styles, such as for consistency from project to project, they're basically empty.)

Type can be informative or decorative or both. You can use the type tools to add paragraphs of text or a single character as an element of your artwork. (In Chapter 10, you can even see how to make custom shapes from your various symbol fonts.) The text can be plain and unadorned or elaborately dressed up with *layer styles*, such as drop shadows, glows, bevel effects, and other effects that you apply to make the layer content fancier. (Layer styles are discussed in Chapter 11.) However you use it, text can be a powerful element of both communication and symbolism. Take a look at Figure 12–3, in which I use the Type tool to add the binary code to the left and even the musical notes below. (You can see the individual layers of Figure 12–3 back in Figure 9–1.)

But before you add any text to your artwork, you need to have a good handle on the various type tools, panels, menus, and options available to you. I start with an introduction to Photoshop's type tools.

FIGURE 12-2:
Use the
Character
Styles and
Paragraph
Styles panels
to ensure
consistency
and to make
changes
quickly.

You can also use type as symbolic or decorative elements.

A type tool for every season, or reason

Photoshop offers four type tools — or, perhaps more accurately, two pairs of type tools — that assist you with adding text to your images. The Horizontal Type

tool and the Vertical Type tool (the first pair) create *type layers*, which show up as special layers in the Layers panel that enable you to later re-edit the text that you put there. The Horizontal Type Mask tool and the Vertical Type Mask tool (the second pair) make selections on the active layer, similar to using the Rectangular Marquee and Lasso tools (as I describe in Chapter 7). When creating more than one line of type, the Horizontal Type tool starts the subsequent lines below the first. Keep in mind, however, that the Vertical Type tool will add additional lines of type to the *left* of the first line.

When working with type layers, you can easily make changes to the font, font size, and even the text itself at any time. In addition, you can add layer styles and blend the text with other elements of your artwork using blending modes and reduced opacity.

You can ignore the type mask tools. Instead, use the regular type tools, \Re / Ctrl+click the layer thumbnail in the Layers panel to load a selection in the shape of the text, and then click the eyeball symbol to the left to hide the type layer. Later, if necessary, you can easily reload the selection — or make changes to the text and load a new selection.

When working with a text-shaped selection, add a new empty layer on which you can create a text-shaped stroke or fill, or work with an existing layer's content. You might, for example, make a text-shaped selection to delete or hide an area of another layer, as you can see in Figure 12-4.

FIGURE 12-4:

/Ctrl+click
a type layer's
thumbnail
to make a
text-shaped
selection for
editing other
artwork.

Whether working with type layers (or the type mask tools), you have the option of using either horizontal or vertical type. The difference between type that is set vertically and the very common horizontal type rotated 90 degrees is illustrated in Figure 12–5.

You can select type options before adding text to the image, or you can change your options afterward. When you make the type layer active in the Layers panel — but haven't yet selected any text in your image — any changes that you make are applied to all the text on the layer. You can also click and drag to select some of the text on the layer and make changes to only those characters or words.

When you're done adding or editing text, you can end the editing session in any of a number of ways:

- Click the check mark button (or the Cancel button) on the Options bar (visible only when text is being added).
- >> Press the Escape key.
- Switch to a different tool in the Toolbox.
- >> Press # +Return or Ctrl+Enter.
- 第 +Shift+click or Ctrl+Shift+click to finish that type layer and start a new type layer.

By default, when adding type, pressing the Escape key will commit the text and end the editing session. In Preferences Type, you can change this behavior back to the older behavior so that pressing the Escape key will cancel the type layer.

FIGURE 12-5:

Vertical type stacks the individual characters. You can rotate horizontal type for a different look.

What are all those options?

Here you are, the proud owner of the world's state-of-the-art image editor, and now you're adding text, setting type, and pecking away on the keyboard. You're faced with a lot of variables. Which options are you going to need all the time? Which ones are you going to need now and then? Which ones can you ignore altogether? Read on as I introduce you to the various text and type variables, and toss in a few general guidelines on which options are most (and least) frequently required.

Take a look at Figure 12-6, in which you can see (in all their glory) the most commonly used text attributes, all of which are available to you from the Options bar whenever a type tool is active.

FIGURE 12-6:
Use the
Options bar
to quickly and
easily change
the primary
attributes of
your text.

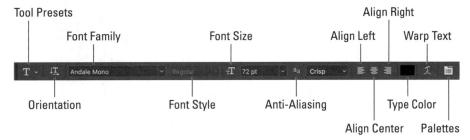

You can change the following text attributes via the Options bar, which is usually available at the top of your screen:

- >> Tool Presets: The Tool Presets panel enables you to select a predefined set of options that you've already saved. Set up each as a preset and then activate all the options with a single click. (See Chapter 3 for more detailed information on tool presets.)
- >> Orientation: The Orientation button toggles existing type layers between horizontal and vertical. Regardless of what text is selected, the entire type layer is flipped when you click this button.
- >> Font menu: Click the triangle to the right of the Font Family field to open the Font menu, showing all your active fonts in alphabetical order. You can also click in the field itself and use the arrow keys to switch fonts. If you select some type with a type tool first (as shown in Figure 12-7), using an arrow key automatically applies the change to the selected characters. If no characters are selected, you change the entire type layer.

FIGURE 12-7: Select specific characters, such as the words SELECTING THEM, to change some, or make no selection to change all.

Change only some characters by SELECTING THEM with the Type tool.

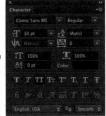

- >>> Font Style: When a font has multiple styles built in, you can choose a variation of the font from the Font Style menu. Styles include Regular (or Roman), Bold, Semibold, Italic, Condensed, Light, and combinations thereof (as shown in Figure 12-8). Some fonts, however, have no built-in styles.
- Font Size: You can select a font size in three ways: by typing a number in the Font Size field, by clicking the triangle to the right of the field and selecting a font size from the pop-up menu that appears, or by clicking

FIGURE 12-8: Some fonts have many styles available.

the Tt icon to the left of the Font Size field and then dragging left or right to change the value in the field. Font size is generally measured in points (1 point = $\frac{1}{12}$ inch), but you can elect to use pixels or millimeters. Make the units change in Photoshop's Preferences (choose Preferences $\stackrel{1}{\hookrightarrow}$ Units & Rulers, not Preferences $\stackrel{1}{\hookrightarrow}$ Type). Keep in mind that when type is measured in points, the image's resolution comes into play. (Resolution is discussed in Chapter 2.)

Anti-aliasing: Anti-aliasing softens the edges of each character so that it appears smooth onscreen. As part of this process, anti-aliasing hides the corners of the individual pixels with which the text is created. When outputting to a laser printer or other PostScript device, anti-aliasing isn't required. It is, however, critical when printing to an inkjet or when producing web graphics or designing for tablets and smartphones. Smooth is a good choice unless your text begins to look blurry, in which case you should switch to Crisp. Use the Strong option with very large type when the individual character width must be preserved. When designing for onscreen projects (web pages, tablets, smartphones, and so on), choose System or System Gray for anti-aliasing.

WARNING

Never choose System or System Gray for text that will be printed, either on an inkjet or using a PostScript device. These two anti-aliasing methods are designed to help text appear properly in web browsers.

>> Alignment: The three alignment choices on the Options bar determine how lines of type are positioned relative to each other. The buttons do a rather eloquent job of expressing themselves, wouldn't you say? *Note:* Don't confuse the term *alignment* with *justification*, which straightens both the left and right margins (and is selected in the Paragraph panel).

- >> Type color: Click the color swatch on the Options bar to open the Color Picker and select a type color. You can select a color before adding text, or you can change the color of the text later. If you start by selecting a type layer from the Layers panel, you'll change all the characters on that layer when you select a new color in the Color Picker. Alternatively, use a type tool to select one or more characters for a color change, as shown in Figure 12-9.
- >> Warp Text: Warp Text, which I discuss later in this chapter, bends the line of type according to any number of preset shapes, each of which can be customized with sliders. (The text in Figure 12-9 uses the Arc Lower warp style.) Keep in mind, however, that the Warp Text feature isn't available when the Faux Bold style is applied through the Character panel. (I talk about faux styles later in this chapter.)

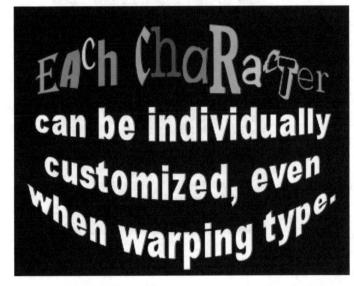

FIGURE 12-9: Select any individual character and change its font, color, size, or any other attribute.

REMEMBER

Each character in a type layer can have its own attributes. Click and drag over one or more characters with a type tool and then use the Options bar or Character panel to change the text attributes. Color, font, style — just about any attribute can be assigned, as shown in Figure 12–9.

TIP

Like many word processing programs, you can select an entire word in Photoshop by double-clicking the word (with a type tool). Triple-click to select the entire line. Quadruple-click to select the entire paragraph. Click five times very fast to select all the text on that layer.

Taking control of your text with panels

For incredible control over the appearance of your text, use the Character and Paragraph panels. In addition to all the text attributes available on the Options bar, the panels provide a wide range of choices. With them, you can customize the general appearance of the text or apply sophisticated typographic styling. The Character and Paragraph panels can be shown and hidden by clicking the Panels button near the right end of any type tool's Options bar or through the Window menu.

You can use the Character panel to edit a single selected character, a series of selected characters, or the entire content of a type layer. Figure 12–10 shows what you face when "building character" using this panel.

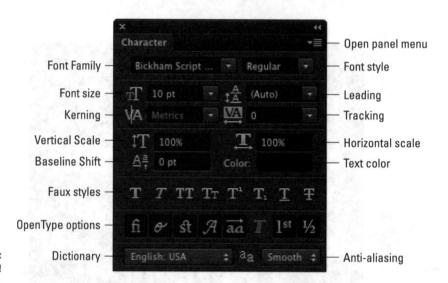

FIGURE 12-10: More choices!

When an OpenType font is selected in the upper-left field, the Character panel offers OpenType options as buttons. Which buttons are grayed out and which are available depends on which features are built into that particular OpenType font.

Unless you're a typographer, a number of the fields in the Character panel might require explanation:

>> Leading: Leading (pronounced *LED-ding* rather than *LEED-ing* and which refers to the lead strips of metal that typesetters used to place between lines of type) is the vertical space between lines of text. Generally, you'll leave Leading set to Auto. However, you can select one or more lines of text (select the whole line) and change the spacing. Adding more space gives the text an airy, light appearance. Reducing the leading tightens up the text, which enables you to fit more lines in the same area.

- **>> Kerning:** The space between two characters is determined by the kerning built into a font. You can, however, override that spacing. Click with a type tool between two letters and then change the setting in the Kerning field to change the distance between the letters. You might, for example, want to reduce the kerning between a capital *P* and a lowercase *o* to tuck the second character protectively under the overhang of the taller letter. This can produce a cleaner and better-connected relationship between the two characters.
- >> Scaling: Vertical and horizontal scaling modifies the height and width of the selected character(s). You'll find this useful primarily for customizing short bits of type rather than long chunks of text.
- Baseline Shift: Produce subscript and superscript characters, such as those used in H₂O and E = mc², with the Baseline Shift field. It's generally easier to use the Superscript and Subscript styles (see the next bullet on faux styles).
- >>> Faux Styles: Use faux styles to apply the appearance of a character style, even when they're not built into the font. From the left, as the buttons show, the available faux styles are Bold, Italic, All Caps, Small Caps, Superscript, Subscript, Underline, and Strikethrough. Select the character or characters to which you want to apply the style, and then click the appropriate button or buttons. Generally speaking, if a font offers a specific style on the Font Style menu, you'll use the font's built-in style rather than the faux style. Remember that you can't use Faux Bold when you want to warp text.
- >> OpenType Options: OpenType fonts, which can include many more glyphs (characters) than can TrueType or Type 1 fonts, may include a number of special features, including (from left) Standard Ligatures, Contextual Alternates, Discretionary Ligatures, Swashes, Stylistic Alternates, Titling Alternates, Ordinals, and Fractions. If you type certain character combinations, a single character, more visually pleasing, will be substituted. Not all OpenType fonts include all options.
- **>>> Dictionary:** Photoshop has more than 50 dictionaries built in, including three different English dictionaries (USA, Canadian, and UK). And, wonderfully or confusingly depending on your personal linguistic talents, you can assign dictionaries on a word-by-word (or even character-by-character) basis. You could, for example, insert a *bon mot* into the middle of your text in the language of your choice, assign the appropriate language dictionary, and not have that phrase trigger an alert when you run a spell check (which you do by choosing Edit ♣ Check Spelling).

If you click in your image window and start typing but no characters appear, check the Layers panel to make sure no layer is hiding your type layer and verify in the Options bar that your text color isn't the same as the background over which you're typing. If neither of those factors is the problem, it's likely an invalid setting in the Character panel (perhaps Baseline Shift). Press the Escape key, and then right-click on the Type tool icon at the left end of the Options bar and select Reset Tool.

You'll probably find yourself using certain sets of options pretty regularly in Photoshop. Luckily for you, you don't need to make changes on the Options bar and Character panel every time you want to, for example, add headlines or titles in Minion Pro Bold, 24 pt, no anti-aliasing, tracking +180, faux bold, with standard ligatures. Set up the options once and then click the Create New Tool Preset button in the panel at the left end of the Options bar, as shown in Figure 12–11. The next time that you want those specific text attributes, select the preset from that list or the Tool Presets panel, and you're ready to type! (Also take a look at the "Working with Styles" section, later in this chapter.)

FIGURE 12-11: Tool presets can save you lots of time.

The Paragraph panel is used, not surprisingly, with paragraph type. The alignment options that you see in the upper left of the Paragraph panel in Figure 12-12 can be applied to both point type and type on a path, but you can usually access your alignment options much more easily from the Options bar.

I use the term *type container* when I discuss the Paragraph panel and paragraph type. Think of it as a rectangular column of text, with the words flowing from line to line,

FIGURE 12-12: Most of this panel is only for paragraph type.

just as they do when you compose email or use a word processor. You drag a type tool to create the rectangle, and then you type inside that rectangle. In contrast, when you simply click a type tool and start typing, you need to press Return (Mac) or Enter (Windows) at the end of each line.

You can find specific information about some of these options later in the chapter (when I discuss paragraph type), but here's a quick look at the choices in the Paragraph panel:

>> Alignment: As the text flows from line to line in your type container, the *alignment* option determines how the lines will stack. You can align the text for

- a straight left edge or a straight right edge, or you can have the lines stack centered upon each other.
- >> Justification: Unlike *alignment*, which balances one margin of a paragraph, *justification* equalizes both the left and right margins of a paragraph. As you can see by the icons, the difference among the four options is the last line in the paragraph. That last line can be aligned left, centered, aligned right, or stretched to fit from left to right (called *full justification*).
- >> Indent Margins: Paragraphs of text can be indented from the left margin or the right. Even if you have only a single word selected, the entire paragraph is indented. Harkening back to that last term paper you wrote (whenever that might have been), think in terms of a block quote. You can also use negative numbers in the Indent Margin fields, which extends the paragraph beyond the margin.
- >> Indent First Line: You can indent the first line of your paragraphs (or extend the first line to the left past the margin with a negative value) without having to press the Tab key. The option can be set before you start adding text and is applied to each paragraph.
- >> Space Before/After: When your type container includes multiple paragraphs (created by pressing the Return/Enter key), you can specify the distance that's automatically added between them. Rather than pressing the Return/Enter key an extra time between paragraphs, set the spacing in the Paragraph panel.
- >> **Hyphenation:** If you're using justification rather than alignment, I recommend keeping the Hyphenate check box selected. When words at the ends of lines of justified type aren't hyphenated, the spacing within the lines can get rather messy. If you don't like the look of hyphens along the right margin, deselect the Hyphenate check box or change the hyphenation settings, as described later in this chapter.

Keep in mind that after you drag a type tool to create a type container, you can have as many paragraphs as fit. When you reach the end of a paragraph, press Return/Enter. A new paragraph is created within the type container. Consider the type container to be a column of text, such as you'd see in a newspaper, magazine, or newsletter.

The panel menus — even more options

Like most of Photoshop's panels, clicking the Menu button in the upper-right corner of the Character or Paragraph panel opens the Panel menu, which holds a cornucopia of options you probably never need to see. (Consider this: If it were a *really* important option, it would be easier to get to, wouldn't it?) Not all menu

options are available for all fonts. Some of the options are merely command forms of the panel menus (such as the faux styles). A number of the options apply only to *OpenType fonts*, which include a much larger selection of *glyphs* (characters) than do other fonts.

Here are a couple of panel menu options with which you should be familiar:

- >> Fractional Widths: When selected, Photoshop uses this option to adjust the spacing between letters on an individual basis. Will you or I spot the difference? Not with large type, but if you're creating small text (especially for the web or smart devices), deselect this option. How small is small? Generally 10 points or smaller.
- >> System Layout: Unless you need to match the appearance of text in TextEdit for Mac or Windows Notepad, leave this option deselected. When might you need it? When designing interface items for a program or game.
- >> No Break: When working with paragraph type, you can select one or more words and choose No Break to prevent them from being hyphenated. You might want to do this with words that are difficult to recognize when split between two lines.
- >>> Roman Hanging Punctuation: Found on the Paragraph panel menu, this option permits the smaller punctuation marks located at the left and right margins of justified text to hang out past the margins. When commas and the like are outside the margin, the margin itself has a cleaner look. Don't use this option if your layout can't handle text that extends past the edges of your column.
- Adobe Composer: This choice is actually quite simple: Single-Line Composer looks at one line of type to determine hyphenation. Every-Line Composer looks at the entire block of text, generally producing a more pleasing appearance.
- >> Reset (panel name): If you're seeing some strange behavior from your type tools, you might want to invoke the Reset Character and Reset Paragraph commands. They restore the settings in their respective panels to the defaults, eliminating any errant setting that might be causing the problem.

Remember that you can right-click the tool icon at the left end of the Options bar and select Reset Tool (or Reset All Tools) to immediately return to the tool's default settings. If the Type tool doesn't seem to be working correctly, reset and then reselect your options.

Working with Styles

The Character Style panel is used to define a character style based on the character format (font, size, style, and so on), the advanced format (scaling, baseline shift), and OpenType features (when working with an OpenType font, of course). Later, even in another document, you can load and apply the character style and instantly reformat the selected text in the style as defined. A paragraph style, created using the Paragraph Style panel, includes all the features found in a character style, plus paragraph-specific options, such as indentation, composition, justification, and hyphenation.

After applying a character style or paragraph style, you can select some or all of the text and make changes to any character or paragraph attribute. Keep in mind this hierarchy: Any attribute you define after assigning a style trumps the attribute as defined in that style. If both a paragraph style and a character style are applied to the same text, attributes defined in the character style trump those in the paragraph style. Say, for example, that the paragraph style specifies Minion Pro as the font and the character style specifies Myriad Pro; the text will be Myriad Pro.

You can click the New Style button at the bottom of either panel, and then double-click the style to open a panel in which you manually select each style attribute. Alternatively, create some text and with that text selected, click the New Style button. The new style will use the attributes of the selected text. If you assign a style and then manually make changes to attributes, a small plus sign appears next to the style name in the panel. Later, if desired, click the left button at the bottom of the panel to restore the attributes with which the style was defined. The second button at the bottom of the panels redefines the style, incorporating those attributes you manually changed.

Styles are stored within a document saved in the PSD (Photoshop) format. For example, if you have styles in Document-1.psd that you'd like to use in Document-2.psd, here's what you would do: Open Document-2.psd, open the appropriate styles panel, select the styles panel menu command Load Styles, navigate to and select Document-1.psd, and then click the Open button.

You may never use the Character Styles and Paragraph Styles panels, especially if you already have numerous Type tool presets, but they are a very powerful way to speed formatting of text — and to ensure consistency from word to word, paragraph to paragraph, and project to project.

ADOBE'S FIND AND MATCH FONT FEATURES

You receive a document or template from a colleague or client and it uses fonts that you don't have installed on your computer. Such a situation used to be a nightmare: searching for the font, purchasing, downloading, installing, restarting the computer, reopening Photoshop, reopening the document. Not anymore! Now Photoshop will automatically identify the missing fonts, download them from Adobe (assuming you're online at the time), install them, and update the font layers. Did I mention "automatically"? And because you have a Creative Cloud subscription, the Adobe fonts are free. What if the missing font is not an Adobe font? If you don't need to edit the text, no problem. If you do need to edit the text that uses a non-Adobe font, you can replace it with the most appropriate Adobe font.

How about those wonderful clients who bring in an advertisement clipped from a magazine to show you the absolutely-positively-most-perfect-font-ever for their new project, and you have absolutely no idea what font that might be? You open Photoshop, select the Type tool, open the Font menu, and scroll down the seemingly endless list of the word *Sample* displayed in different fonts, trying to find the closest match. (Remember that you set the size of the "Sample" in the Type > Font Preview Size menu.) No matter how close you think you get to matching the font, the client isn't quite satisfied. Surprise!

Adobe made this situation easier. You scan the sample of the unidentified font, use a selection tool to encompass a good sample of the font, and then go to Type \(\tilde{\to}\) Match Font. After a quick analysis, the dialog box shows you similar fonts, both on your computer and available to download from Adobe. One little note: If the type overlays a very complex or busy background, Match Font may have trouble identifying which pixels are the font and which are the background pattern. You can use Select \(\tilde{\to}\) Color Range to isolate the font (if the color differs from the background) or perhaps use Levels or Hue/ Saturation to mute the background.

Putting a picture in your text

Enough of that heavy stuff for now — time to take a look at one of the coolest things that you can do with text. Here's an easy way to create a text-shaped picture, one that's fully editable.

- 1. Using File ♥ Open or by double-clicking an image file, open a photo in Photoshop.
- 2. If the Layers panel has a layer named Background, click the Lock icon to the right of the layer name to unlock it. If the image has multiple layers, choose Layer Aerge Visible.

You want to work with a single regular (not background) layer for this project. Background layers don't support transparency, and no layers can be placed below a Background layer.

- 3. Add your type with the Horizontal Type tool.
- 4. Click the type layer in the Layers panel and drag it below the image layer.
- In the Layers panel, Option+click (Mac) or Alt+click (Windows) the line between the two layers.

The two layers are joined together, as shown in Figure 12-13. When you clip two layers, the lower layer serves as a *mask* for the upper layer. The upper layer is visible only where the lower layer has pixels and adopts the opacity of those lower-layer pixels.

6. Finish the image with a layer style (applied to the lower layer) and any other artwork that the project requires.

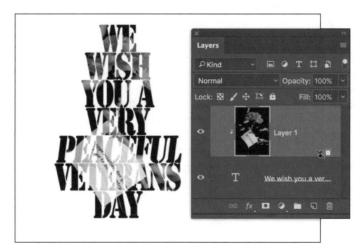

"Clip" the upper layer to the lower layer.

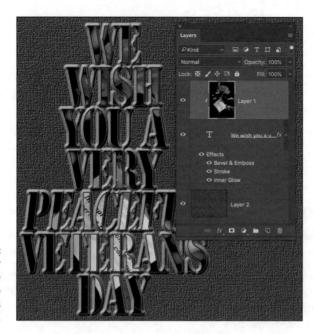

Add layer styles to the lower layer so that the effects are visible.

Creating Paragraphs with Type Containers

Although the vast majority of the text that you add to Photoshop artwork is *point* type — that is, type that exists on just one or a couple of lines — you'll certainly find situations in which you need to use paragraph type in a type container. The primary advantage of using paragraph type is *word wrap*. While you type, the text automatically starts a new line every time it reaches the margin.

"Why is that a big deal?" you might ask. "I don't mind pressing the Return or Enter key at the end of each line." Ah, but consider the ever-present (when you type like me) typographical error! Or what if the very first sentence of your manual-Return paragraph is missing a word? To insert that word and maintain a visually pleasing right margin, you'd need to go back and redo every line of type. With paragraph type, the content of each line automatically adjusts as you insert that forgotten word.

The difference between point type to create a column of type and paragraph type is comparable with the difference between a typewriter and a word processor. (If you remember using Wite-Out and Liquid Paper on typewritten pages, raise your hand, but not for very long — I don't want to tire you out.)

Adding a type container is simple. Click and drag with the Horizontal Type tool (or, in some rare cases, you might want to use the Vertical Type tool), and then start typing. (Keep in mind that a paragraph of text created with the Vertical Type tool has the first line along the right margin and subsequent lines are added to the left, making for rather difficult reading in Western languages.) The type automatically starts the next line as soon as you press enough keys to reach the far margin. You can keep typing until you fill the type container. Press Return or Enter whenever you want to start a new paragraph within your type container.

Remember what I said near the beginning of this chapter about the *Lorem ipsum* placeholder type? It's just there to enable you to visualize the font and various options before you start typing. Adjust the variables for your text and then start typing, and it automatically vanishes. (And if you hate seeing that placeholder text, disable it in Preferences Type.)

You can also copy/paste text from a word processing or text-editing program. You can, for example, open a Microsoft Word document in Word, select the text that you want by clicking and dragging, and then choose Edit 🖒 Copy to place the text into the computer's memory (on the *Clipboard*). Switch to your Photoshop document; select a font, font size, and other attributes (or select a character style or paragraph style after pasting); drag a type container; and then choose Edit 🖒 Paste (or the assigned keyboard shortcut) to place your text inside the container. When the text you need already exists, you not only save time by using copy/paste, but you also eliminate the possibility of introducing typos.

But what if you have more text than fits in the type container? Unlike Illustrator and InDesign, you can't *link* two type containers, enabling the excess text to automatically move to the next container. Photoshop does, however, remind you that your text doesn't fit by showing you a symbol in the lower-right corner of the type container's *bounding box* — the dashed line surrounding the type container. As you can see in Figure 12–15, the lower-right anchor point of the bounding box has a plus sign in it.

When you have more text than the type container can hold, you have a number of options:

- **Enlarge the type container.** Click one of the bounding box's anchor points and drag to increase the size of the type container. Making a type container a little bit wider often gives you an extra line or two of text at the bottom.
- **>> Shrink the font.** Select the text with a keyboard shortcut (ℜ +A/Ctrl+A) and select a smaller font size on the Options bar.

This is placeholder text, filler words and sentences used when preparing a layout before the actual text is available. Page layout programs, such as Adobe InDesign, generate random nonsense or use prepared placeholder text that you can insert into a text frame. It doesn't really matter what the placholder text is about, as long as it uses normal-length words and sentences so that is looks like real text. That lets you better visualize how the layout will look when the real text is later added to the type container.

While you could theoretically use a single word, copied and pasted repeatedly to fill the type container, I prefer to copy a section of text from a document, any document, and then through the Type tool to create a container in which I can then paste. For a project such as this, however, the pasted text must be non-controversial and not touch on such subjects as religion, politics, and the New York Yankees.

You can paste a couple of paragraphs of type repeatedly to fill your type container, but I suggest that you have at least two complete paragraphs before you start repeating the text over and over again. Generating random text or using a prepared placeholder text file is convenient and works great in a page layout program. Random text generated by InDesign may appear to be in a foreign language, but is actually just nonsense, strings of random letters, in random lengths, with periods at the ends of the "sentences" and line breaks at the 2nd, of "paragraphs,". If you, look, closely at random places.

line breaks at the at random place

FIGURE 12-15:

A plus sign in the lower-right anchor point warns you that text doesn't fit in the type container.

- >> Decrease the space between lines. Select the text and decrease the leading the amount of space between lines of type in the Leading field found in the upper right of the Character panel. By default (the Auto setting in the Leading field), Photoshop uses an amount equal to 120 percent of the font size. You can often reduce the leading to 1 or 2 points larger than the font size before you start overlapping lowercase letters with descenders (g, j, p, q, and y) and uppercase letters on the line below.
- >> Edit the text. Rephrase the text, using fewer words to convey the same message. If you're not the author, however, this option might not be available.

You can also use a path created with any of the Shape tools or the Pen tool as a type container. Select the tool, use the Options bar to set it to create a path (rather than a shape or pixels), then drag the tool in the image window. With that done, switch to the Type tool, click within the path, and add your text.

Selecting alignment or justification

Photoshop gives you several options for controlling the appearance of your margins. In the "Taking control of your text with panels" section, earlier in this chapter, I outline a number of options that you can find on the Paragraph panel menu.

But let me go into more detail about a couple of options that you have when adding paragraph type.

Perhaps the most important decision (other than font and font size) that you make when preparing paragraph type is a choice of alignment or justification. When text is *aligned left*, the left margin is perfectly straight, and the right margin is *ragged*, with each line ending where it ends, without any relationship to the lines of type above and below. A column of text that's *aligned right* has a clean right margin and a ragged left margin. If you choose *center aligned*, the middle of each line of text is centered. Take a look at Figure 12–16 for a visual comparison.

his text is left-aligned. When a column of text is Since we're not used to center-aligned, the middle of each line of seeing a ragged left margin, right alignment Left-aligned text has a straight margin along the left edge of the text (the makes the text a bit more text is stacked up. Both left margin), aligning the first character of each line. the left and the right difficult to read. Perhaps margins are ragged. Well, if each line is exactnot as difficult as cen-That is, of course, where the term left aligned origi-nates. If you look around you (not this minute, just in ter-aligned text, but a right-aligned column of text makes the eye jump a bit as it moves from line to ly the same length, the margins will appear to be justified, but that's not general), you'll see quite a bit of left-aligned text. likely to happen. Center alignment is best used line. Use right alignment for special effect and to Some magazines, many flyers, and lists of all sorts for such attention-grabbalance certain two-colbing purposes as adverumn layouts that have a tisements. Can you are left-aligned. As are the graphic or other non-text imagine trying to read an entire novel with each page centered-aligned? paragraphs in many books! element between them. It's not at all uncommon to Do not, however, punish have a ragged right margin. Left-alignment is perfectly acceptable for your reader by using It might drive you com-pletely bonkers! column after column of right-aligned text. I might many projects. be one of those readers.

FIGURE 12-16: Compare the left and right margins of each column of text.

Unlike alignment, justification gives you straight margins on both sides of the column of text. The four justification options to the right at the top of the Paragraph panel (see Figure 12–12) differ only in how they treat the last line of a paragraph. The last line can be independently aligned left, center, or right; or it can be fully justified, spreading the last line from margin to margin. You shouldn't use the fourth option unless that last line (of every paragraph) is rather full because it looks rather strange when just a couple of words are stretched edge to edge.

Ready, BREAK! Hyphenating your text

When a word is too long to fit on the current line of text, either it can be moved to the beginning of the next line (wrapped) or it can be broken into two parts: one finishing the upper line and the other starting the next line (hyphenated). The default hyphenation settings are shown in Figure 12–17.

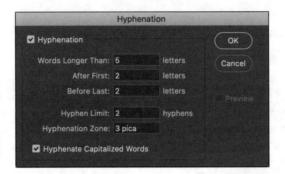

PIGURE 12-17:
Default
hyphenation
values give you
good results
and a pleasing
appearance.

The hyphenation options are for the truly geeky, <code>my-typography-is-my-life</code> types. The defaults are excellent and can suffice for all but the most precise layouts (which you should be doing in InDesign). If you want to fine-tune how hyphenation is applied (or have far too much time on your hands), select Hyphenate from the Paragraph panel menu to open the options shown in Figure 12–17. The Hyphenation check box (upper left) activates/deactivates hyphenation. The top three fields govern which words to hyphenate and what limits to place on the hyphenation. (Think of the second and third fields as <code>Hyphenate or cram into the line without hyphenating.</code>) The lower two fields control the appearance of the margin, limiting the number of consecutive lines that can be hyphenated and the maximum distance from that margin that a hyphen can be placed.

Shaping Up Your Language with Warp Text and Type on a Path

You can change the line along which your type flows either by using the Warp Text feature or by typing on a path. Type warping uses predefined shapes to which your type is formed (and can be used with both point and paragraph type), and typing on a path uses a custom path (and is used only with point type).

Warping type and placing type along a path are great ways to spice up your message as long as you don't overdo it and make the message illegible or distract from the overall appearance of your artwork. Warp Text is a quick and easy way to bend text, whereas placing type on a path is a more complex — and more controlled — technique.

Applying the predefined warps

With a type layer active in the Layers panel and a type tool selected, click the button to the right of the color swatch on the Options bar. That opens the Warp Text

dialog box, as shown in Figure 12-18, in which you choose both the distortion you want to apply as well as the settings.

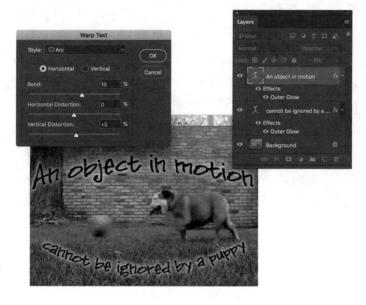

FIGURE 12-18: The illustration uses two separate type layers, each with its own Warp Text settings.

Photoshop offers 15 different Warp Text presets, each of which you can customize by dragging any of three sliders. Negative numbers can be used, too, reversing the warp. You can also set the Bend slider to 0 and adjust the lower two sliders to create the appearance of depth or perspective for a type layer, but keep in mind that the Horizontal and Vertical buttons aren't available for some of the styles. Warp Text is one of Photoshop's truly fun features. The best way to become familiar with it is to open the dialog box and test-drive each of the variations. And don't forget to try the Horizontal and Vertical buttons when they're available!

Customizing the course with paths

You can use the shape tools or the Pen tool to create a custom path along which you add your text. (You find full information about paths and shapes in Chapter 10.) To add type along a path, simply select the Horizontal Type or Vertical Type tool, click the path, and type. The flow of the type from the point on the path where you click is determined by the alignment option that you select from the Options bar or the Paragraph panel. If the text is left aligned, characters are added to the right of the point where you click (called the *point of origin* for the type). Left alignment is great when adding type along an open path, such as the upper path in Figure 12–19. You might, however, want to choose center alignment when adding type along the top of an arc or circle, so you can click on the top of the arc and not worry about dragging the type later to center it.

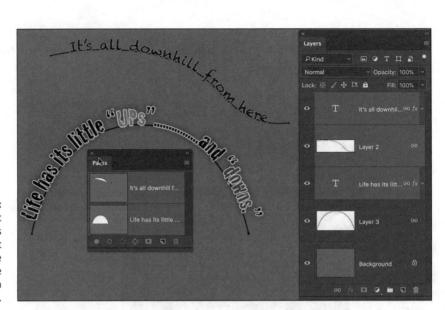

FIGURE 12-19: Text alignment determines where the text goes from the point where you click on the path.

If you want type to go in two different directions — say, pointed upward along both the top and the bottom of a circle — and you want the appearance to be uniform, with the same radius for each arc of text, create two separate paths and two separate type layers, as shown in Figure 12-20.

FIGURE 12-20: Sometimes you need to create two separate type layers, using two separate paths, to achieve your artistic goals.

After you add your type to the path, you can press the # /Ctrl key and reposition the type along the path by dragging. When you press and hold # /Ctrl, the type tool's cursor changes to an I-beam cursor with a heavy black arrow on either side,

indicating which way you can drag the type. You see the type's point of origin as a hollow diamond on the path (not to be confused with the hollow squares that represent the path's anchor points). Figure 12–21 gives you a zoomed-in look at the converted cursor and a comparison of the point of origin diamond and the anchor point square. Note, too, that not only can you drag type along a path, but you can also drag it *across* the path, flipping over the type.

After flipping type across a path, you might need to adjust the *tracking* (the space between characters), which is the second field from the top on the right in the Character panel. And don't be afraid to click in the type and press the spacebar a few times to adjust the placement of words along the path.

FIGURE 12-21: When you drag the cursor across the path a short distance, type flips over.

and the second s

- » Discovering the painting tools
- » Traversing the panels and selecting colors
- » Painting the fine-art way with specialty tips and tools
- » Adding colors to artwork in other ways

Chapter **13**Painting in Photoshop

ainting. The word evokes images of brushes and palettes and color being precisely applied to canvas. Or, perhaps, images of drop cloths, ladders, rollers, and buckets — color being slopped on a wall and spread around. It doesn't generally bring to mind digital image editing. But painting certainly has a place in your arsenal of Photoshop skills, even if you never create an image from scratch.

In addition to painting landscapes and portraits (which you certainly can do in Photoshop, if you have the talent and training), you can use Photoshop's painting tools for a variety of other tasks. For example, you can paint to create masks and layer masks, adjust tonality or sharpness in specific areas, repair blemishes and other damage in an image — even to create graphic elements and special effects.

In this chapter, I concentrate on those editing-related painting skills and give you a quick look at painting with the Mixer Brush tool and the airbrush and *erodible* brush tips (like a pencil that eventually needs sharpening). I introduce you to the basic concepts of painting in Photoshop and also walk you through the basic brush-related tools and the Brush and Brush Presets panels, concentrating on those features that you most likely need (as well as a few of the other, more artistic features). To wrap up the chapter, I give you a look at other ways to add areas of color to your images, including the very useful Gradient tool.

Discovering Photoshop's Painting Tools

Nothing in Photoshop gives you more precise control of color in your image than using the Pencil tool with a 1-pixel brush. Remember that your image consists of a whole lot of little colored squares (pixels) and that the color of those individual squares is what produces the appearance of a tree or a sunset or even good ol' Uncle Bob. If you zoom in really close on an image, you can paint pixel by pixel — you could even create an entire image, one pixel at a time! You are, however, much more likely to use the Brush tool with a much larger brush tip to add strokes of color, rather than working one pixel at a time.

As you work in Photoshop, you'll also find many very important roles for the brush-using tools other than painting imagery. From touching up dust and scratches in a scan to removing distant power lines from a photo to perhaps adding wispy hairs to soften the outline of a head, you have lots of reasons to paint in Photoshop (many of which you can read about in Chapters 8 and 9). When you're capable and confident using the Brush tool, you might even find it the best way to make selections in your image. Selections with the Brush tool? That's right — painting in an alpha channel creates or refines a saved selection. (You can read about alpha channels in Chapter 7.) Photoshop even has a brush-using tool that you can use to make selections directly. The Quick Selection tool, like the Magic Wand, selects areas of similar color. However, instead of Shift+clicking in a variety of areas with the Magic Wand to add to your initial selection, you simply drag the Quick Selection tool. The brush diameter, selected on the Options bar, tells Photoshop the size of the area you want to search for similarly colored pixels.

In addition to the Quick Selection tool, you have 19 other tools that use brushes available in Photoshop. Here's a quick look at the various capabilities of those tools:

- >> Painting tools: The Brush, Pencil, and Mixer Brush tools (all discussed a bit later and in more depth) add the selected foreground color to the active layer as you click or drag the tool.
- **Eraser tools:** These tools (also discussed in more depth in pages to come) can make areas of a layer transparent or can paint over pixels with the current background color (if the layer doesn't support transparency).
- >>> Healing tools: The Spot Healing Brush and Healing Brush are designed to repair texture, like smoothing wrinkles or adding the appearance of canvas. With the Healing Brush, you first designate a source point an area from which you want to copy texture by Option/Alt+clicking and you then drag the brush over the area targeted for repair. The Spot Healing Brush, on the other hand, automatically samples the texture around an area and makes the target area match its surroundings. With the Content-Aware option, this tool can better match the healed area to the surrounding image. Quite cool!

- >> Color Replacement tool: Nested with the Brush and Pencil, the Color Replacement tool replaces the color over which you drag with the foreground color. Remember that, by default, the Color Replacement tool alters only the color, not luminosity, so painting with black over pink gives you gray rather than black. From the Options bar, you can set the tool to change luminosity rather than color to darken or lighten, or choose to match hue or saturation.
- >> Stamp tools: The Clone Stamp tool, unlike the Color Replacement tool or the Healing Brush, doesn't copy an attribute (such as color or texture), but actually copies pixels. It's like having copy/paste in a brush. Option/Alt+click a source area and then move the cursor and drag where you want to copy those pixels. It's powerful! The Pattern Stamp tool paints with a selected pattern, using the blending mode and opacity that you designate on the Options bar. The Pattern Stamp tool is sometimes a good way to add texture selectively.

When working with the Clone Stamp tool and the Clone Source panel, you can specify and move between up to five different source points. You also have the option of showing an overlay, which lets you see in advance what dragging the tool will do to your artwork.

Tucked in with the focus tools is the Smudge tool. Click and drag to smear pixels along the path. (I find the Smudge tool especially useful for dragging out wispy hairs from heads that appear perhaps too well defined and smooth.)

>> Toning tools: The Dodge tool lightens, the Burn tool darkens — and if you use the defaults, they do it too much! When using these tools to adjust luminosity in your image, it's best to start with an Exposure setting of about 15% and paint carefully, perhaps repeatedly, rather than making a huge change with Exposure set to 50%.

The Sponge tool is nested with the Dodge and Burn tools. Use it to either increase or decrease saturation as you drag. (Decreasing saturation with the Sponge tool is a great way to create an image that's partially grayscale.)

The Healing Brush and the Clone Stamp have a button to the right of the Sample menu on the Options bar. When the Sample pop-up menu is set to All Layers or the Current & Below option, that button gives you the option of ignoring adjustment layers. You might want to use this option if, for example, you're cloning or healing from multiple layers below an adjustment layer to a new layer that itself would be affected by the adjustment layer. This prevents the adjustment from being applied twice.

Painting with the Brush tool

You control where the Brush tool works by selecting a brush tip of a particular size, shape, and *hardness* (the fuzziness, or lack thereof, along the edges of a round brush tip). Remember, too, that you can use the Brush and other painting tools to create subtle changes in existing colors. By selecting an appropriate blending mode and opacity, you can mix the painting color into the existing colors in your image. Make these basic decisions from the Options bar, shown for the Brush tool in Figure 13–1.

FIGURE 13-1:

Make the primary decisions about painting tool behavior from the Options bar.

As you see in Figure 13–1, the Options bar gives you access to a miniature Brush Settings panel (click the arrow to the right of the brush size) from which you can pick a brush tip, change its size, orientation, roundness (some brush tips), and adjust the hardness of the brush's edges. (Only round brush tips use the Hardness adjustment on the Options bar.) You also have a handy button just to the right of the arrow button to toggle the visibility of the full Brush panel on the Options bar. The five sample lines to the right show Hardness, from 0% to 100% in 25%

increments, all using a 40-pixel brush. The Brush tool can use any brush tip that you have in the Brush panel — and, as you can read later in this chapter, you can customize the brush tip in a variety of ways.

The default sets of brushes available in the Brushes panel and through the Options bar are pretty limited and specialized. Open the panel's menu by clicking the button in the upper-right corner and selecting Legacy Brushes to add dozens of very useful brushes to the panel. You can see some of the legacy sets in Figure 13–1.

You're actually ready to paint in Photoshop already! Select a foreground color, select the brush size that you want, decide how hard or fuzzy the edges should be, change the blending mode and opacity (if desired), and drag the tool in your image. (And, perhaps best of all, no turpentine needed for cleaning up — just switch tools in the Toolbox.)

As you work with the brush-using tools, always remember that the selected brush tip is applied as a series of individual impressions, called *instances*. Consider an instance to be a single impression of the brush tip, like tapping a pen once on a piece of paper — it leaves a single dot. Take a look at the outer borders in Figure 13-2. Changing the brush tip's Spacing value in the Brush Settings panel shows how instances appear. In the upper left, the spacing is set to the default 25% and a continuous line results. To the upper right, Spacing is set to 67%, and the individual brush tip instances are visible as overlapping circles. To the lower left, Spacing is set to 133% — this is a setting that you might use for a dotted or dashed line — and each brush tip instance is visible individually.

FIGURE 13-2: Changing the Spacing makes the individual brush tip instances visible.

If you need to paint with one continuous line and no *instances* (such as when doing delicate touch-up work in a layer mask), deselect the Spacing option in the Brush panel. Even when zoomed in, you won't see the brush tool "jump" from one instance to the next.

If you know you have the cursor set to show the brush tip, but you're seeing the tiny little crosshairs instead, check the Caps Lock key on your keyboard. Caps Lock toggles between precise and brush-size cursors for the brush-using tools. (During the discussion of Photoshop's Preferences in Chapter 3, I show a comparison of the three brush cursor options in Figure 3-10.)

When you change the Brush tool's Opacity setting on the Options bar, you change the appearance of the stroke as a whole. Changing the Flow setting (also on the Options bar), on the other hand, changes the amount of color applied with each instance of the brush tip. When the flow is reduced and the spacing is set to less than 100%, the overlapping area of each brush instance appears darker (or lighter when painting with, for example, white on black). To the right of the Flow field

is the Airbrush button. When the Airbrush is on (the button turns dark), the Flow value takes on more meaning. As you paint with the Brush in Airbrush mode with a reduced Flow setting, pausing the cursor with the mouse button down allows color to build up (become more opaque) as if you were using a real airbrush. You can use the Airbrush both as a traditional airbrush artist and to simulate spray paint. You can see both in Figure 13–3.

FIGURE 13-3: Airbrushing and spray painting with the Airbrush option for the Brush tool.

To the right of the Airbrush button you find the Smoothing field and the related gear button to control smoothing options. When painting curved strokes, the Smoothing option helps keep the stroke from becoming too sharp as you change directions. Depending on your input device and the amount of smoothing you've selected, you may see a slight delay onscreen as you paint. You also have a Smoothing pane in the Brush Settings panel (discussed in the "Working with Panels and Selecting Colors" section).

TIP

With a video card that supports OpenCL drawing, you can rotate the image onscreen for easier painting — not rotate the canvas, but rotate the onscreen image! This can be great for fine-tuning a layer mask or doing other delicate painting tasks. Using the Rotate View tool (nested with the Hand tool) permits you to arrange the artwork for your most comfortable painting stroke. While dragging the Rotate View tool, an onscreen compass's red arrow always orients you to the top of the

image. When you want the image oriented back to the top, simply double-click the Rotate View tool icon in the Tools panel.

Adding color with the Pencil tool

The Pencil tool differs from the Brush tool in one major respect: Regardless of the Hardness setting in the Brush panel, the Pencil tool always uses a hardness value of 100%. With the Pencil tool active, the Options bar offers the miniature Brush panel, a choice of blending mode and opacity, as well as an Angle field for nonround brush tips. To the right is a special button named Auto Erase (when using the narrow Options bar, it doesn't have a name). When selected, this option doesn't actually erase, but rather lets you paint over areas of the current foreground color using the current background color. Click an area of the foreground color, and the Pencil applies the background color. Click any color other than the foreground color, and the Pencil applies the foreground color.

Removing color with the Eraser tool

Another of your primary painting tools is the Eraser. On a layer that supports transparency, the Eraser tool makes the pixels transparent. On a layer named Background, the Eraser paints with the background color. On the Options bar, the Eraser tool's Mode menu doesn't offer blending modes, but rather three behavior choices. When you select Brush (the default), the Options bar offers you the same Opacity, Flow, and Airbrush options as the Brush tool. You can also select Pencil, which offers an Opacity slider, but no Flow or Airbrush option (comparable to the actual Pencil tool). When Mode is set to Block, you have a square Eraser tool that erases at the size of the cursor. (When you click or drag, the number of pixels erased is tied to the current zoom factor.) Regardless of which mode is selected, the Options bar offers one more important choice: To the right of the Angle field, you find the Erase to History check box. When selected, the Eraser tool paints over the pixels like the History Brush, restoring the pixels to their appearance at the selected state in the History panel.

A couple of variations on the Eraser tool are tucked away with it in the Toolbox, too. The Background Eraser tool can, in fact, be used to remove a background from your image. However, it's not limited to something in your image that appears to be a background. Remember that digital images don't really have backgrounds and foregrounds or subjects — they just have collections of tiny, colored squares. What does this mean for using the Background Eraser? You can click and drag on any color in the image to erase areas of that color. You can also elect to erase only the current background color and designate the foreground color as protected so that it won't be erased even if you drag over it.

The Magic Eraser, like the Magic Wand selection tool (see Chapter 7), isn't a brush-using tool, but this is a logical place to tell you about it. Click a color with the Magic Eraser tool, and that color is erased, either in a contiguous area or throughout the image, depending on whether you have selected the Contiguous option on the Options bar. And, like the Magic Wand, on the Options bar you can set the tool to work on the active layer or all layers, and you can also set a specific level of sensitivity (Tolerance). Here is the one difference between the two: The Magic Eraser is, in fact, a painting tool in that you can set an opacity percentage, which partially erases the selected pixels.

Working with Panels and Selecting Colors

To select and customize brush tips, Photoshop offers the Brush Settings and the Brushes panels (both shown in Figure 13-4). Select a brush tip in the Brush Settings panel (or in the Brush panel or on the Options bar), and then customize it to do your bidding using the options in the Brush panel.

The Brush panel's menu includes the New Brush Group command. If you often use certain brushes together and want to streamline the Brush panel to make those brushes more easily located, select the brush tips and create a group. Expand and collapse groups in the panel as desired.

You must have a brush-using tool active to access the Brush Settings panel. If the active tool doesn't use brushes, the entire panel is grayed out and unavailable. However, regardless of what tool is active, clicking a brush preset in the Brush panel automatically switches you to the Brush tool.

An overview of options

The Brush Settings panel, like the Layer Style dialog box, has a column on the left that lists options. Like the Layer Style dialog box, you mark the check box to activate the feature, but you have to click the name to open that pane in the panel. As you can see in Figure 13-4, the Brush Settings panel menu offers very few commands, whereas the Brush panel menu includes variations in how to display the panel content, some housekeeping commands for resetting/loading/saving brushes, and a list of brush sets in the bottom half of the menu.

Don't overlook those little lock icons to the right of the various pane names in the Brush Settings panel. Click the lock to preserve the settings in that pane while you switch among brush tip presets. Any unlocked attributes revert to those with which the brush tip was created. Locking, for example, Shape Dynamics retains those settings even if you switch to a totally different brush tip.

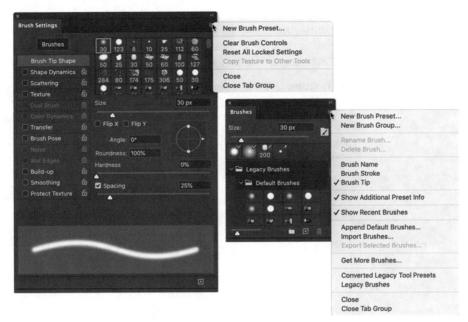

FIGURE 13-4:
The Brush
and Brush
Presets panels,
with their
panel menus,
provide lots of
options.

Here, in order, are the Brush panel panes and the options in those panes to which you should pay attention:

- >>> Brushes: This button (just above the names of the panes) opens the Brush panel, where you pick the basic brush tip shape from the brushes loaded in the panel. You can also resize the brush tip, but that's it. (Note that you can also select a brush tip in the Brush Tip Shape panel of the Brush Settings panel.)
- >>> Brush Tip Shape: Without a check box to the left or a lock icon to the right, Brush Tip Shape is the pane in which you can select and customize a brush tip. (Refer to the Brush Tip Shape pane in Figure 13-4.) This is perhaps the most important part of the Brush panel. In this pane, you can select a brush tip, change its size, alter the angle at which it's applied, change the heightwidth relationship (Roundness) of the tip, and adjust the Spacing setting.
- Shape Dynamics: Dynamics in the Brush panel add variation as you drag a tool. Say you're working with a round brush tip and choose Size Jitter. As you drag the brush tip, the brush tip instances (the individual marks left by the brush as you drag) will vary in diameter. The Shape Dynamics pane offers Size Jitter, Angle Jitter, and Roundness Jitter. Each of the "Jitters" can be set to fade after a certain number of brush tip instances or can be controlled with the stylus that you use with a Wacom tablet. Angle can also be set to Direction, which forces the brush tip to adjust the direction that you drag or the direction of the selection or path you stroke. Use Shape Dynamics to add some variation and randomness to your painting, as shown in Figure 13-5.

- >> Scattering: Scattering varies the number of brush tip instances as you drag as well as their placement along the path you drag. Like Shape Dynamics, Scattering can be set to fade or can be controlled with a Wacom tablet.
- >> Texture: Use the Texture pane to add a pattern to the brush tip, as shown in Figure 13-5. You can select from among the same patterns that you use to fill a selection. Texture is most evident when Spacing is set to at least 50%.
- >> Dual Brush: Using a blending mode you select, the Dual Brush option overlays a second brush tip. You could, for example, add an irregular scatter brush to a round brush tip to break up the outline as you paint.
- >> Color Dynamics: Using the Color Dynamics pane, you can vary the color of your stroke as you drag. This comes in most handy for painting images and scenes rather than, say, working on an alpha channel. Just as you might add jitter to the size, shape, and placement of a grass brush while creating a meadow, you might also want to add some differences in color as you drag. You could pick different shades of green for the foreground and background colors and then also add jitter to the hue, saturation, and brightness values as the foreground and background colors are mixed while you drag. (See the greenery in Figure 13-5.)
- >> Transfer: Think of this pane as Opacity and Flow litter. You can add variation to the opacity and flow settings from the Options bar to change the way paint "builds up" in your artwork.
- >> Brush Pose: When working with a tablet and stylus, this panel enables you to ensure precision by overriding certain stylus-controlled variations in a stroke. If, for example, you want to ensure that the brush tip size doesn't change, regardless of how hard you press on the tablet, open Brush Pose, set Pressure to 100%, and select the Override Pressure check box. You can also override the stylus's rotation and tilt as you paint, setting any value from -100 to +100 for both tilt axis values and 0 to 360 degrees for rotation.
- >> Other Options: At the bottom of the left column are five brush options that don't have separate panes in the Brush panel. They're take-it-or-leave-it options - either activated or not.
 - Noise: Adding Noise to the brush stroke helps produce some texture and breaks up solid areas of color in your stroke.
 - Wet Edges: Wet Edges simulates paint building up along the edges of your stroke.
 - Build-up: The Build-up check box simply activates the Airbrush button on the Options bar.

- Smoothing: Smoothing helps reduce sharp angles as you drag your mouse or stylus. If the stroke you're painting should indeed have jagged turns and angles, disable Smoothing.
- Protect Texture: The Protect Texture option ensures that all the brushes
 with a defined texture use the same texture. Use this option when you
 want to simulate painting on canvas, for example.

FIGURE 13-5:
Use jitter to add variation to the application of your selected brush tip.

When creating a dashed line or stroking a path with a nonround brush tip, go to the Shape Dynamics pane of the Brush panel and set the Angle Jitter's Control pop-up menu to Direction. That enables the brush tip to rotate as necessary to follow the twists and turns of the selection or path that it's stroking. (You'll generally want to leave Angle Jitter set to 0% so that the stroke follows the selection or path precisely.)

Creating and saving custom brush tips

You can use any artwork as a custom brush tip. With the artwork on a transparent or white background (you don't even need to make a selection), choose Edit Define Brush Preset, type a name, and click OK. Your new custom brush is added to the Brush panel. After you define a piece of artwork as a brush, you can add that image to any project with a single click or drag.

Remember that a brush tip is always grayscale, regardless of the color in the artwork from which it was defined, and that it will be used to apply the foreground color. Also keep in mind that the maximum size for a brush tip is 5,000 pixels in either dimension.

Picking a color

If you want to apply a specific color to your image with a painting tool, you have to be able to select that color, right? Photoshop provides you with a number of ways to select a color:

- >> Click a saved color swatch in the Swatches panel.
- >> Enter numeric values or drag sliders in the Color panel.
- Click a color swatch at the bottom of the Toolbox, on the Options bar, or in the Color panel to open the Color Picker.
- >> Select a sample size and specify which layers to sample on the Options bar. When set to Point Size (the default), the Eyedropper samples only the one pixel directly under the cursor. You can set the Eyedropper to set the foreground color to an average of a 3 x 3 sample to avoid having one stray pixel misrepresent the area of the image you want to sample. The sample size average can be as large as 101 x 101 pixels. (Remember, too, that you can right-click with the Eyedropper to change the sample size without having to visit the Options bar.)
- >> Specify which layers to sample on the Options bar. When working with layered documents, the Eyedropper offers a number of sampling options. You can elect to pick up the color on the currently active layer, the active layer and the layer immediately below it in the Layers panel, all layers, all layers except adjustment layers, and the current layer and the next pixel layer below (ignoring any adjustment layers in between).

The Eyedropper's Options bar offers the Show Sampling Ring option. When active and the Eyedropper is in use, the Sampling Ring is a pair of concentric circles (as shown to the upper-right in Figure 13–6). The outer ring is neutral gray to isolate the inner ring from surrounding colors. The bottom half of the inner ring shows the current foreground color, whereas the top half shows the color over which you have dragged the cursor. If you find it distracting, disable it on the Options bar.

In both the Toolbox and the Color panel, the foreground color is shown in the swatch to the upper left, and the background swatch is partially hidden behind it. Swap the foreground and background colors by pressing the X key on your keyboard. Reset them to the default black and white by pressing the D key.

In Chapter 5, I introduce the Color panel and the various ways you can define color with it. Now take a look at the Color panel's big brother, the Color Picker. (See Figure 13–6.) (If, in Preferences General, you have elected to use the system color picker rather than the Adobe version, your color picker will differ.) Note the reminder in the title bar of the Color Picker window that tells you whether you're changing the foreground or background color. (If you find that you're changing the background color when you want to change the foreground color, exit the Color Picker, open the Color panel, and click the foreground swatch.) The best way to get a feel for the incredible versatility of the Color Picker is to open it (click a color swatch at the bottom of the Toolbox or in the Color panel) and click each of the buttons to the left of the numeric fields. Each option changes how the Color Picker appears as well as how it defines color.

FIGURE 13-6: Use the Color Picker to define colors with precision. The Eyedropper's Sampling Ring is visible to the upper-right.

The default Color Picker configuration uses the radio button to the left of the H (Hue) field. It presents you with a vertical rainbow slider (the hue) and a square area that defines saturation (left-right) and brightness (up-down). Click or drag in the square area to the left and drag the slider up and down to pick a color. (Compare the two swatches to the left of the Cancel button to see the new color above the previously selected color.) If you click the button to the left of the S field, the slider shows saturation, and hue and brightness are defined in the square area to the left. Starting to see the pattern? Check out the configuration for Brightness (B)

as well as the RGB and Lab options. And note that you can type numeric values to define a color as CMYK, but there are no buttons to the left to reconfigure the Color Picker. Likewise, you can type in the # (hexadecimal) field below the B field, but you can't use it to reconfigure the Color Picker. (Hexadecimal color definition is used with HyperText Markup Language [HTML] code in web pages.)

Between the two color swatches in the top center and the buttons to the right are a pair of little icons that aren't always visible. (Check them out in Figure 13–6 if they're not currently showing in your own Color Picker.) The top warning triangle tells you that the current color can't be reproduced within your working CMYK color profile. Unless you're preparing artwork for commercial offset press, ignore it — it has nothing to do with your inkjet printer, for example. If, on the other hand, you *are* working on a press–destined project, click the swatch just below the warning triangle to jump to the nearest reproducible color.

The lower icon, a little cube symbol, lets you know that your current color isn't web-safe. Web-safe colors are the couple hundred colors that are exactly the same in the base color scheme for both Mac and Windows. If visitors to your website have their monitors — or other devices — set to show only 256 colors, everyone sees the same thing with web-safe colors. Generally, you can safely ignore the warning because the variation isn't worth worrying about. (If you do want to work with web-safe colors, click the swatch below the warning cube icon and then select the Only Web Colors check box in the lower-left corner.)

After you define a custom color with the numeric fields or by clicking in the sample colors to the left, you can easily save the color to the Swatches panel by clicking the Add to Swatches button. Should you need to reselect that specific color later, or even when working on another image, it's right there in the Swatches panel, exactly as originally defined.

Also note the Color Libraries button. Clicking that button swaps the Color Picker for the Color Libraries dialog box, in which you can select spot colors. *Spot colors*, which I explain in Chapter 5, are special premixed inks that can be specially requested when preparing a job for a commercial printing press. Adding a spot color ensures that the color will appear in the final product exactly as expected. However, because they generally require an extra pass through a press, adding spot colors increases the cost of your printing. (Remember that if you want the color to print as a spot color, you don't paint with it, but rather create a *spot channel* to identify where the spot color appears in your artwork.) Spot colors can be used to define colors for nonpress jobs, but the color is converted to your working color mode and printed with a mixture of your regular inks. Return to the Color Picker from Color Libraries by clicking the Picker button.

Fine Art Painting with Specialty Brush Tips and the Mixer Brush

Traditionally trained artists have a whole load of options available when using the Brush tool. Depending on what sort of brush tip is selected in the Brush Preset or Brush panel, the Brush panel itself changes configuration. Check out the *erodible* brush tips which, like the pastel and charcoal sticks they represent, actually wear down as you use them! The profile of the tip changes as you work. You'll also find airbrush and watercolor brush tips with such Brush panel options as Distortion, Granularity, Spatter Size, and Spatter Amount.

As you start to explore these brush tips and their capabilities, I suggest that you open the Brush Presets panel menu and switch the view to Large (or Small) List. The thumbnails will still be visible, but the actual names of the brush tips will give you more insight into how each behaves before you select one. Brush tip names with the words Stiff or Bristle are designed for use with the Mixer Brush (discussed later in this section).

Exploring erodible brush tips

Brush tips with names such as Square Pastel, Charcoal Pencil, and Round Water-color are erodible tips. Options in the Brush panel for erodible brush tips are shown in the middle panel in Figure 13-7.

For erodible tips, Size is the brush size before it starts to wear down. The Softness determines how quickly the tip erodes, with zero being the softest and a setting of 100% maintaining the brush tip — no eroding. Preset erodible brush shapes available include point, flat, round, square, and triangle. The Sharpen button resets the brush tip to its default shape.

Introducing airbrush and watercolor tips

Airbrush and watercolor brush tips, with names such as Watercolor Build Up, Watercolor Wash, Airbrush Soft Low Density Grainy, and Watercolor Spatter Big Drops, use the options shown in the Brush Settings panel to the right in Figure 13-7.

When working with an airbrush or watercolor tip, the options in the Brush panel include Hardness (think of it as the density of the spray), Distortion (the amount of overspray or spread), Granularity (fine spray or speckles or color), Spatter Size (the size of the droplets), and Spatter Amount (the number of droplets).

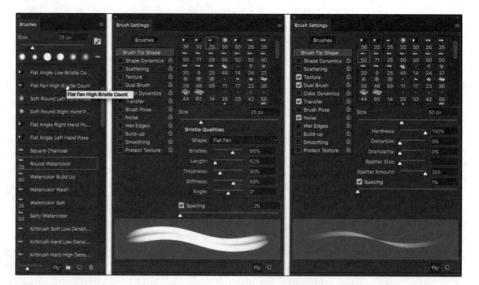

FIGURE 13-7: Erodible, airbrush, and watercolor tips add fine-art capabilities.

Keep in mind that selecting an airbrush brush tip does not activate the Airbrush option on the Options bar. If you want to combine an airbrush tip with airbrush action (so that color builds up when you pause the cursor), click the Airbrush button on the Options bar.

Think about pixel dimensions before selecting these tips — the maximum working area for these tips is about 100 pixels in diameter. You may find times when, to achieve your artistic vision, you need to open a separate document at smaller dimensions, paint in that image, and then use Image Size to scale before copying into your working document. Alternatively, work on a small document, save it, and then use the Place command to add it to your working document as a Smart Object.

Mixing things up with the Mixer Brush

The Mixer Brush, nested in the Toolbox with the Brush tool, is designed to give traditionally trained artists a more familiar feel. Also best used with a Wacom tablet or Cintiq and a stylus, this tool takes painting several steps forward. The bristle tips available for the Mixer Brush are designed to work more like the physical brushes used to add physical paint to physical canvas, but in a digital sort of way. (The bristle tips can be used with other painting tools, but they pretty much behave like the static tips, the brush tips normally used with the other tools.)

The Mixer Brush can apply the foreground color interactively with pixels already on the active layer. Using a "wet" brush (selected on the Options bar) liquefies or melts the existing colors on the layer, pulling them along (with the foreground color) as you drag the tool. To minimize interaction with existing colors, use a "dry" brush or add a layer and paint on the new layer. For a comparison of brushes using the wet (upper stroke) and dry (lower stroke) options, as well as a look at the Mixer Brush Options bar and the Brush Presets panel, see Figure 13–8.

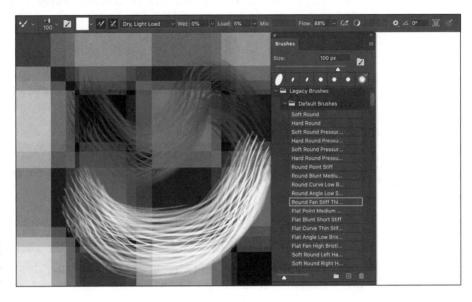

The upper stroke is "wet" and the lower is "dry."

Some options for the Mixer Brush (going from the upper left in Figure 13–8) deserve explanation:

- >> To the right of the standard tool preset and mini-Brush panel, the color swatch represents the current brush *load*, the paint on the brush. Clicking the swatch opens the Color Picker; clicking the triangle to the right of the swatch provides an easy way to *clean* the brush (so that it interacts only with existing colors on the layer) or to reload the brush (add color to the mix).
- >> The two buttons to the right of the color swatch can be used to automatically reload the tool after each stroke and to automatically clean the brush after each stroke. The two buttons can be used together.
- >> The pop-up menu to the right of the Auto-Load and Auto-Clean buttons provides a list of dry, moist, wet, and very wet presets from which to choose.
- >> The Wet field controls how the brush interacts with color already on the layer. The wetter the brush, the more it picks up color (and blends with the current brush load) on the layer. A low value overlays the load color without mixing in the existing colors.

- >> The Load field controls how much "paint" is added to the brush. With a low value, the color runs out quickly and strokes are short. With a high value, the strokes continue to add color. The load settings are most apparent when using a dry brush.
- >> The Mix field also contributes to how the load color and existing color on the layer interact. A low value uses lots of the load color, whereas a high value uses more of the color already on the layer. Mix isn't used with dry brushes (because they don't interact with the existing colors).
- >> The Flow field is yet another variable for the amount of color added by the Mixer Brush. Low values result in a more transparent stroke, whereas very high values produce opaque strokes (which tend to be shorter because the brush, you might say, "runs out of paint").

The Mixer Brush can also interact with strokes applied by the Brush and Pencil tools. And as you fine-tune your masterpiece, remember that you can push this paint around with the Smudge tool and use the Blur, Sharpen, Dodge, Burn, and Sponge tools, too. Sometime when you need a break, open a new empty document, select the Mixer Brush, and explore your inner Rembrandt (or Salvador Dalí, perhaps).

Don't forget about the Oil Paint filter in Photoshop's Filter ➪ Stylize menu. You'll find information about using it in Chapter 14.

Filling, Stroking, Dumping, and Blending Colors

You have several more ways to add color to your artwork, none of which use brushes at all. You can, for example, make a selection and fill the selection with color by choosing Edit ⇔ Fill, or you can add a band of color along the edge of the selection by choosing Edit ⇔ Stroke (using the dialog boxes shown to the right in Figure 13-9).

Deleting and dumping to add color

The first time you press the Delete/Backspace key, the keystroke opens the Fill dialog box. The Content-Aware option is sort of a "smart fill." The area surrounding the current selection is analyzed and Photoshop fills to match that surrounding area as seamlessly as possible. If you simply want to delete to the current background color, hold down the \mathcal{H} /Ctrl key and press Delete/Backspace. You can also fill with the current foreground color by using Option/Alt with Delete/Backspace.

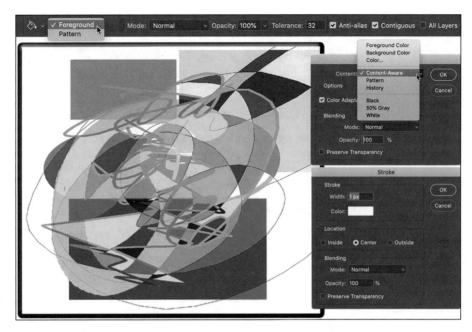

Photoshop offers several non-brush ways to add color to your images.

You can also "dump" color into your image with the Paint Bucket tool, nested below the Gradient tool in the Toolbox. Use the Paint Bucket tool to fill an empty selection with color or to replace the color on which you click with the foreground color. Don't forget vector shapes, either! They're a great way to add perfectly defined areas of solid color to an image. (You can read about working with shapes in Chapter 10.)

Using gradients

You can add *gradients*, which are subtle blends of color, quite easily to your artwork. Follow these steps:

1. Make a selection.

Unless you make a selection first, the gradient fills your entire layer. If you want the gradient to fill the entire layer, don't make a selection first.

2. Select the Gradient tool.

Click the Gradient tool in the Toolbox. If you don't see it, look for it nested with the Paint Bucket tool.

3. Select a gradient.

You can open the Gradient panel by clicking the triangle to the right of the sample gradient on the Options bar. (See Figure 13-10.) You can also click the sample gradient on the Options bar to open the Gradient Editor.

4. Choose a shape.

The five buttons to the right of the sample gradient on the Options bar show the shapes available for the Gradient tool. (From the left, the buttons are Linear, Radial, Angle, Reflected, and Diamond.)

Choose additional options.

You can pick a blending mode and opacity, flip the colors in the gradient with the Reverse option, choose Dither to help disguise the transitions between colors, and select the Transparency option to preserve any transparency defined in the gradient.

6. Drag the Gradient tool.

Where you start and in which direction you drag ultimately determine the appearance of the gradient.

The background gradient in Figure 13–10 uses the Angle Gradient option on the Options bar and the gradient that you see in the Gradient Editor. Notice in the Gradient Editor the *Opacity stops* (above the sample being edited) and *Color stops* (below the sample). The *stops* — the squares with points positioned along the sample gradient — determine the color or opacity of the gradient at that particular point. By default, there's a smooth and even blend between neighboring stops, but you can adjust the blend by dragging the small diamonds you see on either side of the opacity and color stops. (*Hint:* The active stops use filled triangles instead of hollow triangles with their little squares.)

Click anywhere along the top (opacity) or bottom (color) of the gradient to add a new stop. Drag stops to move them. Option/Alt+drag a stop to duplicate it. Change the attributes of the selected stop with the options just below in the Gradient Editor.

WARNING

After designing your new gradient, remember to click the New button to add it to the Gradient panel. But keep in mind that custom gradients aren't really saved until you use the Gradient panel's menu command Export Selected Gradients to create sets on your hard drive. If you don't save your custom gradients, they'll be gone if you need to reset Photoshop's Preferences file. (See Chapter 3 for more on saving presets.)

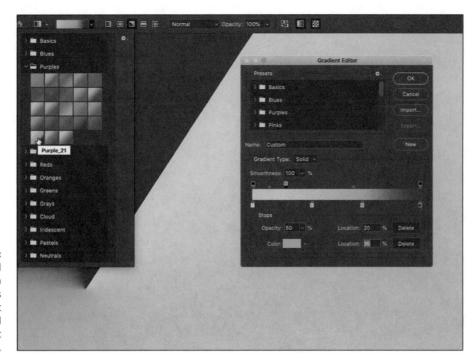

FIGURE 13-10:
Control
gradients with
the Options
bar, Gradient
panel, and
Gradient
Editor.

- » Being productive with "fix it" filters
- » Getting artsy with creative filters
- » Adding wackiness (and precise correction) with Liquify
- » Taking a quick look at some specialized filters

Chapter **14**

Filters: The Fun Side of Photoshop

he Photoshop Filter menu includes some 75 commands that you can use to fix, flatter, finesse, and freak out your photos. Open the Filter Gallery to access almost 50 additional filters. You can use most of the filters on most of your artwork and some of the filters on some of your artwork, and you probably won't ever use quite a few of the filters.

In this chapter, I start you off with a discussion of the Smart Filters feature, something you should get used to using just about every time you apply a filter. Next, you get a look at what I call the "production" filters, the key filters you use to improve or repair your images, including the improved filters for sharpening and the capability to use Camera Raw as a filter on any image, on any layer. (See Chapter 6 for information on working with Camera Raw.) Following that, I show you the basics of two of the most fun features in all of Photoshop: the Filter Gallery and Liquify. Not only are they fun, but you can also use them to do wondrous things to your artwork. The new Neural Filters are next, including the active filters, those in beta testing, and the proposed filters. I wrap up the chapter with a look at several other key filters.

Smart Filters: Your Creative Insurance Policy

One of the most important concepts to keep in mind when working with filters is Smart Filters. When you apply a filter to a pixel layer, that's it — the pixels are changed. But, when you apply a filter to a Smart Object, you create a Smart Filter. With Smart Filters, you can apply one or more filters to a Smart Object and later change your mind about what settings — or even what filters — to use, without reverting to a saved copy of the file or using the History panel. Unlike adjustment layers, which are, in fact, separate layers in the image, Smart Filters work more like layer styles. They appear in the Layers panel below the layer to which they're applied and can be shown or hidden by clicking an eyeball icon. (See Figure 14–1.) And, as with layer styles, you can reopen a Smart Filter by double-clicking it in the Layers panel.

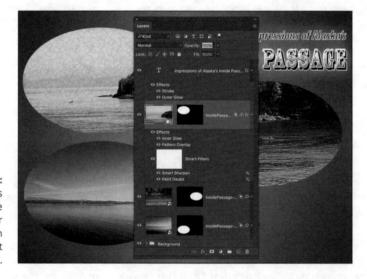

FIGURE 14-1: Smart Filters are more like layer styles than adjustment layers.

The active layer (highlighted in the Layers panel) has both layer effects and Smart Filters applied. (Refer to Figure 14–1.) The type layer above has only layer effects, whereas the other two Smart Objects, below in the Layers panel, have Smart Filters but no layer effects. Clicking the triangle to the far right of a layer name expands and collapses the list of effects and filters applied. Clicking the eyeball icon to the left of an item hides it without removing it. You can delete a Smart Filter by dragging it to the Trash icon (just as you can with layer effects), which removes its effect from the Smart Object. To reopen a filter's dialog box to change settings, simply double-click the filter name in the Layers panel.

Smart Filters can be applied only to Smart Objects (which are discussed in Chapter 9). Luckily, you can convert any pixel-based layer, even a background layer, to a Smart Object simply by selecting that layer in the Layers panel and choosing Layer ➪ Smart Objects ➪ Convert to Smart Object. You can even select multiple layers in the Layers panel and create a single Smart Object with that command. You can then apply a Smart Filter to all the layers in the Smart Object. If you later need to alter the content of the Smart Object itself, doubleclick it in the Layers panel. The Smart Object's contents opens in a separate image window. After making the necessary changes, use the Save command (not Save As) and then close the window. The Smart Object will be updated in your artwork and any Smart Filters will be reapplied.

Because you can easily remove or change Smart Filters, they provide you with a special sort of creative license: the license to experiment and change your mind (or make changes that your boss wants). Because they are nondestructive (they don't make permanent changes to the pixels in your image), you can use Smart Filters without fear of damaging your image. Of course that doesn't mean you shouldn't work on a copy of your beautiful photo — it's always better to safeguard the original image file and work on a duplicate.

The Filters You Really Need

Photoshop has several filters that you can use on just about any image to improve or finesse it. Most photos, for example, benefit from at least a little bit of sharpening to improve the detail in the image. In some cases, you want to decrease the visible detail in an image in some areas to hide defects, or perhaps you want to blur a background to draw more attention to the subject of your shot. And Photoshop has a couple of filters that you'll find handy for correcting lens distortion and reducing noise (specks of red, green, and blue) in digital photos.

Some filters aren't available for images in 16-bit color and some aren't available when you're working in CMYK (cyan/magenta/yellow/black) color mode. Almost all the filters are available for 8-bit RGB and grayscale images. (No filters are available for GIF or PNG-8 images, which use Indexed Color mode.) And keep in mind that you can apply filters to specific areas of an image by making a selection first. (See Chapter 7 for info on selections and masks.) If you need to use a filter and it's grayed out, choose Image ➪ Mode and convert to 8-bit/channel RGB mode.

Sharpening to focus the eye

When looking at an image, your eye is naturally drawn to certain areas first. You generally look at bright areas before dark areas and areas of detail before smoother areas in the image. Compare, for example, the three photos in Figure 14-2 (which were taken using different focal lengths and lens apertures). Using Photoshop's various sharpen and blur filters enables you to control the amount of detail throughout your image or, when working with selections, in specific areas in order to control the areas to which you want to draw attention.

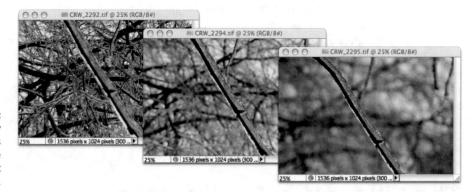

Blurry backgrounds help the subject stand out.

Photoshop offers six sharpen filters, three of which you can ignore. The Sharpen, Sharpen More, and Sharpen Edges filters have no user-definable settings and simply work in accordance with their names. Sure, they do a reasonably good job, but you don't have that all-important control over your images! Skip them in favor of the they-take-some-work-but-they're-worth-it sharpening filters: Unsharp Mask, Smart Sharpen, and the Shake Reduction filter.

Unsharp Mask

The Unsharp Mask filter is, indeed, a sharpening filter, despite the name (which comes from the blurry — unsharp — mask created from a copy of the image and used in the sharpening). As you can see in Figure 14-3, Unsharp Mask offers three sliders to adjust the appearance of your image.

To the left, you see the original image at 150% zoom. The middle image shows the sharpening at 150%. To the right is the sharpened image previewed at 100%.

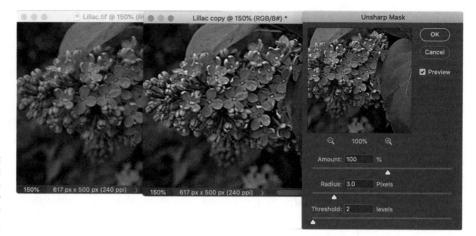

FIGURE 14-3: Despite its name, Unsharp Mask actually sharpens your image.

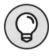

Always evaluate your filters at 100% zoom even if you need to shrink the view to only a critical portion of the artwork. Zoomed in or zoomed out views might not accurately reflect the changes that you're making because the image isn't displayed with one screen pixel representing one image pixel. Although video performance is greatly improved in recent versions of Photoshop, 100% zoom is still the safest view in which to make critical decisions. You can, of course, open a second view of the same image by choosing Window Arrange New Window for [filename].

Unsharp Mask works by identifying lines of strong contrast — the edges of elements within your image — and increases the contrast along those edges. Along the border of a dark area and a light area, Unsharp Mask uses a thin band of light and a thin band of dark to create a light and dark halo along the edges. That makes the edge appear much more defined. Here's how Unsharp Mask's sliders (as shown in Figure 14–3) work to control the effect.

- **>> Amount:** The Amount slider determines how much sharpening is actually applied by controlling the brightness and darkness of the halo. An amount of 50% is often suitable for small images that are already in pretty good shape. Use 100% for general photos. Use larger values, up to 500%, for special effects.
- >> Radius: Use the Radius slider to determine the width of the halo. You typically need a value as low as 1 pixel for small images and perhaps as high as 7 for larger images that don't have a lot of tiny detail.
- >> Threshold: The Threshold slider helps you avoid destroying your image by oversharpening fine details. If the tiniest details in the image get wide, bright halos, they can look garish and unnatural. The higher the Threshold setting, the larger an area must be before sharpening is applied. Typical Threshold settings are 2 for a small image and 5 or 7 for a large image.

Smart Sharpen

The Smart Sharpen filter provides you with an incredible amount of control over the sharpening process. Although it won't (quite) be able to give you a crisp image of that bank robber from the pixelated, blurry surveillance camera (so far, that happens only on TV), it will help you improve just about any image. Those who photograph through microscopes and telescopes might find this filter particularly useful. However, remember that although you might improve an image, some blurs simply won't be removed by sharpening.

Figure 14-4 shows how well Smart Sharpen works with an appropriate image. (Note that the Preview check box is deselected in order to show the unsharpened original to the right. The sharpened version is shown in the filter's window.) In this image, the blurring is consistent throughout the subject of the shot, and there is a reasonable amount of blur. In Figure 14-4, you can see that when you click the arrow to expand the Shadows/Highlights, all three sections of sliders are available. The Reduce Noise option doesn't reduce noise (as would the Noise Reduction filter), but rather reduces the amount of sharpening applied to existing noise so that it doesn't become more prominent. Fading the filter in the shadows also helps keep digital noise less visible. Reducing the amount of sharpening in the highlights can prevent unwanted attention being drawn to small bright areas within the image.

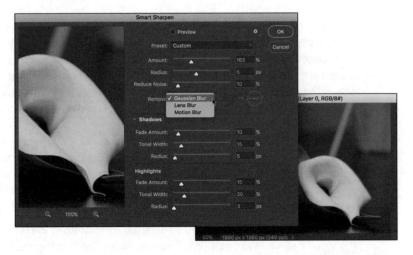

FIGURE 14-4: Smart Sharpen does a great job with appropriate images.

Notice, too, that in the upper section Smart Sharpen enables you to specify any of three types of blurring that can be plaguing your image: Gaussian Blur (a uniform blur), Lens Blur (areas of blur beyond the focal distance of the lens), and Motion Blur (the subject or camera moving while the shot was taken). If you don't see distinct evidence of lens blur or motion blur, stick with Gaussian Blur.

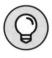

H

When working with Smart Sharpen, try dragging the Amount slider to perhaps 250%. Then drag the Radius slider to the right until you start seeing halos along distinct edges. Back off the Radius slider a bit to reduce the halos, and then bring the Amount slider down to a more reasonable level, to an amount that provides the appropriate sharpening for the image content. And if you liked the older version of Smart Sharpen, click the gear button in the upper-right and select Use Legacy from the menu that appears.

That little gear button to the left of OK offers you the option to use the older (Legacy) sharpening algorithm and, when using it, to choose the More Accurate option. If you're having trouble sharpening a particular image, you might want to give these a try.

Shake Reduction

If you shot at a slightly too-slow shutter speed (or during a minor earthquake), the image may have some blurring because the camera itself moved a bit while the shutter was open. This is most apparent when shooting at the longer focal lengths of zoom lenses. The Shake Reduction filter analyzes the image, selects what it thinks is a representative area of image upon which to base the amount of shake reduction, and then generates a preview. You adjust the sliders (and can change the setting in the Source Noise menu from Auto to Low, Medium, or High). The Detail window (in the lower-right corner of Figure 14-5) enables you to zoom in on an area of the image while making adjustments. The first of the two buttons below the Detail window enable you to undock the window so that you can drag it anywhere in the left section of the dialog box (which isn't particularly useful). Click the Close button in the upper-left of the floating Detail window to send it back to the default area. The second button unlocks the Detail window and you can move the cursor anywhere in the preview to the left to show that area in the Detail window. To zoom in on the image itself, \(\mathbb{H} / \text{Ctrl+click}. \) To zoom out, Option/ Alt+click.

In the Advanced section you can show (or hide) the Blur Detection Regions, the area(s) being used for analysis. You can move the area (drag the dot in the middle) or resize the box (drag the side or corner anchor points). You can also drag new rectangles to add additional areas for analysis or drag the Blur Direction tool along the line of camera motion. The Delete/Backspace keys delete the currently active region. Click the white dot in the center of the active region to temporarily remove it from the analysis.

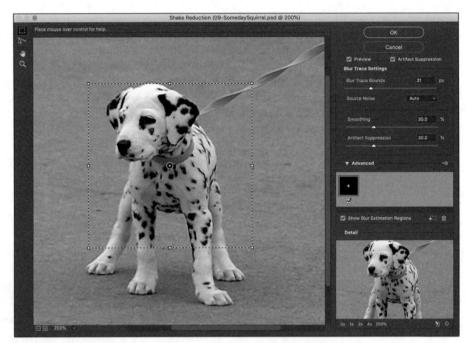

FIGURE 14-5:
Shake
Reduction is
a great way
to sharpen
images
captured with
a slow shutter
speed.

Blurring images and selections

Blurred areas in an image attract less attention than do the sharper parts of the photo (refer to Figure 14–2 for an example). By making a selection, you can selectively apply Photoshop's blur filters. You can also use the blur filters to hide flaws in an image, including dust, noise, and unwanted little bits and pieces in the picture.

Photoshop has five powerful blur filters that can be used individually or collectively through the Blur Gallery. See Figure 14-6. In the Filter Blur Gallery menu, select any of the filters to open its interface. Available filters in the gallery are Field Blur, Iris Blur, Tilt-Shift, Path Blur, and Spin Blur. Click the box to the right of a field name to add that filter to the image; click the name of a filter to open that filter's controls and to adjust its blur.

Photoshop's Blur Gallery also includes Path Blur, which enables you to create a path and blur along that path, and Spin Blur, which enables you to apply a blur around a set of pins. While powerful, you're not likely to find much use for these filters when it's much simpler to use the Lasso tool to define an area to blur (instead of creating a path) and using Photoshop's traditional Blur Radial Blur command.

THE EDIT FADE COMMAND

Immediately after applying just about any filter or adjustment command and after using many of Photoshop's tools, you can adjust the effect with the Fade command, found under the Edit menu. (Keep in mind that Fade is available only *immediately* after using a filter, adjustment, or tool. You can't even use the Save command in between.)

With Fade, you can reduce the opacity of the previous command or tool, thus reducing its impact on your image. You can also change the *blending mode*, which alters how the command or tool interacts with pixel colors prior to your change. Say, for example, you paint a black stroke with the Brush tool set to Normal and 100% opacity. Immediately afterward, you choose Edit Fade Brush. You can then pick a new blending mode and/ or reduce the opacity setting, which changes the painted stroke to appear as if you'd selected the new settings on the Options bar before painting.

You can also apply the Unsharp Mask (or Smart Sharpen) filter and then choose Edit Fade Unsharp Mask, as shown in the figure here. (Yes, the Fade command changes names automatically!) In the Fade dialog box, changing the blending mode from Normal to Luminosity ensures that your Unsharp Mask filter doesn't alter the color of pixels along edges. Using the Fade command this way is the same as if you'd switched to Lab color mode and sharpened only the L channel — without having to switch color modes at all.

Note that the Edit ♣ Fade command isn't available when you're working with Smart Filters. If you need to fade the filter, you can first choose Layer ♣ Smart Objects ♣ Rasterize and then apply the filter. You lose the advantages of working with Smart Objects and Smart Filters, but the Edit ♣ Fade command will be available.

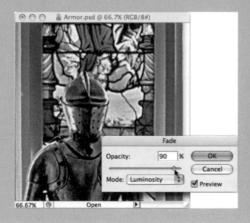

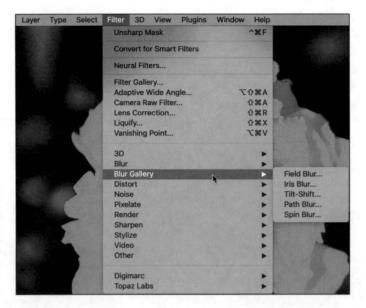

FIGURE 14-6:
The Blur
Gallery offers
five filters,
often best
used with
an image's
background
selected.

Note that each of the first three Blur Gallery filters use "pins" (click in the image window) to control the effect. A pin's amount of blur can be set with the slider in the Blur Tools panel or by dragging along the circle that surrounds the active pin. Click any pin and use the Delete/Backspace key to remove it. Clicking the button to the right of Preview removes all pins, eliminating the blur and enabling you to start from scratch.

Each of the three primary Blur Gallery filters uses pins slightly differently:

- >> Field Blur: Adjust the blur for the first pin to control blur throughout the image. Add additional pins in other parts of the image with different amounts of blur to create fields of blurring. You might, for example, have a pin to the left in the image with a substantial blur and a pin to the right with a lesser amount of blur to gradually blur the image from one side to the other. Alternatively, you might add a pin to the center of the image with little or no blur, and pins in each corner of the image with a substantial blur, leaving only the center in focus.
- >> Iris Blur: Drag the pin (and click to add additional pins) and then adjust the inner and outer rings by dragging anchor points. The outer ring represents where the blur is fully applied, while the inner ring controls how much feathering there is between "in focus" and "blurred." Drag the outer ring's anchor points to control both size and shape, and position the cursor outside the ring and drag to rotate. Drag the diamond-shaped anchor point outward to flatten from an ellipse to a rounded rectangle. You'll probably find that you'll most often use a single pin with Iris Blur.

>> Tilt-Shift: Used to simulate the blurring created by a tilt-shift lens, often used in architectural photography. In tilt-shift photography, the lens elements can be manually adjusted to change the angle between the lens and the plane of capture (the sensor in a digital camera), and to change the position of the lens relative to the center of the image plane. This often produces a band of "in focus," with the areas on either side out of focus. When using Tilt-Shift in the Blur Gallery rather than in the field, drag the dashed lines to establish the point where the blur is fully applied, drag the solid line to control feathering between blurred and focused, and drag the control points on the solid line to rotate. Tilt-Shift's distortion slider can be used to introduce distortion of details in one side of the blur (or both sides with Systemic Distortion active). Typically, Tilt-Shift uses one pin.

The Bokeh panel is used to control the quality of the highlights in the blurred area. Use the Light Bokeh slider to control "blooming" of highlights in the blurred area. Use the Bokeh Color slider to manage saturation in the areas around the highlights. Use the Light Range slider to control how much of (or what part of) the tonal range is controlled by the Light Bokeh slider.

While working in the Blur Gallery, you can hide the pins and circles or lines with the shortcut # +H or Ctrl+H to preview without distraction. For precision, you can show/hide the grid with the shortcut # +' or Ctrl+' (the apostrophe key).

The other Blur filters

Photoshop provides you with almost a dozen blur filters via the Filters (*) Blur menu in addition to those of the Blur Gallery. Some of them you're not likely to use at all, such as the Blur and Blur More filters, which give you no control over the process, and Average, which creates a solid color that's an average of all the colors in the image or selection. (The Average blur does have one valuable use described in Chapter 5 for setting a neutral point in your image.) Some you may use for creative effects, including Box Blur, with which you use a slider to control the vertical and horizontal blurring, and Shape Blur, which blurs based on a custom shape that you select. Motion Blur and the Radial Blur (which has no preview — still!) can be useful, especially when used on a selection within a piece of artwork.

The blur filters with which you're most likely to work are

Gaussian Blur: This filter produces a smoothly blurred version of your image (or an area within a selection in the image) without the distracting artifacts and lines you get by repeatedly applying the Blur More filter. The Radius slider enables you to control the amount of blurring.

- >>> Lens Blur: This filter simulates the effect in which the camera's zoom and aperture create a sharp foreground and a blurry background. You can use an alpha channel (a saved selection) to determine where and how strongly the filter is applied. For a look at the Lens Blur filter in action, see Figure 14-7.
- >>> Smart Blur: This filter controls the blur by recognizing edges (areas of extreme difference along a line of pixels) and blurring within those areas. You can use Smart Blur in Normal mode to eliminate all fine detail in your image, use it again in Edge Only mode to trace edges in the image, and then use the shortcut # +I/Ctrl+I, which produces a black-on-white sketch of your original.
- >> Surface Blur: This filter goes beyond Smart Blur in preserving edges. It restricts the blur to large areas of similar color in the image, eliminating the fine detail. It can be very useful for preparing images prior to using the creative filters of the Filter Gallery (about which you can read later in this chapter).

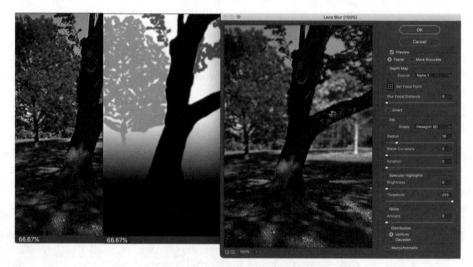

FIGURE 14-7: Lens Blur can use an alpha channel (mask) to control the blur.

Correcting for the vagaries of lenses

Found near the top of the Filter menu, the Adaptive Wide Angle filter is designed for use with wide angle and fisheye lenses. If a lens profile is available (and the lens data is recorded in the image's metadata), the filter will open up with the Correction menu set to Auto and the lens profile will be applied. If the filter cannot determine what lens was used or if there's no available profile for that lens, select Fisheye or Perspective in the Correction menu and manually adjust the image. (The Correction menu also offers Full Spherical as a correction option.)

Adaptive Wide Angle offers five tools in the upper-left corner (shown in Figure 14–8). Use the Constraint tool to drag between two points in the image that should form a vertical or horizontal line, and then drag to the existing curved line, as shown in Figure 14–8. When you release the mouse button, the filter will straighten the image based on that line. Click the Polygon Constraint tool in the four corners of anything in the image that should be rectangular to help the filter minimize distortion. The Move tool can be used to reposition the image in the canvas, and the Hand and Zoom tools perform their usual tasks. Note, too, the Detail window to the right, which gives you a close-up view of whatever section of the image is under the cursor. If you shot a series of images with the same lens, you can save the constraints you used to correct the first image and later load the constraints for additional corrections to other images. You can access the Save and Load commands by clicking the button to the right of the Correction menu.

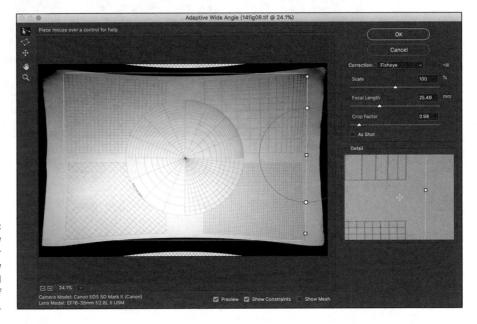

In the preview area the outer edges show the original distortion of the image.

The Adaptive Wide Angle and Lens Correction filters are dandy, but if you shoot Raw, consider using the Lens Corrections tab in Camera Raw instead (see Chapter 6). Working in Camera Raw enables you to make the corrections on unprocessed image data and such corrections can always be tinkered with at a later date.

The Lens Correction filter (choose Filter 🖒 Lens Correction) does a wonderful job of cleaning up *pin cushioning* and *barrel distortion* (the outer edges of your image appear to bend inward or outward, respectively). You'll see pin cushioning when shooting with a telephoto lens at its max zoom and barrel distortion at the lens's lower magnification. Both are most obvious when the photo has what should be

straight lines at the edges. You can also use Lens Correction to adjust the vertical or horizontal plane of an image, as well as perspective (as discussed in Chapter 8). In Figure 14-9, you see the Lens Correction window's rather complex Custom and Auto Correction panels.

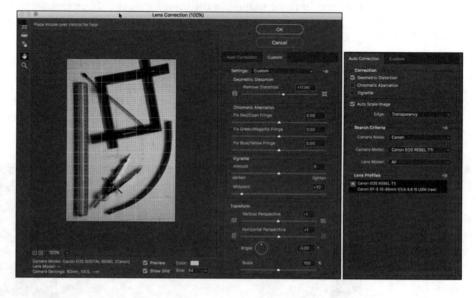

In addition to the extensive control in the Custom panel, Lens Correction also offers Auto Correction.

Here's what you have at your disposal in the Lens Correction window.

In the upper-left corner of the window are five tools:

>> Remove Distortion (top): Select this tool to drag in the preview area to adjust the distortion factor.

>> Straighten (second): This tool is simple: Click and drag along any line in the image that should be straight, and the image is straightened!

>> Move Grid (middle): Use this to reposition the grid overlay, aligning it with the content of your image.

>> Hand and Zoom: The lower pair of tools should look familiar. The Hand and Zoom tools function as they do everywhere in Photoshop: When the image doesn't fit in the window, click and drag with the Hand tool to reposition; click the Zoom tool to zoom in, or Option/Alt+click to zoom out.

In the Custom panel, you can also find

- >>> Remove Distortion slider: The Remove Distortion slider is the heart of this filter. You use this to compensate for pin cushioning or barrel distortion in the image. Drag it back and forth until your image's vertical and horizontal lines are straight throughout the image.
- >> Chromatic Aberration sliders: Sometimes a photograph shows distorted color along angular lines, such as the branches of trees or latticework. You can minimize these colored halos or fringes with the Chromatic Aberration sliders. Generally speaking, you want to zoom in close on a specific area of detail to make the adjustment.
- >> Vignette sliders: Drag the Amount slider to the left to add a dark vignette (fading along the outer edges of the image) or correct a light vignette; drag to the right to add a white vignette or remove a dark vignette. The Midpoint slider increases and decreases the amount of shadowing or highlight along the edges.
- >> Transform controls: Use the Vertical Perspective and Horizontal Perspective sliders to make your image appear parallel to the viewer. Much like using the Perspective Crop option or the Edit ♣ Transform ♣ Perspective command, you're changing the perceived angle of the image to the viewer. (Look back at Figure 8-13 to see perspective adjustment in action.)
- >> Zoom and Grid: Click the minus and plus buttons in the lower-left corner to zoom out and in, or choose a preset zoom factor from the pop-up menu. Click and drag on the Size field's label (the actual word Size) to resize the grid. Click the color swatch to change the color from the default gray. (I liked bright yellow for the image in Figure 14-9.)
- >> Saving and loading settings: From the Lens Correction window's menu (to the right of the Settings pop-up menu), you can save settings and load them later. Because you can name the settings, you can save a set for each of your lenses, at each of their zoom factors, and apply the same correction easily, time after time.

The Auto Corrections panel, shown to the right in Figure 14–9, enables you to apply predefined corrections, based on the camera and lens used to capture the image. Most recent-model high-end DSLRs from major manufacturers are supported, along with a variety of lenses. If you don't see a preset for your camera/lens combination, click the button to the right of Lens Profiles and you can browse lens profiles online — other photographers using the same gear may have posted a lens profile that's right for you. Remember that Auto Correction is used to compensate for the vagaries of the camera/lens combination — lens distortion, chromatic aberration, and light falloff toward the edges of the image (vignetting). Use the Custom panel to correct for the problems listed earlier in this section.

Cleaning up with Reduce Noise

Digital *noise* — those annoying red, green, and blue specks in your image — can ruin an otherwise lovely picture. (To avoid noise, set your camera to the lowest ISO appropriate for the available light and shutter speed.) Photoshop has a filter for reducing (not necessarily eliminating) digital noise in your images. Found in the Filter \Leftrightarrow Noise menu, Reduce Noise can do an excellent job of minimizing the random red, green, and blue pixels in your image.

When you work with Raw images, do all your noise correction in the Camera Raw plug-in. (See Chapter 6.) For images in formats other than Raw, use the Reduce Noise filter.

Here are the steps that I recommend when you use the Reduce Noise filter:

1. Set the details sliders to 0 (zero).

In the Reduce Noise dialog box, drag the Preserve Details and Sharpen Details sliders all the way to the left. This eliminates any interference with the actual noise reduction.

2. Reduce Color Noise.

Use the Reduce Color Noise slider to minimize the red, green, and blue specks in your image. Drag the slider slowly to the right until the color noise is gone.

3. Adjust Sharpen Details.

Increase the Sharpen Details slider 1% at a time until the color noise returns; then back off 1%.

Adjust Preserve Details.

Drag the Preserve Details slider to the right until you have a good balance between image detail and any luminance noise (bright and dark specks) in the image.

If you see noise of one color considerably longer than the others when dragging the Reduce Color Noise slider, click the Advanced button near the top of the dialog box and work with each channel individually, according to its needs. Also note the Remove JPEG Artifact check box at the bottom of the window. If your image is suffering from JPEG compression problems, selecting that check box might help relieve the effects. (JPEG compression often results in visible borders between 8-x-8-pixel squares within your image.) Remember, too, that you can use the button to the right of the Settings pop-up menu to save your correction for future use — it will be added to the Setting menu.

Getting Creative and Artistic

Photoshop offers much more than just "fix it" filters. In the Filter menu and the Filter Gallery (opened through the Filter menu), you'll find more than 80 features designed to help you produce creative artwork.

Photo to painting with the Oil Paint filter

The Oil Paint filter, found in the Stylize section of the Filter menu, is yet another way to create a painterly effect for a photo. Using the six sliders you see in Figure 14-10, you can create a wide range of looks. Oil Paint is best used with images of larger pixel dimensions — you may find it impossible to reduce the settings enough to present an acceptable result on small images. (You can, of course, use Image Size to increase an image's pixel dimensions, work with Oil Paint, and then use Image Size to reduce the pixel dimensions again.)

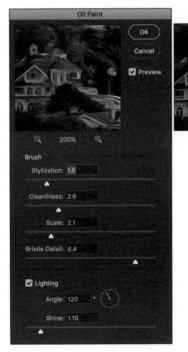

FIGURE 14-10: Oil Paint creates artistic renderings of photographic images.

The filter's Preview shows the current settings on a small area of the image. Click the Preview box to see the filter's settings applied in the image window. In Figure 14–10, to the right, you can see some of the original image.

TIP

Oil Paint identifies contiguous areas of similar color in the image and contours the brush strokes to follow the lines of color. The appearance of the individual brush strokes depends primarily on a balance of the four sliders in the Brush section of the dialog box. When first experimenting with Oil Paint, you might find it easiest to drag the Cleanliness slider all the way to the right, the Bristle Detail slider all the way to the left, and then work with the Stylization and Scale brushes to get a good look for the content of the image with which you're working. After you've nailed the general appearance, fine–tune the strokes with Cleanliness and Bristle Detail.

Don't forget to experiment with the Lighting fields — they can make a *huge* difference in the appearance of the image. Zoom in to 200% and drag the line in the Angle circle slowly back and forth until the image has the right visual balance between brush strokes and detail. (Think of 90 and 270 degrees as being up/down and zero, 180, and 360 degrees as left/right.) Zoom back out to 100% to fine-tune the Shine setting.

The Oil Paint filter requires that Use Graphic Processor be enabled in Photoshop's Preferences Preferences. If your computer's video card doesn't support this feature, Oil Paint won't be available. Keep in mind, too, that Oil Paint is available only for RGB images in either 8-bit or 16-bit color and Smart Objects created from such images.

Working with the Filter Gallery

You can apply and combine lots of Photoshop's creative filters by choosing Filter ⇒ Filter Gallery. This integrated window lets you use multiple filters at the same time rather than guessing which settings will look good with another filter applied later. Each filter remains *live* (you can change the settings) until you click OK. Check out Figure 14–11.

REMEMBE

If Filter Gallery is grayed out and unavailable, head for the Image \Leftrightarrow Mode menu and select 8-Bits/Channel — the Filter Gallery is not available for images in 16-bit color. Keep in mind, too, that the Filter Gallery can be applied as a Smart Filter when working with Smart Objects.

TID

After working with the Filter Gallery for some time you may find that you're only applying one filter at a time. If that's the case, you can open Photoshop's Preferences Plug-Ins and elect to have all the filters and filter groups shown in the Filter menu. You can then open the Filter Gallery directly to the filter you want to apply.

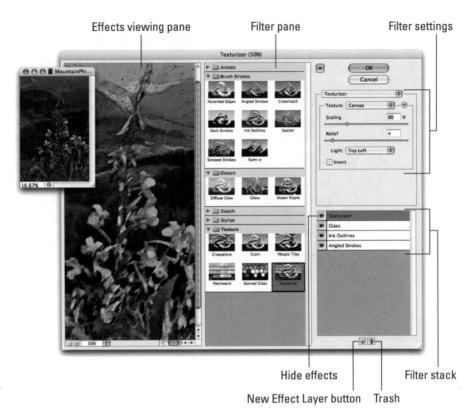

FIGURE 14-11: The expansive Filter Gallery interface.

The basic workflow goes like this: Adjust a filter, add a new filter to the stack, select the new filter in the middle pane, adjust the settings to the right, add a new filter to the stack, and so on. If you adjust your first filter settings and then click another filter in the middle column before adding another effect, you replace the first filter rather than adding to it. (If you Option/Alt+click a new filter, it will be added to the stack rather than replace the active filter in the stack.) Here's my step-by-step strategy for working in the Filter Gallery window:

1. Prepare your image before entering the Filter Gallery.

Many of Photoshop's creative filters work best when you prepare the image (or parts of the image) first. You have a couple of key filters that don't appear in Filter Gallery:

Smoothing detail: Because Photoshop's art-related filters can concentrate
on details in your image, too much fine detail can make your filter effects
crowded and cruddy. Before working with Ink Outlines, for example, try
eliminating the tiny little bits in your image. You could try either Smart Blur
or Surface Blur.

• Adding detail: Many of Photoshop's filters don't do anything if the target area doesn't have some texture or detail with which to work. That's where the Add Noise filter comes in handy, adding dark and light specks to the smooth area. Use the Monochromatic and Gaussian options, with an Amount setting from 10% to 15%. After adding noise to the too-smooth area, consider using the Blur ♣ Motion Blur filter (to create a linear effect) or the Pixelate ♣ Crystallize filter (to make small specks bigger).

2. Don't forget layers and blending modes.

Make a copy of your layer before entering the Filter Gallery so you can later mess around with layer blending modes and opacity to combine the filtered version with the original, which can soften or even enhance the effects you've applied.

3. Option/Alt+click to add a filter or add to the stack before selecting filters.

If you simply click a different filter, it replaces the filter with which you had been working. Either Option/Alt+click the new filter or click the New Filter button in the lower-right corner before clicking the filter you want to add to the stack.

4. Play with the stacking order.

Drag filters up and down in the stack at the lower right to change their order.

The order in which the filters are applied often makes a huge difference in the final appearance of your image.

5. Use the eyeball column.

It's a good idea sometimes to hide one or more effects in the stack while you fine-tune a filter's settings.

REMEMBER

Filters are *cumulative* — meaning that changes that you make to one filter can themselves be changed by other filters in the stack.

Not all creative filters are available in the Filter Gallery. Remember that Photoshop has dozens of filters that are available only through the Filter menu, not through Filter Gallery.

The cheat sheet for this book lists which of Photoshop's creative filters use the current foreground color, background color, or both. Have the correct colors selected before entering the Filter Gallery. (Search for the cheat sheet on dummies. com using the book's title.)

Push, Pull, and Twist with Liquify

Although the Lens Correction and Adaptive Wide Angle filters have added powerful correction tools to your arsenal, you still want to sometimes fix a photograph's perspective or barrel distortion with Liquify. Perhaps. But with Camera Raw's Lens Correction tab and the corrective filters available in Photoshop, Liquify can concentrate on its fun side.

I know of nothing in Photoshop that can bring a smile faster and more easily than creating some strange creature from a friend or loved one in Liquify. I readily admit that the glow produced by the praise of an art critic is gratifying, but does it compare to, "More, Uncle Pete! Give me bigger ears!"? It would certainly be a disservice to the Liquify feature to overlook its powerful image-correction capabilities, so please remember that almost anything you can do to emphasize or enhance an attribute can be done in reverse to minimize that aspect of the image. Make someone short and wide? You can also make them tall and thin. Creating a bulging nose? Create a slim and pert nose. It's all possible with Liquify.

That having been said, examine Figure 14-12, which shows some rather dramatic changes, with the original visible behind and to the left. (This should give you some idea of how useful Liquify can be for more subtle tasks, like trimming tummies, toning arms and legs, thinning noses, and other such work.) Note that Liquify no longer offers an Advanced Mode button — you're always in "advanced mode" now.

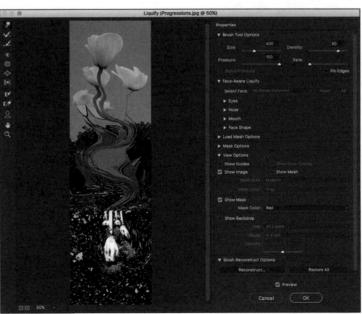

FIGURE 14-12:
Liquify
gives you
unbelievable
control over
the pixels in
your image.

Notice that if you have people in your image, Liquify's Face-Aware Liquify options are available, enabling you to work on eyes, noses, mouths, and face shapes.

Take a look at the tools arrayed along the left edge of Liquify. Here's what they do, starting at the top:

>> Forward Warp: Much like Photoshop's Smudge tool, you click and drag the Forward Warp tool to push the pixels around.

>> Reconstruct: Use the Reconstruct tool as your "undo." Drag over areas that you want to restore to their original appearance. When in Liquify, you can also use the Edit menu's commands Undo, Redo, and Step Backwards and their assigned shortcuts.

>> Smooth: Drag the tool to smooth sharp changes.

>> Twirl Clockwise: Click and hold the mouse button down or drag in a circle to spin the pixels within the brush diameter. And if you want to twirl counter-clockwise, simply add the Option/Alt key.

>> Pucker: The Pucker tool sucks pixels into the center of the brush. You can click and hold or drag the Pucker tool. Holding down the Option/Alt key toggles you to the Bloat tool's behavior (although you don't actually switch tools).

>> Bloat: The opposite of the Pucker tool, the Bloat tool pushes pixels out from the center. Holding down the Option/Alt key switches to the Pucker tool's behavior.

>> Push Left: As you drag the Push Left tool, pixels are shifted to the left of the path along which you drag (not necessarily to your left). If you drag up, the pixels are shifted to the left on the screen; drag down, and the pixels are shifted to the right onscreen. Press the Option/Alt key to reverse the behavior and push pixels to the right of the path.

>> Freeze Mask: One of the most important tools, the Freeze Mask tool lets you protect areas of your image from change. Paint over an area (you see a red mask) to *freeze* it — to keep it from changing.

>> Thaw Mask: Unprotect areas with the Thaw Mask tool. It removes the red overlay and lets you liquify the area again.

Face: When you have people in an image, click the Face tool to help identify their faces.

Hand: As always, the Hand tool lets you reposition an image in the window when it doesn't all fit. Just click and drag your image to move it in the preview window.

>> Zoom: As you might suspect, the Zoom tool functions as it usually does. Click to zoom in, Option/Alt+click to zoom out, and click and drag to zoom in on a specific area.

To the right in the Liquify window are a number of variables and options. Brush Size is the tool brush diameter, Brush Density is comparable to feathering (lower is softer), Brush Pressure controls the strength of the active tool, and Brush Rate controls the speed with which a tool works.

The Reconstruct Options let you restore or partially restore your image to the original appearance. The Reconstruct button opens a slider with which you can back off the changes you've made. Keep in mind that the slider moves from the "Liquified" version to the "pre-Liquify" version of your image. It selectively reverses all the changes made, not just the previous change. The Restore All button returns your image to its pre-Liquify appearance.

You can make a selection before opening Liquify to work on only a portion of your image. If there's a layer mask on the active layer, you can use it as the basis for a "freeze" in the Mask options. In the column of adjustments on the right side of the Liquify window (refer to Figure 14-12), you have options to show a mask and a mesh to help you see what you're doing to the image.

What Are Neural Filters?

NEW

Recently added to Photoshop are the Neural Filters. *Neural*, when you check the dictionary, refers to the nervous system, with roots in the Greek word *neuron*. So, what does that have to do with these filters? Let's put on our Imagination Hats and go with this: The filters use machine learning to improve performance. Machine learning is similar to artificial intelligence. Artificial intelligence is sort of like using a human brain. Human brains contain neurons.

Okay, so that explanation of Neural Filters is sort of a stretch, but I wish I could tell you about some of the wacky names that were suggested and rejected! The key point is that the more people who use the Neural Filters and provide feedback, the better they will perform in the future.

The Neural Filters fall into three categories: Working, in public beta testing, and proposed for public feedback. Some work only in the Cloud, some must be downloaded before they can be used; some are just listed for feedback: Do you think this is a good idea and worth spending resources developing, or is it a filter you would never use?

Of course, depending on when you read this chapter, which filters fall into which category (and which simply fall off the program) is likely to change. But this section describes how things stand as of this writing.

The original Neural Filters

Skin Smoothing is designed to be used primarily with portraits and other images in which faces are easily identified. However, you can also use it with photos containing more than one face (see Figure 14–13). Open the image into Photoshop, open the Neural Filters through the Filter menu, and then click Skin Smoothing to activate this filter. Photoshop shows a little progress circle while it identifies faces; then it offers you a drop-down menu to select the face with which you want to work.

FIGURE 14-13:
Neural Filters
use machine
learning to,
among other
processes,
identify faces
in an image.

All identified faces will be boxed in the image, with the selected face boxed in blue. You can use the Blur slider to blur the entire face and the Smoothness slider to work primarily in areas of skin. As you can see in Figure 14–13, you have several options for saving the result of the filter. It can be applied to the current layer (making permanent changes to the image), applied to a duplicate layer with or without a layer mask, a new layer containing only the altered pixels, or you can select Smart Filter, which automatically converts the image layer to a Smart Object (discussed earlier in this chapter).

Before you click the OK button, I urge you to use the "Are you satisfied with the results?" buttons. Click the happy face or the sad face and in the dialog box that appears, provide a sentence or two of feedback. When possible, include the image file with your feedback. There no risk of your image being used for anything other than improving the performance of the filter; it won't be shown or used otherwise, so including it is perfectly safe and won't risk or violate your copyright.

The second active Neural Filter is Style Transfer. Before you can use it, you it must download it from the Cloud. (Obviously you must be online at the time to use this filter.) You select from any of a number of preset styles to apply that look to your image. Sometime down the road (or perhaps already, depending on when you're reading this), you might be able to have your own custom styles included. That would enable you to, for example, adjust one image from a set captured under similar conditions and apply it to other images from that shoot.

Neural Filters in public beta testing

When you click the Beta Filters icon in Neural Filters (see Figure 14–14), a list of additional filters appears, including Smart Portrait, Makeup Transfer, Depth—Aware Haze, Colorize, Super Zoom, and JPEG Artifact Removal. These filters are available for you to play with and actually use, but they weren't ready for prime—time when this update of Photoshop was released. It's especially important to use the "Are you satisfied with the results?" feedback system to help whip these filters into shape.

FIGURE 14-14: Among the beta Neural Filters is Smart Portrait.

You may find some of these filters to be somewhat slow at times because they do their work in the Cloud. (Again, you must be online to use these filters.) You might enjoy playing with Smart Portrait most of all, but you may find Super Zoom to be the most useful. After you zoom in on the preview and adjust the sliders, the filter crops the image and resizes it to the pixel dimensions of the original. For a description of what each of the beta filters does, park the cursor over the name in the Neural Filters work area and a tooltip appears.

This isn't a warning for you about your work with Neural filters. Rather, it's a warning to you about others working with Neural Filters, specifically Smart Portrait. After you've worked with that filter for a while, you'll see its incredible power. Photoshop doesn't embed a permanent watermark saying, "This image has been digitally manipulated to change its appearance." You have no way of knowing whether some other Photoshop user has changed the look on one or more faces in a photo. Just a slight movement of the Happiness or Anger slider can make someone appear to approve or disapprove of something they're viewing in the photo. Not obviously identifying manipulated images seems to go against Adobe's corporate stance in the Content Authenticity Initiative, found at https://contentauthenticity.org/approach.

Proposed Neural Filters

Below the beta filters are the proposed filters. Click the little i-in-a-circle button to the right of each of the filters' names, and a description and example appear. If it sounds like a filter you think Adobe should invest resources into developing, click the I'm Interested button and provide a brief description of why you're interested.

Some of the proposed filters might seem redundant, such as Dust and Scratches, Noise Reduction, and Photo to Sketch, but the proposed new filters will use machine learning to do a better job than the legacy filters. Eventually. If enough Photoshop users are interested. Then, after the filter goes to beta, those users provide feedback and supply work images. Unless that process happens, these proposed filters may never make it into Photoshop. It's up to you. And her. And him. And even me. If we show enough interest over time and then provide enough feedback, these filters will become working features and (hopefully) do a better job than existing filters for similar tasks.

Do I Need Those Other Filters?

Photoshop has dozens of filters, creative and productive, that you access through the Filter menu rather than through the Filter Gallery. Some do strange and wonderful things to your selection or image, and some just do strange things that you might never need. You can find a description of each of the filters in Photoshop's Help, but a couple of them are worth a bit of attention here.

Adding drama with Lighting Effects

In the Filter Render menu is the powerful Lighting Effects filter, with which you can add spotlights, point lights, and infinite lights. You can choose a preset from the menu in the upper left (see Figure 14-15) or customize the lights by adding and adjusting the lights of your choice. Click one of the three light buttons in the upper left, drag the light into position, and then adjust the light with the sliders in the Properties panel. Select which light is active in the Lights panel. In the image window, you can drag to change the angle of a spot light or an infinite light, the scale of a point light, and the shape of a spot light.

FIGURE 14-15:
A point light in the upper left, a spot light in the lower left, and an infinite light in the center.

The Lighting Effects filter is available for RGB images in 8-bit color only, and for Smart Objects created from such images. If you want to use Lighting Effects with a grayscale image, you can add a Black & White adjustment or adjustment layer, or head to the Image \Leftrightarrow Mode menu and convert to Grayscale and then convert back to RGB.

Maximum and Minimum

In the Filter \circlearrowleft Other menu, the greatly improved Maximum and Minimum filters are perfect for adjusting layer masks. Use Maximum to expand the visible area of the layer and use Minimum to reduce the visible area. Both filters enable you to specify whether to protect the "squareness" or "roundness" of the mask. Remember to click the layer mask in the Layers panel before opening these filters. If the layer thumbnail is active, you'll be creating some rather interesting special

effects rather than modifying the layer mask, with Maximum expanding bright areas and Minimum expanding shadows.

Bending and bubbling

In the Filter Distort menu, you find both the Shear and the Spherize filters, both of which are simpler alternatives to Liquify for many projects. Use the Shear filter to bend a selection back and forth, creating curves. Use Spherize to create a bulging, rounded image. Both Shear and Spherize are easiest to control when you make a selection of your target and copy it to a new layer. Shear works only vertically, so you might need to rotate your image before and after using the filter.

Creating clouds

Clouds make lovely, unobtrusive backgrounds that can be scaled and transformed to produce smoke or steam, and you can even create marbling effects from clouds. (See Figure 14–16.) In the Filter Parameter Render menu, you find Clouds and Difference Clouds. Both filters use a mixture of the foreground and background colors to create a cloud pattern. The Clouds filter replaces the content of the selection or layer (if any), and Difference Clouds interacts with the existing pixels (you can't use it on an empty layer) pretty much like Clouds using the Difference blending mode. Apply Difference Clouds several times, perhaps as many as 20, to create abstract backgrounds and marble patterns, or perhaps to simulate microscope slides.

FIGURE 14-16: The Clouds filter produces pleasant backgrounds.

Power Photoshop

IN THIS PART . . .

Automate parts of your workflow with Actions and the Batch command.

Record your own Actions for a streamlined workflow and precision.

Learn about Photoshop with the Discover panel.

Create multipage PDF files and PDF presentations.

Scan multiple images in one pass.

Produce your own movies with Photoshop's video commands and the Timeline panel.

Work with frame-based animation.

- » Using the new Discover panel
- » Creating contact sheets and PDF presentations in Photoshop
- » Scanning multiple images in one pass
- » Scripting in Photoshop

Chapter 15

Streamlining Your Work in Photoshop

lot of the work that you do in Photoshop is fun — experimenting with filters, applying creative adjustments, cloning over former in-laws, that sort of thing. A bunch of your work, though, is likely to be repetitive, mundane, and even downright boring. That's where automation comes in. If a task isn't fun to do, if you need to speed things up, or if you need to ensure that the exact same steps are taken time after time, automation is for you.

I begin the chapter with a look at Photoshop's Actions and the Batch command, which enable you to process many files automatically. I then introduce the new Discover panel. Next, I take a look at PDF Presentation and Contact Sheet II (used to show and print multiple images on a single page). Following those two powerful features, I show you the Crop and Straighten Photos feature, a neat way to effectively scan multiple images into Photoshop in a single pass. After that, I give you a quick look at scripts, such as the very powerful Image Processor. *Scripts* are sort of little computer programs that you use to control your computer — Photoshop, other programs, your printer, or even an operating system itself.

Ready, Set, Action!

In Photoshop, an *Action* is simply a recorded series of steps that you can play back on another image to replicate an effect or technique. To choose a wild example, say that every image in your new book about Photoshop needs to be submitted at a size of exactly $1,024 \times 768$ pixels at 300 ppi, regardless of content. Record an Action that uses the Image Size command to change resolution and then use the Canvas Size command to expand the image to $1,024 \times 768$ pixels. Use that Action (play the Action) on each image before submitting it. Better yet, wait until all the images for a chapter are ready and then use the Batch command to play the Action automatically on each of them!

Actions and the Batch command not only streamline repetitive tasks; they also ensure precision — that every one of those images will be *exactly* 1,024 x 768 pixels, each and every time. But Actions also have a creative side to them. Like other panels, you open the Actions panel through Photoshop's Window menu. The lower part of the Actions panel's menu (see Figure 15–1) contains sets of Actions that you can load into the panel to produce frame and border effects, text effects, and more. (The content of your Actions panel menu will differ from what's shown in Figure 15–1.) You can also purchase collections of Actions from commercial sources.

To work with an Action, open an image, select the Action in the Actions panel, and then click the Play button at the bottom of the panel. (The three buttons to the left use the near-universal symbols for Stop, Record, and Play; the three to the right use the standard Adobe symbols indicating New Set, New Action, and Trash. Refer to Figure 15-1.)

Any step in the Actions panel that doesn't have a check mark in the left column is skipped when you play the Action. Any step that has a symbol visible in the second column (the Modal Control column) pauses when you play the Action. Click in the second column when you want the Action to wait for you to do something. Perhaps you'll click in that column next to a Crop step so that you can adjust the Crop tool's bounding box. You might click in the second column next to an Image Size step so that you can input a specific size or choose a resampling algorithm. After you make a change or input a value for that step, press Return/Enter to continue playing the Action.

Notice the Save Actions command in the panel's menu in Figure 15–1. Remember that you have to select a set of Actions in the panel, not an individual Action, to use the Save Actions command. If you want to save only one Action, create a new set and Option/Alt+drag the Action to that set to copy it. You can also create a printable text file (.txt) of your Actions set by holding down the \Re +Option/Ctrl+Alt keys when selecting Save Actions. Text versions of your Actions provide an easy reference for what each Action (and step) does to an image.

FIGURE 15-1: The Actions panel menu includes sets of Actions you can load into the panel.

If you get hooked on Actions, you'll also want to try Button Mode in the Actions panel menu. Each Action appears in the panel as a color-coded button. You don't see the steps of the Action, so you don't know whether an individual step is being skipped and you can't change the Modal Control column, but you might like the color-coding to sort your Actions.

Recording your own Actions

The real power of Actions comes when you record your own. Sure, the sets of Actions included with Photoshop are great, and the commercial packages of Actions have some good stuff too, but it's not *your* stuff. When you record your own Actions, you record the steps that work for your images, your workflow, and your artistic vision.

Actions can't float free in Photoshop's Actions panel: Each Action must be part of a set of Actions. Before beginning to record your Action, you can select an existing set or click the fourth button at the bottom of the panel to create a new set. When you have a set selected, you can then click the New Action button (second from right). Then, in the New Action dialog box that appears (as shown in Figure 15-2), assign a name (and color-code for Button Mode and perhaps choose an F-key combination as a keyboard shortcut for playing the Action) and click the Record button. From that point forward, just about everything you do in Photoshop is recorded as part of the Action until you click the Stop button at the bottom of the Actions panel. No worries, though — you can always delete unwanted steps from a recorded Action by dragging them to the Trash icon at the bottom of the Actions panel. And if you want to change something in the Action, you can double-click a step and rerecord it.

FIGURE 15-2: After you click the New Action button, you see the New Action dialog box.

(You'll read this again, but that little Warning symbol hopefully drives home the importance of this info.) Open the image with which you want to record the Action before you start recording. Otherwise that Open step is part of the Action and when you play the Action, it always opens that image and plays the steps on it rather than your intended image. Of course, if you want to use a special image in your Action, say a file that contains your copyright info as a graphic that you want to copy/paste into the image on which you're working, you would indeed record the Open command within the Action (just not as the first step).

REMEMBER

You can record most of Photoshop's commands and tools in an Action, but you can't control anything outside of Photoshop. (For that you need scripting, introduced later in this chapter.) You can't, for example, use an Action to print (controlling the printer's own print driver), copy a filename from the Mac Finder or Windows Explorer, or open Illustrator and select a path to add to your Photoshop document. Here are some tips about recording your own custom Actions:

- >> Open a file first. Open the file in which you're going to work before you start recording the Action. Otherwise, as you have been warned, the Open command becomes part of the Action, and the Action will play on that specific file every time you use it. You can, however, record the Open command within an Action to open a second file perhaps to copy something from that file.
- >>> Record the Close command after Save As. When you record the Save As command in an Action, you're creating a new file on your hard drive. Follow the Save As command with the File □ Close command and elect Don't Save when prompted. That closes and preserves the original image.
- >> Use Percent as the unit of measure. If you need an element in your artwork to be in the same relative spot regardless of file size or shape (like a copyright notice in the lower-right corner), change the unit of measure to Percent in Photoshop's Preferences before recording the Action.
- PRECORD/insert menu commands. When you use a menu command while recording your Action, the actual values that you enter into the dialog box are recorded, too. If you'd rather select the values appropriate for each individual image (perhaps for the Unsharp Mask filter or the Image Size command), insert the command rather than record it. When you reach that specific spot in your process, use the Actions panel menu command Insert Menu Item. (Refer to Figure 15-1.) With the dialog box open, mouse to and select the appropriate menu command; then click OK to continue recording the Action. In Figure 15-3, you see the Insert Menu Item dialog box when first opened (before a command is selected) and after I used the mouse to select the Image Size command from Photoshop's Image menu.
- >>> Record multiple versions of a step, but activate one. Say you want to record an Action that does a lot of stuff to an image, including changing the pixel dimensions with the Image Size command. However, you want to use this Action with a variety of images that require two or three different final sizes. You can record as many Image Size commands as you want in that one Action just remember to deselect the left column in the Actions panel next to each of the Image Size steps except the one you currently want to use.
- >>> Record Actions inside Actions. While recording an Action, you can select another Action and click the Actions panel's Play button the selected Action will be recorded within the new Action.
- >> Insert a message or warning. Use the Actions panel menu Insert Stop command to send a message to anyone who plays your Action. The message could be something like "You must have a type layer active in the Layers panel

before playing this Action" with buttons for Stop and Continue. Or you could phrase it more specifically: "If you have not selected a type layer in the Layers panel, click Stop. If a type layer is active in the Layers panel, click Continue." The more precise the message, the less confusion later. In Figure 15-4, you see the Record Stop dialog box, where you type your message when recording the Action (top), as well as a look at how the message appears when the Action is played back later (bottom).

- >> Insert a conditional Action. If you choose the menu command Insert Conditional while recording an Action, you can choose from a list of situations (as shown to the right in Figure 15-5), and select an existing Action to play. If, for example, you need to have a flattened image for a specific situation, first record an Action by choosing Layer □ Flatten Image. Then, when recording your more complex Action, insert the conditional Document Has Layers and elect to play your Flatten Image Action. If you run the complex Action on an image that's already flattened, Photoshop will skip the Flatten Image Action specified in the conditional.
- >>> Remember Conditional Mode Change and Fit Image. These two commands in the File ▷ Automate menu are designed to be recorded in an Action that you might later use on a wide variety of images.
 - Conditional Mode Change is very handy when your Action (or final result) depends on the image being in a specific color mode. When you record Conditional Mode Change in an Action, every image, regardless of its original color mode, is converted to the target color mode (see Figure 15-5). Say, for example, that you need to apply a certain filter in an Action, but that filter is available only for RGB images. If you record Conditional Mode Change before running the filter, the Action will play properly.
 - Fit Image specifies a maximum width and height that the image being processed must not exceed, regardless of size or shape great for batch-processing images for the web. Fit Image maintains your images' aspect ratios (to avoid distortion) while ensuring that every image processed fits within the parameters you specify. (See Figure 15-5.) If you need all landscape-oriented images to be 800 x 600 pixels and all portrait-oriented images to be 600 x 800 pixels, enter 800 in both the width and the height fields.

Notice the Don't Enlarge check box in the Fit Image dialog box. If you're prepping images for a website and reducing them to a specific size to make them download and display faster, you don't necessarily want to

- *enlarge* some of the images, making them download slower. Disable this option when you're trying to make all the images uniform in size, perhaps for the creation of a PDF presentation (discussed later in this chapter).
- Always record an Action using a copy of your image. Because the steps that you record in the Action are actually executed on the open file, record your Action using a copy of the original image. That way, if something goes wrong, your original image is protected.

FIGURE 15-3:
Using Insert
Menu Item
leaves a dialog
box open when
playing the
Action.

FIGURE 15-4: Insert a Stop to show a message when the Action is played.

FIGURE 15-5:

Insert

Conditional
is accessed
through the
panel menu,
Conditional
Mode Change
and Fit Image
are recorded in
Actions using
the File ♣
Automate
menu.

The Actions panel menu also offers the Allow Tool Recording option. This feature enables you to record tools such as the Brush and the Clone Stamp in Actions. However, the feature has a few limitations. Although you can record the tool, you can't record changing its settings. If, for example, you recorded the Action using a feathered 40-pixel brush tip, you'll need to remember to select that brush tip before playing the Action. In addition, the data recorded for the tool movement is device-specific. If you record the Action on one computer and play it back on a computer using a different video card and/or monitor, the results may be slightly different. Do not depend on Actions that record tool movement for precision!

Working with the Batch command

Choosing File \hookrightarrow Automate \hookrightarrow Batch lets you play back an Action on a number of files. You select an Action to play as well as a folder of image files to play it on; then you decide what you want to do with the files after the Action finishes with them. You can leave the images open in Photoshop, save and close them, or (much safer) save them to another folder, preserving the originals. Figure 15–6 shows the Batch dialog box and also the pop-up menu for the fields in the File Naming area. (When you select a new folder as the Destination in Batch, you must tell Photoshop how you want the new files to be named.)

The Batch command is much simpler than it looks!

You must remember three things when assigning filenames:

- >> Include a variable. Something must change from filename to filename. Select one of the top nine items in the File Naming section's pop-up menu (some version of the original document name or a serial number or a serial letter). It doesn't have to be in the first field, but one element of the filename must be different from file to file.
- >> Don't use a period (.) in any field. You can type in any of the fields (except the last one you use), but for compatibility, stick with letters, numbers, underscores (_), and hyphens (-).
 - Absolutely do not use a period (.) in the filename. The only period that should be used in a filename is the one that's automatically added immediately before the file extension. Including a period earlier in a filename may make that file unrecognizable for some programs.
- >> You have two other decisions of note in the Batch dialog box. When you elect to suppress any Open commands in the Action, you protect yourself from poorly recorded Actions that start by opening the image with which they were recorded. However, if the Action depends on the content of a second file, you don't want to override that Open command. Generally, you want to override any Save As commands recorded in the Action, relying instead on the decisions that you make in the Batch dialog box to determine the fate of the image.

Keep in mind that you can also select some of the images in a folder in Bridge, and then choose Tools ⇔ Photoshop ⇔ Batch from Bridge's main menu to run an Action on just those files. The Source menu will be set to Bridge.

Find It Fast with Discover

The Discover panel in Photoshop is a one-stop shop for help, tutorials, access to Adobe Stock and Fonts, and much more! (See Figure 15-7.) You can use the top fields to find features in Photoshop and information related to them, browse tutorials, access some prerecorded Actions, and use the various items in the Resource Links section to make your Photoshop life generally easier. Among the resources are links to the online User Guide, the community support areas of Adobe.com, an easy way to find Photoshop plug-ins, a link to Adobe Stock and Fonts, and Adobe Live (the Photoshop-specific area of Behance). The Discover panel has been assigned the \#+F (Control+F in Windows). Reapplying the last-used filter now uses the shortcut \(\mathbb{H} + \text{Option} + \text{F} \) (Control + \text{Alt} + \text{F} \) in Windows). And that, of course, messes up the shortcuts that open the last-used filter's dialog box. On Mac, add the Control key; Windows doesn't (at this time) have a comparable shortcut. However, if you go to Edit ➪ Keyboard Shortcuts, you can switch the Last Filter's shortcut back to \#+F (Control+F in Windows), you can open the last used filter dialog box by adding the Option/Alt key.

FIGURE 15-7: Some folks will get hooked on this new feature!

You can also access the panel through the Help menu (not the Window menu, as you would with any other panel). With the panel open, the shortcut 策+F (Control+F in Windows) jumps you to the Find field at the top of the panel. Using the shortcut again (or if the cursor is already in the Find field) hides the panel. If you're browsing tutorials or are in just about any other section of the panel, the arrow to the left of the Find field and the Home button to the right of the Find field return you to the main panel content.

Creating Contact Sheets and Presentations

Presentations and contact sheets are great for showing off your work. Rather than opening an image, showing it, closing, then opening the next image, you have them in a simple presentation format or, with contact sheets, multiple images

on a single page. (Contact sheets are also great for printing multiple images on a single sheet of paper.)

Creating a PDF presentation

Portable Document Format (PDF), the native file format of Adobe Acrobat, is an incredibly useful and near-universal format. It's hard to find a computer that doesn't have Adobe Reader or another PDF-reading program (such as the Mac's Preview), and that helps make PDF a wonderful format for sharing or distributing your images.

You can quickly and easily create both onscreen presentations (complete with fancy transitions between images) and multipage PDF documents (suitable for distribution and printing) by choosing File ♣ Automate ♣ PDF Presentation. (See Figure 15-8.)

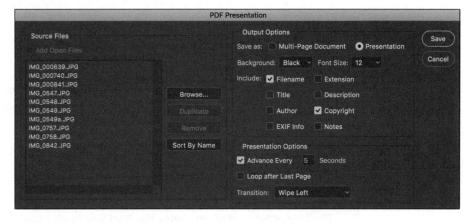

PDF is a great format for sharing images as presentations or as documents.

To create a PDF presentation or a multipage PDF in Photoshop, take the following steps:

 If the files you want to use aren't already open in Photoshop, click the Browse button. You can click and then Shift+click to select a series of images or \(\mathbb{H}\) +click (Mac)/Ctrl+click (Windows) to select individual images.

Hint: You must select the individual images; you can't select only the folder.

After you click the Open button, the filenames appear in the PDF Presentation window. Drag filenames up or down to reorder them.

If, for example, you have a number of images open in Photoshop and select the Add Open Files and the files don't open in order of filename, you can click the new Sort By Name button to re-sort the files in the left column.

2. In the Output Options area, you can elect to create an onscreen presentation or a multipage document.

You can choose to have a white, gray, or black background and what file-related information you want on each slide or page. Electing to include the filename (and perhaps your copyright information) is a good idea when sending images to someone who needs to know the image name to, say, order prints and give you cash for them. A multipage PDF is an excellent way to share a large number of images; a presentation is a great way to show off your work.

3. Select how you want the presentation to play.

You can have the presentation automatically switch images after a given number of seconds (or opt for manual slide advance), you can have the presentation automatically rewind and begin playing again (loop), or you can pick transitions between images. Do your audience a favor and pick a single transition and stick with it — preferably one simple transition, such as Wipe Left or Wipe Right. Those too-busy transitions are the 21st-century version of PowerPoint clip art — fun to play with, but distracting to your audience.

4. Click the Save button.

You see the Save dialog box, from which you pick a location and a name and then click another Save button.

In the Save Adobe PDF dialog box, make things simple for yourself and choose Smallest File Size or High Quality Print from the Adobe PDF Preset pop-up menu at the top.

If you're creating a presentation or want to create a multipage PDF from which the recipient can't print full-size images, choose Smallest File Size. For a multipage document from which you *do* want the client to print great images, use High Quality Print.

The only other area of the dialog box that you really need to consider is Security.

You can assign a password to the file that the recipient needs in order to open and view the presentation or multipage PDF document. Alternatively, you can require no password to open the file, but rather assign a password for printing or changing the file.

At the end of the road, click the Save PDF button to actually generate the final file.

TIP

Do you ever get annoyed by the fact that Photoshop prints only one image at a time? Are there times when you'd like to send a bunch of images to print at the same time, perhaps overnight or while you're at lunch? Create a multipage PDF from the images and print through Adobe Reader or Acrobat, or other programs that can work with multipage PDFs, such as the Mac's Preview.

Collecting thumbnails in a contact sheet

In the old Dark(room) Ages, photographers regularly made a record of which images were on which film strips by exposing those strips on a piece of photographic paper, thus creating a *contact sheet* (the film strips were in contact with the sheet of paper). The contact sheet serves the same purpose as thumbnails or previews in Bridge or the Open dialog box or thumbnail images on a web page — they show which image is which. Hard copy contact sheets are useful to present to a client. You can have Photoshop automate the process for you by choosing File \Rightarrow Automate \Rightarrow Contact Sheet II. (See Figure 15–9.) The procedure is as follows:

- Select a source folder from the Use drop-down list in the Source Images area.
- (Optional) If you want to include the images in any subfolders that might be within that folder, select the Include Subfolders check box.

The Group Images by Folder option starts a new contact sheet for each subfolder.

If you need a printed record of your images, consider Contact Sheet II.

- 3. Using the Units, Width, and Height options in the Document area, describe your document, using the printable area of your page not the paper size.
- 4. Select a resolution.

I recommend 300 pixels per inch (ppi) if printing and 72 ppi if you'll be slicing the image for your website (although resolution really doesn't matter for most web browsers).

5. Use the Mode drop-down list box to choose a color profile (an RGB profile unless printing to a color laser printer) and also decide whether you want to flatten all layers (which makes a smaller but less versatile file).

You can choose to have the images added to the page row by row (the second image is to the right of the first) or column by column (the second image is directly below the first). You can also choose the number of rows and columns, which determines the size of each individual image. You then need to decide whether to use autospacing, to calculate the spacing between images, and whether to rotate images. If your source folder has a mixture of landscape and portrait images, rotating makes sure that each is exactly the same size — although some will be sideways. If image orientation is more important than having identical sizes, don't use the Rotate for Best Fit option. Note in Figure 15–10 that the filenames change size to match the size of the image and, as you can see at the far right of the second row, if the filename is too long, it gets truncated rather than shrinking to an unreadable size. When you have elected to include filenames as captions, Contact Sheet II lets you choose any font installed on your computer for the filenames.

FIGURE 15-10:
To maintain
image
orientation,
don't use the
Rotate for Best
Fit option.

If your folder is filled with portrait-oriented images, you can certainly have more columns than rows so that each image better fills the area allotted for it. For example, when printing 20 portrait images, using five columns and four rows produces larger printed images than using four columns and five rows.

Scanning Multiple Photos in One Pass

You can often save a lot of time by placing multiple photos on the glass of your scanner and scanning them all at one time. You don't need to reopen the scanner software or generate a new preview every time; rather, you just scan one big picture and make individual little pictures from it later in Photoshop. Photoshop's File Automate menu offers a neat timesaving feature named Crop and Straighten Photos, which generates a separate file for each photo it finds in the scan.

For best results, place the photos on the scanner's bed with a slight gap between them. I like to place a sheet of colored paper or plastic on top of the photos, between the backs of the photos and the scanner's lid. (See Figure 15–11.) I use paper or plastic that is a very different color from any color found along the edges of the photos. This gives Photoshop a good idea about where each photo ends and the next begins.

Use a contrasting background to help Crop and Straighten Photos find edges.

After the scan is complete and the image is open in Photoshop, choose File Automate Crop and Straighten Photos. No dialog box, no submenus — just select the command and wait a few seconds while Photoshop identifies the individual scanned images and creates a separate file for each.

Sticking to the Script

You can use AppleScript (Mac), Visual Basic (Windows), and JavaScript (both) with Photoshop. Scripts are much more powerful than Photoshop's Actions because they can control elements outside of Photoshop itself. AppleScripts and Visual Basic scripts can even run multiple programs and play JavaScripts. You can find plenty of information to get you started in books and videos available on the web.

If you shoot in your camera's Raw format, perhaps the most useful of the several prerecorded scripts installed with Photoshop is Image Processor. (See Figure 15–12.) Choose File \hookrightarrow Scripts \hookrightarrow Image Processor to batch-convert your Raw images to JPEG, PSD, or TIFF — and you can even resize the images automatically while converting! (And while Image Processor is designed to work with Raw files, you can actually convert any file format that Photoshop can open.)

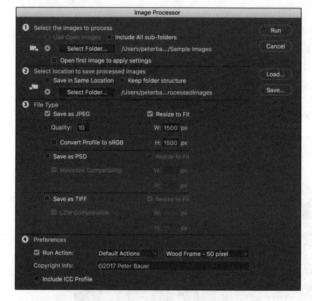

FIGURE 15-12: Image Processor can batch-convert to speed your workflow.

Image Processor is much simpler than it appears:

>> Select the images to process. If the images are already open in Photoshop, great! If not, click the button and select a folder of images. If the source folder has subfolders and you want to process the images in those subfolders, select that option.

>> Choose a destination. You can save the files in the folder of origination (and even maintain the subfolder structure), or you can click the button and select a different folder in which to save the processed images.

Do not click the Select Folder button and select the source folder. If you want to keep the processed images in the same folder as the unprocessed images, simply click the Save in Same Location button. Photoshop is smart enough — most of the time — to recognize the source folder and avoid reprocessing already processed images in an endless loop, but don't risk it.

>>> Select the file format and options. Each of the three file formats offers the option of resizing. JPEG offers options for Quality (the amount of compression — and associated image degradation) and to convert to sRGB (for the web or email). Maximizing compatibility for PSD files ensures that the image can be seen and opened by other programs of the Creative Cloud and earlier versions of Photoshop. TIFF's LZW compression can significantly reduce file size, without degrading the image at all.

At the bottom of the Image Processor dialog box are also the options to run an Action on the images as they're processed, to add your copyright information to the file's metadata (not on the image itself), and to embed the color profile in the image.

Note also the Save and Load buttons. If you set up a couple of folders, one where you dump the originals and another where you save from Image Processor, you can save your usual setup and load it whenever you need to repeat the job.

and the second of the property of the second of the second

And the second of the second o

Chapter 16

Working with Video and Animation

ust about every new digital camera and smartphone has the capability to capture video (with or without audio). Photoshop has some rather impressive tools that enable you to handle most of the movie-making tasks that a digital photographer or designer might need, and in an easy-to-use interface.

In this chapter, I introduce you to the basics of working with imported video. You can also read about creating animations in Photoshop. But remember that Photoshop is an image-editing program and not a full-blown movie-making suite. If you find that your motion picture dreams and aspirations can't be fulfilled by Photoshop, consider installing Adobe Premiere Pro and perhaps Adobe After Effects or Adobe Rush for online videos. If you don't have a full Creative Cloud subscription, the budget-priced Adobe Premiere Elements may be just the ticket.

Importing and Enhancing Video Clips

The heart of Photoshop's video capabilities is the Timeline panel. You also have the 12 commands of the Layer Video Layers menu, a special Motion workspace, and even a set of Actions in the Actions panel menu named, appropriately, Video Actions, all designed to make your work with video both easier and more precise.

Getting video into Photoshop

Getting ready to work with video in Photoshop is as easy as opening any readable video file into Photoshop. Choose File⇔Open, select the file, click OK, and you're on your way! (An open video in the Timeline panel is visible in Figure 16-1.) If you want to restrict the list of files in a folder to only video (or only audio) formats. select Video (or Audio) in the Enable menu at the bottom of the Open dialog box. You can also create a video project starting with one of Photoshop's video presets in the File → New dialog box. Photoshop supports dozens of video, audio, and still image file formats with which you can create your cinematic masterpieces.

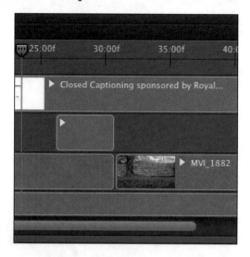

FIGURE 16-1: You can open a video file or create a new project.

After you have your project started, whether from an existing video file or a new document, you have a couple of options for adding additional clips, tracks, and images:

- >> Click the plus button at the right end of the existing video (or audio) track in the Timeline panel. You add an additional segment to the end of that track. (The plus button is visible at the right end of each track in Figure 16-2.) You navigate to and select the file in the Add Media dialog box, comparable to the Open dialog box, and it's added at the end of the existing segment. (You can easily add transitions between the segments, as described later in this chapter.)
- >> Click the button to the right of the video group name and select Add Media. This button also opens the Add Media dialog box.
- >>> Create a new video layer. Choose Layer ▷ Video Layers ▷ New Video Layer from File, which also opens the Add Video Layer dialog box.
- >> Copy/paste from another open file. If you have several segments on a track, the pasted media will be added after the highlighted segment, rather than at the end of the track.
- >> Place a file. Use the File □ Place command to add media as a Smart Object to the selected track. If no track is selected, the Smart Object is added outside the existing video group. (Placing and embedding Smart Objects is discussed in Chapter 9.)

FIGURE 16-2: Video groups and layers outside of groups can overlap to play simultaneously.

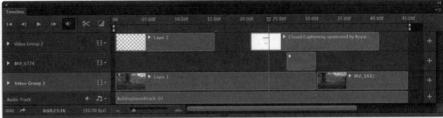

Using either of the first two techniques or the Place command to add a new segment automatically assigns the added file's name to the segment in the Timeline panel and to the layer in the Layers panel. Creating or pasting media uses the next sequential layer number in both the Layers panel and the Timeline panel.

When you open a video file, Photoshop automatically creates Video Group 1 in both the Layers panel and the Timeline panel, as you can see in Figure 16–2. Video groups not only help keep the content of the panels manageable, they also enable you to work with multiple tracks simultaneously. When you create a new document and paste or place media, you can manually create video groups through the button to the left of a track in the Timeline panel.

As you can see in Figure 16–2, segments in different video groups and layers outside of groups can overlap in the timeline. Much like creating an inanimate image using layers in Photoshop, the position on canvas, along with the layer opacity and blending mode, determine how the elements in the Timeline panel interact. The *playhead*, the blue slider at the top of the timeline whose position is also indicated by the vertical red line, shows what frame of the video is visible onscreen at any given moment.

You can scale the timeline in the Timeline panel using the slider in the middle at the bottom of the Timeline panel. Drag to the left to see more of the timeline; drag to the right to zoom in and work with precision.

Adjusting the length of video and audio clips

After clips are added to the Timeline panel, you can change each segment's length, start point, end point, and the order of play by dragging. Position the cursor in the middle of a clip and drag to rearrange the order of segments on a track. You can also change the order in which segments play within a video group by changing the stacking order in the Layers panel. Click the start or end of a segment and drag to "trim," changing what part of the segment plays. The cursor changes to a square bracket with a two-headed arrow when positioned over either end of a segment, as shown in Figure 16–3 on the upper video segment. (The video within the segment to the left of the new start point or, in this example, to the right of the new end point is not deleted — you can later drag the start and end points to change what part of that segment that plays.) For precision, you can also drag the playhead to a specific point on the timeline and right-click the playhead or use the Timeline panel's menu commands to trim or assign the start or end point for a segment.

FIGURE 16-3:
Drag the ends
of segments to
trim; click the
gray arrow at
the right end of
an audio track
to open the
Audio fly-out
panel.

Likewise, you can adjust the start and end points of audio tracks and audio segments. Use the Plus button at the right end of the audio track to add another audio segment to that track, or click the musical note button to the left of the track to add another audio track. You can add music and other audio in a variety of formats to Photoshop's Timeline panel. (I don't need to remind you that recorded music, just like your own photographs, is copyrighted material, right?) Click the gray arrow button at the right end of the audio segment to open the Audio fly-out panel (visible in Figure 16–3), in which you can elect to have the audio fade in, out, or both as well as set the volume for that audio segment.

The start and end of the work area, which determine what part of the entire video will play, can also be set by right-clicking the playhead or through the panel's menu. Alternatively, set the work area by dragging the sliders to the left and right ends of the timeline, visible in Figure 16-3 at the ends of the timeline at 00 and 45:00.

Adding adjustment layers and painting on video layers

Adjustment layers, not surprisingly, can be added to a video production through the Layers panel or the Layer menu. As with regular layers, an adjustment layer is applied to all video layers below the adjustment layer and within the video group. An adjustment layer can be clipped to a single video layer by Option/Alt+clicking in the Layers panel on the line between the adjustment layer and the video layer immediately below. You might, for example, want one segment of a track to appear as grayscale by adding a Black & White adjustment layer in the Layers panel and clipping it to the video layer below it.

You can use many of Photoshop's painting tools when working with video, including the Brush tool and the Clone Stamp tool. Unless you have a problem on one specific frame of video, you want to consider working on a new layer. Keep in mind that there's a major difference between adding a regular layer (choose Layer ➪ New ➪ Layer) and adding a new video layer (choose Layer ➪ Video Layers New Blank Video Layer). A video layer has frames, just like a video captured by a camera, whereas a regular layer is static — its appearance remains the same for whatever duration you specify in the Timeline panel.

Say, for example, that you had a dust speck or a water spot on your lens when capturing video (not that that ever happens). Working with a still image in Photoshop, you might simply use the Clone Stamp to cover that unsightly set of pixels with other nearby pixels. Say also that you captured, oh, maybe three minutes of high-definition video. At 30 frames per second. For a total of 5,400 frames. That's a lot of cloning.

If you clone on the video layer itself or on a new video layer, you'll need to do each frame individually. Instead, if the area is rather similar in each frame, you can add a new regular layer above the problematic video segment and, on the Options bar, set the Clone Stamp tool to sample the current layer and the layer immediately below. Clone once, covering the despicable speck or spot on the new layer, and then in the Timeline panel, drag the "start" and "end" points for that layer to match those of the video segment. (See Figure 16-4.) When played back or rendered, the cloned area covers the flaw on the video layer — every frame fixed with a single clone! (Remember to set the playhead at the beginning of the video segment that needs fixing before Option/Alt+clicking with the Clone Stamp tool to set the source point.)

FIGURE 16-4:
The "regular"
layer will
be visible in
the video for
the entire
duration of the
video segment
below it.

Transitioning, titling, and adding special effects

When working with multiple video segments, you'll generally want your movie to smoothly blend from one clip to another with a *transition*. Photoshop's Timeline panel offers a number of built-in transitions that you can drag between segments on a single track. Click the button immediately to the left of the timeline in the Timeline panel, select the transition, specify the duration for the transition, and then drag the transition onto the track between the two video segments. (See Figure 16–5.) When played back or rendered, the two video segments blend into each other using the selected transition for the specified duration.

FIGURE 16-5: Drag transitions to the timeline to blend adjacent video segments.

Adding a title to the beginning of your cinematic extravaganza (and, of course, your name in the Director and Producer credits at the end) is as easy as adding a type layer and specifying the layer's duration in the Timeline panel. You can also add shapes to a video with the various shape tools, just as you would in any other artwork.

To add some spice to your titles and shapes, consider using keyframes to control the opacity, position, and even size of the type layer. A *keyframe* is a marker in the timeline that specifies when a specific event begins and ends. You might, for instance, want the title of your movie to fade in quickly, remain onscreen while the first frames of the video play in the background, and then slowly fade away. (To get such an effect, you set your keyframes as shown in Figure 16–6.)

FIGURE 16-6: Use keyframes to specify start and end points of special effects.

Visible in the timeline in Figure 16-6 are the diamonds that represent keyframes, which I created using these steps:

Add the type layer: Select the Type tool, specify the font, size, and other
attributes on the Options bar or Character panel; click in the image
window and type your text. End the text editing session by clicking the
check mark at the right end of the Options bar, by changing tools, or by
pressing # +Return or Ctrl+Enter.

In the Layers panel, make sure that the type layer is above your video layers and outside any video group.

2. Position the type layer: Drag the type layer into the position in the image window where you want it to first appear.

You'll also want to drag the left edge of the layer in the Timeline panel to the position along the timeline where you first want it to appear.

- Specify the duration: Click the right edge of the type layer segment in the Timeline panel and drag to the point where you want the title completely gone from the screen.
- **4.** Expand the options for that track: Click the triangle to the left of the type layer's name in the left column of the Timeline panel.

The options are expanded in Figure 16-6.

Add the first opacity keyframe: Position the playhead at the beginning of the title segment, and then click the stopwatch button to the left of the word *Opacity*.

That adds the first keyframe at the playhead position.

6. Set the opacity in the Layers panel.

In this example, because you want the title to fade in, set the layer's Opacity to 0%.

7. Set the second keyframe: Move the playhead to the point in the timeline where you want the title to be completely visible. Click the diamond-shaped button between the arrows to the left of Opacity in the left column of the Timeline panel.

Keep in mind that you can switch the Timeline Unit between Frame Number and Timecode in the Timeline panel's options, which you access through the panel's menu.

- 8. Set the opacity in the Layers panel. Set the Opacity to 100% so that the type layer is completely visible.
- Add the next keyframe: Drag the playhead to the point in the timeline where you want the title to start fading out, and then click the diamondshaped button to add the keyframe.
- 10. Set the Opacity: Well, okay, you want the opacity still set to 100% at this point, so you don't need to change the Opacity in the Layers panel after all.

If, however, you want a different opacity value at this keyframe, you can set the opacity as desired in the Layers panel.

- 11. Add the last keyframe: Move the playhead to the right end of the title segment and click the diamond-shaped button to add the last keyframe.
- 12. Reduce the opacity: In the Layers panel, set the Opacity field back to zero.

Drag the playhead to the beginning (or click the button in the upper-left corner of the Timeline panel), and then click the Play button to preview. Your title will fade in between the first pair of keyframes, remain at 100% opacity between the second and third keyframes, and then fade out between the third and fourth keyframes. Any other tracks you have in the Timeline continue to play.

Notice that you have several other keyframe-controlled options for the type layer in the left column of the Timeline panel. You could, perhaps, use keyframes to control a text warp, perhaps an arc or bulge. You could also use keyframes in conjunction with Photoshop's Edit Transform commands to control the appearance of the type layer. You might, for example, use the Scale command to make your type layer go from a size of two or three points to filling the entire image window, making it appear to zoom in from a distance. Using keyframes to control the Transform Rotate command can make the type layer spin over time. And, of course, you can use these effects in conjunction with each other, so the title could zoom in from a distance while spinning and fading in to 100% opacity. (Click the triangle to the left of a video group in the left column of the Timeline panel and you'll see the keyframe-controlled options for video tracks.)

Transforming video layers

So, how about transforming video clips, scaling or rotating a video segment for special effects? Simply convert a video group or video layer to a Smart Object by selecting it in the Layers panel and choosing Layer Smart Objects Convert to Smart Object.

Keep in mind, too, that after converting a video group or video layer to a Smart Object, you can work with Smart Filters. Consider, if you will, a video clip captured under low-light conditions at high ISO. After adding your Curves or Levels adjustment layer to lighten up the video segment, you may find an unacceptable amount of digital noise. You *could* use the Reduce Noise filter, click the Next Frame button, use the Reduce Noise filter, click the Next Frame button, and use the — well, you get the idea. Instead, convert the video layer to a Smart Object and apply the Reduce Noise filter as a Smart Filter, reducing noise in all frames of the video segment. (Reduce Noise is just one example of Smart Filters that can be effectively used with video clips.)

The Timeline panel also has some nifty effects built right in, including Pan, Zoom, Rotate, and the combinations Pan & Zoom and Rotate & Zoom. These effects are applied to any video or other layer through the Motion fly-out panel, which you open by clicking the small gray arrow at the right end of a segment in the Timeline panel.

But what if you want to apply the effect to only a portion of a video segment? Position the playhead at the point where you want to make a change and click the Split at Playhead button (to the left of the Transitions button in the left column of the Timeline panel) or use the panel's menu command of the same name. The segment is divided at that point. If the video layer is within a video group in the Layers panel, it's simply divided into two segments. If the video layer is outside a video group, the portion to the right of the playhead is cut to a separate video track. If you split a Smart Object, you'll create a pair of Smart Objects, both with any Smart Filters that had already been applied.

Rendering and exporting video

You've added all the video tracks, dragged transitions between segments, created a title with keyframe-controlled special effects, and adjusted your audio to perfection. Now what? Save the file in the PSD file format to preserve all your editing options, of course. But to actually use the video in any other program, or to share it with others, you'll need to use Photoshop's File > Export > Render Video command.

You select a filename and location in the top section of the Render Video dialog box. In the middle section, elect to use Adobe Media Encoder to create a video. (You also have the Photoshop Image Sequence option to create a still image from each frame of the video.) Your video file format options include QuickTime (great for video on a variety of platforms), H.264 (a standard for high-definition video), and DPX (digital picture exchange, often used for video that will be further processed in another program). Each format offers a variety of presets. QuickTime, for example, lets you select a compression scheme and enables you to change the dimensions and frame rate of the final video. With H.264 selected, the Presets menu includes device-specific output settings for iPads, iPhones, Android phones and tablets, a variety of high-definition TV standards, NTSC, PAL, and even YouTube.

Near the bottom of the Render Video dialog box, you'll have the option of specifying a range of frames, if you don't want to render the entire video. If your masterpiece includes an alpha channel (QuickTime only) or 3D objects, you'll also be able to specify how those elements are rendered.

After clicking the Render button, Photoshop will export the video in the selected format, with the selected presets, using the selected filename and location. How long it takes to export the video depends on a number of things, including your hardware, the length of the video, and the preset selected.

Creating Animations in Photoshop

In addition to timeline video, Photoshop provides everything you need to create frame-based animation for use on web pages and in presentations.

Building frame-based animations

Although it is certainly possible to start with a video clip or even a photo when creating a frame-based animation, you may find such projects are better suited to shapes and text. You can certainly export a frame-based animation as a QuickTime video, but to post on your website, you're more likely to use Save for Web to generate an animated GIF. (Remember that the GIF file format uses a color table limited to no more than 256 colors, so it's not generally appropriate for photographic or other continuous-tone images.)

Prior to generating the individual frames of your animation, you'll usually want to create all the elements from which those frames will be created. Keeping each

element on a separate layer makes frame creation a very simple process. After you have all the elements you'll need, open the Timeline panel through Photoshop's Window menu and take a look at the lower-left corner of the panel. If you see the word *Once* or *Forever* with a downward-pointing arrow to the right, you're ready to get started. If you see a button with three little boxes lined up horizontally like (ready for it?) *frames in a movie*, click the button to switch the panel from video timeline to frame animation. (If, for another project, you need to reconfigure the Timeline panel for video timeline, click the button in the lower-left corner.)

In a nutshell, here's how you create a frame-based animation in Photoshop:

 Show/hide layers in the Layers panel. Set the Layer panel content to show those elements you want visible in the first frame of the animation.

If you want the animation to start with an empty screen, hide all the layers.

2. Click the New Frame button.

Below the frames in the Timeline panel are a number of buttons. The New Frame button is second from the right, next to the Trash icon (which is used, naturally enough, to delete frames).

3. Rearrange the content of the Layers panel.

Show/hide layers, move layer content, and otherwise rearrange the image window to set it the way you want for the second frame.

4. Repeat as desired.

Click the New Frame button, rearrange the items, click the New Frame button, rearrange, and so on until you have all the frames you want for your animation.

Use Save for Web to create an animated GIF or export as a QuickTime movie.

And you're done! (Make sure to save the layered document in the PSD file format, just in case you want to make changes or use some of the elements in another animation down the road.)

Creating frame content

If each frame of the animation was identical, there would be no reason to create an animation — it would appear to be a still image. So, from frame to frame, something is usually different to provide the change-over-time that's the basis

for animation. Among the changes you can make in the Layers panel to change the appearance of the animation from frame to frame are

- >> Layer visibility: You can show or hide the content of a layer.
- >> Layer opacity: By changing a layer's opacity from frame to frame, you can make the content of the layer fade in or fade out as the animation plays.
- >> Change position: You can use the Move tool to drag items around on a layer, making them seem to move from frame to frame.
- >> Change blending mode: Changing a layer's blending mode changes the way that layer's content interacts with the content of layers below from frame to frame.
- **Add, remove, or change a layer style:** Consider, for example, a round shape with a Bevel layer style that changes, making the object appear to inflate and deflate from frame to frame.

In the Timeline panel shown in Figure 16–7, you can see how a simple animation can be created by adding a frame, moving the content of the two layers, adding another frame, dragging the objects again, and so on.

FIGURE 16-7:
Over the course
of the animation,
the red ball and
blue square
exchange places
onscreen.

Tweening to create intermediary frames

To create the animation in Figure 16–7, I actually created only 3 of the 13 frames. I let Photoshop do the other 10 frames, saving me time and ensuring that the animation would play smoothly and precisely. I created the first frame, with the red circle in the upper–left corner and the blue square in the lower–right. I then clicked the New Frame button and, in the image window, dragged the red circle to the lower–left and the blue square to the upper–right. After clicking the New Frame button again, I dragged the red circle to the lower–right (where the blue square started) and dragged the blue square to the upper–left (where the red circle started).

After creating my three frames, Photoshop tweened pairs of frames to create the intermediary frames. Tweening creates the frames in between two frames in the Timeline panel. I clicked the first frame and then opened the Timeline panel menu and selected the Tween command. In the Tween dialog box (see Figure 16-8), you can specify how many frames to generate (I chose five), what aspects of the frames you want to blend (I needed to tween only for position because there were no changes to opacity or layer styles), and whether to tween between the selected frame and the next frame or the last frame (I chose Next Frame). I then clicked the second frame I created (frame number 7 at that point,

FIGURE 16-8: Photoshop generated 10 of the 13 frames automatically.

second from last) and repeated the Tween process.

Say that, on your home page, you want a logo to fade out and fade in repeatedly, and you want each fade to be extremely smooth. You could create the logo, set the layer opacity to 100%, add a new frame, reduce the opacity to 99%, add a new frame, reduce the opacity to 98%, and repeat over and over again until you reached 0% opacity. Or you could create the logo at 100% opacity, click the New Frame button, reduce the opacity to 0%, click the first frame, and use the Tween command to generate 99 more frames, tweening for opacity. Add another frame, return the opacity to 99% (your original first frame is at 100%), and then tween 98 new frames between the second-to-last frame and the newly created last frame. Your choice . . .

Specifying frame rate

You control how fast (or slowly) your animation plays by specifying a frame rate. Generally, each frame plays for the same amount of time, so you can click the first frame, Shift+click the last, and select the frame rate of your choice from the menu below any one of the frames. (See Figure 16–9.) If you select No Delay (0.00 seconds), the animation plays as fast as possible. Don't overlook the Other option! You're not restricted to the time delays listed in the menu.

FIGURE 16-9: Select all of the frames and assign a frame rate to control playback speed.

Keep in mind that not all frames need to have the same playback rate. Consider, if you will, the example of the logo that fades in and out on your home page in the previous section of this chapter. There's no reason why the 100% opacity frame couldn't be set to a five- or ten-second delay, with all the other frames set to $\frac{1}{10}$ 0 of a second.

In the lower-left corner of the Timeline panel, you also want to select the repeat for the animation. You can elect to have the animation play once and then stop, to continuously loop (Forever), or you can choose any other number of times for the animation to play in a loop by selecting Other.

Optimizing and saving your animation

If you expect to be adding your animation to a web page or a presentation created in Keynote or PowerPoint, you want to generate an animated GIF. (Keep in mind that if there's no layer named Background in the Layers panel, your animated GIF can support transparency.) After generating all the frames, open the Timeline panel menu and select the Optimize Animation command. The default settings — with Bounding Box and Redundant Pixel Removal both selected — will generate the smallest file, ensuring the smoothest playback. Save the layered and animated file in the PSD file format for future use, and then choose File Save for Web to create the animated GIF. (Remember to select the Transparency option in Save for Web if you don't have a background layer.)

If you want to use your animation with devices that don't play animated GIFs — some smartphones, for example — choose File → Export → Render Video to generate a QuickTime movie.

The Part of Tens

IN THIS PART ...

In each of these chapters, get a look at ten of the very specialized features of Photoshop.

See how to make unwanted objects disappear from a series of photos with Smart Objects and Stack Modes.

Learn to measure and count in Photoshop.

Find out how to integrate your iPad into your Photoshop workflow.

Discover high-dynamic-range (HDR) imaging.

- » Working with 3D artwork
- » Measuring, counting, and analyzing in Photoshop

Chapter **17**

Ten Specialized Features of Photoshop CC

or years, Adobe has heard the pleas of researchers, scientists, and other highly specialized users of Photoshop to include features that fulfill their needs. As I explain, these extended features don't really have a place in the workflow of most Photoshop users. That doesn't mean that you'll *never* use any of these features! You might find a need to calculate a height or a distance using the measuring tools in Vanishing Point, or perhaps use the Count tool. As a photographer, you may find that a couple of the Smart Object stack modes can be used to solve a couple of photographic challenges. And who can resist the temptation to play around with 3D? Figure 17–1 shows the 3D panel and menu commands.

In this chapter, I introduce you to the various special features of Photoshop that once were only in the "Extended" version of Photoshop. This chapter won't get you fully up to speed on how to work with the features; instead, it's meant to quench your curiosity about those features designed for specialists and scientists rather than photographers and designers.

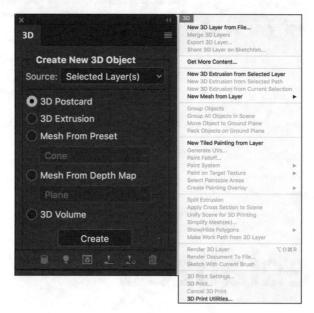

Photoshop CC includes 3D capabilities.

Using Smart Object Stack Modes

Working with Photoshop CC, you can combine a number of images into a single *stack* as a Smart Object. Within the pile of images, you can determine how the pixels in each interact with those in the others. Select several related or contrasting images and add them as layers to a single image, select the layers, and create a Smart Object by choosing Layer Smart Objects Convert to Smart Object. Return to the Layer Smart Object submenu and take a look at the Stack Modes submenu that's now available. These options determine how the content on the layers within the Smart Object interact to produce the appearance of the Smart Object itself. (Not quite the same, but similar to the way layer-blending modes help determine the overall appearance of your artwork.) You can find technical explanations of each option in Photoshop's Help. In Figure 17-2, you see a combination of the layers (shown to the left as thumbnails) using the stack mode Mean, which averages the values for each pixel in each channel. Not quite Merge to HDR, but with some planning and prep, it could be a supplemental technique.

FIGURE 17-2:
Several
exposures
combined into
one image is
just one use of
Smart Objects
and Stack
Modes.

Photographers may also find another great use for stack modes. Using a tripod and the same exposure settings, take a number of photos of a static object with moving objects (people or cars, for example) over a reasonably short period of time (minutes, not hours, so the lighting doesn't change much). Select the thumbnails in Bridge and use Bridge's menu command Tools Photoshop Load Files into Photoshop Layers. (If you're not using Bridge, open the first image, then open each additional image and drag the layer Background from the Layers panel to the first image.) In Photoshop, use the menu command Select All Layers. (You never even noticed that command before? Now you'll use it all the time.) Unless you had a rock-solid tripod, choose Photoshop's Edit Auto-Align Layers command with the Reposition option. Create a Smart Object from the layers by choosing Layers Smart Objects Convert to Smart Object. Choose the Median stack mode and watch all of those moving objects simply disappear, leaving you with just the scene, empty of traffic. Figure 17–3 shows the shots originally taken and the resulting image.

If something very prominent or bright in one of the shots doesn't disappear completely, go back in the History panel to before you created the Smart Object (the Auto-Align Layers step) and delete that particular area from the offending layer, re-create the Smart Object, and reselect the Median stack mode.

Sipeliner-Old pg

FIGURE 17-3:
The cars on either side of the river, the bus, and even the falling snow are removed using Median.

The Mean Stack Mode

Another use of the stack mode Mean that is of value to photographers is noise reduction. Shooting in low light with a high ISO setting can result in images with a lot of noise. Using a tripod or bracing the camera, take several shots, perhaps using the camera's burst mode. (This is a great trick for shooting in a museum that doesn't permit flash photography.) Open the files in Photoshop layers through Bridge or manually, select all the layers, and align. Create your Smart Object from the layers and set the stack mode to Mean to minimize the noise.

Working with 3D Artwork

Photoshop offers lots of 3D capabilities, including 3D extrusions from layers and paths, control over the spatial relationships among objects, improved rendering, and generally improved performance. Figure 17–4 shows many of the features available when working in 3D.

You can use the tools in the 3D Mode section of the Options bar (to the far right) to rotate and roll and drag and slide and scale 3D objects. The 3D panel offers access to each of the materials (think "textures") used with a 3D object, as well as a tab on which you add, subtract, or alter lights used in the 3D scene. (Take a look at the Lighting Effects filter in Chapter 14 for some info on working with lights.)

Tools, menus, and panels specially for working in 3D.

Creating 3D objects

Working with a photo or any other 2D artwork, you can create any of a dozen different 3D shapes, from simple spheres, cubes, and cones to donuts, hats, and wine bottles. (Use the menu command 3D \(\sigma\) New Mesh from Layer \(\sigma\) Mesh Preset.) Working with a layer that contains areas of transparency, you can extrude shapes as well, stretching the layer content backward into a 3D shape. (Use the menu command 3D \(\sigma\) New 3D Extrusion from Selected Layer.) Active selections on a layer and even paths can be used to create extruded objects.

Adding 3D objects

You can use Photoshop's File → Open command, or add a 3D object to an existing project by choosing 3D → New 3D Layer from File. Among the file formats that support 3D that you can open into Photoshop are 3D Studio, Collada DAE, Flash 3D, Google Earth 4 KMZ, U3D, and Wavefront OBJ. Many ready-made 3D objects can be downloaded or purchased from various websites, including Adobe Stock and these vendors:

```
www.turbosquid.com/photoshop-3d
```

www.daz3d.com

www.archive3d.net/

Rendering and saving 3D scenes

After you have your 3D scene looking just the way you want it to appear as a 2D image, use the command 3D \$\sigma\$ Render, followed by File \$\sigma\$ Save As, to save in the file format of your choice. Photoshop uses the Shadow Quality and Ray Tracer High Quality Threshold settings set in the program's Preferences \$\sigma\$ 3D.

You can also use the command 3D ⇔ Export 3D Layer to save the project in any of eight 3D file formats, including Collada DAE, Flash 3D, Google Earth 4 KMZ, 3D PDF, STL, U3D, VRML, and Wavefront OBJ.

If you're interested in working with 3D in Photoshop, I highly recommend that you pick up a copy of a book that goes into more detail on the subject.

Measuring, Counting, and Analyzing Pixels

Designed for researchers and scientists, the measuring capabilities in Photoshop are quite powerful. You can measure just about anything and count the number of whatevers in a technical image, perhaps from a microscope or telescope.

Measuring length, area, and more

If you know the exact size of any element in an image, you can then discover just about anything you want to know about anything else in that image. The key is to set the measurement scale, as shown in Figure 17–5. Open the Measurement Log through Photoshop's Window menu. Click the button in the upper-right corner to open the panel menu. From the Set Measurement Scale options, choose Custom (rather than Default). Drag the Ruler a known distance and then set the custom measurement scale. Afterward, you can use the Ruler to determine the height, width, or length of anything in the image.

In this example, we know that the concrete wall cap on which the squirrel is sitting is exactly 2.25 inches tall. By holding down the Shift key and dragging the Ruler tool from the bottom to the top of the concrete cap (or, of course, top to bottom), you can establish the first measurement by clicking the Measurement Log's Record Measurement button (to the upper left of the Log).

The Measurement Scale dialog box (to the right) opens through the Image Analysis menu or the Measurement Log's panel menu with the command Set Measurement Scale Custom. The Measurement Log's Length field tells you that the Ruler was dragged a distance of 425 pixels. You can then establish the measurement scale to 425 pixels equals 2.25 inches.

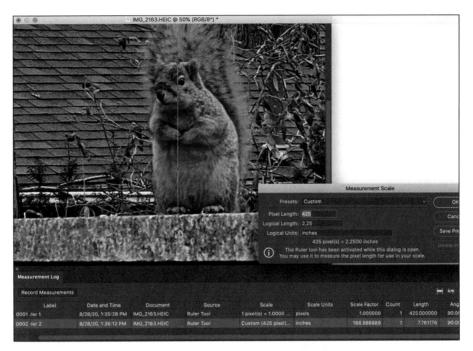

FIGURE 17-5: Customize the Measurement Scale.

By dragging the Ruler from the feet to the top of the squirrel's head (or head to toes, if you prefer) and clicking Record Measurement again, you can precisely measure the height of this squirrel in his current body position. The second recorded ruler Length field tells you that the squirrel is standing at a bit over 7.76 inches.

Using any selection tool, you can also isolate any part of the image, click the Record Measurements button in the Measurement Log panel, and you'll find out more than you ever wanted to know about that particular selection and its content. In addition to the fields visible in Figure 17–5, the Measurement Log can also track (among other things) the height, width, area, and perimeter length of the selection, as well as the minimum, maximum, mean, and median gray values within the selection.

After you have made and recorded all the various measurements you need, you can select all the lines in the Measurement Log (or only a few) and click the third button in the upper-right corner of the panel to export the data for use in a spread-sheet program.

Calculating with Vanishing Point

Photoshop also offers measurement in perspective through Vanishing Point (found in the Filter menu). Suppose, for example, you need to calculate how much wallpaper to order for the room shown in Figure 17–6. You know the height of the window (70 inches) and using that as your known measurement, you can have Photoshop calculate the height and length of each wall. Drag the Measure tool along the edge of the window and enter the known size (70 inches) in the Length field. When you click the four corners of a surface in the image with the Create Plane tool, the length of each side is visible in boxes.

FIGURE 17-6: Measurements can also be made in perspective with Vanishing Point.

Counting crows or maybe avian flu

Nested with the Ruler tool and the Eyedroppers in the Toolbox is the Count tool. Zoom in and start clicking whatever you need to count, whether they're birds in the sky or viruses on a slide. Each item you click is labeled with a number. When you want to record the count, click the Record Measurements button in the Measurement Log. You can also record and work with multiple counts. To the right of the Count Groups menu on the Options bar (see Figure 17–7) are buttons to show/hide the currently selected count group, to start a new count group, and to delete the current count group. Click the color swatch on the Options bar to select a new color for the count group, and you can customize both the size of the circle that marks the count and the marker number — individually for each count group.

(Don't you love the way that Warning symbol in the margin catches your eye?) Adjust the marker and label sizes (and select a color) before you start clicking around in your image with the Count tool, because changing the size after placing your count markers can shift them in the image window, destroying your meticulous placement.

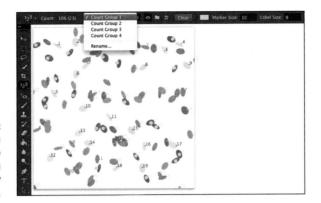

FIGURE 17-7: Click each item and Photoshop keeps a running tally for you.

Viewing Your DICOM Medical Records

If your doctor's office, hospital, or lab has sent you home with a CD (you may need to request the files), it probably contains DICOM (Digital Imaging and COmmunication in Medicine) images. It might contain the results of a CAT scan, MRI, ultrasound, or X-rays, and you can open the files and take a look right in Photoshop. Copy the files to your hard drive. (Don't open files into Photoshop directly from a CD or DVD.) Choose File \hookrightarrow Open. In the Open dialog box, select the frames in which you're interested and then click Open.

In the next dialog box that opens (shown in Figure 17–8), the preview area is likely to be completely black. Make sure that Show Windowing Options is selected. In the Window Preset menu select the appropriate view option. Full is generally a good option, but try the others if appropriate for the image content.

If you selected multiple DICOM images in Photoshop's Open dialog box, you can click each of the thumbnails in the stack to the left to view them one at a time. You can also use the two arrows to the right below the preview to move through the frames.

With multiple images open in the DICOM viewer window, you can click the Select All button in the upper left and then elect to open into Photoshop as layers in an image (the Import Frames as Layers option) or in a grid pattern (the N-Up Configuration option). You can also use Photoshop's File ♀ Place command to add a DICOM image to an appropriate image.

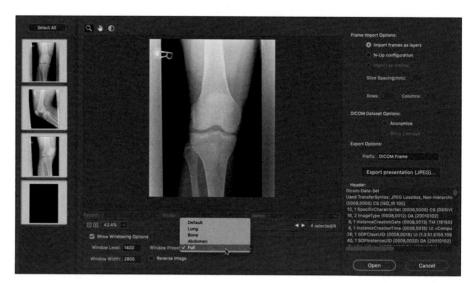

FIGURE 17-8: Review medical imagery right in Photoshop.

Ignoring MATLAB

Photoshop offers all of these interesting features for scientists, researchers, and technicians, so it only makes sense that it should work with some of the file formats they actually use and integrate with their software. When you come across the term *MATLAB* in Photoshop, recognize it as a software environment (sort of like a programming language) that speeds calculations and helps coordinate work in various technical programs. Unless you actually work with MATLAB, in, say, a research lab, you really don't need to know anything else about it. (If you're intrigued by the idea, visit www.mathworks.com.)

- » Introducing Photoshop on the iPad
- » Storing in the Cloud
- » Using your Wacom tablet with Photoshop

Chapter **18**

Ten Ways to Integrate Your iPad

f you're using Apple products and your equipment is reasonably up to date (and you've kept your software current), you can use an iPad as an extension of your laptop or desktop monitor. Much cooler (and less expensive) than dragging that 24-inch, 4K display along with you on the road. And Adobe has a version of Photoshop for the iPad. Not "a Photoshop app for iPad" but rather Photoshop on the iPad. The interface takes some getting used to, and it doesn't (yet) have all the features of Photoshop on your primary computer, but the software is much more powerful than earlier iPad apps for image editing. Does the iPad replace your Wacom tablet? Not necessarily. (I explain why at the end of this chapter.)

Using Sidecar to Add an iPad to Your Screen

In the Mac's System Preferences, you see Sidecar (assuming that your hardware and OS meet the requirements named in the following section). When you open Sidecar (see Figure 18-1), you see a list of all compatible iPads that are either directly connected to or on the same network as your main computer. (That's the one on which you opened System Preferences.)

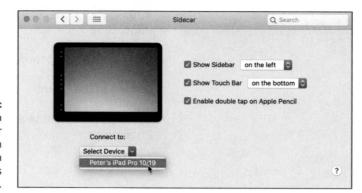

FIGURE 18-1:
You open
Sidecar
through
System
Preferences
on the Mac.

Sidecar System Requirements

Needless to say, Sidecar is an Apple-only feature. Your Mac must be using macOS Catalina (or newer). Computers that work with Sidecar include MacBooks and MacBook Pros from 2016 on; MacBook Airs from 2018 and newer; iMacs from 2017 and later, as well as the iMac Retina 5K, 27-inch from the later part on 2015 and newer; Mac Minis from 2018 on; and Mac Pros from 2019 and newer.

On the iPad side of the equation, you need an iPad Pro (all models); iPad sixth generation or later; iPad Mini fifth generation or later; or an iPad Air third generation or later. (If you're not sure what you have, you can go online to Apple support and check by the model number or serial number.) Regardless of which iPad you're using, it must be running iPadOS 13 or later. Remember that if you have a cable with the proper connectors, you can plug your iPad into your laptop rather than connect wirelessly for Sidecar. The advantages are that the iPad remains charging while you work and, if you're not at home or work, you don't need to rely on a network over which you don't have control.

Arranging Your iPad's Screen

After selecting your iPad in Sidecar, click the box in the upper left (its icon has 12 dots — yes, I counted them) to return to the main System Preferences dialog. Click Displays and then Arrangement (as shown in Figure 18-2).

Typically, the iPad is shown to the right of the primary monitor but, as you can see in Figure 18-2's insets to the right, you can also elect to have the iPad's screen become part of your workspace above or below the primary screen. (You can also, of course, arrange it to the left if that suits your needs — especially handy for southpaws.)

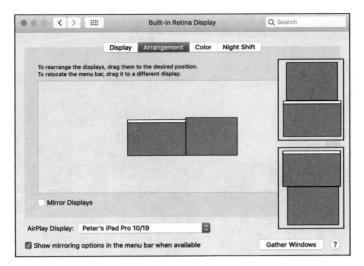

FIGURE 18-2: Set up multiple screens on the Arrangement tab.

When set up, your cursor simply flows from one screen to the other as you move it. You can use your Apple Pencil on the iPad screen for painting, selecting, and anything else you do with a mouse or trackpad.

Mirroring the Screens

In Displays, you also have the option of "mirroring" the screens. Whatever is shown on your main monitor is also shown on the iPad. You might want to do this, for example, when showing work to a client or a student. It can also come in handy in a collaborative workflow when office (or cubical) space is limited.

Maximizing the Screen Space

Okay, so now you have your iPad set up to extend your monitor or screen. What to do with all that extra space? You might have Photoshop on your main screen and Bridge open on the iPad. Or you might want to hog all the space for Photoshop. In Figure 18–3, you see how Photoshop's panels can be on one screen and the working image on the iPad.

In Figure 18–3, the laptop's screen is completely full of all the Photoshop panels that might come in handy while working with that particular image. The image itself is on the iPad's screen, which enables you to use the Apple Pencil as a pressure–sensitive drawing stylus. And, in all honesty, this iPad's screen is much better than the laptop's in terms of resolution and color fidelity.

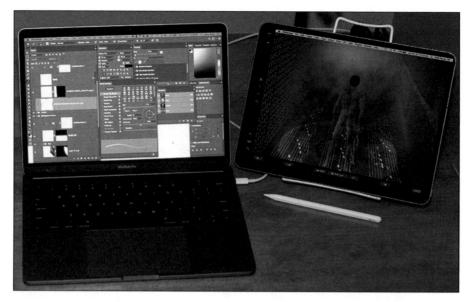

FIGURE 18-3:
The iPad is extending the screen space, arranged (for convenience) to the right in System Preferences.

Making Use of Photoshop on the iPad

Photoshop on the iPad is actually Photoshop, not some watered-down app. Although the interface is significantly different (see Figure 18-4) and not all of Photoshop's features have yet been added, this is actually Photoshop running on the iPad. Unlike many apps, including Lightroom on the iPad, Photoshop on the iPad lets you composite images with layers, make adjustments, and use many of your favorite Photoshop tools. Which features are available depends on when you're reading this. Progress is continuous, and as the engineers get features ready and stable, they're available through updates.

Also in flux is access to Photoshop on the iPad. If you have a subscription to Adobe's full Creative Cloud, you definitely have access to Photoshop on the iPad. If you have the Photography package or subscribe only to Photoshop, you probably also get Photoshop on the iPad. And if you need only Photoshop on the iPad, not any of the desktop programs, you can likely purchase it separately through the App Store. But that's subject to change as the program matures.

Working with the Apple Pencil's pressure sensitivity in Photoshop on the iPad is quite a step up from using a trackpad or mouse. If you have a keyboard that connects to your iPad, most of your familiar Photoshop shortcuts are there at your fingertips (pun intended). But in the Department of Extra Cool is the use of gestures with Photoshop on the iPad. Tap with two fingers to undo; tap with three fingers to redo. Double-tap or long press on tools that have a triangle in the corner to reveal more tools. Those are just a few of the gestures you can use with Photoshop on the iPad, and more are being added regularly.

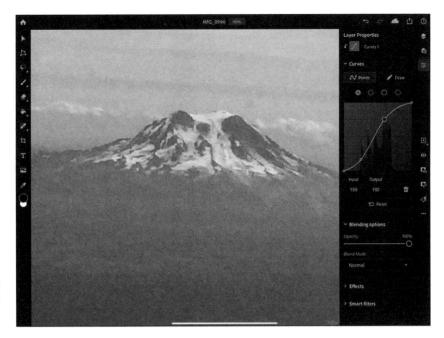

FIGURE 18-4: Photoshop on the iPad has a very different interface but many of the same features.

To see what gestures and shortcuts are current, click the gear icon in the upperright corner and then tap Input. You can also adjust the pressure sensitivity of your Apple Pencil in that section.

Using the Cloud with Photoshop on the iPad and Desktop

When working with Photoshop on the iPad, any document you create from scratch is automatically saved as a Cloud document. You can access Cloud docs both from the iPad and Photoshop on your desktop or laptop. Changes are automatically synced through the Cloud.

To access existing documents in the Cloud (saved there, perhaps, from your laptop while on the road), open Photoshop on your iPad and open the home screen. If the image with which you want to work isn't listed among the recent documents, click Import and Open in the lower-left corner. You can access Photos on your iPad, click Files to navigate through your iCloud docs, or even click Camera to access the iPad's camera and take a new photo.

If you're not able to access your iCloud docs, make sure that you're logged in to your Adobe account. Click the gear icon in the upper right; then click Account to log in. You can also see how much Cloud storage is already used and how much is available. (You can change your subscription to increase your storage if necessary.)

Using Other Adobe iPad Apps

The availability of other iPad apps from Adobe is another moving target: Apps come and they go; they gain and lose features as Photoshop on the iPad matures. Photoshop Express and Photoshop Fix for simple retouching, as well as Lightroom for Mobile, are the basic tools. But after you start working with Photoshop on the iPad, you'll probably use the other apps only on other mobile devices.

Among the apps available for smartphones (iOS and Android) are Photoshop Express, Photoshop Mix, Photoshop Fix, Photoshop Camera, and Illustrator Draw.

Does the iPad Replace My Wacom Tablet?

Not only does the iPad not make your Wacom tablet expendable, you can use them together. After adding the iPad through Sidecar, you need to reopen the Wacom Preferences (through System Preferences) and redefine the corners of the screen to include the iPad. You can use the Wacom stylus in addition to your Apple Pencil (just as you can use it with your trackpad or mouse), but remember which works with which. You can't use your Apple Pencil on the Wacom tablet, and you can't use the Wacom stylus on the iPad's screen.

One of the better ways, at least for me, to keep things straight is to arrange the iPad screen to the top or bottom of the main screen (see the insets to the right in Figure 18–2, shown previously) and keep the tablet to the side. (I'm right-handed, so I keep the tablet to the right. Lefties probably want to swap sides for ease of use.)

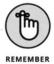

Do not leave the stylus on top of the tablet or the Apple Pencil on top of the iPad. These are input devices and as long as they're in contact with the appropriate surface, they're sending signals to the computer. Make it a habit to use the pen stand for your stylus and to keep the Apple Pencil on the desk or attached to the iPad on the magnetic side to keep it charged.

Setting Wacom Tablet Preferences for Touch Keys and Touch Ring

Remember, too, that (depending on your model), Wacom tablets offer Touch Keys and the Touch Ring. If you're used to using these, you *definitely* want to keep the tablet in your workflow along with your iPad. If you don't use them, it's time to learn. Wacom offers lots of information on its website to help you get started, but remember that you need to set up these features to use them.

After downloading and installing the latest version of the Wacom driver for your tablet, open the Control Panel and customize your tablet. (On a Mac, choose System Preferences > Wacom Tablet. In Windows, choose Start > All Programs > Wacom Tablet > Wacom Tablet Properties.) When you install your tablet's driver, a special Wacom button is added to System Preferences, enabling you to program many features, and you can program different features for different programs. The Control Panel (see Figure 18-5) enables you to assign a specific function or keystroke to each of the ExpressKeys, Touch Ring, and Touch Strips (not available on all models), as well as to program your various pens and mouse.

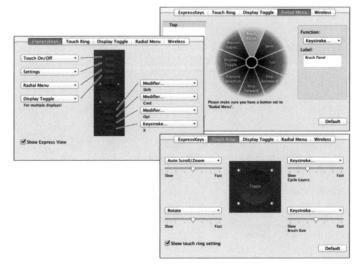

You can program

program different features for various programs.

- » Shooting for HDR
- » Processing, saving, and outputting HDR

Chapter 19

Ten Things to Know about HDR

he world of photography continues to evolve at an amazing pace! Not only has digital photography replaced film for just about all uses, the various Raw file formats are more and more common in both professional and high-end hobbyist photography, and even many smartphones. A typical camera phone now captures as many or more pixels than did an expensive pocket camera just a few years ago. Smartphones that offer an HDR option can help in some challenging lighting conditions, such as a photo of a dark room with the bright outdoors in the windows. The Night mode on recent iPhone cameras uses a version of HDR — and it does a great job! With other phones and cameras, you can create magnificent images using Photoshop's Merge to HDR feature. I begin this chapter with an explanation of high dynamic range photography, give you some pointers for capturing the images that you'll use in an HDR image, and then explain how you actually combine and use HDR photos.

Understanding HDR

HDR stands for *high dynamic range*. The dynamic range is the visual "distance" from black to white. By making that visual distance greater, you create a wider tonal range in the image. The world we see around us contains far more range than can be reproduced on a monitor, printed to paper, or even saved in a 16-bit image. (See Chapter 5 for an explanation of 8-bit, 16-bit, and 32-bit color.)

Consider, for example, shooting an image in a room with windows on a sunny day. If you expose your image for the content of the room, whatever is outside is blown out and completely white. (See the examples in Figure 19–1.) If you expose for the outside, the content of the room is in shadow. So, why not create an image in which the content of the room *and* the world outside the windows are *both* properly exposed?

FIGURE 19-1:
You can
expose for
the room
and lose the
highlights, you
can expose for
the highlights
and lose the
room, or you
can have both
with HDR.

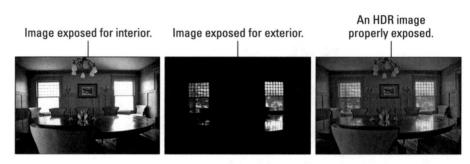

It may be that HDR is the future of photography, just as digital has supplanted film. But until we have DSLR cameras that can capture true HDR images natively and as easily as some smartphones, as well as a way to better take advantage of the enhanced tonal range when printing, HDR may not become our "default" setting. Is HDR something about which you should be aware, so that you can take advantage of its potential to meet difficult challenges in your own photography? Absolutely!

Remember, too, that you can open a series of Raw images shot for merging to HDR and open them together into Camera Raw. In the new Camera Raw workspace, you select Merge to HDR by selecting all the thumbnails in the Filmstrip and then pausing the cursor over a thumbnail and selecting the triple dots that indicate more menu options. (Or you can select the thumbnails and right-click to select Merge to HDR.)

If everything works perfectly, you see a preview with the Align Images and Auto Tone boxes selected. You also see two buttons, Cancel and Merge (after which you select a name and location for the new DNG file). Try all four of the Deghost options (including Off) to determine which works best with your images, and then click the Merge button. (If the images were shot properly, you likely don't need the Show Overlay option.) Camera Raw generates a .dng file that you can further refine in Camera Raw if desired.

Capturing for Merge to HDR Pro

To merge several exposures into an HDR image, you need to have several exposures with which to work. There are two ways to meet the challenge: You can shoot a series of exposures, or shoot one Raw image and make several copies with different exposure values.

If you want the absolutely best results from Merge to HDR Pro, keep two words in mind: *manual* and *tripod*. Those are the keys to capturing multiple exposures for use with Merge to HDR Pro. The only variable you want to change from shot to shot is the camera's shutter speed — everything else, including focus, should remain the same. Your tripod should be sturdy and level, and a cable release is a good idea. You can use auto focus and auto exposure to set the lens and get an exposure recommendation from the camera. But then switch the lens to manual focus and set the camera to manual exposure. Before each exposure, adjust only the shutter speed.

How many exposures do you need? I recommend a minimum of three (the best exposure possible for the scene's midtones, one "overexposed" for detail in the shadows, and one "underexposed" for detail in the highlights). Each scene differs to some degree, but you'll want to capture as much of the tonal range as possible. It is better, however, to use seven separate exposures with Merge to HDR Pro. More than that is rarely necessary, and most scenes can be captured in five exposures.

If you are familiar with *exposure values*, try for a range of perhaps seven, including three below and three above the "optimal" exposure. If that's unfamiliar territory, try shooting the optimal exposure, then taking a shot at ¼ the shutter speed of the first shot, and then taking a shot at four times the original shutter speed.

TIP

Okay, so say that you don't have a tripod and there's a shot that's just crying for HDR. Set your camera to auto-bracket at the largest increment possible, set the camera to "burst" mode, get as settled as possible, frame the shot, focus, take a deep breath, let the breath out halfway, pause, then gently press and hold the shutter button. In burst mode, three (or more, depending on your camera) shots are taken as quickly as the camera can operate. In auto-bracket mode, the exposure is automatically changed for each shot. (Note that you need to set the camera to auto exposure bracketing, sometimes seen as AEB, not white-balance bracketing. Check your camera's User Guide.)

Preparing Raw "Exposures" in Camera Raw

Alternatively, and usually with quite good results, you can change the exposure after the fact using Camera Raw. (You'll want to use a Raw image, not a JPEG image, for this technique.) Here's how:

- 1. Shoot the best exposure possible.
- 2. Transfer the image to your computer.
- 3. Open the image into Camera Raw.

Make sure that Camera Raw's Workflow Options — click the line of info below the preview — are set to 16-bit color.

- 4. Adjust the image until it looks perfect.
- 5. Click the Open button to open from Camera Raw into Photoshop.
- 6. Copy the image into a new file and save in the TIFF format.

Choose Select ♣ All, then choose Edit ♣ Copy, followed by File ♣ Close (don't save), and then File ♣ New. (The preset will be set to Clipboard, so just click the Create button.) In the Layer menu, select Flatten Layers. Choose Edit ♣ Paste followed by File ♣ Save As, choose TIFF as the file format, and save. Using this procedure strips out the EXIF data, making sure that Merge to HDR Pro doesn't use the wrong exposure value.

- 7. Reopen the original Raw file into Camera Raw.
- 8. Drag the Exposure slider to the left to reduce the exposure by 2.

Two is just a general guideline — watch for maximum detail in the highlights.

9. Click the arrow to the right of Open and select Open Copy.

Opening as a copy prevents Camera Raw from overwriting the earlier adjustment in the file's metadata.

10. Copy the image into a new file and save in the TIFF format.

Repeat Step 6, using a sequence number or other change to the filename to differentiate from the first TIFF.

- 11. Reopen the Raw file into Camera Raw a third time.
- 12. Drag the Exposure slider to the right to increase the exposure by 2.

Again, two is just a starting point — you want to see maximum detail in the shadows.

- 13. Again select Open as Copy.
- 14. Copy the image into a new file and save in the TIFF format.

Repeat Step 6, using a third filename.

You can now use these three adjusted images in Merge to HDR, as described in the following section. The results likely won't be as great as using a series of separate exposures, but should be better than a single exposure.

Working with Merge to HDR Pro

After you have the exposures from which you want to create your HDR masterpiece, you need to put them together using Photoshop's Merge to HDR Pro.

You can open Merge to HDR Pro either through Photoshop's File Automate menu or you can select the images to use in Bridge and use Bridge's menu command Tools Photoshop Merge to HDR Pro. If you open through Photoshop, you'll either need to open the images into Photoshop first, or navigate to and select the images to use. In Merge to HDR Pro, if the images are already open in Photoshop, click the Add Open Files button. If the images haven't been opened yet, choose the Browse button. The files should all be in the same folder on your hard drive.

Be patient with Merge to HDR Pro — it has a lot of work to do before you get to play with the combined exposures. When the calculations are done, the Merge to HDR Pro window opens (as shown in Figure 19-2). If the option is offered, you can elect to manually set the exposure value (EV) for the images.

Each of the images in the merge is shown as a thumbnail below the preview. You can deselect each image to see what impact it has on the combined exposure. (After you click the green check mark, give Merge to HDR Pro a couple of moments to redraw the preview.) If you're working with seven exposures and one seems to degrade from the overall appearance, leave that thumbnail's box deselected.

By default, Merge to HDR Pro assumes that you want control over the image right away and sets the Mode menu to 16-bit color and Local Adaptation. You then have the options shown in Figure 19-2, as well as a few others, including the Curve panel (as shown in Figure 19-3).

FIGURE 19-2: Merge to HDR opens after the images have been processed.

So, what are all those options you see in Figure 19-2 and Figure 19-3?

- >> Preset: If you have a series of similar images that require the same adjustments, you can save and load presets.
- >>> Remove Ghosts: When you're capturing multiple exposures, especially outdoors, moving objects in your image may have left "ghosts" behind. This option helps minimize those moving objects.
- **>> Edge Glow:** Use the Radius and Strength sliders in combination to increase the perceived sharpness of the image.
- >> Tone and Detail: Think of the Gamma slider as your contrast control.

 Dragging to the right flattens the contrast between highlights and shadows; dragging to the left increases the contrast. The Exposure slider controls the overall lightness (to the right) or darkness (to the left) of the image, just like the Exposure slider in Camera Raw. The Detail slider sharpens the smallest bits in the image.

- >> Advanced: Visible in Figure 19-2, the Advanced tab shares space with Curve in Local Adaptation. The Shadow and Highlight sliders here control the lower and upper parts of the image's tonal range. For both sliders, dragging left darkens and dragging right lightens. The Vibrance slider controls the saturation of the near-neutral colors and Saturation controls all the colors in the image. (These sliders, too, are comparable to their counterparts in Camera Raw and are discussed in more detail in Chapter 6.)
- >> Curve: Click the curve to add an anchor point and drag up/down or enter numeric values to adjust the tonality of the image. The Corner option produces a sharp change in the angle of the curve, which is generally not desirable. The button to the right of Corner resets the curve.

FIGURE 19-3: In 16-bit mode with Local Adaption, you have quite a bit of control.

Switching the Mode menu to 32-bit color restricts your adjustment options. If you uncheck the Complete Toning in Adobe Camera Raw box, you can drag the slider to adjust the image's white point. Clicking OK opens the image into Photoshop for any additional adjustments.

Note that 16-bit and 8-bit offer the same options, but I don't recommend converting from 32-bit to 8-bit in Merge to HDR Pro. If you need an 8-bit version of the image, work in 16-bit, and then after perfecting the image in Photoshop and saving as a 16-bit PSD or TIFF file, use the Image \Leftrightarrow Mode \Leftrightarrow 8-Bits/Channel command to convert and use Save As (or the Export menu's Save for Web command) to save the 8-bit copy.

Keep in mind that when the changes you make in Merge to HDR's 16-bit mode are finalized, the unused parts of the 32-bit tonal range are discarded. Working in 16-bit mode in Merge to HDR Pro can be convenient, but you can also stay in 32-bit mode, open into Photoshop with the OK button, save the 32-bit image, and then do all the adjusting available in Merge to HDR Pro — and *much* more — in Photoshop. Want to fine-tune or change the image sometime down the road? Sure, why not? Simply reopen the saved 32-bit image and readjust, paint, filter, whatever, and then save again. Need a 16-bit copy to share or print? Save first as 32-bit, adjust, and then use Save As to create the 16-bit copy.

Saving 32-Bit HDR Images

A 32-bit image can be saved in a number of file formats, including Photoshop's PSD and Large Document Format (PSB), as well as TIFF and some specialized formats. Unless you're sending the image to another program (perhaps when working with computer animation) or a client who has requested a specific format, stick with PSD, PSB, or TIFF.

HDR Toning

Found in the Image ♣ Adjustments menu, HDR Toning (see Figure 19-4) is your 32-bit image adjustment master tool. It offers the same Local Adaptation, Equalize Histogram, Exposure and Gamma, and Highlight Compression options found in Merge to HDR Pro. (Each of the options is described in the "Working with Merge to HDR Pro" section, earlier in this chapter.) Although it's also available for 16-bit and 8-bit images, HDR Toning is designed to work with the 32-bit images you create with Merge to HDR Pro. You'll also see HDR Toning when you convert to 16-bit or 8-bit color through the Image ♣ Mode menu.

FIGURE 19-4: HDR Toning offers the same options as Merge to HDR Pro's 16-bit mode, but in 32-bit color.

Painting and the Color Picker in 32-Bit

In Photoshop you can paint in 32-bit color — with some caveats. The Brush, Pencil, and Mixer Brush tools (but not Color Replacement) are available. The Blur, Sharpen, Smudge, and Eraser tools are also available in 32-bit color, but not Dodge, Burn, Sponge, Background Eraser, or Magic Eraser. Type layers, shapes, and paths are also at your command. You can add color to a 32-bit image with the Gradient tool, but not the Paint Bucket. And although the History Brush is available, the Art History Brush is not. The Content-Aware Move, Patch, Healing Brush, Spot Healing Brush, and the Red Eye tool are disabled. Also, 32-bit images can have multiple layers and layer styles. Be aware, too, that not all blending modes are available in 32-bit color. Normal, Darken, Multiply, Lighten, Difference, and about a dozen less commonly used blending modes are enabled for tools and layers.

Working with painting tools and gradients requires a way to define color in 32-bits. When you open the Color Picker while working with a 32-bit image, you'll see something different. In Figure 19-5, the 32-bit Color Picker shows some additional features. In addition to working with HSB and RGB fields, color is defined with the Intensity slider. Think of "intensity" as "exposure." It permits color values that go beyond RGB's 255/255/255. Define the color *and* choose how light or dark the exposure is — it's sort of a fourth dimension of color definition.

FIGURE 19-5: The incredible range of 32-bit color requires a new way to define "color."

The bar at the top shows the last-selected color below and the current selection above. You can click any of the six previews to the left or the six to the right to jump to that color. You control how different each of the 12 previews is from the current color with Preview Stop Size.

Filters and Adjustments in 32-Bit

The list of filters available in 32-bit color is even shorter than the list for 16-bit color found back in Chapter 14. You can't use most of the Neural Filters, Filter Gallery, Adaptive Wide Angle, Camera Raw, Lens Correction, Liquify, and Vanishing Point. However, you do have most of the rest of Photoshop's filters available. Don't forget that 32-bit images can be converted to Smart Objects to apply Smart Filters!

The only adjustment layers that can be added to 32-bit images are Brightness/Contrast, Levels, Exposure, Hue/Saturation, Photo Filter, Channel Mixer, and Color Lookup, along with Solid Color, Gradient, and Pattern in the New Fill Layer menu. In the Adjustments menu, you'll also find HDR Toning and Desaturate at your service.

Selections and Editing in 32-Bit

Not surprisingly, the Rectangular Marquee, Elliptical Marquee, Single Row, Single Column, Lasso, and Polygon Lasso tools are available when working in 32-bit color because they simply create selections around pixels. Also not surprising is the unavailability of the Magnetic Lasso tool because it works its magic based on identifying differences between neighboring colors. And, on the subject of magic, the Magic Wand is also out of commission when working in 32-bit color, but you can work with the Object Selection and Quick Selection tools in your HDR image.

And after you have made your initial selection, you'll find that Select and Mask and Select \Rightarrow Focus Area, Subject, and Sky are fully functional in 32-bit color, as are the Select \Rightarrow Modify commands and Transform Selection. You can also save and load selections (alpha channels) and work in Quick Mask mode in 32-bit images.

Printing HDR Images

Okay, well, you can't really print the entire tonal range of a 32-bit image — no printer (or paper) can handle the range. In fact, you can't print an image in 32-bit color at all from Photoshop (the Print and Print One Copy commands are disabled). What you *can* do is print a 16-bit (or 8-bit) image that has outstanding highlights, outstanding shadows, and outstanding midtones.

After saving the 32-bit original, use Photoshop's Image Mode 16-Bits/Channel command to convert to 16-bit color (using Local Adaptation, as described earlier in this chapter). After changing the color depth, choose Image Image Size to set your desired print size. You can either deselect the Resample check box and enter your desired print dimensions, letting Photoshop calculate the new resolution, or you can use the Resample option and input both the print dimensions and resolution. The resampling algorithm should be set to Automatic or Preserve Details, not Nearest Neighbor or Bilinear, neither of which is appropriate for most photos. (Those are your only four options when resampling a 32-bit image.)

When the image is ready, open Photoshop's File \hookrightarrow Print window. Choose the printer and click the Print Settings button to set up the printer. Choose the specific paper on which you will be printing and disable the printer's color management. Choose the printer's resolution and — if your printer has the capability — select 16-Bit Output.

To the right in Photoshop's Print dialog box (as shown way back in Figure 4-11), make sure that Photoshop is managing colors and that you have selected the printer's own profile for the specific paper on which you are printing. Generally, you should use the Relative Colorimetric rendering intent and Black Point Compensation. (Note that if your print is way too dark, Black Point Compensation should be disabled.)

You need to make all the printer-specific choices by clicking the Print Settings button before clicking the Print button. If you want to save this 16-bit version of the image, use Save As to create a new file. Using the Save command would overwrite the 32-bit original HDR image.

And there you have it — ten things you should know about HDR. You're now ahead of the curve and ready for the Next Big Thing in digital photography!

On behalf of everyone involved with the production of this book, let me say thanks for coming along for the ride. Please stay safe — and we wish you peace, love, and happiness!

Appendix

Photoshop CC's Blending Modes

Blending modes in Photoshop CC determine how the pixels on one layer interact with pixels on lower layers and how painting tools interact with pixels already present on the active layer and layers below.

- Normal: Normal is the default blending mode for new layers and the basic painting tools. Depending on opacity, the upper pixel completely blocks the lower pixel.
- >> Threshold: When working with images in Indexed Color or Bitmap color modes, Threshold is the "Normal" blending mode. Because Indexed Color uses a maximum of 256 distinct color and Bitmap uses only black and white, most blending modes are not available when working in those color modes.
- >> Dissolve: Only semi-transparent pixels produce changes in the image's appearance. Those pixels are randomly scattered, producing rough edges on anti-aliased artwork.
- >> Darken: The Darken blending mode compares the individual color component channels (RGB or CMYK) of the base and blend colors and retains the lower value (RGB) or higher value (CMYK). It works on each channel individually for each pixel.
- >> Multiply: The Multiply blending mode multiples the color values of each base and blend pixel (RGB or CMYK) and uses the resulting value, which is always darker unless blending with black.
- >> Color Burn: Color Burn simulates the darkroom technique used to darken areas of a photo by increasing exposure time for that area. Blending dark colors over a base color produces a darker resulting color. Color Burn generally increases contrast. White as a blend color produces no change.
- >> Linear Burn: Like Color Burn, Linear Burn generally darkens (except where the base color is white). Linear Burn decreases brightness rather than increasing contrast.

- **>> Darker Color:** While the Darken blending mode looks at the luminosity of each pixel channel-by-channel, Darker Color looks at the overall luminosity of the base and blend pixels and retains whichever is darker. It generally produces less of a color shift than does Darken.
- >> Lighten: The Lighten blending mode compares the individual color component channels (RGB or CMYK) of the base and blend colors and retains the higher value (RGB) or lower value (CMYK). It works on each channel individually for each pixel.
- >> Screen: Screen is the mathematical opposite of the Multiply blending mode. The inverse of each pixels' color value is multiplied. The resulting color is lighter than the base color.
- >> Color Dodge: The opposite of Color Burn, the Color Dodge simulates the darkroom technique of lightening areas of a photo by reducing the exposure time. It's much like Photoshop's Dodge tool, but generally results in both lighter and less saturated result colors.
- >> Linear Dodge (Add): The base color is lightened to reflect the blend color. Blending with black produces no change.
- >> Lighter Color: While the Lighten blending mode looks at the luminosity of each pixel channel-by-channel, Lighter Color looks at the overall luminosity of the base and blend pixels and retains whichever is lighter. It generally produces less of a color shift than does Lighten.
- >> Overlay: Consider Overlay to be a mix of the Multiply and Screen blending modes. If the blend colors are light, it works like Screen and if the blend pixels are dark, it works like Multiply. Overlay often produces a shift in hue as well as brightness.
- >> Soft Light: Soft Light combines the effects of Color Dodge and Color Burn. If the blend color is light, the result is lighter; if the blend color is dark, the result is darkened. Soft Light is often a more subtle option to Overlay.
- >> Hard Light: Hard Light is a more vivid version of Soft Light. Darker areas on the blend layer produce darker result colors; lighter areas on the blend layer produce lighter result colors. Painting with dark and light shades of gray on a layer set to Hard Light can be an effective way to increase contrast in specific areas of an image.
- >> Vivid Light: Vivid Light is much like Overlay in that it both darkens and lightens, but it also generally increases saturation significantly.
- >> Linear Light: The Linear Light blending mode works much like Vivid Light and can be considered a mix of Linear Dodge and Linear Burn. Lighter blend pixels produce lighter result colors; darker blend pixels produce darker results.

- Linear Light works with brightness values, which can better protect hue in the resulting colors than can Vivid Light.
- >> Pin Light: Pin Light combines the Darken and Lighten blending modes. Where blend colors are darker than the base color, they are retained, but if the base color is darker, it's retained. When working with light blend pixels, the lighter of the blend and base colors is retained.
- >>> Hard Mix: The Hard Mix blending mode produces a posterizing effect by forcing similar colors to a single value. When working with RGB images, the channel values for blend and base colors are added. Any value over 255 is set to 255, if less than 255, the value is set to 0. Each channel value is calculated individually for each pixel. The result is an image that consists entirely of black, white, red, green, blue, cyan, magenta, and yellow pixels.
- >> Difference: The Difference blending mode compares the brightness of the blend and base colors and the lower value is subtracted from the other. Black produces no change, while white will invert the pixel's color.
- >> Exclusion: Exclusion is a less dramatic version of Difference.
- >> Subtract: Subtract compares the base and blend values in each channel for each pixel and subtracts the blend value from the base value, generally resulting in a darker image with substantial color shifts.
- **>> Divide:** The blend color is divided by the base color, channel by channel, for each pixel. It generally produces a much lighter result color.
- >> Hue: This blending mode retains the luminosity (brightness) and saturation values of the base color and substitutes the hue value of the blend color.
- >> Saturation: The base color's luminosity and hue are retained and the blend color's saturation value is used.
- >> Color: The base color's luminosity is retained, and both the hue and saturation of the blend color are applied.
- >> Luminosity: The base color's hue and saturation are retained, and the blend color's luminosity is used.
- >>> Behind: Used by painting tools, this blending mode applies the foreground color to pixels on the active layer according to the pixels' transparency.

 Completely opaque pixels are not changed. (With gray, this blending mode can be used to paint shadows "behind" artwork on the layer.)
- >> Clear: Used with painting tools and shape tools set to add pixels to a layer, this blending mode works much like the Eraser tool, reducing the opacity of pixels on a layer.
- >> Replace: (Spot Healing Brush and Healing Brush only) This blending mode is used to help preserve texture along the edges of the brush strokes.

- >> Pass Through: (Layer groups only) Any adjustment layer within the group is applied to all layers below it within the group and below the group. (To restrict an adjustment layer to only the layers below it within the group, change the group's blending mode from Pass Through to Normal.)
- >> Add and Subtract for Calculations and Apply Image: The RGB value of each channel is added or subtracted and the Scale factor (1.0 to 2.0) is used as a divisor. (A Scale value of 2 averages the channel values.) An offset factor can be added as a constant applied to or subtracted from each calculation.

Index

with Curves command, 106

with Desaturate defined, 144 **Numbers** command, 114 limiting, 170-171 3D artwork, 372-374 with Equalize command, 117 Adjustments menu 8-bit color, 102-104 with Exposure command, 106 changing exposure, 96 16-bit color, 102-104, 397 with Gradient Map command, overview, 92-93 32-bit HDR images 112-113 Shadows/Highlights adjustments for, 396-397 with HDR Toning adjustment, 93-97 command, 114 editing, 397 toning tools, 96 with Hue/Saturation filters for, 396-397 Adjustments panel, 108 command, 107-108 painting, 395-396 Adobe apps, 382-384 in individual channels, 117-118 saving, 394 Adobe Bridge, 60, 67-69, 371 with Invert command, 110-111 selections and, 397 Adobe Camera Raw plug-In with Levels command, 106 Edit Panel in with Match Color command, Basic section, 134-136 Α 114-116 Calibration section, 141–142 overview, 104-105 Actions Camera Raw Cancel with Photo Filter command, Batch command and, 342-343 button, 142 109-110 overview, 336-337 Color Grading section, with Posterize command, 111 recording, 337-342 138-140 with Replace Color command, Adaptive Wide Angle filter, 187, Color Mixer section, 138 116-117 316-317 Curve section, 136-137 with Selective Color Add and Subtract for command, 113 Detail section, 137-138 Calculations and Apply with Shadows/Highlights Done button, 142 Image blending mode, 402 command, 113-114 Effects section, 141 Add Media dialog box, 354 with Threshold command. Geometry section, 140-141 Add To button, 150 111-112 Open button, 142 additive color mode, 99 with Vibrance command, Optics section, 140-141 adjusting color 106-107 HDR images and, 390-391 with Black & White adjusting curves, 90-92 command, 109 Raw files and, 121-125 adjusting exposure, 96 with Brightness/Contrast user interface adjusting length of videos, command, 106 355-357 Adjustment Brush tool, 130 with Channel Mixer adjusting 32-bit HDR images, Before and After buttons, command, 110 396-397 126-127 with Color Balance adjusting tonality, 82 Camera Raw Preferences command, 108 button, 132 Adjustment Brush tool, 130 with Color Lookup Color Sampler tool, 131 adjustment layers, 106 command, 110 Crop tool, 127-128 adding, 168-170 with commands, 106 Graduated Filter tool, adding on videos, 357-358

130-131

Adobe Camera Raw plug-In (continued) histogram, 132 overview, 126 presets, 133-134 preview area, 132-133 Radial Filter tool, 131 Red Eye Reduction tool, 129-130 Rotate tool, 127-128 Sampler Overlay button, 131 Spot Removal tool, 128–129 Trash button, 127 workflow options, 133-134 Adobe Composer option, 270 Adobe Creative Cloud, 382 advanced blending, 251-254 Advanced Blending options, 253 Advanced tab, 393 airbrush, 297-298 AirDropping images, 78 Align Edges option, 217 aligning text, 276-277 Alignment buttons, 264 Alignment option, 268-269 Allow Tool Recording option, 342 alpha channel, 29-30, 164-166 Amount slider, 95, 309 anchor points adjusting curves with, 91-92 modifying, 230-231 paths and, 222 pins, 184-185 transforming, 162-163 Angle Gradient option, 302 Angle/Use Global Light option, 242 animations, 362-366 anti-aliasing, 151, 264 Appearance option, 50 AppleScript, 350

arranging iPad screen, 380–381
aspect ratio, 25, 71–73, 127
audio clips, 355–357
Audio fly-out panel, 356
Auto commands, 84–85
Auto Corrections panel, 319
auto recovery, 11
auto-bracket mode, 389
Auto-Collapse Iconic Panels
option, 50
Auto-Enhance option, 154
Auto-Show Hidden Panels
option, 50

B

banding, 44, 103 barrel distortion, 317 Baseline Shift field, 267 Basic pane, 136 Basic section, 134-136 Batch command, 342-343 Before and After buttons. 126-127 Behind blending mode, 401 Bevel and Emboss laver effect. 243-244 binary code, 18 Bitmap color modes, 101, 399 Black & White command, 109 Blacks slider, 132 Blend Clipped Layers as Group option, 253 Blend Interior Effects as Group option, 253 blending, 251-254 blending modes Edit Fade command and, 312 layers and, 364 overview, 195-198 in Photoshop, 399-402 Bloat tool, 326 Blur Direction tool, 311

Blur tool, 117 blurring alpha channel, 166 filters for, 312-316 Bokeh panel, 315 Border option, 161 bounding box, 275, 366 brightness, 82 Brightness/Contrast command, 86, 106 bristle tips, 298 Brush Pose panel, 292 Brush Settings panel, 286 Brush Tip Shape panel, 291 brush tips airbrush, 297-298 creating, 293-294 erodible, 297 Mixer Brush, 298-300 saving, 293-294 watercolor, 297-298 Brush tool, 46, 53, 117, 286-289 Brushes button, 291 Build-up check box, 292 bump map, 164 Burn tool capabilities of, 285 channels and, 117 fixing problems in images with, 177-178 overview, 96-97 Button Mode, 337

C

Cache Levels option, 52
Calibration section, 141–142
camera, 11, 21, 60–61
Camera Raw Cancel
buttons, 142
Camera Raw Preferences
button, 132

center alignment, 277 Channel Mixer command, 110 Channels option, 253 Channels panel alpha channels and, 165 overview, 118 Character panel, 266-270 Chromatic Aberration sliders, 319 CIELAB mode, 100 Clarity slider, 135 Clear blending mode, 401 Clip the adjustment layer to the layer immediately below button, 168 clipping, 95-96, 199-200, 227 Clone Stamp tool, 128, 175-178, 285 closed path, 222 Cloud filter, 332 CMYK mode, 56, 99 color, 55, 76 adding with Pencil tool, 289 adjusting Black & White command, 109 Brightness/Contrast command, 106 Channel Mixer command, 110 Color Balance command, 108 Color Lookup command, 110 Curves command, 106 Desaturate command, 114 Equalize command, 117 Exposure command, 106 Gradient Map command, 112-113 HDR Toning command, 114 Hue/Saturation command, 107-108 individual channels, 117-118 Invert command, 110-111 Levels command, 106

Match Color command. 114-116 overview, 104-105 Photo Filter command, 109-110 Posterize command, 111 Replace Color command, 116-117 Selective Color command, 113 Shadows/Highlights command, 113-114 Threshold command. 111-112 Vibrance command, 106-107 deleting, 300-301 depth, 102-104 dumping, 300-301 Flesh Tone Formulas and. 118-120 models, 101-102 modes, 98-101 overview, 97-98 picking, 294-296 printing and, 74-76 removing with Eraser tool, 289-290 selecting creating and saving custom brush tips, 293-294 options, 290-293 overview, 294-296 Color Balance command, 108 Color blending mode, 197, 401 Color Burn blending mode, 399 Color Correction slider, 114 Color Dodge blending mode, 400 Color Dynamics panel, 292 Color Grading section, 138-140 Color Intensity slider, 115 Color Libraries button, 296 Color Lookup command, 110

Color Mixer section, 138 Color Noise Reduction slider, 137 Color Overlay, 246-248 Color panel, 101-102 Color preferences, 55-57 color profile, 98 Color Range command, 158-159 Color Replacement tool, 180, 285 Color Sampler tool, 119, 131 Color Selection option, 242 Color stops, 302 color table, 100 Color/Brig slider, 95 combining paths, 232-233 commands 16-Bits/Channel command, 397 Auto commands, 84-85 Batch command, 342-343 Black & White command, 109 Brightness/Contrast command, 86, 106 Channel Mixer command, 110 Color Balance command, 108 Color Lookup command, 110 Conditional Mode Change command, 340 Content-Aware Scaling command, 29-30 Create Layers command, 240-241 Curves command, 106 Desaturate command, 114 Despeckle command, 181 Edit Fade command, 312 Equalize command, 117 **Export Selected Styles** command, 255 Export Shapes command, 219 Exposure command, 106 Fit Image command, 340

commands (continued) Global Light command, 240 Gradient Map command. 112-113 Grow command, 161 HDR Toning command, 114 Hide All Effects command, 241 hotkeys for, 43, 86 Hue/Saturation command. 107-108 individual channels, 117-118 Invert command, 110-111 Levels command, 86-89, 106 Match Color command, 114-116 New Brush Group command, 290 Photo Filter command. 109-110 Place command, 355 Posterize command, 111 Replace Color command, 116-117 Save Selection command, 164 Scale Effects command, 241 in Select menu, 157-158 for selection Color Range command, 158-159 Edit in Ouick Mask mode. 163-164 Focus Area command, 159-160 mask-related, 164 modifying selections, 161 Sky selection command, 161 Subject selection command, 160 transforming selections, 161-163 Selective Color command, 113 Shadows/Highlights command,

Threshold command, 111–112 undo. 12-14 Vibrance command, 106-107 commercial printing, 28, 34-35 Complete Toning in Adobe Camera Raw check box, 393 complex selections, 201-204 compositing images blending modes and, 195-198 clipping groups and, 199-200 complex selections and, 201-204 feathering and, 200-201 layer masks and, 198-199 layers and, 192-194 opacity and, 198-199 with Photomerge, 208-209 Smart Objects and, 194-195 transparency and, 198-199 with Vanishing Point, 204-208 composition, 23 compound paths, 230, 232-233 Conditional Mode Change command, 340 contact sheets, 345-349 Content-Aware Fill, 182-183 Content-Aware Scaling command, 29-30 Contiguous check box, 154 Contour option, 242 contrast, 135 control points, 222 Corner option, 393 correcting lenses, 316-319 Count tool, 376-377 Create Layers command, 240-241 Create New Tool Preset button, 268 Create Plane tool, 376 Crop tool, 127-128 cropping

to aspect ratio, 71-73 removing elements in images by, 181-182 resampling vs., 27 cumulative filters, 324 Cursors preferences, 52-53 Curvature Pen tool, 225 Curve option, 393 Curve section, 136-137 curved segments, 222-226 curves, 90-92 Curves adjustment, 166 Curves command, 106 Curves dialog box, 90-91, 95 Custom Shape tool, 216-217 customizing paths, 229-231, 233-234 tool presets, 47-48 workspaces, 44-47

D

Darken sliders, 129 Darken/Darker Color blending mode, 198, 399-400 Datacolor, 57, 76 **Decontaminate Colors** option, 156 Defringe slider, 130 Deghost options, 388 Dehaze slider, 135 Delete adjustment layer button, 169 Delete Path button, 228 deleting color, 300-301 Depth option, 133 Desaturate command, 114 Deselect command, 157 deselecting, 57 Despeckle command, 181 Detail section, 137-138 Detail slider, 392

113-114

Similar command, 161

lavers and, 31 Color Mixer section, 138 DICOM medical records. 377-378 Curve section, 136-137 overview, 30-31 Dictionary field, 267 PDF file format, 33, 35 Detail section, 137-138 Difference blending mode, Done button, 142 Photoshop Raw file 197, 401 format, 125 Effects section, 141 digital negative, 93 PNG file format, 34, 36 Geometry section, 140-141 digital photos, 31-33 for PowerPoint, 35-36 Open button, 142 digitizing, 18 PSB file format, 33 Optics sections, 140-141 digits, 98 PSD file format, 31, 35, Effects section, 141 105, 271 Direct Selection tool, 167, 230 EPS file format, 34 TIFF file format, 32, 34 direction lines, 222 Equalize command, 117 for web graphics, 33-34 Discover panel, 40, 344 Eraser tools, 284, 289-290 for Word, 35-36 Dissolve blending mode, 399 erodible brush tips, 297 File Handling preferences, 51-52 Divide blending mode, 401 Exclusion blending mode, 401 files, saving, 11-12 DNG file format, 123 **Export Selected Styles** fill layers, 170 Dodge tool command, 255 Fill Path button, 228 capabilities of, 285 Export Shapes command, 219 Fill Path command, 229 channels and, 117 exporting videos, 361–362 Fill slider, 196, 199 fixing problems in images with, exposures 177-178 Filmstrip, 123 command for, 106 overview, 96-97 filters modifying, 96, 390-391 Done button, 142 for 32-bit HDR images, slider for, 135 396-397 Don't Enlarge check box, values, 389 340-341 alpha channel and, 166 eyeball column, 193 Drop Shadow, 250 for blurring, 312-316 eyedroppers, 89-90 Dual Brush option, 292 Cloud, 332 dumping color, 300-301 for correcting lenses, 316-319 F Duotone mode, 101 Field Blur filter, 314 gallery of, 322-324 Face tool, 326 Gaussian Blur filter, 315 F Fade command, 14 Iris Blur filter, 314 Fade slider, 115 Edge Contrast field, 153 Lens Blur filter, 316 Faux Styles field, 267 Edge Detection option, 155 Lighting Effects, 331 feathering, 146-148, 200-201 Edge Glow option, 392 Liquify, 325-327 Field Blur filter, 314 Edit Fade command, 312 file formats Maximum and Minimum, Edit in Quick Mask mode, 331-332 for commercial printing, 34-35 163-164 neural, 327-330 for digital photos, 31-33 **Edit Panel**

DNG file format, 123

EPS file format, 34

GIF file format, 34

IPS file format, 32

IPG file format, 32-34, 180

Basic section, 134-136

Camera Raw Cancel

buttons, 142

Calibration section, 141-142

Color Grading section, 138-140

Oil Paint filter, 321-322

Shake Reduction, 311-312

overview, 307

Reduce Noise, 320

Sharpening, 308

filters (continued) Shear, 332 Smart Blur filter, 316 Smart Filters, 306-307 Smart Sharpen, 310-311 Spherize, 332 Surface Blur filter, 316 Texturizer filter, 188 Tilt-Shift filter, 315 Unsharp Mask, 308-309 Find and Match feature, 273 Fit Image command, 340 Fixed Aspect Ratio option, 151 Fixed Size option, 151 fixing perspective, 185-187 Flatness field, 227 Flesh Tone Formulas, 118-120 floating panels, 40 Flow field, 300 Focus Area command, 159-160 Focus tools, 285 folder structure, 66-67 fonts Find and Match feature, 273 menus for, 263-264 paths and, 233-234 size of, 264 foreshortening, 185 Forward Warp tool, 326 Fractional Widths option, 270 frame content, 363-364 frame rate, 366 frame-based animations. 362-363 frames, intermediary, 365 freeform tool, 152 Freeze Mask tool, 326 Frequency field, 153 full justification, 269

functionality of Photoshop, 8-9

Fuzziness slider, 116, 158

G

Gamma slider, 96, 392 gamut, 98-101 Gaussian Blur filter, 315 Geometry section, 140-141 GIF file format, 34 Global Light command, 240 Global Refinements option, 155 glyphs, 270 Gradient Map command, 112-113 Gradient Overlay, 248 gradients, 301-303 Graduated Filter tool, 130-131 **Graphics Processor Settings** option, 52 grayscale, 56, 99 grids, 92, 223, 254 groups, 193 Grow command, 161 Guides, Grid & Slices preferences, 54

H

Hand tool, 318, 326 Hard Light blending mode, 197, 400 Hard Mix blending mode, 401 hardness, 286 Healing Brush, 128 Healing tools, 284 Hide All Effects command, 241 high dynamic range (HDR) images 32-bit, 394-397 Adobe Camera Raw plug-In and, 390-391 defined, 104 Merge to HDR Pro and, 389-394 overview, 387-388 printing, 397-398 toning, 114, 394-395

high-key image, 83 highlights, 83, 132, 135 histogram, 132 Histograms panel, 82-84, 103 History Brush tool, 12-13, 143 History brushes, 285 History Log preferences, 49 History States option, 52 hotkevs for anchor point, 91 for Bridge, 60 for Channels panel, 165 for clipping layers, 199 for closing windows, 62 for Color Sampler tool, 131 for commands Levels command, 86 Undo command, 43 for copying selection to new layer, 176 for Curves dialog box, 90 for Discover panel, 344 for duplicating, 206 for exiting editing session, 218 for Free Transform, 176-177 for grids standard, 223 toggling between, 92 transparency, 254 for hiding pins, 315 for Invert, 203 iPad and, 382 for Levels menu, 46-47 for merging layers, 177 modifying, 46 for panels, 44 for pasting, 206 for Preferences, 49 for Quick Mask mode, 163 for resetting, 294 for search function, 39

for selecting	layers, 192–194	printing
commands, 157	opacity, 198–199	alternatives, 76–77
deselecting, 57	overview, 191	color, 74-76
multiple images, 68	with Photomerge, 208-209	cropping to aspect ratio,
Sharpening slider and, 137	transparency, 198–199	71–73
for Smart Blur filter, 316	vanishing point, 204–208	resolution, 73–74
for swapping colors, 294	digitizing, 18	purchasing, 62
for tools	emailing, 78	renaming, 69–71
Brush tool, 53	file formats and	resampling, 25–27
Brush tools, 46	commercial printing, 34-35	resolution of, 21, 28
marquee selection tools, 149	overview, 30-33	sharing, 77–78
Ruler tool, 54	PowerPoint and Word, 35–36	sizing
for shape tools, 214	web graphics, 33-34	command for, 23–27
Transform tool, 206	fixing problems in	overview, 134
for transforming anchor	Clone Stamp tool, 175–178	resolution and, 22–23
points, 163	de-glaring glasses, 179	steroscopic, 32
for zooming, 206	fixing perspective, 185–187	temperature in, 109–110
Hue, Saturation, and Lightness	noise, luminance, 181	text and
sliders, 116	noise, overview, 179–180	aligning, 276–277
Hue blending mode, 401	Red Eye tool, 174–175	Character panel and,
Hue/Saturation command,	removing unwanted objects,	266–270
107–108	181–185	hyphenating, 277–278
Hue/Saturation dialog box, 108	removing wrinkles, 175-176	justification and, 276–277
hyphenating text, 269, 277–278	rotating, 187	options for, 262–265
	Sky Replacement feature, 188	overview, 257–260
1	whitening teeth, 179	shaping, 278–281
ICC profiles, 56	high-key, 83	steps for adding, 272–274
Ignore Selection when Applying	loading	styles for, 271
Adjustment check box,	from camera, 60–61	type containers and, 274–278
114, 116	overview, 59-60	type tools for, 260–262
Image Processor script, 350	scanning, 61–66	websites and, 78
images	low-key, 83	importing
AirDropping, 78	opening, 10	styles, 238
compositing	organizing, 66–69	videos, 354–355
blending modes, 195–198	overview, 18	Indent First Line option, 269
complex selections, 201–204	PDF format, 78	Indent Margins option, 269
creating clipping groups,	Photoshop and, 11	Indexed Color mode, 100, 399
199–200	pixels in	individual channels, 117–118
feathering, 200–201	interacting with, 18–20	Info panel, 119
importance of Smart Objects, 194–195	resolution, 21–30	Inner Glow, 246
layer masks, 198–199		Inner Shadow, 245
,,		

installing lasso selection tools, 152–153 Layers panel, 42 Photoshop, 14-15, 58 Lasso tool, 152 Leading field, 266 plug-ins, 14-15 launching Photoshop, 10 lenses, 316-319 instances, 287-288 Layer Mask Hides Effects Levels adjustment, 166 option, 253 Interface and Preferences Levels command, 86-89, 106 preferences, 50-51 layer masks, 198-199 Levels menu, 46-47 intermediary frames, 365 Layer pop-up menu, 115 Light Bokeh slider, 315 Intersect With button, 150 layer styles Lighten/Lighter Color blending Inverse command, 157 creating mode, 198, 400 Invert command, 110-111 Bevel and Emboss, 243-244 lighting, 76 **iPad** Color Overlay, 246-248 Lighting Effects filter, 331 Adobe apps for, 382-384 dialog box, 241-242 line screen frequency, 28 arranging screen of, 380-381 Drop Shadow, 250 Linear Burn blending mode, 399 hotkeys and, 382 Gradient Overlay, 248 Linear Dodge blending mode, 400 integrating, 379-380, 383-384 Inner Glow, 246 Linear Light blending mode, maximizing screen space, Inner Shadow, 245 400-401 381-382 menu, 239-241 Link icon, 167 mirroring screens, 381 opacity, fill, and advanced linking layers, 193 Wacom drawing tablet and, blending, 251-254 384-385 Liquify filter, 325-327 Outer Glow, 250 Iris Blur filter, 314 Load field, 300 Pattern Overlay, 248-249 Load Statistics button, 116 Satin, 246 loading Stroke, 244-245 images overview, 235-237 JavaScript, 350 from camera, 60-61 preserving, 255 JPG file format, 32-34, 180 overview, 59-60 saving, 254-255 JPS file format, 32 scanning, 61-66 Styles panel, 237-239, 254-255 justification option, 269 settings, 319 layer vector mask, 227 Localized Color Clusters option, layers K 116, 159 adding masks to, 167 lossy compression, 35 Kerning field, 267 adjustment, 357-358 low-key image, 83 keyboard shortcuts. See hotkeys blending modes and, 364 luminance noise, 181 keyframes, 358, 360 changing appearance of, Luminance slider, 115 keystoning, 185 219-220 Luminosity blending mode, compositing images and, Keywords tab, 68 197, 401 192-194 Knockout option, 253 defined, 192 file formats and, 31 M fill layers, 170 Magic Wand tool, 154 Lab color mode, 100 opacity of, 364 Magnetic Lasso tool, 153 landscape aspect ratio, 71 transforming in videos, 361

Magnetic option, 225

Large Thumbnail option, 238

visibility of, 364

models for color, 98-102 settings for, 288 marquee selection tools, 148-152 modification selection slider for, 128, 196, 199 commands, 161 masking stops for, 302 layers and, 198-199 moiré patterns, 65-66, 130 Open button, 142 selection commands for, monitor resolution, 21 Open Documents as Tabs 164-167 option, 51 Move Grid, 318 Match Color command, 114-116 Multichannel color mode, 101 Open in Photoshop as Smart Objects option, 134 MATLAB, 378 multicolor shape layer, 220-221 maximizing screen with iPad, open path, 222 Multiply blending mode, 196, 381-382 247, 399 OpenType fonts, 270 Maximum and Minimum filter, OpenType Options field, 267 331-332 Optics section, 140-141 N Mean Stack Mode, 372 optimizing animations, 366 Measurement Log panel, 375 nested groups, 193 Options bar, 42 neural filters, 327-330 Median stack mode, 371 organizing images, 66-69 Memory Usage option, 51 Neutralize check box, 115 Orientation button, 263 New Adjustments Layer menus Outer Glow, 250 menu, 107 Adjustments menu out-of-gamut colors, 158 New Brush Group changing exposure, 96 Output Settings option, 156 command, 290 overview, 92-93 Output Sharpening menu, 134 New Layer button, 89 Shadows/Highlights Overlay blending mode, 196, New Path button, 228 adjustment, 93-97 247, 400 New Selection button, 149-150 toning tools, 96 No Break option, 270 Layer pop-up menu, 115 P noise for layer styles, 239-241 luminance, 181 Paint Bucket tool, 301 Levels menu, 46-47 option for, 292 New Adjustments Layer painting menu, 107 overview, 179-180 32-bit HDR images, 395-396 reducing, 130, 137, 320 Output Sharpening menu, 134 in alpha channel, 166 in Photoshop, 39-40 resolution and, 23 Brush panel and slider for, 242 Source pop-up menu, 115 creating and saving custom Normal blending mode, 196, brush tips, 293-294 Type color menu, 265 247, 399 options, 290-293 Merge button, 388 picking color, 294-296 Merge Shape Components option, 233 brush tips for, 297–300 Merge to HDR Pro, 388-394 color and, 300-303 Object Selection tool, 153 metadata, 124-125 tools for Offset sliders, 96 midtones, 83, 90, 95 Brush tool, 286-289 Oil Paint filter, 321-322 Minimize Clipping button, 96 Eraser tool, 289-290 opacity mirroring screens with iPad, 381 overview, 284-286 compositing images and, Mix field, 300 Pencil tool, 289 198-199 Mixer Brush, 298-300 on videos, 357-358 laver styles and, 251-254

of layers, 364

Modal Control column, 337

panels Search, Learn, and Help Pen Tool panel, 38 3D panel, 372 curved segments and, 222-226 Shape Dynamics panel, 291 Actions panel, 336 overview, 222 Styles panel, 237-239, 254-255 Audio fly-out panel, 356 Paths panel and, 226-229 Swatches panel, 294 Auto Corrections panel, 319 Pencil tool, 289 Texture pane, 292 Bokeh panel, 315 Performance preferences, 52 Timeline panel, 353-355 Brush Pose panel, 292 perspective, 201 Tool Presets panel, 263 Brush Settings panel, 286 Photo Filter command, 109-110 Transfer panel, 292 Brush Tip Shape panel, 291 Photomerge, 208-209 panoramas, 208-209 Channels panel, 118, 165 photos, 31-33 **PANTONE**, 57, 76 Character panel and, 266-270 Photoshop paragraphs Clone Source panel, 285 Actions in panel for, 266-270 Color Dynamics panel, 292 Batch command, 342-343 with type containers, creating. Color panel, 101-102 overview, 336-337 276-278 Discover panel, 40, 344 recording, 337-342 type of, 258 **Edit Panel** analyzing pixels in, 374–377 Pass Through blending Basic section, 134-136 basics of, 7-10 mode, 402 Calibration section, 141–142 blending modes in, 399-402 Patch tool, 175-176 Camera Raw Cancel color in Path from Selection button, 228 buttons, 142 depth, 102-104 paths Color Grading section, models, 101-102 combining, 232-233 138-140 modes, 98-101 creating with Pen Tool Color Mixer section, 138 overview, 97-98 curved segments, 222-226 Curve section, 136-137 computer operations and, overview, 222 Detail section, 137-138 10 - 12Paths panel, 226-229 Done button, 142 counting pixels in, 374–377 customizing, 229-231, 233-234 Effects section, 141 creating contact sheets in, overview, 211-213 Geometry section, 140-141 345-349 panel for, 42, 226-229 Open button, 142 customizing, 44-48 selecting, 230 Optics section, 140-141 Discover panel in, 344 shapes and Histograms panel, 82-84 functionality of, 8-9 changing appearance of hotkeys for, 44 images and, 11 layer, 219-220 Info panel, 119 installing, 14-15, 58 custom, 217-219 Layers panel, 42 keyboard shortcuts in, 12 Custom Shape tool, 216-217 Measurement Log panel, 375 launching, 10 multicolor shape layer, options for, 50 learning, 38-39 220-221 Paragraph panel and, 266-270 limitations of, 9-10 tools for, 214-216 Paths panel, 42, 226-229 measuring pixels in, 374-377 Pattern Overlay, 248–249 in Photoshop, 40-42 menus in, 39-40 Pattern Stamp tool, 285 Properties panel, 107, 214 mobile app for, 382-383 PDF. See Portable Document resizing, 41 **Format** panels in, 40-42

installing, 14-15 presentations in, 345-349 pixels preferences for, 54 analyzing, 374-377 saving files, 11-12 binary code and, 18 PNG file format, 34, 36 scanning multiple photos in, 349 point of rotation, 177 blending modes and, 399-402 scripts in, 350-351 clipping, 95-96 point type, 257 selective undo command, Polygon Constraint tool, 317 counting, 374-377 12 - 14Polygonal Lasso tool, 152-153 defined, 8 settings in dimension of, 13 Portable Document Format Color, 55-57 (PDF) file format interacting with, 18-20 Cursors, 52-53 creating, 78 measuring, 374-377 File Handling, 51-52 creating presentations with, resolution and 345-347 Guides, Grid & Slices, 54 defined, 21-22 overview, 33 History Log, 49 Image Size command, 23-27 printing and, 35 Interface and Preferences. overview, 22-30 50-51 portrait aspect ratio, 71 picking, 28-30 Performance, 52 posterization, 88, 103, 111 Place command, 355 Plug-Ins, 54 PostScript, 213 playhead, 355-356 Product Improvement, 55 PowerPoint, 35-36 plug-ins Scratch Disks, 52 preferences management Adobe Camera Raw Technology Previews, 55 Color, 55-57 Adjustment Brush tool, 130 Tools, 49-50 Cursors, 52-53 Before and After buttons. Transparency & Gamut, 54 File Handling, 51-52 126-127 Units & Rulers, 54 Guides, Grid & Slices, 54 Camera Raw Preferences Workspace, 50-51 button, 132 History Log, 49 specialized features of hotkeys for, 49 Color Sampler tool, 131 3D artwork, 372-374 Interface and Preferences, Crop tool, 127-128 50-51 Count tool, 376-377 Edit Panel, 134-142 Performance, 52 MATLAB, 378 Graduated Filter tool, Mean Stack Mode, 372 130-131 Plug-Ins, 54 overview, 369-370 Product Improvement, 55 histogram, 132 Scratch Disks, 52 using Smart Object stack overview, 126 modes, 370-372 Technology Previews, 55 presets, 133-134 Vanishing Point, 376 Tools, 49-50 preview area, 132–133 viewing DICOM medical Radial Filter tool, 131 Transparency & Gamut, 54 records, 377-378 Red Eye Reduction tool, Units & Rulers, 54 tools in, 42-43 129-130 for Wacom drawing tablet, 385 troubleshooting, 57-58 Rotate tool, 127-128 Workspace, 50-51 user interface (UI) of, 39-42 Sampler Overlay button, 131 presentations, 345–349 Photoshop Raw file format, 125 Spot Removal tool, 128–129 Preserve Luminosity check pin cushioning, 317 Trash button, 127 box, 108 Pin Light blending mode, 401 presets, 47-48, 133-134, 392 workflow options, 133-134 pins, 184-185, 314-315

preview area, 132-133 Raw files printer resolution, 21 Adobe Camera Raw plug-In and, 121-125 printing camera and, 11 alternatives to, 76-77 exposures and, 390-391 file formats for, 34-35 Reconstruct tool, 326 HDR images, 397-398 **Record Measurements** images button, 375 color, 74-76 recording Actions, 337-342 cropping to aspect ratio, Rectangular Marquee tool, 73 71-73 Red Eve Reduction tool, 129–130 resolution, 73-74 Red Eye tool, 174-175 **Product Improvement** preferences, 55 reducing noise, 23, 180, 320 Properties panel, 107, 214 Redundant Pixel Removal, 366 Protect Texture option, 293 Refine Mode option, 155 PSB file format, 33 reinstalling, 58 PSD file format Relative radio button, 113 overview, 31 Remember Settings option, 156 printing and, 35 Remove Distortion slider, 319 saving in, 11 Remove Distortion tool, 318 spot colors and, 105 Remove Ghosts option, 392 styles stored in, 271 Remove IPEG Artifact check box, 319 publishing software, 10 Remove IPEG Artifact Pucker tool, 326 option, 180 Pupil Size sliders, 129 removing unwanted objects, Puppet Warp feature, 183-184 181-185 Push Left tool, 326 renaming images, 69-71 rendering, 361-362, 374 O Replace blending mode, 401 Replace Color command, quarter tones, 91 116-117 Quick Selection tool, 153-154 Reposition option, 371 resampling, 25-26, 397 R Reselect command, 157 Radial Filter tool, 131 Reset adjustment button, 169

Image Size command and, 23-27 monitor resolution, 21 overview, 22-30, 134 picking, 28-30 printer resolution, 21 for printing, 73-74 for scanning, 63-64 Review previous adjustment button, 169 RGB mode, 55, 99 Rights-managed images, 62 Roman Hanging Punctuation option, 270 Rotate tool, 127-128 Rotate View tool, 288-289 rotating images, 187 Royalty-free images, 62 ruler, 54 Ruler tool, 187, 374

S

Sample All Layers option, 154 Sampler Overlay button, 131 Satin layer effect, 246 saturation, 130, 135-136, 393, 401 Save Selection command, 164 Save Statistics button, 116 saved path, 227 saving 3D scenes, 374 32-bit HDR images, 394 animations, 366 brush tips, 293-294 files, 11-12 masking and, 165 settings, 319 workspaces, 45 scale, 201, 213 Scale Effects command, 241

Reset option, 270

defined, 21-22

camera resolution, 21

image resolution, 21

resizing, 41

resolution

Radius sliders, 95, 155, 309, 392

raster image processor (RAP), 99

Range Mask feature, 130

raster, 20, 146-147, 212

ragged text, 277

Range slider, 250

Scale Styles check box, 24 marquee, 148-152 changing appearance of layer, 219-220 Object Selection tool, 153 scanning custom, 217-219 Ouick Selection tool, 153-154 moiré patterns and, 65-66 Custom Shape tool, 216-217 Select and Mask button. overview, 61-63 multicolor shape layer, 155-156 resolution for, 63-64 220-221 Selective Color command, 113 scattering, 292 tools for, 214-216 selective undo command, 12-14 Scratch Disks preferences, 52 sharing images, 77-78 Send 16-Bit Data option, 103 Screen blending mode, 196, sharpening Set Measurement Scale 247, 400 alpha channel, 166 options, 374 Screen Modes option, 50 filter for, 308 settings management scripts, 69, 335 Lab color mode and, 100 Color, 55-57 Search, Learn, and Help Cursors, 52-53 slider for, 130, 137 panel, 38 Shear filter, 332 search function, 39 File Handling, 51-52 Show Channels in Color Guides, Grid & Slices, 54 Select All command, 157 option, 50 Selection from Path button, 228 History Log, 49 Show Menu Color option, 50 Interface and Preferences, selections Show Sampling Ring option, 294 50 - 5132-bit HDR images and, 397 Sidecar, 124, 379-380 Performance, 52 adjustment layers and, 168-171 Similar command, 161 Plug-Ins, 54 anti-aliasing and, 146-148 Sky Replacement, 188 Product Improvement, 55 commands for Sky selection command, 161 Scratch Disks, 52 Color Range command, Technology Previews, 55 Smart Blur filter, 316 158-159 Smart Filters, 306-307 Edit in Quick Mask mode, Tools, 49-50 163-164 Transparency & Gamut, 54 Smart Guides, 54 Focus Area command, Units & Rulers, 54 **Smart Objects** 159-160 Workspace, 50-51 importance of, 194–195 mask-related, 164 masks and, 167 shadows, 83, 135 modification, 161 Shadows slider, 132 opening file as, 12 in Select menu, 157-158 stack modes, 370–372 Shadows/Highlights adjustment, Sky selection command, 161 93-97 Smart Radius option, 155 Subject selection Shadows/Highlights command, Smart Sharpen filter, 310-311 command, 160 113-114 smooth anchor points, 222 transformation, 161-163 Shake Reduction filter, 311-312 Smooth tool, 326 compositing images and, Shallow option, 253 Smoothing option, 293 201-204 Shape Dynamics panel, 291 Smudge tool, 117, 285 feathering and, 146-148 shape layer, changing Soft Light blending mode, hotkeys for, 68 appearance of, 219-220 197, 400 masks and, 164-167 shape path, 227 Soften Edge option, 159-160 overview, 144-146 shape tools, 213 source point, 284 tools for shapes Source pop-up menu, 115 lasso, 152-153 text and, 278-281 source state, 13 Magic Wand tool, 154 vectors and

Space Before/After option, 269 Space option, 133 special effects, 358-360 specifying frame rate, 366 specular highlights, 110, 178 Spherize filter, 332 Sponge tool, 175, 178, 285 spot channel, 296 spot colors, 105 Spot Healing Brush, 175-176 Spot Removal tool, 128-129 stacking order, 193 stacks, 69 Stamp tools, 285 static tips, 298 steroscopic images, 32 stock images, 62 stops, 302 Straighten tool, 127, 318 Strength slider, 392 stroke, 212 Stroke layer effect, 244-245 Stroke Path button, 228 Stroke Path command, 229 styles panel for, 237-239, 254-255 for text, 271 Subject selection command, 160 submenu, 39 subpaths, 232 subscriptions, 382 Subtract blending mode, 401 Subtract From button, 150 subtractive color mode, 99 Suitcase Fusion, 15 Surface Blur filter, 316 Swatches panel, 294 System Layout option, 270 System Preferences dialog box, 380-381

Т Targeted Adjustment tool, 137 **Technology Previews** preferences, 55 temperature in image, 109-110 Temperature slider, 135 text aligning, 276-277 Character panel and, 266-270 hyphenating, 277-278 justification and, 276-277 options for, 262-265 overview, 257-260 Paragraph panel and, 266-270 shaping, 278-281 steps for adding, 272-274 styles for, 271 type containers and, 274-278 type tools for, 260-262 Texture pane, 292 Texture slider, 135 Texturizer filter, 188 Thaw Mask tool, 326 three-quarter tones, 91 Threshold blending mode, 399 Threshold command, 111-112 Threshold slider, 309 thumbnails, 347-349 TIFF file format, 32, 34 Tilt-Shift filter, 315 Timeline panel, 353-355 Tint check box, 109 Tint slider, 135 titling in videos, 358-360 Toggle adjustment layer visibility button, 169 Toggle Sampler button, 131 tolerance, 154

changing exposure, 96 overview, 92-93 Shadows/Highlights adjustment, 93-97 toning tools, 96 Auto commands and, 84-85 defined, 81 eyedroppers and, 89-90 in Histograms panel, 82–84 Levels command and, 86-89 overview, 85-96 Tone and Detail option, 392 Tone Curve, 137 Tone sliders, 95 toning HDR images, 394-395 Toning tools, 285 Tool Presets panel, 263 Tools panel, 156 Tools preferences, 49-50 tracking, 281 Transfer panel, 292 Transform controls, 319 transforming anchor points, 162-163 layers in videos, 361 selections, 161-163 transitioning in videos, 358-360 transparency, 64, 198-199 Transparency & Gamut preferences, 54 Transparency Shapes Layer option, 253 Trash button, 127 troubleshooting, 57-58 Twirl Clockwise tool, 326 Type color menu, 265 type containers, 274–278 type layers, 261 type on a path, 258 type tools for text, 260-262

tonality

adjusting, 82, 90-92

Adjustments menu and

U

UI. See user interface UI Font Size option, 50 undo command, 12-14, 43 Units & Rulers preferences, 54 unsaved path, 227 Unsharp Mask filter, 308–309 Use Global Light option, 242 Use Selection in Source to Calculate Colors check box. 115 Use Selection in Target to Calculate Adjustment check box, 115 user interface (UI) of Adobe Camera Raw plug-In Adjustment Brush tool, 130 Before and After buttons. 126-127 Camera Raw Preferences button, 132 Color Sampler tool, 131 Crop tool, 127-128 Graduated Filter tool, 130-131 histogram, 132 overview, 126 presets, 133-134 preview area, 132-133 Radial Filter tool, 131 Red Eye Reduction tool, 129-130 Rotate tool, 127-128 Sampler Overlay button, 131 Spot Removal tool, 128-129 Trash button, 127 workflow options, 133-134 of Photoshop, 39-42

V

Vanishing Point, 204-208, 376 Vector Mask from Path button, 228 vectors creating with Pen Tool curved segments, 222-226 overview, 222 Paths panel, 226-229 customizing path of adding, deleting, and moving anchor points, 230-231 combining, 232-233 fonts, 233-234 overview, 229-230 masking with, 167 overview, 211-213 shapes changing appearance of layer, 219-220 custom, 217-219 Custom Shape tool, 216-217 multicolor shape layer, 220-221 tools for, 214-216 Vibrance command, 106-107 Vibrance slider, 135–136, 393 videos

painting on, 357–358
adding special effects to,
358–360
adjusting length of, 355–357
exporting, 361–362
importing, 354–355
rendering, 361–362
software for editing, 10

adding adjustment layers and

titling in, 358–360 transforming layers in, 361 transitioning in, 358–360 View option, 155 Vignette slider, 141, 319 visibility of layers, 364 Visual Basic, 350 Visualize Spots option, 129 Vivid Light blending mode, 400

W

Wacom drawing tablet, 384-385 Warp Text button, 265 warp type, 258 watercolor brush tips, 297-298 web design software, 10 web images, 28, 33-34, 78 web-safe colors, 296 Wet Edges option, 292 Wet field, 299 white point, 135 Whites slider, 132 Word, 35-36 word wrap, 274 work paths, 215 workflow options, 133-134 workspaces, 44-47

X

X-Rite, 57, 76

Z

zooming, 69, 318-319, 327

English State

See a see and the see as the see

PT THE STATE OF TH

Later Born Carl W

W. N. Constant

Says. Programme State.

The area was

An analysis of the second seco

Walley Jan Harry Land

15 Apr. 219 117

den by the

About the Author

Peter Bauer is a member of the Photoshop Hall of Fame and an award-winn fine-art photographer. He has authored more than a dozen books on Ade Photoshop, Adobe Illustrator, computer graphics, and photography. For more that two decades, he directed the Help Desk for the world's largest Photoshop user organization. Pete is also the host of video-training titles at Lynda.com and a contributing writer for *Photoshop User* magazine. He has contributed to and assisted on such projects as special effects for feature films and television, major book and magazine publications, award-winning websites, and fine-art exhibitions. He serves as a computer graphics efficiency consultant for a select corporate clientele, and shoots exclusive photographic portraiture. As a consultant, he analyzes photographic and video imagery to verify authenticity. Pete's prior careers have included bartending, theater, broadcast journalism, professional rodeo, business management, and military intelligence interrogation. Pete and his wife, Dr. Professor Mary Ellen O'Connell, of the University of Notre Dame Law School, live in South Bend, Indiana.

Author's Dedication

I have written (and John Wiley & Sons, Inc., has published) this book for you — the many who learn and live by the written word. Whether you're reading on paper or tablet, these words and illustrative figures were put here for you. There is no irony in the fact that you'll use these words to produce pictures.

Author's Acknowledgments

First, I'd like to thank Steve Hayes and the rest of the superb crew at John Wiley & Sons that put the book together (including Susan Christophersen). Next, of course, are the fabulous team at Adobe that actually puts Photoshop in our hands. Casey Atud, Stephen Nielson, and the others who participated in the briefings and forums were instrumental in ensuring that this book contained current information (as of the deadlines, of course). The soundtrack to which this book was updated featured Cody Jinks and The Tonedeaf Hippies. My faithful companions in the studio during the updated included the bulldogs Auggie and (the late) Oscar. Most of all, of course, I thank my wife, the amazing Dr. Prof. Mary Ellen O'Connell of the University of Notre Dame Law School. Her support as deadlines loomed was critical to the completion of this project. I hope I can return the favor someday.

dedgments

Hayes

tor: Susan Chistophersen

. Mark Hemmings

Debbye Butler

Production Editor: Siddique Shaik

Cover Image: Peter Bauer